SYMBOLS OF AMERICA

SYMBOLS OF AMERICA

Hal Morgan

A Steam Press Book

VIKING

VIKING
Viking Penguin Inc., 40 West 23rd Street,
New York, New York 10010, U.S.A.
Penguin Books Ltd, Harmondsworth,
Middlesex, England
Penguin Books Australia Ltd, Ringwood,
Victoria, Australia
Penguin Books Canada Limited,
2801 John Street, Markham
Ontario, Canada L3R 1B4
Penguin Books (N.Z.) Ltd,
182–190 Wairau Road,
Auckland 10, New Zealand

First published in 1986 by Viking Penguin Inc.
Published simultaneously in Canada

Nearly all of the designs and trade names in
this book are registered trademarks. All that are
still in commercial use are protected by United
States and international trademark law.

LIBRARY OF CONGRESS CATALOGING IN
PUBLICATION DATA
Morgan, Hal.
 Symbols of America.
 "A Steam Press book."
 Bibliography: p.
 1. Trade marks—United States. I. Title.
T223.V2M7 1986 602'.75 85-40560
ISBN 0-670-80667-6

Printed in the United States of America by
Kingsport Press, Inc., Kingsport, Tennessee
Set in Trump Mediaeval by DEKR Corporation,
Woburn, Massachusetts
Designed by Hal Morgan of Steam Press

CONTENTS

Introduction 7

Part I
VISIONS OF AMERICA
Patriotic Symbols 17
Animals 24
Plants 34
Maps and Landmarks 38
Famous Faces 43
Pioneers and Cowboys 46
Tall Tales 50
Race 52
War 64
Sports 66
The Language 68

Part II
SYMBOLS OF COMMERCE
Farming 74
Medicine 79
Hair 87
Tobacco 89
Liquor 96
Stores 102
Canned and Frozen Food 104
Beverages 112
Flour and Rice 121

Baking Needs 126
Breakfast 130
Condiments 135
Snack Food 136
Fruit and Vegetables 148
Bread 153
Restaurants and Hotels 154
Machinery and Electronics 161
Hardware 166
Oil 168
Transportation 173
Paint 182
Soap 184
Office Supplies 189
Clothing 192
Shoes 196
Insurance and Finance 198
Publishing and Entertainment 202
Sporting Goods 209
Trade Unions 210
Clubs and Groups 214
Sports Teams 218
Some Foreign Favorites 222

Acknowledgments 225
Bibliographic Notes 227
Index 229

INTRODUCTION

In 1893 the foreman at a North Dakota flour mill invented a hot breakfast cereal made from the cracked centers of wheat kernels. The mill owners gave him permission to make up a few packages as a trial shipment to their New York City broker, and, with the help of the other workers, he set about boxing some of the cereal to see if it would sell. Someone suggested the name Cream of Wheat, and the men carefully hand-lettered the words on the packages. To brighten the boxes up a little more, one of the owners found an old printing plate of a black chef with a spoon over his shoulder.

That test shipment of a few cartons of Cream of Wheat must, even then, have looked like a crude job of packaging. But it had all the elements necessary for success—a new product that turned out to be popular with the public, an appealing brand name, and a commercial symbol that made the package easy to identify and gave it a friendly personality to make up for its remote source. The chef who helped to pilot that success is still the Cream of Wheat trademark, though he's been modified slightly over the years.

By the 1890s the idea of adding picture symbols to packages was already well established. Procter & Gamble had been using a moon and stars design on its shipping crates and soap wrappers since 1851, the Arm & Hammer, Bull

Durham, White Owl, and Underwood devil trademarks had been introduced in the 1860s, and the 1870s and '80s had seen the birth of the Quaker Oats man, the Smith Brothers, the Baker's Chocolate waitress, the Coca-Cola signature, the Anheuser Busch eagle, and John Deere's leaping deer trademark. Symbols like these, and the many thousands that have followed, stand behind a tremendous number of American business success stories. These little pictures, which we accept as a familiar part of our daily lives, are at once a powerful economic force and a reflection of our cultural history. The stories of their beginnings and of the companies and products that they represent offer a portrait of American business since the middle of the last century.

Trademarks have roots that reach back to ancient pottery and stonemason's marks, which were applied to hand-crafted goods to identify their source. Pottery and clay lamps were sometimes sold far from the shops where they were made, and buyers looked for the stamps of reliable potters as a guide to quality. Marks have been found on early Chinese porcelain, on pottery jars from ancient Greece and Rome, and on goods from India dating back to about 1300 B.C. Stonecutters' marks have been found in Egyptian buildings from about 4000 B.C., but these

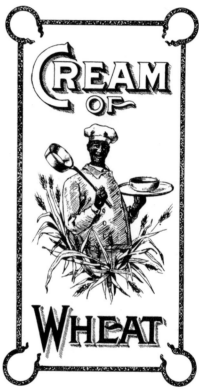

Cream of Wheat trademark, 1895

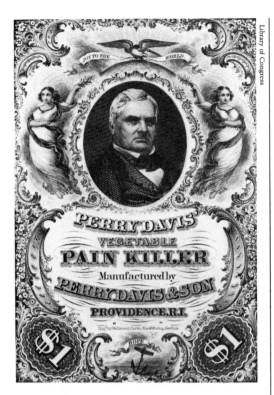

Library of Congress

Perry Davis' Vegetable Pain Killer label, 1854

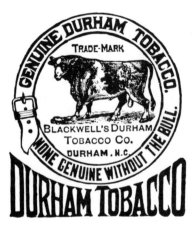

Bull Durham tobacco label, 1889

must have had a different purpose, perhaps as evidence in workers' wage claims. Livestock brands have also been used since ancient times, as can be seen in Egyptian wall paintings and European cave paintings. But these were marks of ownership rather than true trademarks, which are used in the trade of goods to identify their source.

In medieval times potters' marks were joined by printers' marks, watermarks on paper, bread marks, and the marks of various craft guilds. In some cases, these were used to attract buyer loyalty to particular makers, but the marks were also used to police infringers of the guild monopolies and to single out the makers of inferior goods. An English law passed in 1266 required bakers to put their mark on every loaf of bread sold, "to the end that if any bread be faultie in weight, it may bee then knowne in whom the fault is." Goldsmiths and silversmiths were also required to mark their goods, both with their signature or personal symbol and with a sign of the quality of the metal. In 1597 two goldsmiths convicted of putting false marks on their wares were nailed to the pillory by their ears. Similarly harsh punishments were decreed for those who counterfeited other artisans' marks.

By the time Europeans began to settle in North America, the concept of trademarks had been established. But it was not until the nineteenth century, when dramatic changes occurred in the way goods were made and sold, that trademarks and package labels grew into a strong, positive factor in the American economy. As individually packaged goods replaced bulk-packed merchandise, manufacturers found a new sign board—the wrappers, boxes, and labels—on which to promote their names to customers. And as the practice of advertising ma-

tured, industry found itself selling brand names directly to the public, rather than hoping the retail merchant would do the job.

The makers of patent medicines pioneered in the merchandising of packaged brand-name goods through the first half of the nineteenth century. Names like Swaim's Panacea, Fahnestock's Vermifuge, and Perry Davis' Vegetable Pain Killer became well known to the public in the years before the Civil War. By their nature, the potions were suited to packaging in small bottles, and because they were not necessities, the drugs had to be promoted. The money spent on advertising the quack medicines kept many American newspapers afloat. To be sure buyers picked out the right bottle from the rack of patent medicines in a store, the manufacturers printed elaborate and distinctive labels, often with their own portrait featured in the center.

Tobacco manufacturers also broke ground in the use of brand names and marks. The Virginia and North Carolina tobacco crop had been grown for export from the early 1600s, and through the first half of the nineteenth century, manufacturers packed bales of tobacco under labels such as Smith's Plug and Brown and Black's Twist. In the 1850s many manufacturers found that more creative names helped to sell their tobacco. Cantaloupe, Rock Candy, Wedding Cake, and Lone Jack are among the inventions of that decade. During the 1860s the manufacturers began to package their wares in small bags instead of bales, for sale directly to the consumer. Their experiments with picture labels and decorations to make the packages attractive led to such trademark symbols as the Durham bull.

Other merchandise soon followed the path laid down by patent medicine and tobacco, as the Industrial Revolution shifted production

from the hands of local artisans and farmers to the machines of larger and more remote factories. As late as 1860, most people either made their own clothes, had them made by a tailor, or bought them secondhand. By 1900 most Americans bought clothes ready-made, sewn in standardized sizes at distant factories and shipped to local stores. Brand names and labels assured the buyers that the goods came from a reliable source. Mid-century painters mixed their own paints from ingredients such as linseed oil, white lead, and pigments, but by 1900 they had come to rely on factory-mixed tins of paint for a more consistent level of quality. Before the Civil War, shoppers bought their food from open bins and barrels at a general store. By 1900 they could choose from hundreds of boxed, bagged, and canned foods bearing nationally distributed brand names. Twenty years later they were buying their food at supermarkets, where they chose their food from open shelves without help or advice from the grocer.

In the course of sixty years, from 1860 to 1920, factory-produced merchandise in packages largely replaced locally produced goods sold from bulk containers. This change brought with it the widespread use of trademarks. A local merchant who sold candles that he made himself had no need for an identifying mark. People bought their candles directly from him, and in his shop there was no question of who made the candles or how good they might be. But Procter & Gamble made candles in Cincinnati and shipped them to merchants in other cities along the Ohio and Mississippi rivers. In 1851 wharf hands began to brand crates of Procter & Gamble candles with a crude star; the firm soon noticed that buyers downriver relied on the star as a mark of quality. Merchants refused the can-

dles if the crates arrived without the mark. So Star brand candles were marked with a more formal star label on all packages and began to develop a loyal following.

As the use of brand names and marks spread, so did the practice of package imitation. Any well-known brand or mark was prey for unscrupulous counterfeiters, who took advantage of the public's carefully earned faith in a product. Medieval law had protected the public from the worst of these abuses, but protection for the trademark owners was much longer in coming. The U.S. Constitution provided rights of ownership in copyrights and patents but made no mention of trademarks. In 1791 Secretary of State Thomas Jefferson considered the request of a Boston sailcloth maker named Samuel Breck to be allowed the exclusive use use of a mark on his goods. Jefferson reported to Congress that it would "contribute to fidelity in the execution

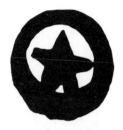

Two versions of the Procter & Gamble trademark: top, about 1851; bottom, 1875

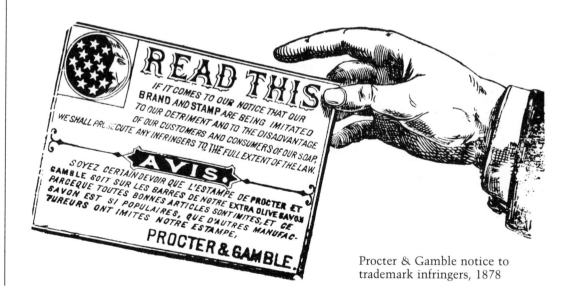

Procter & Gamble notice to trademark infringers, 1878

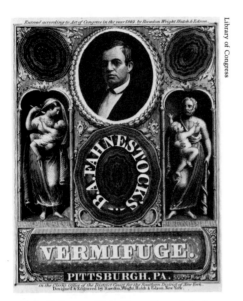

B.A. Fahnestock's Vermifuge label, registered with the District Court of Southern New York in 1849

Underwood devil, 1870

of manufacturing, to secure to every manufactory, an exclusive right to some mark on its wares, proper to itself." With the allowance that federal protection could only extend to those marks "which relate to commerce with foreign nations, and among the several States, and with the Indian Tribes," he recommended a system of registration at the various district courts.

Until 1870 this was the procedure followed by those who wanted formal protection for their marks and labels, though the law behind such registrations remained confused. Many mistakenly thought that protection fell under the copyright clause of the Constitution, which granted Congess the power "to promote the Progress of Science and useful Arts, by securing for limited Times to Authors and Inventors the exclusive Right to their respective Writings and Discoveries." But as manufacturers did not really qualify as "Authors and Inventors," and as the rights to trademarks remained in force as long as the marks were used, and not "for limited Times," the arrangement rested on a shaky foundation. Nevertheless, a steady flow of marks and labels came into the district courts for registration, growing steadily in volume through the 1840s, '50s, and '60s.

Congress finally separated the registration of trademarks and labels in 1870, with the enactment of the country's first federal trademark law. Under the law, registrants were required to send a facsimile of their mark, with a description of the type of goods on which it was used, to the Patent Office in Washington, along with a $25 fee. One of the first marks submitted to the Patent Office under the new law was the Underwood devil, which was registered to William Underwood & Company of Boston on November 29, 1870, for use on "Deviled Entremets."

The registrations that have come into the Patent Office—now the Patent and Trademark Commission—over the decades since 1870 have provided the basic source of artwork for this volume. From the very beginning, Patent Office rules required a clear drawing of the design on a ten- by fifteen-inch sheet of stiff, calendered paper. An 1877 copy of the regulations further specified that "all drawings must be made with the pen only, using the blackest India Ink. Every line and letter (signatures included) must be *absolutely black.* . . . All lines must be clean, sharp, and solid, and they must not be too fine or crowded." These drawings, now numbering well over a million, have been saved, along with the addresses of the registrants and the information about use required with registration.

That first trademark law lasted only nine years before the Supreme Court ruled it unconstitutional, challenging its basis in the copyright clause. A new law, drafted in 1881, was grounded in the commerce clause, which gives Congress the power "to regulate Commerce with foreign Nations, and among the several States, and with the Indian Tribes." The lawmakers had apparently been cowed by the Supreme Court's 1879 ruling, as they did not take full advantage of the clause's power and provided protection only for trademarks "used in commerce with foreign nations or with the Indian tribes." The 1881 law held sway until replaced in 1905; we can only imagine the favorable terms manufacturers must have given to Indians in order to meet the conditions of trademark registration.

Major revisions of the trademark law were enacted in 1905 and 1946, expanding protection to marks used in interstate commerce and closing many of the gaps found in the earlier laws. The

Lanham Act of 1946, for instance, allowed federal registration of service marks—marks used to designate services rather than products—and collective marks, such as union labels and club emblems. Some of these marks had been in use without federal trademark protection since the nineteenth century.

The protection afforded trademarks by the laws from 1870 on encouraged manufacturers to rely on them more and more heavily as business tools. Companies learned that a well-advertised and carefully managed trademark could be built into a valuable asset, one that attracted and held a loyal customer following. The commercial symbols became the public faces, or personalities, of the products and companies they represented. People imbued the trademarks with all that they knew or felt about the business behind them, based on reaction to the package and trademark, experience with the product, and the messages and images given by advertising. If public reaction to the symbols was positive, manufacturers could count on a reliable base of business.

This awareness of the importance of trademarks grew slowly over the last part of the nineteenth century, keeping pace with the growing understanding of the power of advertising. By 1898, when the giant National Biscuit Company introduced its first nationally sold cracker, one of the company's first considerations was to create a picture symbol for the brand. The symbol the firm came up with, the Uneeda biscuit slicker boy, made a dramatic debut in a series of spectacular magazine advertisements.

Commercial symbols, such as the Uneeda biscuit boy and the Quaker Oats man, have since grown tremendously in number, and companies now recognize their importance in helping to form a lasting bond between a product and the consumer. In a sense, the symbols have stepped into the shoes of the old merchant/tradesmen— the familiar local figures who sold a town its food and other goods in the days before packaged national brands. The marks offer a personal connection, however tenuous, to the distant factories that produce the goods we buy. While we can no longer go into a village store and count on buying the same locally made soap that we bought last year—as people could in the early part of the last century—we can find Ivory soap or Bon Ami cleanser in any supermarket and be assured that they will be just like the packages of the same brand that we bought ten, twenty, or thirty years ago.

In 1904 Nabisco ran an ad in *The Ladies' Home Journal* to boast of its success with Uneeda Biscuits, which, at least in part, was due to the appeal of the slicker boy:

> *When San Francisco folks are eating Uneeda Biscuits for breakfast, New Yorkers are having them for lunch, and the people in between are just getting hungry for more. We were right when we said to the whole country, "Uneeda Biscuit."*

The ad points up the great shift that was then taking place in America. Foresighted companies were connecting thousands of isolated local markets into a lucrative national one, and holding the loyalty of customers through advertising, consistent product quality, and the careful use of trademarks.

Uneeda biscuit slicker boy, 1898
Warshaw Collection, Smithsonian Institution

Time to Re-tire?
Fisk Tire boy, 1907

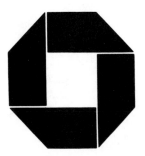

Chase Manhattan
Bank trademark,
1960

Many early trademarks were created by the founders of the companies, or by people involved with the businesses in their starting years. The Coca-Cola signature was penned in 1887 by Frank Robinson, the company's bookkeeper, who happened to have some experience in calligraphy; William Danforth, the founder of the Ralston Purina Company, chose the checkerboard symbol because of a boyhood memory; and many early businessmen decided to put their own portraits on their packages. But with the growing awareness of the importance of trademarks came the involvement of design professionals in the process of trademark selection. The advertising manager for Sherwin-Williams & Company created the famous Cover the Earth trademark in 1895, and a young advertising artist named Burr E. Giffen sketched the Fisk Tire boy in 1907. N.W. Ayer & Son, one of the country's leading advertising agencies, created the Uneeda biscuit slicker boy for the National Biscuit Company in 1898, and one of Ayer's advertisements became the Morton Salt girl in 1914.

In the 1930s professional industrial designers began to rework packages and trademarks to make a company's entire line of products compatible and identifiable. William O'Neill created a strong and spare oval trademark for Esso oil products in 1937, as part of a design program that covered oil cans as well as gas station signs. Jim Nash redesigned the McCormick spice packages in 1938, the prominent feature being a bold, modern "Mc" symbol that identified the packages instantly on grocery store shelves.

In the 1940s and '50s this emphasis on product-line design spread to include all of a company's operations, from delivery trucks to business cards to television advertising. The trademark became the focal point of a growing number of corporate-image makeovers as companies were made to realize just how exposed they were to the public eye. Raymond Loewy—designer of the 1934 Hupmobile, the 1940 Greyhound bus, and the modern Lucky Strike package—created the International Harvester and TWA logos as part of major corporate-identity programs; Paul Rand's work for IBM included not just a new trademark but a philosophy of advertising and package design. Lippincott & Margulies, the country's biggest corporate-design firm, is responsible for the trademarks of Chrysler, Amtrack, Weyerhaeuser, and U.S. Steel, all created as elements in carefully planned corporate-identity systems.

Accompanying this shift in thought about the scope of trademark applications—from one geared to packages and print advertisements to one that encompassed electronic media and all of a company's business activities—came an equally dramatic change in ideas about design. After World War II the representational images of the nineteenth century began to give way to abstract designs inspired by the spare, geometric forms of the Bauhaus. Some of these modern designs are quite striking in their clarity and simplicity. The octagonal symbol of the Chase Manhattan Bank, created by Chermayeff & Geismar Associates in 1960, is a classic example of good, strong design, perfectly suited to the wide range of applications for which it was created. But the abstract modern style has also brought a flood of less inspired imitations and marks that do not serve their purpose as distinctive and readily identifiable symbols. Many of

the banking and insurance marks that followed the Chase Manhattan Bank's design are confusing in their similarity (see page 201).

In this evolution from quaint, homemade package designs to deeply self-conscious corporate-identity programs, trademarks have perhaps simply followed the movement of the corporations they represent—many of which have changed from single-product firms to businesses with wide and divergent interests. But in the process we have lost, or almost lost, many wonderful and popular designs. Mobil's Pegasus and RCA's Nipper were largely abandoned in the 1960s as too old-fashioned and not representative of the companies' desired images in the modern marketplace. Borden's Elsie the Cow symbol was also dropped for a time, until a market-research study showed that shoppers liked Elsie and wanted her back. And recently, the Prudential Insurance Company's Rock of Gibraltar symbol has been restyled into an abstract and barely recognizable wedge.

The aim of the trademark designer is to create distinctive and memorable symbols that promote a positive image of the companies and products they represent. Clearly, the great variety of design styles encompassed by the trademarks in circulation today helps to promote the effect of recognizable individuality. Many of the older designs have earned the status of cherished relics of the American past and are effective sales tools because of their long histories. And many of the newer marks are equally effective in conveying the images of companies with more modern outlooks.

The designs in this book have been selected for both historic and artistic merit. The choice has ultimately been a subjective one, but an effort was made to include the best-known marks from a broad range of industries to illustrate both the growth of those businesses and the evolution of trademark design. Since the emphasis of the book is on symbols rather than words, many famous brand names have been passed over in favor of picture trademarks.

Together, these trademark designs form a panoramic image of American popular culture. They celebrate our excitement over such great national events as the Klondike gold rush, the westward movement, and our entries into World War I and World War II. They play up to our infatuations with baseball, cowboys, the founding fathers, log cabins, the Old South, and such all-American creatures as buffaloes, grizzly bears, alligators, and bald eagles. And they trace our changing attitudes toward racial and ethnic minorities. Many of the symbols have become so famous that they are key elements in our national culture, and are among our most important ambassadors abroad—the Coca-Cola symbol, the golden arches of McDonald's, the Heinz keystone and pickle, the Camel cigarette package, and the Levi Strauss two-horse label.

On a more personal level, trademark and package designs form an important part of our experience of being Americans. These are the symbols—the personalities—of the products we have bought, of the food we have eaten, and of the companies that we have relied on throughout our lives.

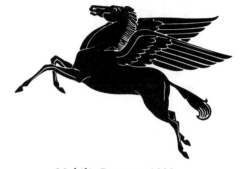

Mobil's Pegasus, 1933

Part One

VISIONS OF AMERICA

NOTE: The date given for each design is the year in which application was made for trademark registration. In some cases the design was in use many years earlier.

Cigar box label, date unknown

Patriotic Symbols

Uncle Sam, the bald eagle, the American flag, the Capitol dome, and the Statue of Liberty are all symbols of the United States. We connect them in our minds to our image of and feelings about the country, often in an idealistic sense. And because those feelings and thoughts are generally positive, merchants and manufacturers have frequently used patriotic imagery to attract instant goodwill to their products. Uncle Sam has sold coffee, whiskey, shoes, and even pesticides, while the bald eagle has been roped into the promotion of beer, laundry starch, and embalming fluid. Nineteenth-century businessmen also wrapped the American flag around their merchandise with abandon, but a revised trademark law in 1905 specifically forbade registration of the flag as part of a commercial mark or label, since its use suggested that the federal government was somehow involved in a product's manufacture.

(A) **Liberty skin purifier,** F. Levy, New York, New York

(B) **Homer Laughlin pottery ware,** East Liverpool, Ohio. The symbol represents the triumph of American pottery over British imports. This is the company that later made Fiesta Ware pottery.

(C) **American files and rasps,** Nicholson File Company, Providence, Rhode Island

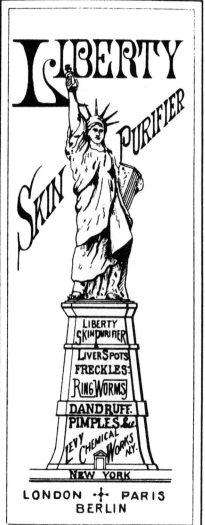

(A) 1885

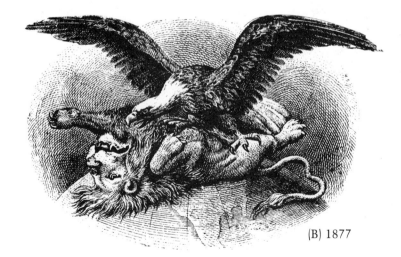

(B) 1877

(C) 1923

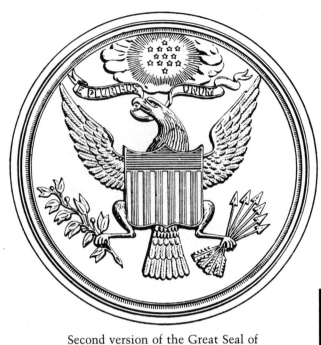

Second version of the Great Seal of the United States, cut in 1841

(A) 1942

(B) 1938

American Mutoscope & Biograph Company
11 E. 14th St. New York, N.Y.

(C) 1905

The bald eagle first appeared as an American icon on the Great Seal of the United States in 1782. The eagle had not been an important American symbol prior to its adoption for the seal, and it took some false starts before it finally won that spot. The Continental Congress, at the same July 4, 1776 meeting that ratified the Declaration of Independence, assigned Thomas Jefferson, Benjamin Franklin, and John Adams the task of drawing up an official national seal. The three men had some trouble reaching a consensus. Jefferson wanted an elaborate scene of the Pharaoh pursuing Moses and the Israelites through the parted waters of the Red Sea. Franklin inclined toward the classical, with Virtue and Sloth vying for the attention of Hercules. Eventually, they agreed on a sketch of Liberty and Justice flanking a shield with the coats-of-arms of the various countries from which the colonists had come.

Congress heard their recommendation on August 20, 1776, but decided to give the matter more thought. A second committee, in 1780, suggested a seal with a thirteen-stripe shield supported by Peace and a warrior, with a cluster of thirteen stars overhead. Again, the idea was put on hold. Charles Barton of Philadelphia drew up a modified version in May 1782 that included a tiny eagle over the shield, but his proposal, too, was rejected. Finally, in June 1782, Charles Thomson, secretary of Congress, took matters into his own hands and sketched a design with a bald eagle as the central element. Its wings and legs were outstretched. In its claws it clutched an olive branch and a cluster of thirteen arrows, and in its beak a banner with the motto *E Pluribus Unum.* This proposal, at last, met with the approval of Congress. The design was officially adopted on June 20, 1782, and the bald eagle, by vote of Congress, became the national bird.

(A) Pitney-Bowes postage meters, Pitney-Bowes, Inc., Stamford, Connecticut
(B) American Presidential Lines, Ltd., Oakland, California
(C) American Mutascope and Biograph films, American Mutascope and Biograph Company, New York, New York

(A) Lithocarbonized articles, Ira Taylor, New York, New York

(B) Honest Dollar guano, R.A. Woolridge & Co., Baltimore, Maryland

(C) Imperial embalming fluid, Imperial Fluid Company, Syracuse, New York

(D) United States Postal Service, Washington, D.C.

(E) Union malt liquor, Union Brewing Company, Rochester, New York

(F) Liberty Bell toilet paper, Scott Paper Co., Philadelphia, Pennsylvania

(A) 1891

(B) 1889

(C) 1898

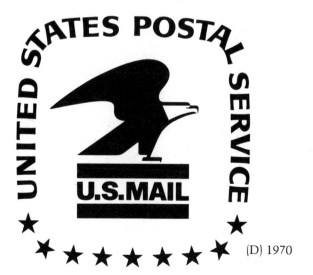

(D) 1970

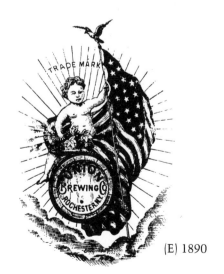

(E) 1890

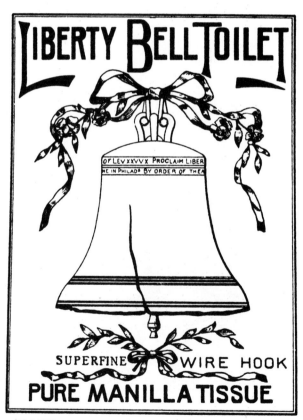

(F) 1905

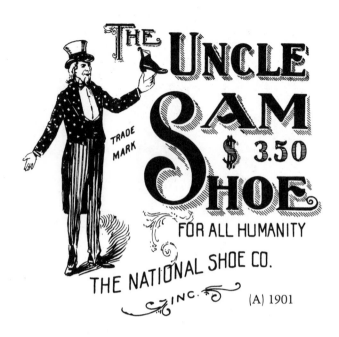

THE UNCLE SAM $3.50 SHOE

TRADE MARK

FOR ALL HUMANITY

THE NATIONAL SHOE CO.

INC.

(A) 1901

Uncle Sam's

(B) 1921

(C) 1901

MADE IN U.S.A.

TRADE MARK

(D) 1900

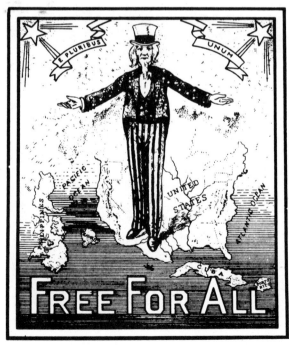

E PLURIBUS UNUM

PACIFIC OCEAN

UNITED STATES

ATLANTIC OCEAN

PHILIPPINES

CUBA

PORTO RICO

FREE FOR ALL

(E) 1901

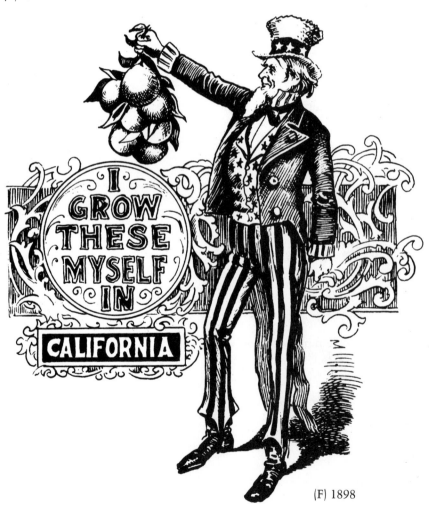

I GROW THESE MYSELF IN CALIFORNIA

(F) 1898

Uncle Sam, the cartoon personification of the United States, made his debut during the War of 1812. There is some evidence to suggest that the name came from a Troy, New York, meat packer who supplied provisions to the U.S. Army during the war. According to accounts set down much later, workers at Samuel Wilson's packing plant joked that the initials US, which they stamped on the barrels of meat, stood for "Uncle Sam" Wilson. At a distance of more than a hundred and sixty years, it is difficult to pin the name with any certainty to Wilson, but the use of the nickname Uncle Sam for the United States did begin during the War of 1812, and it is entirely possible that Wilson's plant was the source. Congress was satisfied enough with the story that it adopted a resolution in 1961 hailing Wilson as "the progenitor of America's national symbol." His gravestone at the Oakwood Cemetery in Troy is inscribed, "In loving memory of 'Uncle Sam.'"

The familiar picture of Uncle Sam, a tall, thin gentleman with a white goatee, striped pants, and a top hat, took many years to evolve. During the American Revolution, the British introduced two derisive caricatures of the typical American—Brother Jonathan and Yankee Doodle. Yankee Doodle showed up in type more than he did in pictures, but Brother Jonathan appeared in political cartoons as the gawky country-bumpkin adversary of England's portly John Bull. He eventually took on the characteristic garb of top hat and morning coat and the American pastime of whittling. When Uncle Sam arrived during the War of 1812, cartoonists began to use him interchangeably with Brother Jonathan, and gradually Uncle Sam became the preferred symbol.

Uncle Sam really came into his own during the Civil War. His lean frame lent itself to caricatures of Abraham Lincoln, and over the course of the war he took on many of Lincoln's features, most notably his beard. He also began to appear more regularly in the familiar striped trousers. Thomas Nast, America's most popular political cartoonist in the years just after the Civil War, gave Uncle Sam his more mature white hair and beard, and by his consistent treatment helped to fix a standard look and outfit.

(A) **The Uncle Sam shoe,** National Shoe Co., Inc., Boston, Massachusetts
(B) **Uncle Sam's exterminating chemicals,** Uncle Sam Chemical Company, New York, New York
(C) **Yankee Doodle macaroni,** James H. Baker, Kansas City, Missouri
(D) **Made in U.S.A. boots and shoes,** W.W. Spaulding & Co., Haverhill, Massachusetts
(E) **Free For All fabrics,** Grinnell Willis, New York, New York
(F) **Riverside Navel Orange Company,** Riverside, California
(G) **Uncle Sam's coffee,** Faxon Brothers, Boston, Massachusetts

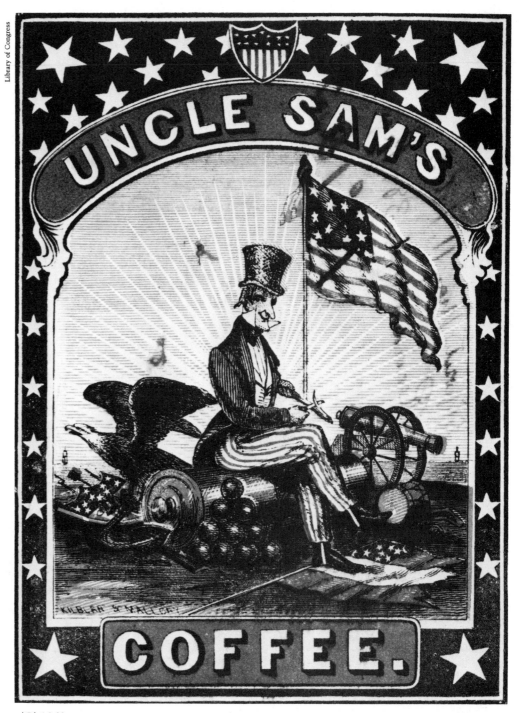

(G) 1863

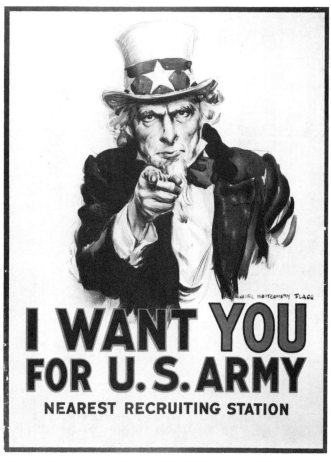

James Montgomery Flagg's World War I recruiting poster, painted in 1917

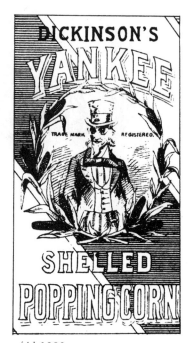

(A) 1893

Perhaps the most famous of all the renditions of Uncle Sam is the one painted by James Montgomery Flagg for a World War I recruiting poster, with the message "I Want You for the U.S. Army." Flagg's Uncle Sam is so immediate and so powerfully direct that the Army has called his pointing finger back into service over and over again.

(A) Yankee shelled popping corn, The Albert Dickinson Company, Chicago, Illinois
(B) Uncle Sam cleanser, Lexington Manufacturing Co., Baltimore, Maryland
(C) Uncle Sam ale, Conway Bros. Brewing & Malting Co., Troy, New York
(D) Lexington electrical apparatus, Lexington Electric Products Co., Inc., Newark, New Jersey

(B) 1905

(C) 1906

(D) 1947

22

(A) **Liberty rice,** Pacific Trading Co., Inc., San Francisco, California
(B) **Capitol carbon paper,** Interchemical Corporation, New York, New York
(C) **Capitol Mills knitted hosiery, undershirts, and drawers,** Guy, Curran & Co., Washington, D.C.
(D) **Betsy Ross flour,** International Milling Company, Minneapolis, Minnesota
(E) **Capitol grooved phonograph records,** Capitol Records, Inc., Los Angeles, California
(F) **Plymouth Rock phosphated gelatine,** Plymouth Rock Gelatine Co., Brighton, Massachusetts

(A) 1929

(B) 1948

(C) 1906

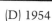

(D) 1954

(E) 1955

(F) 1905

Animals

(A) 1756

Soon after the **(A,B) Hudson's Bay Company** received its charter to extend trade into North America from Hudson Bay in 1670, it adopted a coat of arms to represent its primary interest in furs. Since the company was based in London, the animals chosen for the crest were natives of both Europe and America—symbolic of the fur trade in the New World, but familiar to English patrons. Two elks hold the crest, decorated with four beavers inside and a fox on top. Early versions of the crest gen-erally depict a fine fox, and strange-looking sets of elk and beaver. For though the last two animals are European natives, they had been all but extinct there for centuries, and knowledge of them had come down largely through medieval bestiaries. Slowly, as the company learned more about its territory and became more familiar with the animals it hunted, the beavers on the crest began to look less like rats or hedgehogs and more like true beavers. The elk took much longer to come around. Through the nineteenth century they were drawn as various forms of deer, rather than the proper European elk, which has its counterpart in the American moose. A pair of real elk, or moose, finally took charge in 1927.

During its evolution to zoologically correct beavers and moose, the Hudson's Bay Company emblem also changed from a decorative heraldic device to a true trademark, used to identify the company's products and business activities. The assembled creatures on the mark seem to announce themselves as native Canadians, and make clear that the company they represent has a long heritage in the northern fur trade.

Many other companies have used the strong identifying characteristics of native animals for their trademarks. Moose have been used to suggest that a product is Canadian-made, or from the north woods of Wisconsin or Maine; pelicans and alligators have been used as marks for businesses in Florida and the Gulf Coast states. Certain animals have ties to particular states—badgers to Wisconsin, bears to California, and buck deer ("buckeye") to Ohio—and they show up over and over as trademarks.

(C) Brown Moose boots, Badger State Tanning Company, Sheboygan, Wisconsin

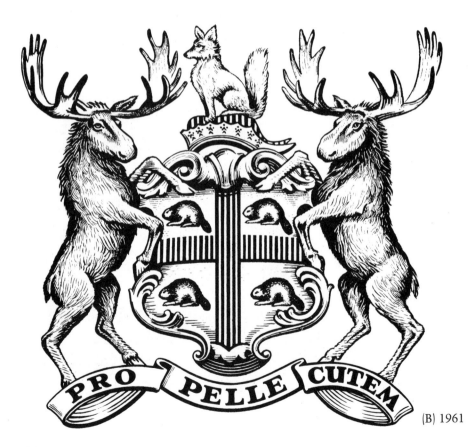

(B) 1961

(C) about 1920

(A) Heron Brand oranges, A.W. Price, Pierson, Florida
(B) Moosehead beer, Moosehead Breweries Limited, Dartmouth, Nova Scotia
(C) Buckeye binder twine, Aultman, Miller & Company, Akron, Ohio
(D) Lumen nonferrous alloys, Lumen Bearing Company, Buffalo, New York
(E) Beaver Brand cheese, Anton C. Thuraas, Minneapolis, Minnesota
(F) Pinene medicated plasters, Robert Thomas Jr., Thomasville, Georgia

(A) 1889

(B) 1979

(C) 1887

(D) 1905

(E) 1893

(F) 1900

25

(A) 1905

KENWOOD

WOOL
PRODUCTS
Classic

(B) 1938

(A) **Red Fox wheat flour,** Sweet Springs Milling Company, Sweet Springs, Missouri

(B) **Kenwood wool products,** F.C. Huyck & Sons, Rensselaer and Albany, New York

(C) **Three Crow baking soda,** John Bird Company, Rockland, Maine

(D) **Robin's Best wheat flour,** Robinson Milling Company, Salina, Kansas

(E) **Badger canned corn,** P. Hohenadel Jr., Janesville, Wisconsin

(F) **Bob White fertilizer,** American Fertilizing Company, Norfolk, Virginia

(C) 1907

(D) 1936

(E) 1905

BOB WHITE
FERTILIZER

(F) 1906

(A) **Frogline hats,** J.T. Asch & Sons, New York, New York

(B) **Razorback hand-operated tools,** Union Fork & Hoe Company, Columbus, Ohio

(C) **Kernels cigars,** L.S. Palmer, Belmont, Ohio

(D) **Wild Pigeon mineral water,** Wild Pigeon Mineral Springs Company, Portland, Oregon

(E) **Possum canned sardines,** Seacoast Canning Company, Eastport, Maine

(F) **Squirrel Brand nuts and candy,** Squirrel Brand Company, Cambridge, Massachusetts

(B) 1937

(C) 1906

(A) 1914

(D) 1906

(E) 1925

(F) 1913

27

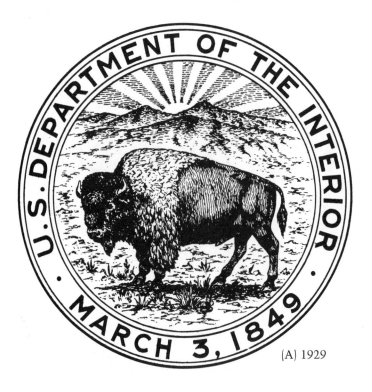

(A) 1929

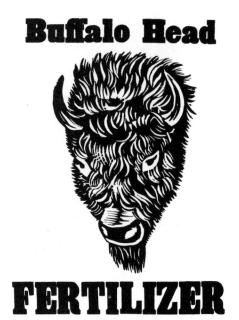

Buffalo Head

FERTILIZER

(B) 1878

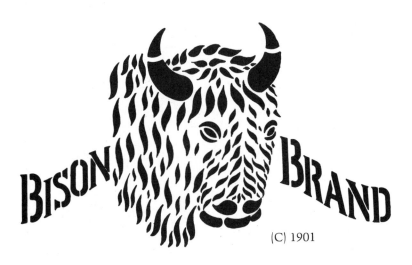

(C) 1901

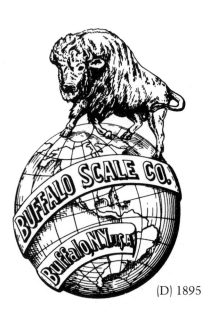

(D) 1895

The American bison, or buffalo, one of the most distinctive North American creatures, is firmly connected with the history of westward expansion. Because of its romantic image and its American range, the bison has rivaled the bald eagle as a subject for trademark artists.

It is a sad irony that during the very years the bison was gaining commercial fame on trademarks for pottery, tobacco, cotton goods, and machinery, it was being destroyed in the wild in a systematic, brutal slaughter. Bison once ranged from the Sierra Nevadas east to the Atlantic Coast, with their principal concentration on the Western plains. By 1800 the animal had been exterminated east of the Mississippi River. Then hunters turned their attention to the huge herds on the plains, encouraged by a government that reasoned that the Plains Indians would be more easily subdued if deprived of their most important source of food. Between 1850 and 1885 as many as one hundred million plains bison were slaughtered. By 1890 the bison had been brought to the brink of extinction. Only the efforts of conservationists saved the few remaining herds.

(A) Department of the Interior Seal
(B) Buffalo Head fertilizer, Ames, Manning & Ames, Hagerstown, Maryland
(C) Bison Brand cotton seed oil, Elbert & Gardner, New York, New York
(D) Buffalo measuring scales, Buffalo Scale Company, Buffalo, New York
(E) Buffalo stock food, Corn Products Manufacturing Company, Chicago, Illinois
(F) Iron Stone earthenware, Knowles, Taylor & Knowles, East Liverpool, Ohio
(G) Buffalo smoking tobacco, August & Mitchell, Richmond, Virginia

(E) 1907

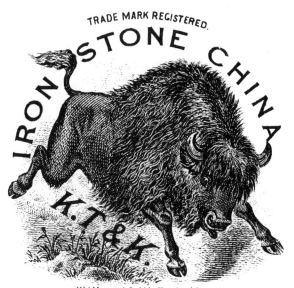

TRADE MARK REGISTERED.

IRON STONE CHINA

K.T&K.

W.J.Morgan & Co.Lith.Cleveland,O.

(F) 1877

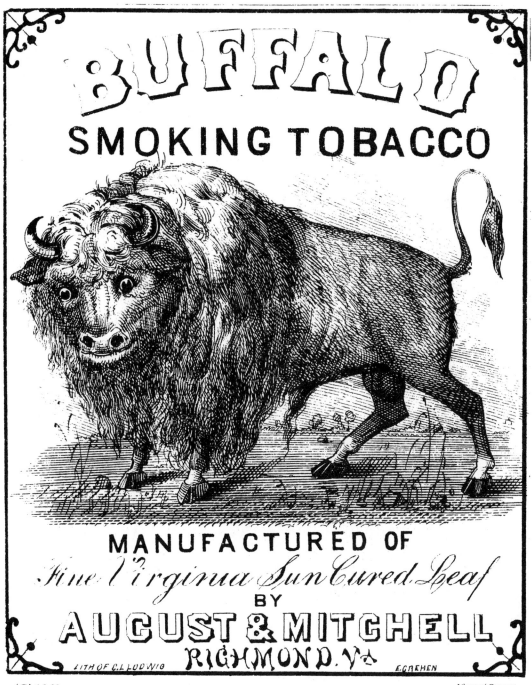

BUFFALO

SMOKING TOBACCO

MANUFACTURED OF

Fine Virginia Sun Cured Leaf

BY

AUGUST & MITCHELL

RICHMOND, Va

LITH OF C.L.LUDWIG

E.OREHEN

(G) 1868

In 1944 Walt Disney's Bambi was used on a Forest Service poster to spread the idea of forest fire prevention. The poster was so popular and successful that the Forest Service, with the guidance of the Wartime Advertising Council, decided to create its own cartoon animal to continue the campaign. Albert Staale, an artist with a specialty in cocker spaniel paintings, was hired to draw a bear to be used on a series of posters. The animal had to fill a list of specifications: "nose short (Panda type), color black or brown; expression appealing, knowledgeable, quizzical; perhaps wearing a campaign (or Boy Scout) hat that typifies the outdoors and the woods." Staale's solution was a handsome, upright brown bear named Smokey.

(A) Smokey Bear first appeared on a 1944 poster, dousing a campfire with a bucket of water. Three years later he spoke his famous line, "Remember, only YOU can prevent forest fires!" He is now a protected symbol of the Forest Service, endowed with special trademark status by an act of Congress.

The poster Smokey has a live counterpart in a "living symbol" at the National Zoo in Washington, D.C. The first live Smokey was a black bear cub rescued from a fire in New Mexico's Lincoln National Forest in 1950. The badly burned cub was nursed back to health at a ranger station, then donated to the zoo in Washington so that he could help spread Smokey's message. Since then, there has always been a living symbol of Smokey Bear at the zoo.

(B) Bull Frog canned foods, Gibbs Preserving Company, Baltimore, Maryland
(C) Jack Rabbit wheat flour, Rea-Patterson Milling Company, Coffeyville, Kansas
(D) Snapper lawn mowers, McDonough Power Equipment, Inc., McDonough, Georgia

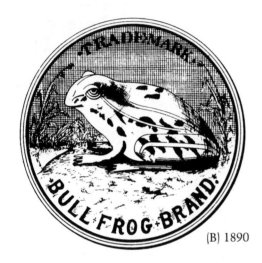

(B) 1890

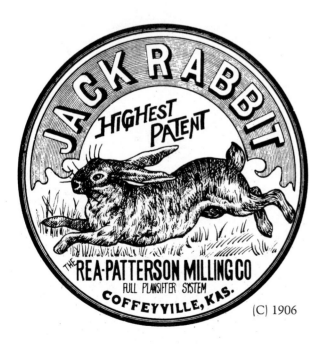

(C) 1906

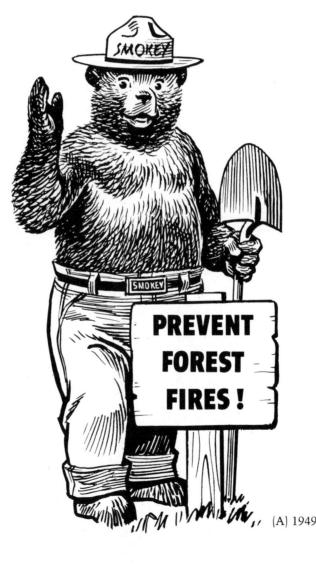

(A) 1949

(D) 1975

(A) Beaver wall board and building paper, Beaver Manufacturing Company, Buffalo, New York
(B) Brer Rabbit molasses, Penick & Ford, Ltd., New York, New York
(C) Wolf furnishings, Harris Wolf, Chicago, Illinois
(D) Alligator matches, F. Mansfield & Company, St. Louis, Missouri
(E) Turkey coffee, A.J. Kasper Company, Chicago, Illinois
(F) Gopher Brand wheat flour, Montevideo Roller Mill Company, Montevideo, Minnesota

(A) 1906

(B) 1938

(C) 1891

(D) 1874

(E) 1908

(F) 1906

31

BULKED.

(A) 1889

(B) 1945

MISSOURI
Size I.
BEAR BRAND

(C) 1883

(F) 1912

(D) 1889

BRAND

"SHEDS WATER"

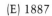

(E) 1887

(A) Porcupine Chop teas, Merritt & Ronaldson, New York, New York
(B) Badger State carbonated beverages, Badger State Bottling Company, Watertown, Wisconsin
(C) Oriole remedies for diseases of the blood, liver, and kidneys, T. Kemink, Grand Rapids, Michigan
(D) Buffalo oars, handspikes, and capstan bars, De Grauw, Aymar & Co., New York, New York
(E) Pelican yeast powder, Michel & Company, New Orleans, Louisiana
(F) Big Blue B'ar soap, Southern Cotton Oil Company, Savannah, Georgia and Gretna, Louisiana

PORCUPINE CHOP

(A) 1888

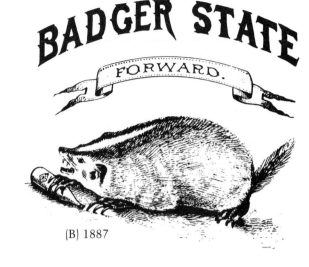

(B) 1887

(C) 1891

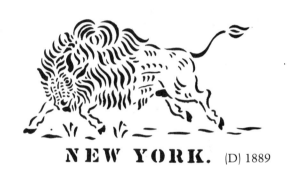

(D) 1889

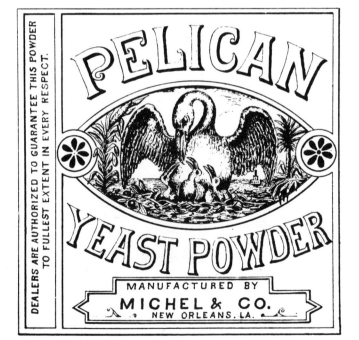

(E) 1887

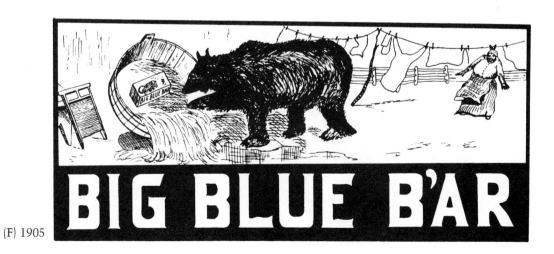

(F) 1905

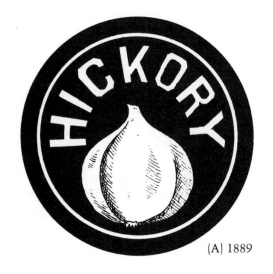

(A) 1889

Plants

Just as animals have been used on trademarks to suggest the state or country of a product's manufacture, so have plants been used as local icons. Spruce trees bring to mind the northern forests, while cedar and pawpaw trees do service for southern companies. The hickory has long represented the American heartland, the pine tree stands for the state of Maine, and the maple leaf is the national symbol of Canada. And since plants have been used as ingredients in perfumes, patent medicines, and other products, they have often served as more specific symbols.

(A) Hickory plug tobacco, James H. Spencer, Martinsville, Virginia
(B) Cedar Tree Brand oranges, lemons, and peaches, John T. Waller, Pasadena, Florida
(C) Munyon's Paw-Paw pills for billiousness and constipation, Munyon's Homeopathic Home Remedy Company, Philadelphia, Pennsylvania
(D) Dr. Wood's Norway Pine cough syrup, Foster, Milburn & Company, Buffalo, New York

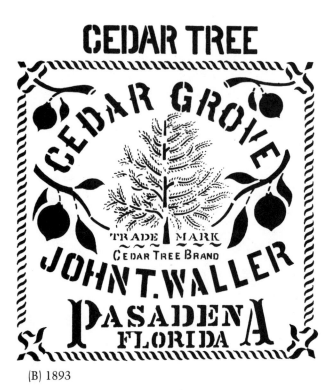

(B) 1893

(C) 1905

(D) 1892

34

(A) 1894

(A) **Sprucine chewing gum,** Albert F. Levi, Cincinnati, Ohio

(B) **Moccasin canned goods,** Foley Bros. & Kelly Mercantile Company, St. Paul, Minnesota

(C) **Maple City soap,** Maple City Soap Works, Monmouth, Illinois

(D) **Two Leaf paper towels,** Straubel Paper Company, Green Bay, Wisconsin

(E) **Pine Cone boots, shoes, and leather,** Rice & Hutchins, Inc., Boston, Massachusetts

(F) **Frisby's May Cream cosmetic,** Hattie Wentworth Frisby, Taunton, Massachusetts

(C) 1905

(D) 1947

(B) 1899

(F) 1893

(E) 1900

35

(A) 1924

(B) 1960

(A) Dale Brand fresh grapes and citrus fruits, Arizona Orchard Company, Phoenix, Arizona

(B) Buckeye-Beckett papers, Beckett Paper Company, Hamilton, Ohio

(C) Hartwell hickory tool handles, Hartwell Brothers, Memphis, Tennessee

(D) Air Canada, Montreal, Quebec. Designed by Stewart Morrison Roberts, Ltd.

(E) Chestnut Brand canned fish, Custis P. Upshur, Astoria, Oregon

(F) Bagley's Dandelion Compound, Bagley Dandelion Compound Company, St. Johnsbury, Vermont

(G) Prairie Flower flour, S.H. Cockrell & Company, Dallas, Texas

(C) 1923

(D) 1964

(E) 1892

(F) 1893

(G) 1886

Lumber and paper companies, because of their business in timber, have naturally turned to trees for their trademarks. With the movement to more abstract trademarks in the fifties and sixties, a number of these symbols have evolved into very close cousins.

(A,B) International Paper Company, New York, New York. The modern logo was designed in 1960 by Lester Beall. After the presentation to the company's directors, chairman John Hinman remarked, "That's a hell of a thing to do to a good spruce tree." He came around, however, after a heated discussion.
(C) Weyerhaeuser Company, Tacoma, Washington. The tree-in-a-triangle trademark was designed by Russ Sandgren of Lippincott & Margulies. He later founded his own design firm, Sandgren & Murtha.
(D) Boise Cascade Corporation, Boise Idaho. Designed by Dean Smith in 1964 and revised in 1970 by Sandgren & Murtha.
(E) Paquita Lily perfumed articles for the toilet, Victor Klotz, New York, New York
(F) Wackendorf's May Apple Alterative, a remedy for diseases of the blood, kidneys, and liver, Frank Perry Bailey, Zanesville, Ohio

(E) 1893

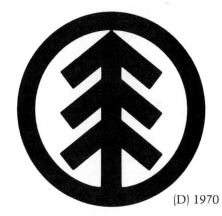

(F) 1901

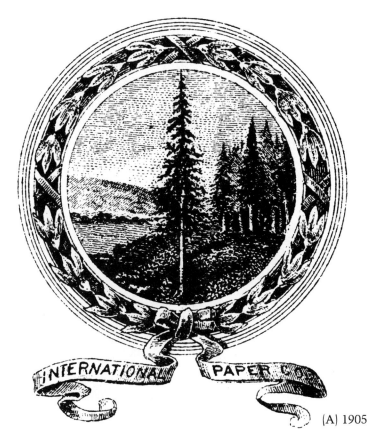

(A) 1905

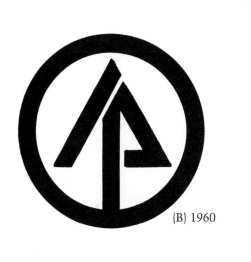

(B) 1960

(D) 1970

(C) 1959

37

(A) 1907

Maps and Landmarks

Maps and well-known landmarks have often been used on trademarks to take advantage of national and local pride and to harness that goodwill to specific commercial products. When that ploy seemed overworked, manufacturers sometimes turned to local nicknames, such as "pan-handle" for northern Texas, or "tar heel" for natives of North Carolina, to attract regional loyalty with humor.

(A) **1000 Mile axle grease,** Leechburg Oil and Paint Company, Leechburg, Pennsylvania
(B) **Pillar Rock canned salmon,** New England Fish Company, Seattle, Washington
(C) **Miss America canned vegetables,** Dorgan-McPhillips Packing Corporation, Mobile, Alabama

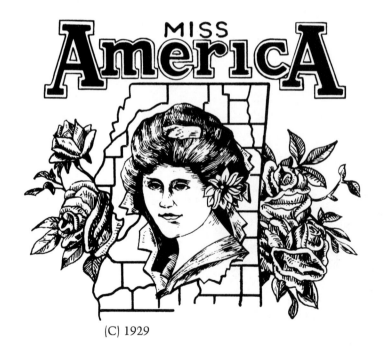

(C) 1929

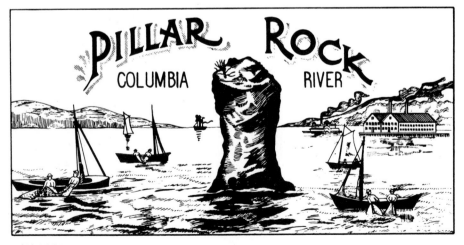

(B) 1931

(A) **White House apple cider,** National Fruit Product Company, Alexandria, Virginia

(B) **The Heart of America wheat flour,** Rodney Milling Company, Kansas City, Missouri

(C) **Nation Wide overalls,** J.C. Penney Company, Salt Lake City, Utah, and New York, New York

(D) **Potomac coffee,** John H. Wilkins Company, Washington, D.C.

(E) **Sweeping the Nation sweeping compound,** Badger Plug Company, Appleton, Wisconsin

(F) **Nation-Wide foods,** Nation-Wide Service Grocers, Brockton and Hyannis, Massachusetts

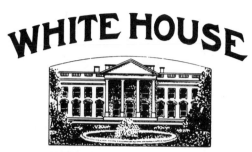

(A) 1917

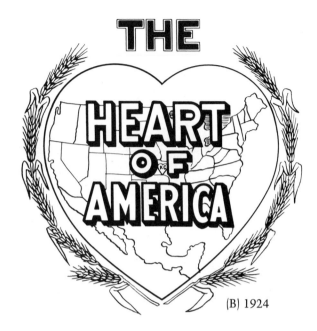

(B) 1924

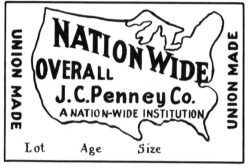

(C) 1922

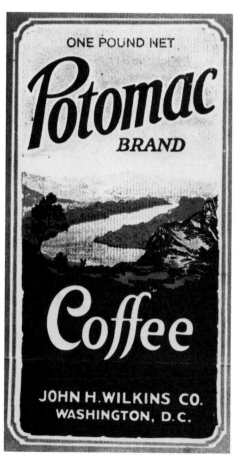

(D) 1925

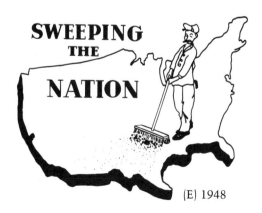

(E) 1948

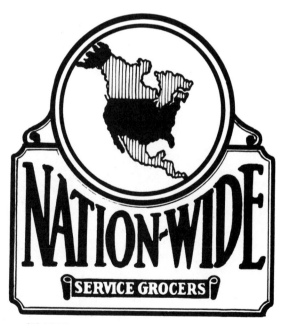

(F) 1930

(A) 1906

(B) 1942

(C) 1951

(F) 1943

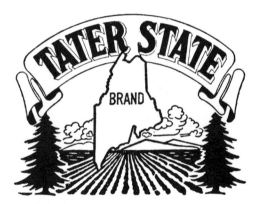

(D) 1940

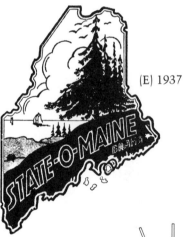

(E) 1937

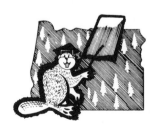

(G) 1962

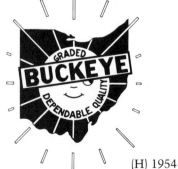

(H) 1954

(A) **Iron Brand linen collars,** Schein & Lasday, Pittsburgh, Pennsylvania
(B) **Kentucky Wonder wheat flour,** Hopkinsville Milling Company, Hopkinsville, Kentucky
(C) **Penn-Pakt canned vegetables,** D.E. Winebrenner Company, Hanover, Pennsylvania
(D) **Tater State potatoes,** Aroostook Potato Growers, Inc., Presque Isle, Maine
(E) **State-O-Maine fresh, frozen, smoked, and salt fish,** Portland Fish Company, Portland, Maine
(F) **California Bear fresh vegetables,** California Lettuce Growers, Inc., Guadalupe, California
(G) **Beaver State wood shakes,** Wood Feathers, Inc., North Portland, Oregon
(H) **Buckeye potatoes,** Ohio Potato Growers Association, Columbus, Ohio

(A) **Peninsular fresh and condensed milk,** Michigan Condensed Milk Company, New York, New York

(B) **Texas cement,** Texas Cement Company, Dallas, Texas

(C) **Corn Belt canned corn,** Bloomington Canning Company, Bloomington, Illinois

(D) **Puritan paints,** Devoe & Raynolds Company, New York, New York

(E) **Tar Heel whiskey,** H. Clarke & Sons, Salisbury, North Carolina

(F) **State of California potatoes,** Sunny Farms, Edison, California

(G) **Lone Star peanuts,** Barnhart Mercantile Company, St. Louis, Missouri

(H) **Pan-Handle wheat flour,** Wichita Valley Mill & Elevator Company, Wichita Falls, Texas

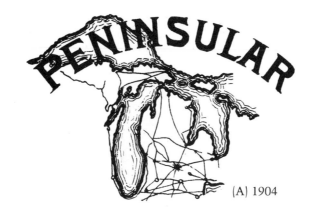

(A) 1904

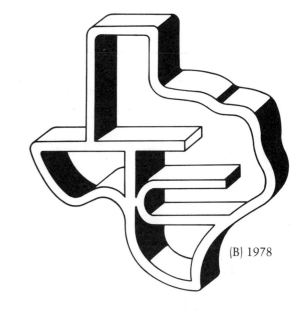

(B) 1978

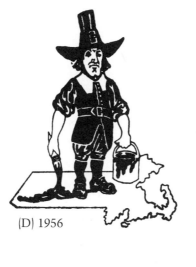

(D) 1956

(C) 1906

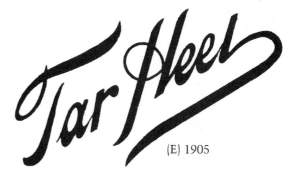

(E) 1905

(F) 1970

(G) 1908

(H) 1891

41

(A) 1928

(B) 1945

(C) 1954

(D) 1899

"Old Faithful"

(E) 1925

(F) 1899

Famous Faces

Past presidents, patriotic heroes, and great military leaders have provided manufacturers with another handy short cut to public familiarity and goodwill for their products. The portraits of George Washington, Abraham Lincoln, and Benjamin Franklin dignify our currency; businessmen have expanded that commercial role even further by using the portraits as trademarks for tobacco, sugar, and horse collars.

(A) George Washington chewing and smoking tobacco, R.J. Reynolds Tobacco Company, Winston-Salem, North Carolina
(B) Martha Washington powdered sugar, Joannes Bros. Company, Green Bay, Wisconsin
(C) Old Abe cigars, Thomas E. Brooks & Company, Red Lion, Pennsylvania
(D) Franklin confectioners' sugar, Franklin Sugar Refining Company, Philadelphia, Pennsylvania
(E) Washington "Dee-Cee" shirts, overalls, and suspenders, Washington Manufacturing Company, Nashville, Tennessee

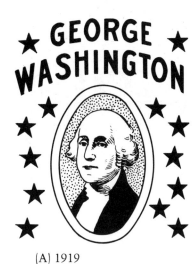

(A) 1919

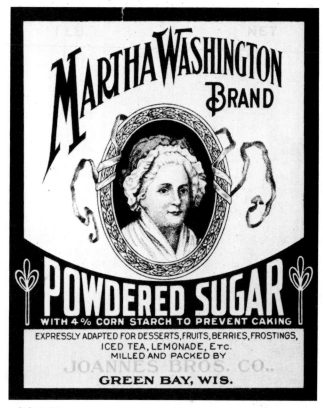

(B) 1922

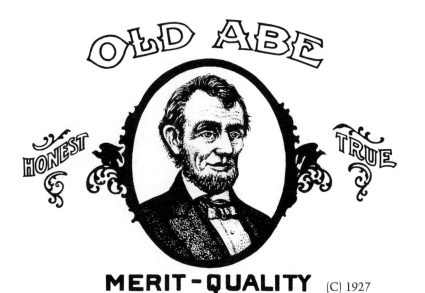

(C) 1927

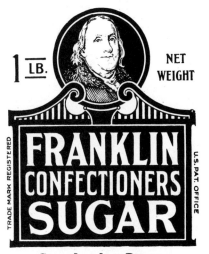

(D) 1914

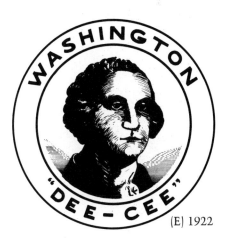

(E) 1922

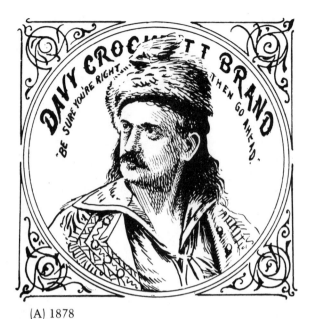

(A) 1878

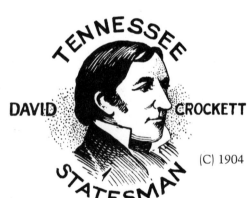

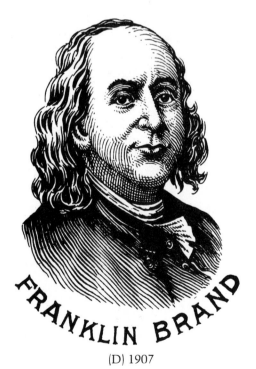

(D) 1907

(A) **Davy Crockett Brand cigars,** J.D. Loomis, Suffield, Connecticut

(B) **Revere Ware copper-clad cooking utensils,** Revere Copper and Brass Incorporated, New York, New York. Direct descendant of a copper rolling mill founded in 1801 by Paul Revere.

(C) **Tennessee Statesman chewing tobacco,** Gilbert, Son & Company, Murray, Kentucky

(D) **Franklin Brand canned fruits and vegetables,** Franklinville Canning Company, Franklin, Indiana

(E) **Lincoln paints and varnishes,** Lincoln Paint & Color Company, Lincoln, Nebraska

(F) **Custer coffee and canned vegetables,** Keil Company, Billings, Montana

(G) **Lincoln Cork Faced horse collars,** Cork Faced Collar Company, Lincoln, Illinois

(H) **Jeff Davis wheat flour,** Sweet Water Mill Company, Sweet Water, Tennessee

(I) **Washington oranges,** Davis Tillson, Orange Bend, Florida

(J) **Stonewall Jackson self-rising wheat flour,** Shenandoah Milling Company, Shenandoah, Virginia

(B) 1969

(C) 1904

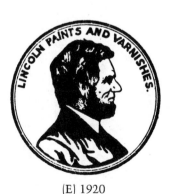

(E) 1920

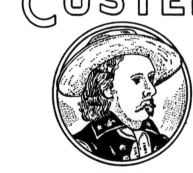

(F) 1937

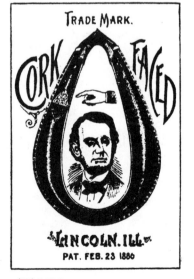

(G) 1892

JEFF DAVIS

(H) 1890

HAND PICKED

TILLSON'S ORANGE BEND GROVE, FLA.

TRADE MARK

"WASHINGTON"

DAVIS TILLSON (I) 1892

(J) 1925

(A) 1868

Pioneers and Cowboys

As trademarks began to come into common use in the years before the Civil War, the country's attention was focused on the great westward migration. From the 1820s through the 1850s, streams of wagon and pack-horse groups crossed the western plains, traveling over the Santa Fe, California, and Oregon trails from a starting point in Independence, Missouri. The scout, the pioneer, and the wagon train became part of the country's romantic self-image, figures in the exciting westward expansion that seemed to offer unlimited opportunity for a young and growing nation.

After the Civil War the pioneers and settlers were joined by another character in the growing mythology of the West—the cowboy. Settlers who came to Texas in the 1830s found huge herds of wild longhorn cattle, descendants of stock from Spanish missions. Fortunes were made by those who learned how to capture and manage the herds, as over several decades the cattle trade grew into a great business. The railroads that reached into the West in the late 1860s opened the Eastern market to the cattle ranchers, and massive cattle drives in the 1870s and '80s brought the herds north from Texas to railroad depots in Abilene, Dodge City, and Cheyenne. A new frontier worker, the cowboy, learned the skills to manage the wild longhorns, and his wide-brimmed hat, lasso, and leather chaps became part of the Western image.

(A) Westward Ho tobacco, James Geary, Chicago, Illinois
(B) Pioneer cheroots, Herman Rosenberg, Richmond, Virginia
(C) Bronco fresh citrus fruit, Redlands Foothill Groves, Redlands, California

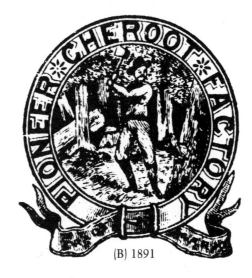

(B) 1891

(C) 1944

46

(A) **Scout smoking tobacco,** Terry & Porterfield
Tobacco Company, Dayton, Ohio
(B) **H. Royer manufactured leather, or rawhide,** H.
Royer, San Francisco, California
(C) **Bininger's Pioneer bourbon,** A.M. Bininger &
Company, New York, New York
(D) **Pioneer macaroni, spaghetti, vermicelli, and
noodles,** Aug. Nasse & Sons, St. Louis, Missouri

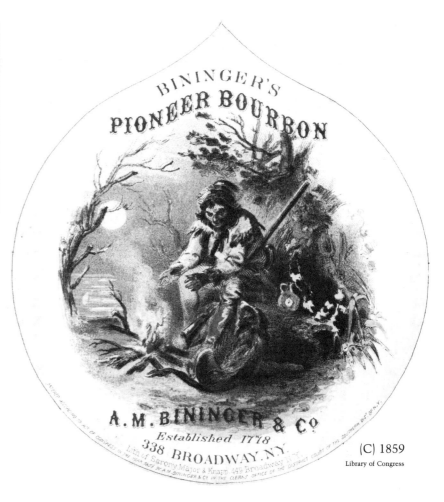

(C) 1859
Library of Congress

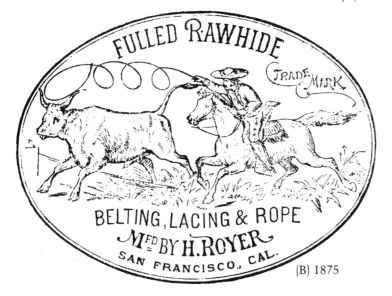

(B) 1875

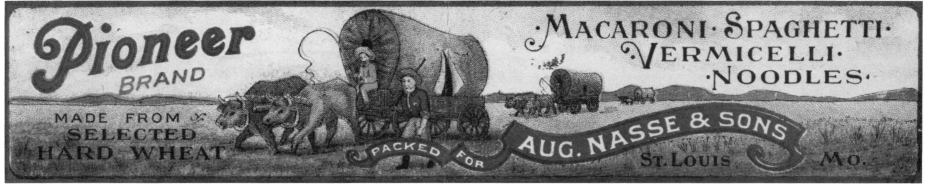

(D) about 1900

Warshaw Collection, Smithsonian Institution

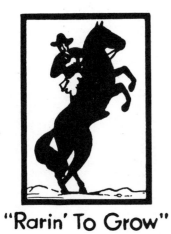

"Rarin' To Grow"

(A) 1953

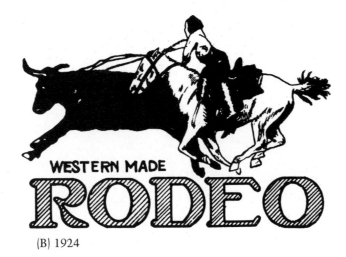

WESTERN MADE
RODEO

(B) 1924

(A) **Rarin' To Grow flower and vegetable seeds,** Hygrade Seed Company, Fredonia, New York
(B,C) **Rodeo clothing,** Hicks-Hayward Company, El Paso, Texas
(D) **Oxidental glue,** A. & C.W. Holbrook, Providence, Rhode Island
(E) **Western Delight wheat flour,** John F. Meyer & Sons Milling Company, St. Louis and Springfield, Missouri
(F) **Longhorn wagons,** Southern Rock Island Plow Company, Dallas, Texas

OXIDENTAL

TRADE MARK

(D) 1892

RODEO

(C) 1921

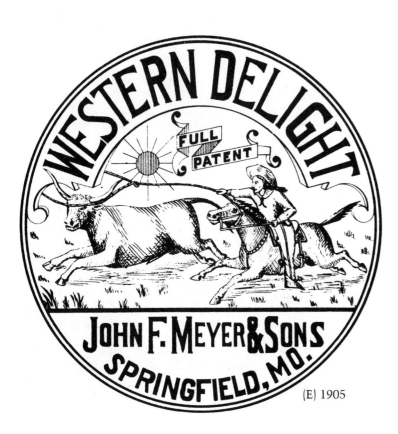

WESTERN DELIGHT

FULL PATENT

JOHN F. MEYER & SONS
SPRINGFIELD, MO.

(E) 1905

TRADE MARK REGISTERED

Long Horn. (F) 1900

48

The discovery of gold at Sutter's Mill, near Sacramento, California, triggered the 1849 gold rush, adding further to the flood of Americans moving West. The gold digger, though a dirtier and less romantic figure than the cowboy, earned a place in the public's picture of the Old West.

(A) **Gold Digger fresh fruits,** Oroville United Growers, Oroville, Washington

(B) **Wells Fargo Bank,** San Francisco, California. Founded in 1852 by Henry Wells and William G. Fargo, two officers of the American Express Company, to provide banking and express services to the booming California economy. Wells Fargo was involved in the operation of the short-lived Pony Express in 1861, which carried mail between Missouri and California.

(C) **Lariat wheat flour,** Dodge City Milling & Elevator Company, Dodge City, Kansas

(D) **Miles boots and shoes,** W.H. Miles Shoe Company, Richmond, Virginia

(E) **Longhorn toilet bowl gaskets,** Kirkhill Inc., Downey, California

(F) **Panmalt coffee,** Cody-Powell Coffee Company, La Crosse, Wisconsin

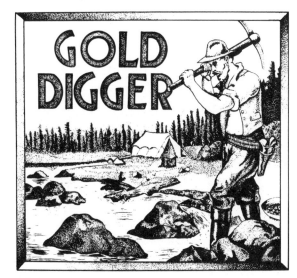

(A) 1944

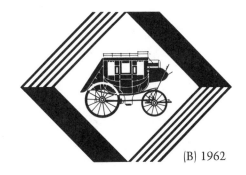

(B) 1962

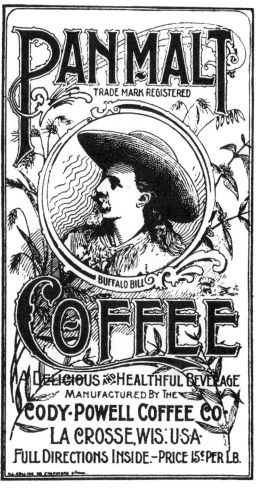

(F) 1893

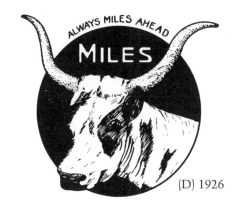

(D) 1926

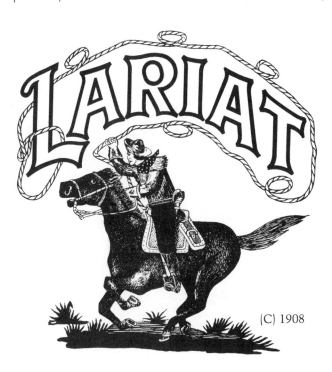

(C) 1908

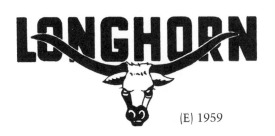

(E) 1959

Tall Tales

The tall tale is a peculiarly American form of humor, one rooted in the rough boasting of eighteenth-century frontiersmen. By the time of Davy Crockett, the exaggerated story had become a common and accepted form of speech. Crockett was said to have slept as a baby in a twelve-foot cradle, the upturned shell of a six-hundred-pound snapping turtle. He had the biggest knife in Kentucky and a dog that could bring down a buffalo.

When manufacturers began to use illustrated labels and picture trademarks to sell their products, many drew on the American tall-tale tradition in vastly overstating the size and quality of their products. They pictured baking soda so powerful it could force a cake through the top of an oven, tomatoes so huge it took two men to lift one, and flies big enough to steal a house.

(A) Eureka seed corn, Walter D. Ross, Worcester, Massachusetts
(B) Green Mountain grapes, S. Hoyt's Sons, New Canaan, Connecticut
(C) New wire screens and wire screen doors, Neuhaus Manufacturing Company, Glen Rock, Pennsylvania
(D) Indian River and Lake Worth Pineapple Growers Association, Eden, Florida

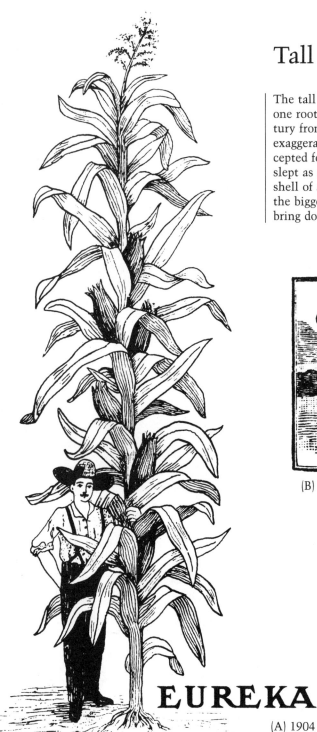

(A) 1904

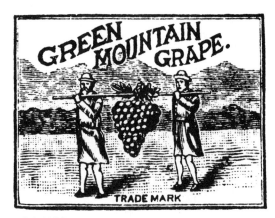

(B) 1889

(C) 1907

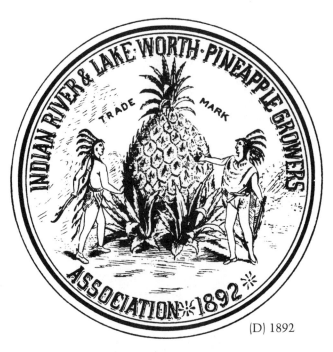

(D) 1892

Paul Bunyan, perhaps the most famous tall tale character, is a relatively modern invention. W.B. Laughead had heard exaggerated stories as a young man working in the Minnesota logging camps. In 1914, when given the job of creating an advertising campaign for the Red River Lumber Company of Minneapolis, he drew on the many stories he had heard and attached them to the single character of Paul Bunyan. The lumber company found the giant to be so popular that they expanded his adventures into a promotional booklet. Though the Paul Bunyan stories have since multiplied and expanded, they owe their start to Laughead's ads and booklets.

(A) **Paul Bunyan lumber,** Red River Lumber Company, Minneapolis, Minnesota
(B) **Paul Bunyan canned vegetables,** Paul Bunyan Foods, Seattle, Washington, Minneapolis, Minnesota, and Omaha, Nebraska
(C) **Beef Steak canned tomatoes,** Anderson & Campbell, Camden, New Jersey. This business later turned into the Campbell Soup Company.
(D) **Big Bonanza baking powder,** Smith, Hanway & Company, Baltimore, Maryland

(A) 1921

(B) 1949

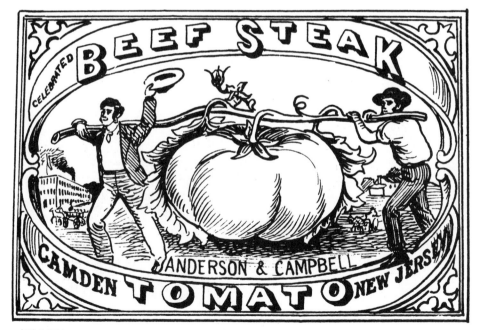

(C) 1874

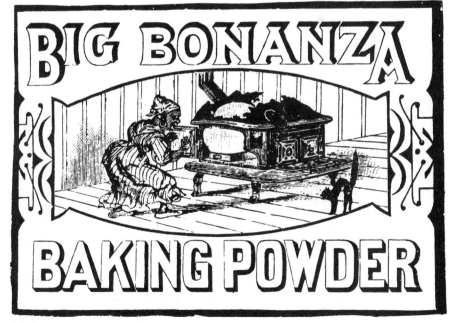

(D) 1878

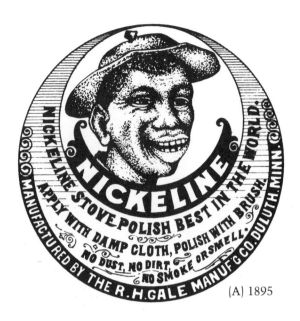

(A) 1895

Race

In our not-too-distant past, grotesque racial caricatures and stereotypes were accepted in America as an ordinary form of humor. Advertisements and packages showed black Americans with thick, saucer lips and eyes wide with fear; or Asian Americans with long braids, swallowing live rats. These "humorous" depictions clearly had a cutting edge, and their profusion served to reinforce white notions of racial superiority. Even the less grotesque representations of blacks as servants or cooks had the same effect, driving home the concept that blacks were suited to menial jobs.

The most objectionable of these caricatures are now out of circulation, but it is important to our understanding of American culture to see what was once the common portrayal of the black and Asian races.

(A) Nickeline stove polish, R.H. Gale Manufacturing Company, Duluth, Minnesota
(B) Nigger Head Brand canned fruits and vegetables, Aughinbaugh Canning Company, Baltimore, Maryland
(C) Polo boot blacking, C.G. de Tonnacour, Montreal, Quebec
(D) Gold Dust washing powder, The N.K. Fairbank Company, Chicago, Illinois. The idea for the Gold Dust twins came from a cartoon in the English humor magazine, *Punch,* showing two black children washing each other in a tub. The caption read, "Warranted to wash clean and not fade." A company executive thought this funny and had an artist draw the twins for the washing powder package in 1887. At one time they were among the best known commercial symbols in America.

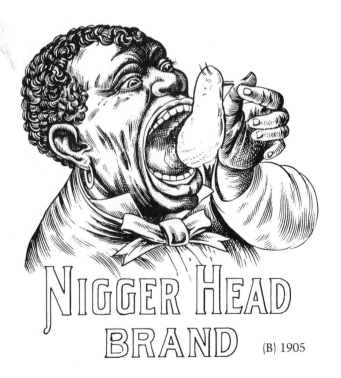

(B) 1905

(C) 1905

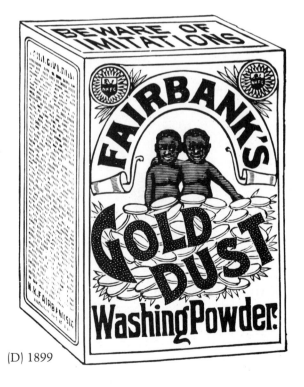

(D) 1899

(A) **New Orleans syrup, molasses, and sorghum,** New Orleans Coffee Company, New Orleans, Louisiana
(B) **Alligator Bait whiskey and gin,** Bluthenthal & Bickart, Atlanta, Georgia
(C) **Dandy paper bags,** Union Bag & Paper Company, New York, New York
(D) **Knox gelatine,** Charles B. Knox, Johnstown, New York
(E) **Emmet Professional harmonicas,** William Tonk & Brother, location unknown

(A) 1904

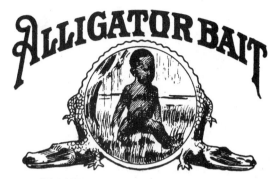

(B) 1907

(C) 1908

(D) 1899

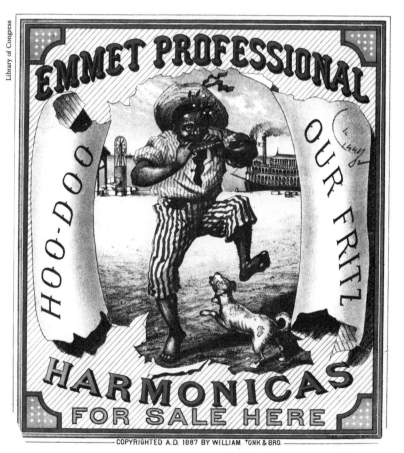

(E) 1887

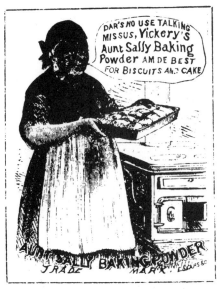

(A) 1875

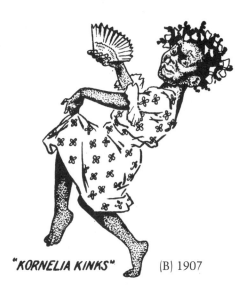

"KORNELIA KINKS" (B) 1907

(A) **Aunt Sally baking powder,** George H. Vickery, Hyde Park, Pennsylvania
(B) **Kornelia Kinks, trademark for H-O cornflakes,** H-O (Hornby's Oatmeal) Company, New York, New York
(C) **Old Virginia Log Cabin smoking tobacco,** manufacturer unknown
(D) **Sanford's ginger,** manufacturer unknown

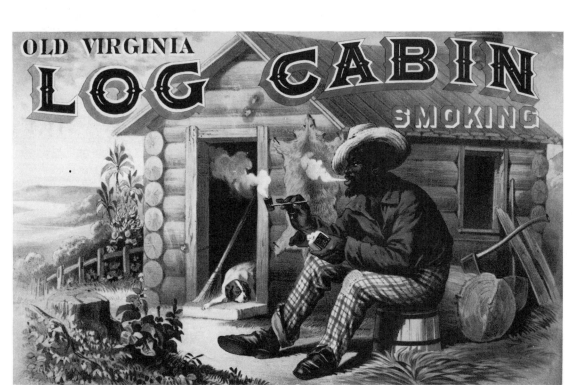

(C) about 1890

Warshaw Collection, Smithsonian Institution

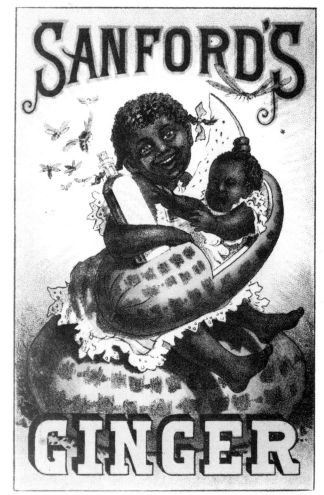

(D) about 1890

Library of Congress

(A,B,C,D) Aunt Jemima hails from St. Joseph, Missouri, where in 1889 a local newspaperman named Chris L. Rutt came up with the idea of making a self-raising pancake mix. Inspiration for the name came from the vaudeville team of Baker and Farrell, who visited St. Joseph that fall. The high point of their show was the song "Aunt Jemima," which apparently had a catchy tune that set the town humming.

Rutt later sold the business to the R.T. Davis Mill & Manufacturing Company, also of St. Joseph, and the new owners launched Aunt Jemima to fame with a display at the 1893 Columbian Exposition in Chicago. To reinforce the brand image, the company hired Nancy Green, a black cook from Montgomery County, Kentucky to *be* Aunt Jemima. She stood outside the booth and cooked pancakes—more than a million of them during the course of the fair.

For the next thirty years, until her death in 1923, Green traveled the country in the persona of Aunt Jemima, who remained on the packages as a frightening caricature of a black mammy for most of that time. In 1917 Aunt Jemima was finally redrawn as a real person, though she has remained a smiling stereotype of a household helper. The Quaker Oats Company has made and sold the mix since 1924.

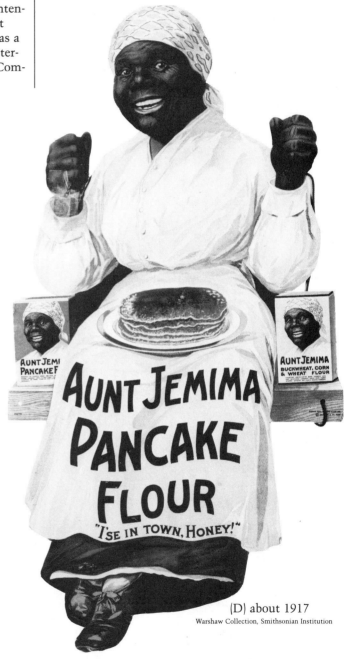

(D) about 1917
Warshaw Collection, Smithsonian Institution

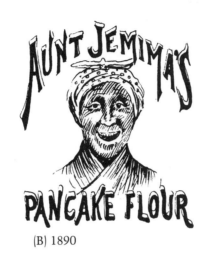

(B) 1890

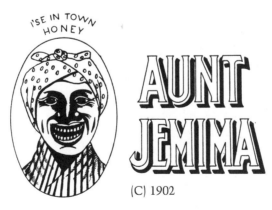

(C) 1902

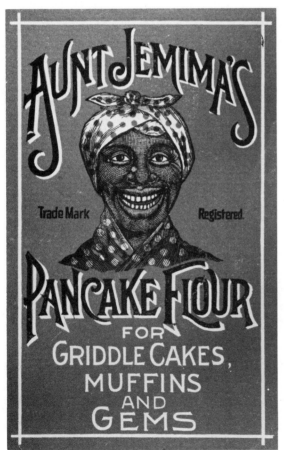

(A) 1905

55

(A) 1885

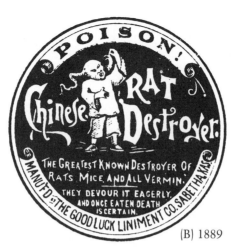

(B) 1889

(A) **Laugh at Mice vermin exterminator,** C.B. O'Neill, Paterson, New Jersey

(B) **Chinese Rat Destroyer poison,** Good Luck Liniment Company, Sabetha, Kansas

(C) **Rough on Rats vermin exterminator,** manufacturer unknown

(D) **Grove's Yellow Kid chewing gum,** Grove Company, Salem, Ohio

(E) **Yaller Kid candy,** James A. McClurg & Sons, New York, New York. The Yellow Kid was the principal character in the first newspaper comic strip, created by R.F. Outcault for the *New York World* in 1895. The strip became very popular, both for the *World*, and for William Randolph Hearst's *New York Journal*, where Outcault brought his talents in 1896. Outcault somehow recognized the commercial potential of his character and, beginning in 1896, licensed his use on a variety of products, including candy, cookies, and two competing brands of chewing gum. He later granted licenses with even greater abandon for the character Buster Brown (see page 196).

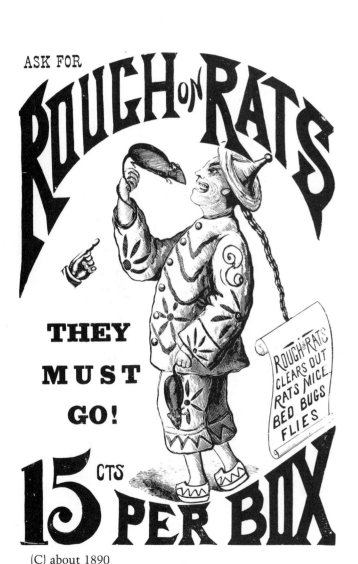

(C) about 1890

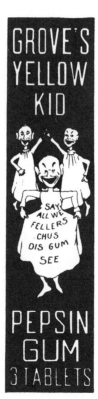

(D) 1897

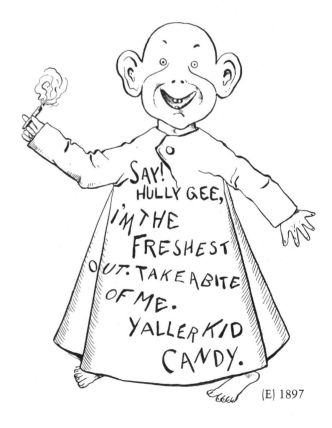

(E) 1897

The American Indian fared a little better in the stereotyped image created by commercial artists. But, as with the portrayals of black and Asian Americans, the picture fell far from the truth and closer to the mythical, romanticized Indian of popular fiction. In nineteenth-century novels and stories the Indian appeared, variously, as a heartless and bloodthirsty savage, as a sensitive man of nature, and as an honest and noble primitive. When companies adopted Indians as trademarks, they were appealing to these idealized notions. They also used the Indian as other manufacturers used buffaloes and eagles: as a symbol of America, a notice that the product behind the label was American-made.

It is significant that the use of Indians on trademarks reached a peak from the 1880s through the early years of this century, after the last Indian resistance in the West had been crushed. It had then become safe to look back fondly on a great and noble culture that had been largely destroyed.

(A) **Hiawatha canned corn,** Well-Stone Mercantile Company, Duluth, Minnesota
(B) **Wampum canned goods,** Stone-Ordean-Wells Company, Duluth, Minnesota
(C) **Bow-Spring dental rubber,** Samuel S. White, Philadelphia, Pennsylvania
(D) **Sheboygan carbonated beverages,** Sheboygan Mineral Water Company, Sheboygan, Wisconsin

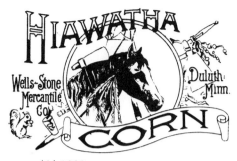

(A) 1893

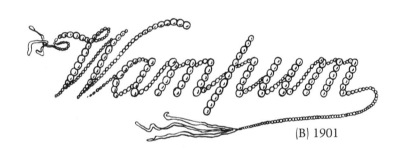

(B) 1901

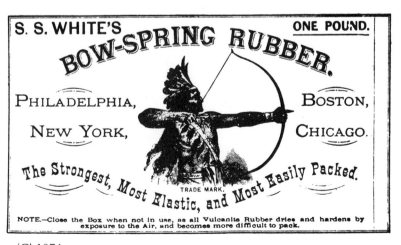

(C) 1874

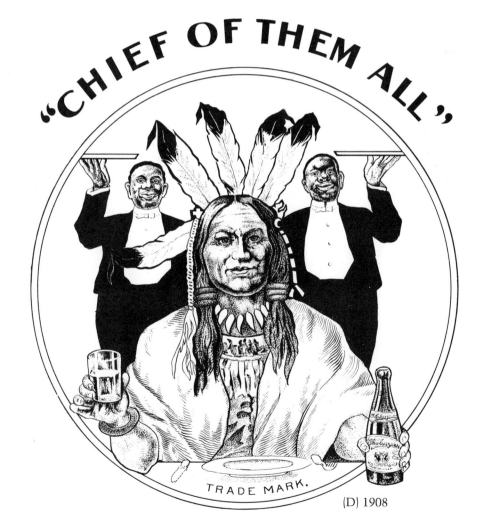

(D) 1908

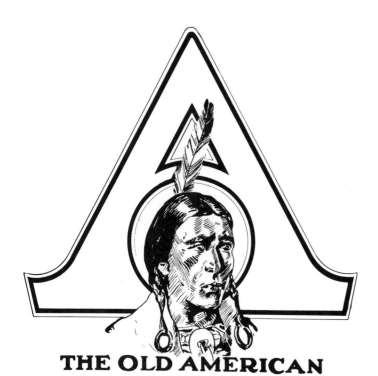

THE OLD AMERICAN

(A) 1924

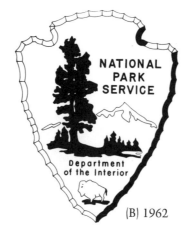

NATIONAL
PARK
SERVICE

Department
of the Interior

(B) 1962

(A) **The Old American asphalt roofing,** American Asphalt Roof Corporation, Kansas City, Missouri
(B) **National Park Service,** United States Department of the Interior, Washington, D.C.
(C) **Shawmut wheat flour,** Whitney & Wilson, Rochester, New York
(D) **Cherokee coal,** Cherokee Coal Company, Louisville, Kentucky
(E) **American copper wire and cable,** American Copper Products Corporation, Elizabeth Port, New Jersey

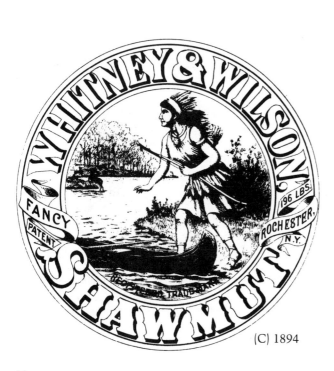

(C) 1894

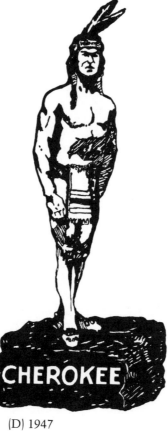

CHEROKEE

(D) 1947

(E) 1922

William Wright mixed the first batch of **(A,B) Calumet baking powder** in 1889, in a rented Chicago room that doubled as a laboratory and bedroom. The name is a common one in the Chicago area, where there are a Calumet Park, Calumet River, Calumet Lake, and Calumet Harbor. It was first used by the French as a name for the peace pipe offered to Père Marquette when he explored the shores of Lake Michigan in 1675. The Calumet baking-powder business became part of General Foods in 1928.

(C) American baking powder, Konn B. Sayres, Cincinnati, Ohio
(D) Tru-Type fresh citrus fruit, Winter Haven Fruit Sales Corporation, Winter Haven, Florida
(E) Totem Pole canned and packaged foods, Seattle Pure Food Company, Seattle, Washington

(D) 1935

(E) 1906

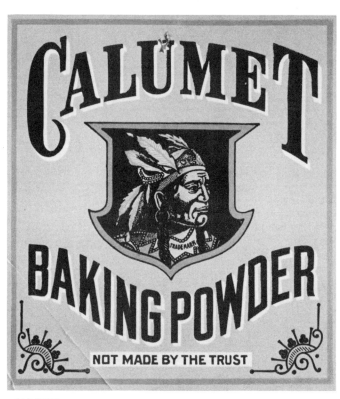

(A) 1905

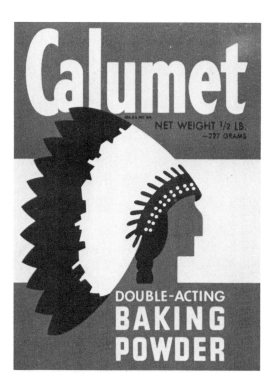

(B) 1950

(C) 1889

(E) 1904

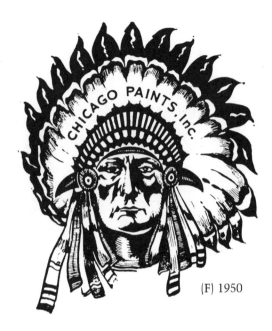

(F) 1950

(A,B,C,D) R.R. Donnelly & Sons Company chose an Indian for a trademark because its Lakeside Press in Chicago stood near the site of the 1812 Fort Dearborn massacre, in which settlers were driven from the region by hostile Indians. The company has been in the printing business in Chicago since 1864, and with plants in nine states it is now one of the country's largest printers. J.C. Leyendecker designed the firm's first mark in 1897. Theodore Hapgood revised it in 1926, with a slightly less horrific warrior, Rockwell Kent drew an art deco version in 1930, and Joseph Carter returned to a simplified, traditional mark in 1953.

(E) Royal sewing machines, Illinois Sewing Machine Company, Rockford and Chicago, Illinois
(F) Chicago Chief paints, Chicago Paints, Inc., Chicago, Illinois

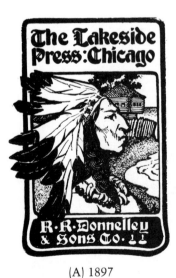

(A) 1897

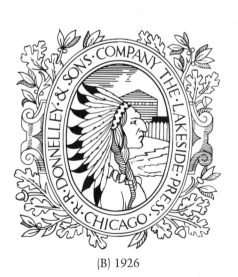

(B) 1926

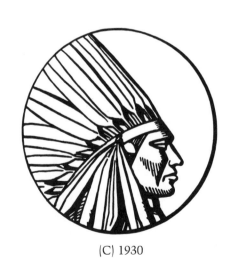

(C) 1930

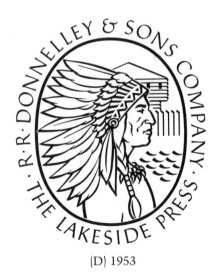

(D) 1953

Powhattan, the symbol of **(A) the American Tobacco Company**, was the chief of a confederacy of Algonquin tribes when the first English settlers landed at Jamestown. His area of control extended through eastern Virginia and into Maryland, and included more than one hundred tribal villages. Although he did not resist the settlement at Jamestown, he objected to hunting and exploring parties that ventured further into the Algonquins' domain. According to legend, had his daughter Pocahontas not interfered, he would have killed Captain John Smith. Pocahontas was captured in 1613 in a raid by the settlers and held hostage at Jamestown. In 1614 she married John Rolphe, the first of the Jamestown settlers to grow a commercial crop of tobacco. This may be the connection that inspired American Tobacco to adopt Powhattan as its trademark.

(B) Chickasaw barrels, kegs, pails, and buckets, Chickasaw Cooperage Company, Memphis, Tennessee

(C) Red Warrior axes, James H. Mann, Lewistown, Pennsylvania

(D) Wachusett heavy sheetings, Jackson Company, Nashua, New Hampshire

(E) National Shawmut Bank of Boston, Boston, Massachusetts. The bank has used an Indian on its banknotes since at least 1854. A young Boston artist named Adelbert Ames Jr. sculpted the bust of the Shawmut Indian in 1910. According to the bank, he is Obbatinewat, the Mushauwomeog sachem who signed a treaty with Miles Standish in 1621.

(A) 1900

(B) 1905

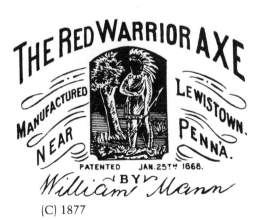

(C) 1877

WACHUSETT

(D) 1871

(E) 1953

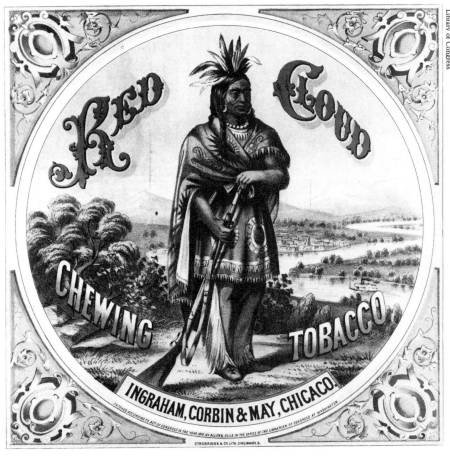

(D) 1872

The **(A,B,C) Savage Arms** Indian is a fearsome warrior who looks like he's jumped from the pages of a classic Western novel. The gun company chose the stereotype to match the name of its founder, Arthur Savage. Savage started his gun business in Utica, New York, in 1894, after spending most of his thirty-seven years in the West Indies and Australia. His first gun was the Model 99, a hammerless, lever-action rifle so well designed that it remains in production today. In the company's 1900 catalogue, E.T. Ezekial of Wood Island, Alaska, wrote a letter to say he'd killed a whale with the gun. The warrior symbol came along in 1906; he's been modified over the years to look less and less savage.

(D) Red Cloud chewing tobacco, Ingraham, Corbin & May, Chicago, Illinois. Red Cloud (1822–1909) was a chief of the Ogalala tribe, who commanded both Sioux and Cheyenne warriors in attacks on U.S. soldiers around Fort Kearny, in what is now Nebraska, during 1866. In 1868 he signed a treaty that provided for a Sioux reservation that covered all of South Dakota west of the Missouri River.

(E) Silent Sentinels electrical relays and relaying systems, Westinghouse Electric Corporation, East Pittsburgh, Pennsylvania

(A) 1913

(B) 1953

(C) 1984

(E) 1948

The Minnesota Cooperative Creameries Association began doing business in 1921 in Arden Hills, Minnesota, as a central shipping agent for a group of small, farmer-owned dairy cooperatives. The association's business centered largely on the sales of butter produced by the cooperatives, and after three years it decided to add a single brand name to the packages. Farmers in the member cooperatives were asked to send in their ideas for a name, and of the suggestions that came in, the association picked **(A) Land O' Lakes**. No one remembers how the Indian maiden came to be, but by the end of 1924 she appeared on the butter cartons with the new name. The association has since changed its name to Land O' Lakes, Inc. It is now the country's largest food-marketing cooperative, serving more than 350,000 family farmers.

(B) Winona fabric gloves, Stott & Son Corporation, Winona, Minnesota
(C) Minnehaha coal, Hickory Grove Coal Mining Corporation, Rochester, New York
(D) Wayagamack wood pulp, Wayagamack Pulp & Paper Company, Limited, Three Rivers, Quebec. Current owner Consolidated Paper Corp., Ltd., Montreal, Quebec.

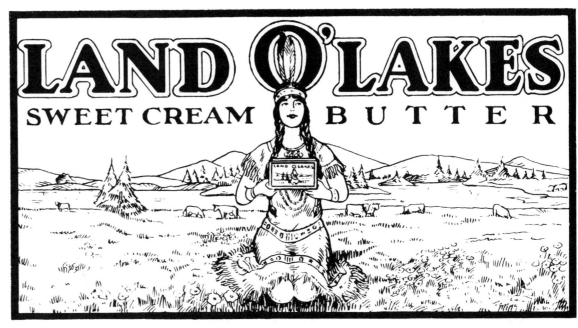

(A) 1930

(B) 1946

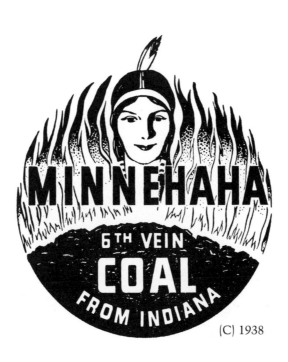

(C) 1938

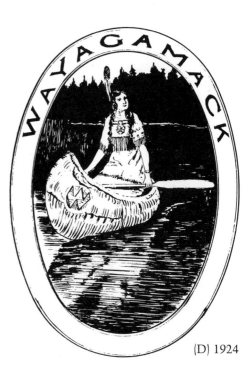

(D) 1924

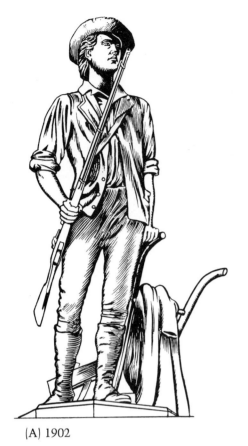

(A) 1902

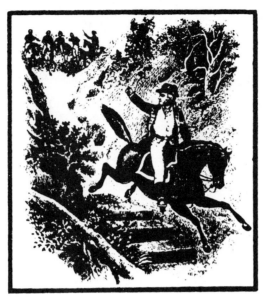

(B) 1895

War

Because wars have demanded a special patriotic surge from the American citizenry, and because, once over, they have formed key chapters in the country's history, manufacturers have sometimes used idealized images of war to draw patriotic loyalty to their products.

(A) Minuteman prepared tapioca, Whitman Grocery Company, Orange, Massachusetts

(B) Putnam Fadeless dyes, Monroe Drug Company, Unionville, Missouri. Major General Israel Putnam escaped the pursuit of six British soldiers in 1789 by steering his horse down a steep, rocky hill near Horseneck, New York.

(C) Iron Clad paints, Iron Clad Paint Company, Cleveland, Ohio. The picture is of the *Monitor*, the Union's armored warship that beat the Confederacy's *Merrimac* in battle in 1862.

Trade

IRON CLAD
PAINT

Mark

(C) 1878

(D) 1906

(D) Davy Crocket whiskey, Union Distilling Company, Cincinnati, Ohio. Davy Crockett died at the Alamo, along with all of the other defenders, in the 1842 war for Texas's independence from Mexico.

(E) Let's Go America sweat shirts and polo shirts, Norwich Knitting Company, Norwich, New York

(F) March fresh vegetables, Souza Bros. Packing Company, Santa Maria, California

(G) All Out portable fire extinguishers, National Powder Extinguisher Corporation, Jersey City, New Jersey

(H) Rough Rider axle grease, Great Western Oil Refining Company, Erie, Kansas

(I) Doughboy wheat flour, Mennel Milling Company, Toledo, Ohio

(J) First Call California pears, H.H. Titcomb, Concord, California

(E) 1941

(F) 1943

(G) 1941

(H) 1907

(I) 1918

(J) 1941

Sports

Baseball and other sports have provided lighter conflicts for the public to rally behind. Though team loyalties have generally been too regional to merit representation on branded goods, the sports themselves have served on a number of trademarks. Baseball in particular has been a rich source for the trademark and label artists. (See pages 218–221 for the emblems of professional sports teams.)

(A) The First Nines cigars, A.H. Atherton, Connecticut
(B) The Bat chewing and smoking tobacco, M.D. Neumann, Chicago, Illinois
(C) Short Stop medicinal preparations, H.M. O'Neil, New York, New York

(B) 1888

(C) 1888

(A) 1867

Library of Congress

(A) **Speedball carbonated beverage,** Frank Pitzer, Washington, D.C.
(B) **Fans cigarettes,** Tobacco Products Corporation, New York, New York
(C) **Grand Slam ice milk product,** McDowell and Eddy, Los Angeles, California
(D) **Batter-Up candy,** Paul F. Beich Company, Bloomington, Illinois
(E) **Fan-Jaz carbonated beverage,** Edward M. Ellis, Memphis, Tennessee
(F) **Gridiron hosiery,** Abraham & Straus, New York, New York

(A) 1905

(B) 1923

(C) 1934

(D) 1934

(E) 1908

(F) 1905

FINER "N" FROG HAIR

(A) 1904

The Language

Manufacturers have mined the language for new and distinctive trade names, and many times their search has ended in colloquial expressions or slang terms—words and sayings that are part of the spoken but not the written language. Crackerjack popcorn and peanut candy was named in 1895, the same year the word *crackerjack* appeared in the language to mean *great* or *terrific* (see page 139), and the name of the soft drink Moxie has come to mean *courage* or *spunk* (page 119). Other slang words like *A-OK*, *newfangle*, and *hunky-dory*, have been used as trade names to convey a sense of fun and popularity to the buying public.

(A) Finer "N" Frog Hair furniture polish, Winfield L. King, West Newton, Pennsylvania
(B) La Hunkidori cigars, S. Salomon, New York, New York
(C) Hunkidori boots and shoes, Hand Made Boot & Shoe Company, Chippewa Falls, Wisconsin
(D) Tom, Dick & Harry soap, N.K. Fairbank Company, Chicago, Illinois
(E) John Doe chewing and smoking tobacco, United States Tobacco Company, Richmond, Virginia. The nickname for the common man grew out of a practice in British courts of using the name for witnesses who wished to conceal their identity.

(D) 1905

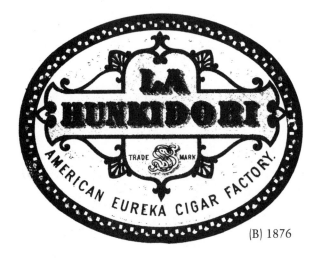

(B) 1876

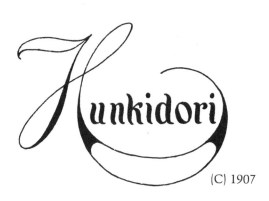

(C) 1907

(E) 1900

(A) Lang's Takes The Cake chocolate icing, Albert H. Stillwell, Philadelphia, Pennsylvania. The word *cake* has been used to mean a prize or honor since the 1700s. In the cakewalk, a word used from the 1860s, black dancers competed for a cake.

(B) Cinch smoking and chewing tobacco, Independent Snuff Company, Chicago, Illinois. The expression, meaning *easy* and *sure*, was in use in the early 1890s.

(C) Cool As A Cucumber hats, S. Shethar & Company, New York, New York

(D) On Track cigars and cigarettes, Gustav Fuchs, Chicago, Illinois

(E) Easy Pickin toothpicks, Weis Manufacturing Company, Toledo, Ohio

(F) "Nufangl" trousers, David Present, New York, New York

(A) 1893

(B) 1906

(C) 1874

(D) 1884

(E) 1905

(F) 1902

(A) 1904

(B) 1901

(A) Dogongood knitted stockings and underwear, Joseph A. Parker, Portsmouth, Virginia

(B) A O-K metal polish, Charles Ulrich & Company, Buffalo, New York. The expression grew out of *A number 1*, for *best quality*, which was in use by the 1840s. *A-OK* became popular in the 1960s when it was used by astronauts in the U.S. space program.

(C) Jim Dandy OK molasses, H.T. Cottam & Company, New Orleans, Louisiana

(D) Lulu of Waterloo scouring powder, Michael Paint Company, Waterloo, Iowa. The term *lulu* for something great or extraordinary, has been used since 1886 and comes from the woman's name.

(E) Lu-Lu popcorn, Louis A. Archer, Milwaukee, Wisconsin

(F) No Humbug cigars, L. Hirschhorn & Company, New York, New York

(G) Beats All rubber erasers, American Lead Pencil Company, New York, New York

(C) 1893

LULU OF WATERLOO

(D) 1901

Lu=Lu (E) 1901

(F) 1877

BEATS ALL

(G) 1905

In 1882 P.T. Barnum bought a huge African elephant named Jumbo from the London Zoo and added him as a star attraction to his circus. The elephant's name quickly entered the language as a word meaning *extra large*.

(A) Clark's Jumbo sugar-coated popcorn, George E. Clark, Cleveland, Ohio
(B) Jumbo Brand canned oysters, fruits, and vegetables, Miller Bros. & Company, Baltimore, Maryland
(C) Jumbolene lotions for the skin, Thomas Jenness & Son, Bangor, Maine
(D) McKinley's "Jumbo" grapes and grape vines, Jeremiah S. McKinley, Orient, Ohio
(E) The Rag chewing and smoking tobacco, M.C. Wetmore Tobacco Company, St. Louis, Missouri. *Chew the rag*, an expression for talking, dates back to the 1880s.
(F) Son of a Gun pistols, Russell Parker, New York, New York
(G) "23 Skidoo" liquid metal polish, Samuel R. Olmsted, New York, New York. *23 skidoo* became a popular slang expression around 1905, a variation on the older *skedaddle*.

(A) 1883

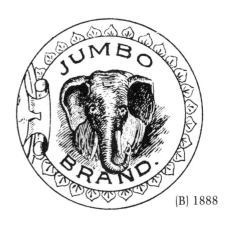

(B) 1888

(C) 1884

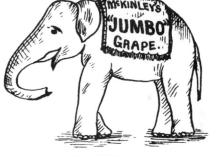

(D) 1893

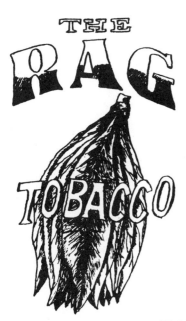

SMOKE OR CHEW (E) 1900

(F) 1898

(G) 1906

(A) 1900

(B) 1897

SQUARE DEAL

(C) 1907

FAIR & SQUARE.

(D) 1889

(E) 1904

(F) 1901

(G) 1904

Part Two

Symbols of Commerce

Farming

The word *brand*, as applied to trademarked merchandise, derives from the practice of burning marks onto barrels, boxes, and livestock as proof of ownership. English monasteries branded their horses and cattle as early as the twelfth century; by the fourteenth century, laws required brand marks on all livestock allowed to graze in the royal forests. Eventually, the brands on wine barrels and shipping crates evolved from marks of ownership into marks of origin and became trademarks in the modern sense.

By the seventeenth century, the English livestock brand had become a relic, lingering only in a few forested areas. But the settling of the American West, with its vast unfenced rangelands, brought the cattle brand back as an economic necessity. Ranchers could not keep their animals separate on the open rangeland and relied on branded marks to keep their mingled herds distinct.

The great cattle drives of the 1870s and '80s that brought Texas longhorns north to railroad shipping depots in Wyoming, Colorado, and Kansas, required a widely recognized system of ownership marks. Ranchers organized cooperative spring roundups to sort the cattle and to brand the new calves. Unbranded cattle were known as mavericks, and when found, were sold to raise money for the ranchers' associations. Cowboys learned to recognize the brands by such colorful names as Running W, Little Snake, Mule Shoe, and Three Feathers, but for added protection, the marks were registered with the county clerk and compiled into directories. Some cattlemen placed advertisements in local newspapers to display their marks and warn off would-be rustlers. Their threats were backed up by laws that carried a death sentence for anyone caught stealing cattle or changing a brand by adding to the design.

Short Horn Bull JOHN C. BRECKINRIDGE, imported by W. H. Jackson.

Illustration from the 1865 *Texas Stock Directory*, showing brand mark on a prize bull

Page from the 1865 *Texas Stock Directory*, showing brands and ear marks

The invention of barbed wire in 1874, the spread of farming settlers onto the plains, and the construction of railroad lines directly into the cattle-growing regions led to the end of the cattle drives and, eventually, to the confinement of cattle on limited ranges. But the cattle brand has survived, as much a mark of pride in the Western heritage as an important mark of ownership.

(A) **Universal barb wire liniment,** C.J. Clark, Liberty, Nebraska

(B) **W. M. barbed wire,** Washburn & Moen Manufacturing Company, Worcester, Massachusetts

(C) **Mess Pork hog medicine,** Samuel A. Clark, Chicago, Illinois

(D) **Dr. Hess heave powder,** Dr. Hess & Clark, Ashland, Ohio

$50.00 REWARD for information leading to conviction for theft of my cattle. Branded as per cut herewith and sometimes on left hip or shoulder. Some have point of left horn sawed off. Some also have old brands. Horses have same brand on left hip. WILLIAM ELLIS, Antlers, Oklahoma. Range Pushmataha County.

1916 classified advertisement

Barker Texas History Center, The University of Texas at Austin

(A) 1887

(B) 1892

(C) 1884

(D) 1905

GARRETT'S HOGG-NOGG TRADE MARK

(D) 1895

(E) 1904

(A,B,C) **John Deere** grew up in Middlebury, Vermont, and began a career there as a blacksmith. In 1836, at the age of thirty-two, he packed up his belongings and headed west for the rich new farmlands then being settled near the Mississippi River. At Grand Detour, Illinois, he found a promising community in need of a blacksmith and set up his forge. His horseshoes and hand tools found satisfied customers, but he quickly discovered that the rich Illinois soil required a type of plow different from what he had learned to make in New England. The thick dirt stuck to the bottom of a conventional iron plow in a clump that swelled until the farmer stopped to scrape it off.

Deere studied the problem, experimenting with smoother materials and different shapes, until he came up with a sharp-edged steel plow forged from a broken saw blade that sliced cleanly through the soil. He made the first steel plow in 1837 and three more the next year. Then word began to spread. By 1842 he was making twenty-five plows a week, and he soon moved the factory to Moline, on the Mississippi River, to be nearer his source of steel.

The business adopted the leaping deer trademark in 1873 and has kept the animal on its logo through more than a century of changing tastes in design. The earliest design had to be applied to farm tools by a combination of stencil (for the lettering) and the transfer process (for the deer). Simplification over the years has made the design both bolder and easier to apply. It appears most often today in a color combination known at the home office as John Deere Agricultural Green and John Deere Agricultural Yellow.

(D) Garrett's Hogg-Nogg hog remedies, James Garrett, Boone, Iowa
(E) Capewell horse nails, Capewell Horse Nail Company, Hartford, Connecticut

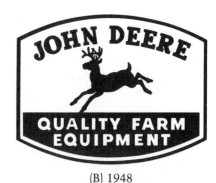

JOHN DEERE QUALITY FARM EQUIPMENT

(B) 1948

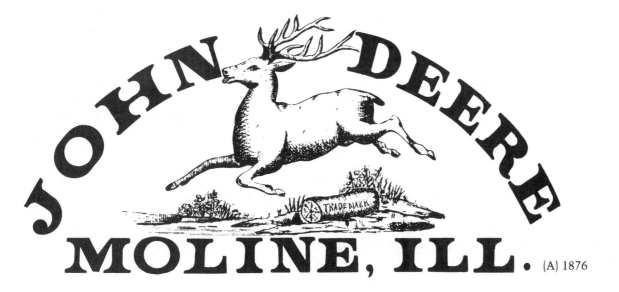

JOHN DEERE MOLINE, ILL. TRADE MARK

(A) 1876

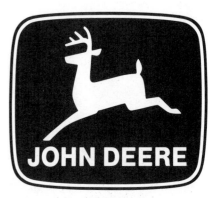

JOHN DEERE

(C) 1984

The most cherished strand in the lineage of the **(A) International Harvester Company** is the one that goes back to Cyrus Hall McCormick, who invented the mechanical reaper in 1831. The first practical harvesting machine, McCormick's reaper worked a revolution on the farm by replacing labor-intensive sickles and scythes. It opened the door to large-scale farming in the West and displaced a pool of laborers from farm work into industry.

McCormick at first licensed his invention to other manufacturers, then in 1846 opened his own factory in Chicago. That business merged in 1902 with four other firms to become the International Harvester Company. McCormick's son, Cyrus H. McCormick, became the new conglomerate's first president. International Harvester turned an early eye toward power tractors, establishing a dominant position in the field before World War I. The company's 1922 Farmall tractor fixed the standard tractor structure that has held sway ever since—two large, high-mounted rear wheels that provide traction while clearing low crops, and a pair of small, narrowly set front wheels that fit between the rows.

Raymond Loewy designed the International Harvester logo in 1946, after a meeting with company officials. As Loewy remembered it, "I left Chicago for New York on the train and sketched a design on the dining car menu, and before we passed through Fort Wayne, International Harvester had a new trademark." He liked its strength and its suggestion of the front end of a tractor, with the dot of the i as the operator's head. The company revised the design slightly in 1973.

O.H. Benson thought up the **(B) 4-H Club** cloverleaf emblem in 1908 as a symbol for his program for farm children in the Wright County, Iowa, school system. To Benson, the *H*'s stood for head, heart, hands, and hustle. (The hustle has since been changed to health.) Many clubs in other states that sponsored corn-growing contests and other agriculture projects for young people adopted the 4-H symbol as well. It gained national status in 1924 as the official emblem of the youth programs run by the Cooperative Extension Service of the Department of Agriculture and the state land-grant institutions.

(C) Egomatic egg candler and grader, Otto Niederer Sons, Inc., Titusville, New Jersey
(D) The Make-Um-Lay poultry powder, Charles Brewer, Vineland, New Jersey
(E) Prall's horse colic capsules, Delbert E. Prall, Saginaw, Michigan

(A) 1946

(C) 1945

HORSE COLIC CAPSULES.

(E) 1893

(B) 1924

(D) 1880

(A) **The Grange** got its start in the unsettled years just after the Civil War, as a fraternal organization (the Order of Patrons of Husbandry) to unite farmers North and South. The first local chapter was the Fredonia Grange No. 1, established in western New York on April 12, 1868. The National Grange, the central body of the organization, lobbied actively for laws and programs to benefit farmers across the country. It counts among its victories a powerful Department of Agriculture (its head was appointed a member of the president's cabinet in 1889 as a result of Grange pressure), the Rural Free Delivery and Parcel Post systems, the establishment of agricultural colleges, Food Stamps, and the school-lunch program.

Throughout its history the Grange has added a stong progressive voice to the country's political affairs. It admitted women on an equal basis from the beginning, fought against monopolistic businesses long before that became a popular cause, and has always worked for programs that would benefit the general public as well as farmers.

(B) **Future Farmers of America** was organized in Kansas City in 1928 by vocational agriculture students, some of whom had formed local groups as early as 1917. Today the FFA is made up of high-school students preparing for careers in agriculture, forestry, and horticulture. It provides supervised job experience programs and offers awards for excellence at school and at work. The dominant motif of the FFA emblem, adopted in 1928, is the cross-sectioned ear of corn that rings the design. Corn was chosen as a native American crop, grown in every state. Not incidentally, it makes a nice circular design.

The small metal flying-corn signs that dot the roadside throughout the Midwest are the mark of farmer-dealers for (C) **DeKalb seeds**. DeKalb started in 1912 as the DeKalb County Soil Improvement Association, a group run by farmers for farmers. It moved from soil management into seeds, oil and gas exploration, and livestock marketing, and today, as DeKalb AgResearch, is a business with annual sales of more than $600 million. The flying ear of corn was first used in a 1936 advertisement for hybrid corn, with the headline, "Let DeKalb Quality Hybrids be your Mortgage Lifter." The winged corn has been lifting mortgages ever since as the company's primary trademark.

(D) **Dr. S.W. Kahn's hog medicine,** Solomon W. Kahn, Peru, Indiana
(E) **Sulz-Bacher veterinary liniment,** Mirum Sulz-Bacher, New York, New York

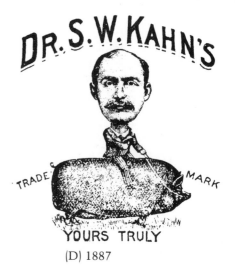

YOURS TRULY

(D) 1887

(E) 1889

(A) 1962

(B) 1972

(C) 1966

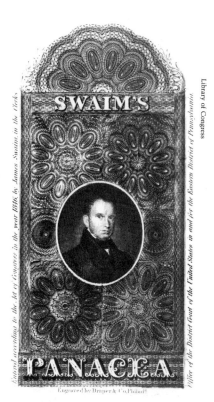

(A) 1846

Medicine

The makers of patent medicines rank among the most colorful and successful entrepreneurs of the last century. To promote the sale of such strange-sounding concoctions as Robertson's Infallible Worm-Destroying Lozenges, Hamilton's Grand Restorative, and Swaim's Panacea, they pioneered in the use of national advertising and brand-name packaging. And because they owned many of the first nationally recognized products in a highly competitive business, their legal disputes laid important groundwork on which the first trademark laws were later built.

Labels for patent medicines produced in the first decades of the nineteenth century relied on loquacious names and descriptions of frightening diseases to make their pitches to the buyer. Only later, in the 1840s and '50s, did they begin to include pictures and trademark symbols to build public recognition. The **(A) Swaim's Panacea** label, adopted in 1846, framed a portrait of James Swaim within a forest of printer's embellishments. An engraving of Saint George and the Dragon identified bottles of **(B) Hostetter's Celebrated Stomach Bitters** from 1859.

After the Civil War the nostrum makers grew even more inventive with their labels and advertisements. The Charles A. Vogeler Company of Baltimore found little demand for its Keller's Roman Liniment, bottled with a portrait of Caesar on the label and the claim that the formula had come down from the Romans. So the name was changed to **(C) St. Jacobs Oil**, a recipe allegedly prepared by the monks of the Black Forest, and the firm found a ready market for the same mixture.

(D) Bonnore's Electro Magnetic Bathing Fluid, Louise A. Bonnore, San Jose, California

(E) Mug-Wump Specific, Sackett & Neat, New Albany, Indiana

(C) 1887

(B) 1875

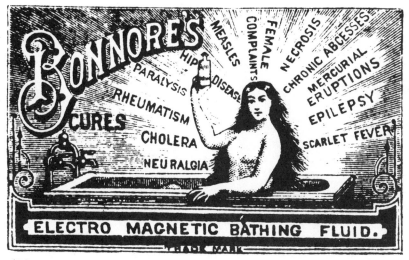

(D) 1881

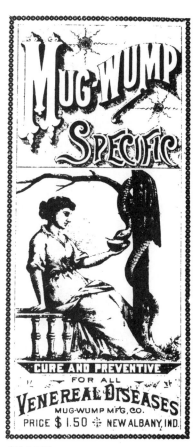

(E) 1888

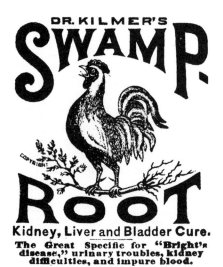

DR. KILMER'S SWAMP ROOT

Kidney, Liver and Bladder Cure.

The Great Specific for "Bright's disease," urinary troubles, kidney difficulties, and impure blood.

(A) 1891

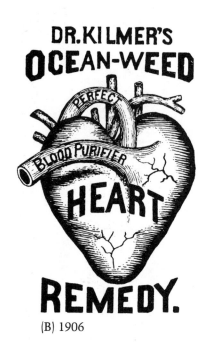

(B) 1906

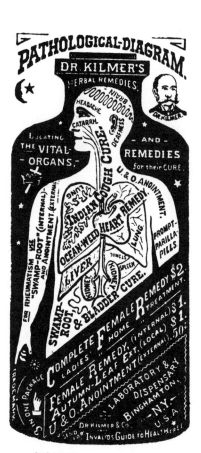

(C) 1885

(A,B,C) Dr. S. Andral Kilmer expanded his Binghamton, New York, practice in the late 1870s with a line of bottled remedies that he prepared and sold with the help of his brother Jonas. He began with Dr. Kilmer's Complete Female Remedy, and continued with Dr. Kilmer's Swamp Root, Dr. Kilmer's Ocean Weed Heart Remedy, and many others. The Kilmers found a formula for success in striking graphics and a generous measure of alcohol—12 percent in Dr. Kilmer's Swamp Root, the most popular potion in the line.

But it was Jonas's son, Willis Sharpe Kilmer, who turned the business into a gold mine through effective advertising.

In 1888 he graduated from a two-year advertising course at Cornell and turned his expertise loose on the family firm. For the first few months his handiwork brought the enterprise to the brink of bankruptcy. But then new customers from all over the country lifted the company to the top ranks of the patent-medicine business. By 1912 Willis Kilmer had pocketed a fortune of $30 million. Dr. Kilmer's Swamp Root is still sold by Gibson Auer Labs in Cody, Wyoming, and it still features old S. Andral's picture on the box.

Scientific advances in medicine often brought more questionable advances in patent drugs. William Radam, owner of a seed store and nursery in Austin, Texas, read something of Louis Pasteur's discoveries in bacteriology and formulated his own theory of microbes. His researches led to an all-purpose cure for disease, **(D) Radam's Microbe Killer**, which he claimed was harmless to humans in any dosage but brought certain death to the microbes that swarmed through the body. Legitimate doctors and pharmacists attacked the drug as the worst form of quackery— chemical analysis revealed it to be more than 99 percent water, with trace amounts of sulphuric and hydrochloric acids—but their criticism barely affected Radam's business. He appealed directly to the public in newspaper advertisements. Much of the population undoubtedly first learned of the germ theory of disease through Radam's distorted claims and explanations.

(E) Wheel In Your Head? headache tablets, James D. Wilson, Lexington, Kentucky

(F) Electrozone liquid preparation, Herman M. Johnson, San Francisco, California

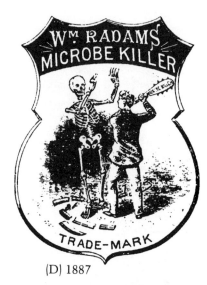

(D) 1887

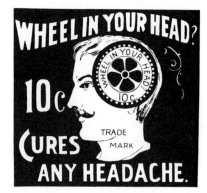

(E) 1896

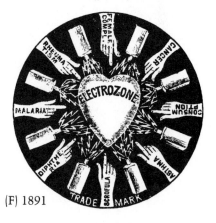

(F) 1891

(A) **Carter's Little Liver Pills** were made in New York City from the early 1870s as a cure for "headache, dizziness, biliousness, torpid liver, constipation, and sallow skin." The crow became a feature of the pills' packages in 1877, and soon afterward the firm started to advertise on a national scale. Judging by the host of imitators, the pills must have done well. (B) **Dr. Williams' Pink Pills for Pale People**, made in Brockville, Ontario, used the same alliterative device, brought closer to perfection with a match of four words. The pills claimed to be the answer not only for pale people but for those on the verge of death. According to the instructions packed with the pills, they could cure consumption and partial paralysis, as well as such lesser complaints as loss of ambition, feebleness of will, and confusion of ideas. Other imitators included (C) **Dr. Coderre's Red Pills for Pale and Weak Women,** (D) **Dr. Wilson's Blue Pills for Blue People,** and Dr. Hope's Tiny Tablets for Tired Nerves.

Two New York City druggists, Alfred B. Scott and Samuel W. Bowne, developed (E) **Scott's Emulsion** in 1870 as a palatable form of cod liver oil. At first they promoted the oil only to doctors, but good results from general advertising in Cuba and Panama led them to experiment with newspaper ads in the United States. Some years later Alfred Scott recalled wondering whether "so distasteful an article as cod liver oil could be advertised so as to make a large and permanent business." He needn't have worried. In 1895 *Printer's Ink*, the trade journal of the advertising industry, described Scott & Bowne as "probably the largest advertisers in the world." Scott's Emulsion is still made, though the world's children are fortunate that it has found competition in chewable vitamins.

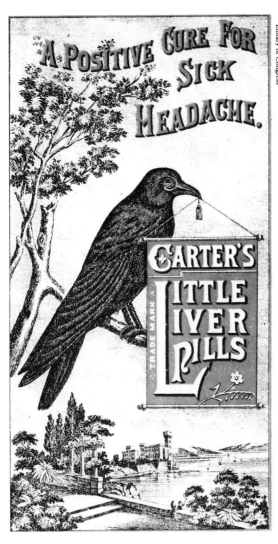

Library of Congress

(A) about 1890

(B) 1887

(C) 1897

(D) 1901

(E) 1890

Many patent-medicine makers took their promotion a step beyond printed advertisements and sent medicine shows and entertainments out into the country. This practice dates back at least to colonial times. A 1773 law in Connecticut barred these "plays, tricks, juggling or unprofitable feats of uncommon dexterity and agility of the body," which were used to lure the public into buying "unwholesome and oftentimes dangerous drugs." During the nineteenth century the shows grew more sophisticated, reaching a pinnacle of sorts in the 1880s and '90s.

Clark Stanley was a true snake-oil huckster, known in his day as the Rattlesnake King. According to his autobiography, he learned the recipe for his **(A) Snake Oil Liniment** from the medicine man of the Moki Pueblo at Wolpi, Arizona, whom he impressed with his fancy shooting. He began to sell the liniment in Texas in 1886 as a cure for rheumatism and expanded his territory through the Southwest, arriving with a flourish at the 1893 Columbian Exposition in Chicago. There he made the liniment "in full view of the audience, killing hundreds of snakes," which were shipped to him by his two brothers. After the Exposition, he set up a factory in Providence, Rhode Island, seemingly an odd place to make such a Western nostrum. Chemists who analyzed the liquid found kerosene, camphor, and turpentine, but not a trace of rattlesnake oil.

Perhaps the biggest medicine shows of all time were those staged by John E. Healy and "Texas Charley" Bigelow for their line of **(B) Kickapoo Indian medicines.** The two men first joined forces to sell a liver pad in a road show through the South in 1879, and while together schemed of more ambitious ventures. Healy, a New Haven native, saw the popularity of Indian cures and envisioned a medicine show using real Indians. Bigelow, a Texas farm boy with a flair for promotion, came up with the story behind the medicine. He had been saved from a violent fever by the Kickapoo medicine men. They brought him back from "the verge of the grave" with their Sagwa and Indian Oil, and in gratitude he agreed to act as their agent in selling the cures to the world. The Kickapoos themselves gathered the herbs; Healy and Bigelow, at their New Haven factory, simply put the remedies in convenient packages.

Kickapoo Indian Sagwa was the first and most important formula in the line. The literature described it as a compound of roots, herbs, barks, gums, and leaves, which "purges out the foul corruptions which contaminate the blood and cause derangement and decay." "Buffalo Bill" Cody endorsed it as "a remarkable medicine . . . for what it claims to do it has no equal." According to medicine-show legend, it was made from aloes and stale beer. The partners soon added Kickapoo Indian Salve, Kickapoo Cough Cure, Kickapoo Indian Oil, and Kickapoo Indian Worm Killer to their catalogue of goods.

The success of the Kickapoo cures had little to do with their contents or healing merits, but relied on the entertainments by which they were promoted. The basic act included five or six Indians, several collection men and musicians, and a "scout." A purported medicine man among the Indians gave a speech in his native tongue, interpreted by the scout in a dramatic tale of the discovery and secret nature of the medicines. At the end of this double oration, the musicians struck up their instruments, the Indians whooped and beat their drums, and the rest of the troupe went into the crowd to sell Sagwa.

During the late 1880s and early 1890s, Healy and Bigelow fielded more than seventy-five such troupes at a time, employing hundreds of Indians. They occasionally staged Kickapoo spectaculars, which used up to a hundred performers to re-create an Indian attack on a wagon train, thwarted by heroic cowboys. The shows ended with an impressive prairie fire and an equally impressive sale of remedies.

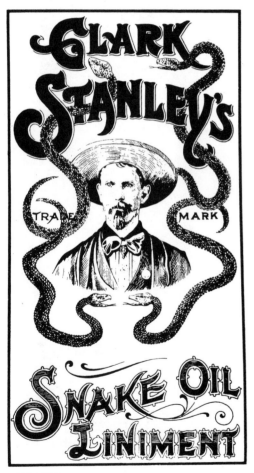

(A) 1898

(B) 1892

82

Oh, we'll sing of Lydia Pinkham,
And her love for the human race,
How she sells her Vegetable Compound,
And the papers, the papers
 they publish, they publish her face!

(A) Lydia Pinkham, the prim Victorian lady on the Vegetable Compound bottle, etched her face into the minds of millions through advertising. When her husband brought the Pinkham family to financial ruin in 1873, Lydia, with the help of her three sons, began to sell a remedy for female complaints that she had made for years on the family's kitchen stove. Legend attributes the recipe to a machinist named George Clarkson Todd, who offered it in payment of a $25 debt. Lydia herself, however, was a collector of folk remedies and a student of medicinal herbs, and may well have invented the formula.

Whatever the recipe's source, the Pinkham family put it to good use. Beginning in 1875, they made a concerted effort to spread the word beyond their Lynn, Massachusetts, neighborhood. Lydia brewed the herbs, kept the books, and helped write the advertising copy, while her sons Will and Dan distributed pamphlets and fliers, placed newspaper ads, and generally took care of sales. The turning point for the Vegetable Compound came in 1881, when the family put Lydia's picture on the label. Sales, which had been growing slowly, saw a sudden boom. Women apparently trusted her grandmotherly face and transferred that trust to the Vegetable Compound.

Through the 1880s Lydia Pinkham's face was so frequently advertised that she became a celebrity of the highest order. Small-town newspapers used the picture with some abandon, relying on it as a portrait for such figures as Queen Victoria, President Cleveland's bride, and actress Lily Langtry. The famous jingle, sung to the tune of "Our Redeemer," came out of Dartmouth College in the 1880s and, with a growing string of verses, spread to other college glee clubs.

Sadly, the Pinkhams did not live to enjoy their good fortune. Will and Dan both died of consumption in the fall of 1881. Lydia Pinkham followed them to the grave on March 17, 1883. The business stayed in the hands of the surviving children, reaching an annual sales volume of $3 million in 1925. Only in 1968 did the family sell its interest. Lydia Pinkham's Vegetable Compound is now made and sold by Cooper Laboratories.

With the swelling fortunes of the patent-medicine makers came public agitation for some form of protection from their abuses. For though many remedies were as harmless as they were useless, others were genuinely dangerous. **(B) Heroin** was first sold as a proprietary medicine, the name a trademark of a German chemical company. **(B) Cocaine** was a popular remedy ingredient—this example was a trademark for pills containing the drug. By the 1890s newspapers carried ads for drug-addiction cures—for opium, laudanum, and cocaine—alongside the growing number of ads for packaged remedies.

Reformers and progressive legislators called for laws to force the disclosure of ingredients on all proprietary medicines and to restrict the sale of those made with addictive and poisonous chemicals. The American Medical Association, the Women's Christian Temperance Union, and other women's clubs joined in the battle. With the lobbying leadership of Dr. Harvey Washington Wiley, chief chemist of the Department of Agriculture, the reformers swayed the U.S. Senate into passage of a pure food and drug bill in 1906.

Americans might have waited another decade for the House to make the bill a law, but for the timely publication of Upton Sinclair's *The Jungle*. Sinclair's portrayal of conditions in Chicago's meat-packing houses was so revolting and received such wide publicity that meat sales plummeted to half their normal level. The public clamor for action on food and drug legislation ensured speedy passage to a toughened version of the Senate bill. President Roosevelt signed the Pure Food and Drug Act on June 30, 1906, bringing the curtain down on a flamboyant era in the American drug business.

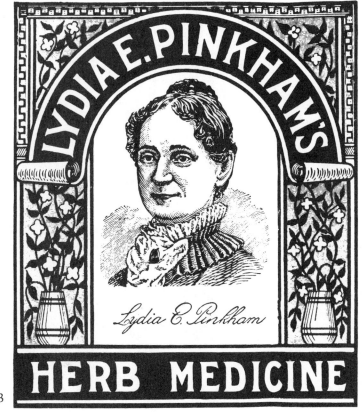

(A) 1933

HEROIN.

(B) 1898

(C) 1895

83

The pharmaceutical companies that prospered under the Pure Food and Drug Act may have lacked the special flair of their predecessors, but they have more than made up for it in calm reliability. Dr. William Erastus Upjohn developed the "friable pill" in 1884—a pill that could be easily crushed into a powder and that would dissolve quickly inside the body. He patented his process, and with his brother, Dr. Henry U. Upjohn, founded the Upjohn Pill and Granule Company in Kalamazoo, Michigan, to capitalize on the idea. From the start the Upjohns openly stated the ingredients of their pills and other medicines, and focused their sales efforts on other physicians.

The 1894 trademark for **(A,B,C) Upjohn's Friable Pills** put a heavy emphasis on the crushable nature of the pills. After the friable-pill patent expired and other companies began to make them by the same method, the thumb portion of the trademark gradually gave way to the name Upjohn. Today the company relies on the name alone as its symbol.

(D,E) Dr. Edward Robinson Squibb came into the drug business through his work as director of the first laboratory for the Naval Hospital in Brooklyn in the 1850s. He designed equipment to manufacture extracts from raw drugs and built a perfected still for the distillation of ether—then important as the primary surgical anesthesia. At the Navy's suggestion, he founded his own company in 1858 to provide a source of reliable drugs to the armed forces. He stayed with the company until his death, in 1900, actively working toward the ideal of pure, standardized medicines.

Dr. Squibb's sons sold the company in 1905 to Theodore Weicker and Lowell M. Palmer. One of Weicker's first moves was to design the Greek-columned Squibb seal, which has endured with small changes as the familiar symbol of E.R. Squibb & Sons. A 1920 revision **(D)** changed the *efficiency* column to *efficacy*. The wavy lines in the background were intended to suggest the look of hammered gold. In 1961, the company attached a base with the word *research*, and in 1968 the design firm of Lippincott & Margulies gave the seal a major overhaul **(E)**. They painted over the graffiti on all the pillars, shrunk the whole building, and made the name Squibb the prominent feature of the mark.

(A) 1894

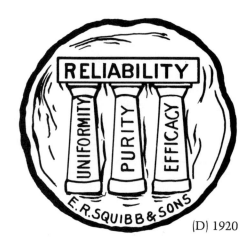

(D) 1920

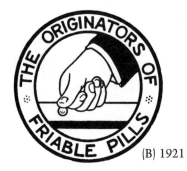

(B) 1921

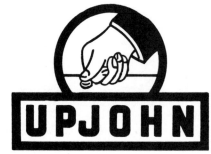

(C) 1938

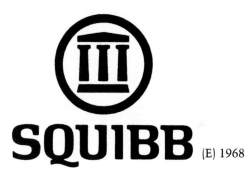

(E) 1968

(A) Smith Brothers' cough drops got their start in the Poughkeepsie, New York, restaurant of James Smith, who brought his family there from Scotland with a fifteen-year layover in St. Armand, Quebec. As a sideline, Smith sold candy, employing his eldest son, William, to hawk it through the streets of the city. William, known as the Candy Boy in his youth, was later to gain fame as Trade on the familiar Smith Brothers cough-drop box, opposite his brother Andrew, better known as Mark.

Legend attributes the cough drop recipe to a roving peddler named Sly Hawkins, who swapped it for a meal. The drops were first advertised in 1852 as James Smith & Sons Compound of Wild Cherry Cough Candy "for the Cure of Coughs, Colds, Hoarseness, Sore Throats, Whooping Cough, Asthma, &C, &C." The name and claims would later be abbreviated.

William and Andrew took over the restaurant after their father's death in 1866, devoting more and more of their attention to the cough drops. They converted a barn on the edge of town into the country's first cough-drop factory. They expanded sales by offering the candies to other retailers, maintaining their own brand name by providing glass dispensers and paper envelopes clearly marked "Smith Brothers." To discourage counterfeits and substitutions, they molded the intitials *SB* onto each drop.

As the fame of the candies spread, the Smith brothers made improvements in selling and packaging. In 1877 they began to offer the cough drops in packages printed with their own portraits, a change they would never regret. The same portraits are still on the packages. Under the aliases of Trade and Mark, William and Andrew Smith have become two of America's best-known businessmen. Smith Brothers' cough drops remained in the Smith family until 1963, when the business was sold to Warner Lambert.

Robert Wood Johnson formed a partnership with George J. Seabury in 1867 to make and sell Benson's Capcine Porous Plasters. This ancestor of the Band-Aid was recommended for weak backs, kidney trouble, coughs, sprains, rheumatism, and pains of all sorts. Over the course of his career Johnson fortunately steered toward more legitimate medications. In 1876 he heard Sir Joseph Lister speak in New York City on the dangers of airborne germs as a cause of infection in the operating room. The concept of bacterial infection made a lasting impression, as Johnson pondered practical applications of the discovery. He left Seabury in 1886 to join a competing business started by his two brothers, James Wood and Edward Mead Johnson.

The new firm of **(B) Johnson & Johnson** kept its hand in the proprietary medicine business with such remedies as Quiniform pills, Carapin (for "Dyspepsia, Indigestion, and Diphtheria"), and Johnson's Capsicin Plaster—a direct competitor to the Benson's Plasters Robert Wood Johnson had abandoned. But early on, the Johnsons added a line of antiseptic surgical dressings, and it was this solid and respectable foundation that saw the business through the changes brought on by the 1906 Pure Food and Drug Act.

Besides their name, Johnson & Johnson has since 1888 relied on another powerful trademark—the red Greek cross. Clearly, this is a valuable asset in a business so closely related to health care. The American Red Cross Society also has a strong claim on the symbol, as it has been used since 1863 by the International Committee of the Red Cross. Since this use is protected under the Geneva Convention, Johnson & Johnson has had to maintain a tight grip on the cross through some buffeting legislation.

In 1905 a special federal law gave the American Red Cross exclusive use of the symbol, but some vigorous lobbying by Johnson & Johnson and other concerned firms brought an amendment in 1910 allowing use by those who had adopted the design as a trademark prior to 1905. That exception still holds, even though the Geneva Convention of 1929 explicitly forbids use of the emblem by "private persons or organizations . . . whether as trademarks, commercial labels, or portions thereof." In 1945 the Senate passed a bill to fully implement the Geneva Convention on this point, but it was defeated in the House. Johnson & Johnson products still bear the red cross symbol, as do such other pre-1905 products as Red Cross shoes, Red Cross salt (with a Maltese cross), and the Red Cross Nurse pump-spray disinfectant and deodorizer.

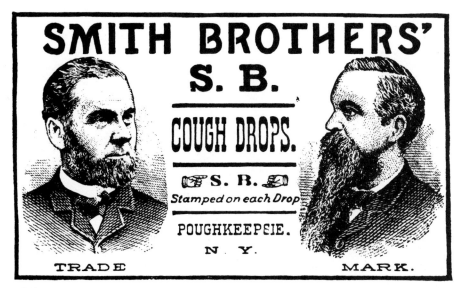

SMITH BROTHERS'
S. B.
COUGH DROPS.
S. B.
Stamped on each Drop
POUGHKEEPSIE.
N . Y .
TRADE MARK.

(A) 1905

Johnson's
Antiseptic
BABY POWDER.
PERFUMED
FOR ✚ AND
TOILET NURSERY.
Johnson + Johnson
NEW BRUNSWICK,
N. J.

(B) 1905

The special problems of the human foot did not escape the notice of the early medicine makers. Cures for foot odor, corns, and other pedal discomforts have long been a part of the remedy repertoire. J. Little & Co., of Piedmont, West Virginia, registered the elaborate talking symbol for **(A) Little's Original Ointment for Sweaty Feet** just a few years after the country's first trademark law went into effect. The floating conversation is drawn in the style of the period's political cartoons

(newspaper comics did not appear for another twenty years). N.W. Stiles' **(B) 24-Hour Corn Cure** relied on a less genteel image of pigs munching on a feast of corn to get its message across.

The most famous and successful of all the feet healers was **(C,D) Dr. Scholl**, who really was a doctor and ran the company until just before his death in 1968. William M. Scholl became interested in the plight of the foot while working at his first job in a Chicago shoe store in 1899. So great

was his concern that he decided to enroll at the Illinois Medical College (now Loyola University). Between his studies and a night job he found time to experiment with foot remedies, and in 1904 began to sell an arch-support device as the first product in the Dr. Scholl line.

For a time Dr. Scholl did everything for the new business—making the foot aids at night and selling them during the day. He is remembered as a man with a flair for salesmanship. To drive

points home on a sales call, he often pulled a skeleton of the human foot from a specially built coat pocket for a dramatic and memorable demonstration. Dr. Scholl maintained his inventive energy through a career that spanned six decades. Most years he added at least five or six new products to the line, and none was ever discontinued during his lifetime.

(E) Pedolatum ointment, King Laboratories, Tyler, Texas

(A) 1876

Dr. William M. Scholl

(C) 1981

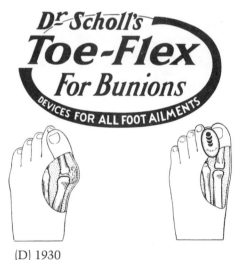

(D) 1930

PEDOLATUM

(E) 1956

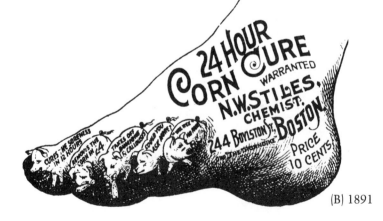

(B) 1891

Hair

Some people don't have enough of it, some have too much, and fortunes have been made attacking the problem from both sides.

Hair restorers and baldness cures flourished in the nineteenth century before the Pure Food and Drug Act put a stop to the unsubstantiated claims made for the remedies. The oil strikes in western Pennsylvania brought a crop of petroleum-based baldness cures in the late 1870s before inventors and engineers could find more practical uses for the new fuel. William E. Jervey, of New York City, built his **(A) Flowers of Petroleum** into a thriving business, despite what must have been a steady stream of dissatisfied customers.

(B) Herpicide hair and scalp remedy, Herpicide Company, Detroit, Michigan
(C) Capo-Oil hair preparation, Samuel D. & Charles W. Robison, Pittsburgh, Pennsylvania
(D) Hair Root scalp treatment, Kilmer Company, New York, New York
(E) Koko hair preparation, Koko-Maricopas Company, London, England
(F) Tulepo hair restorer and dandruff cure, James Lefevre Bradley, Plainfield, New Jersey

(A) 1879

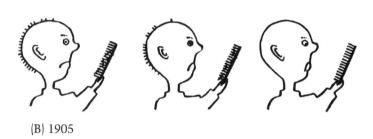

(B) 1905

(C) 1897

HAIR-ROOT (D) 1900

(E) 1897

(F) 1905

(A,B) King C. Gillette harbored the aspirations of an inventor for years before he dreamed up the safety razor in 1895. When a young man, Gillette worked as a salesman for the Crown Cork and Seal Company, manufacturers of the disposable bottle cap. In his spare time he worked at inventing. But his tinkering didn't amount to much until his boss, William Painter, the inventor of the bottle cap, offered a tantalizing piece of advice. Why not think of something that is used only once and thrown away? Something that customers have to keep buying again and again?

Clearly this was sound advice, the key to Painter's huge success. But, just as clearly, it would not be easy to invent another disposable necessity. Gillette took the idea to heart. For years he imagined disposable replacements for virtually every object he used or came in contact with. As he later recalled, he became "obsessed" with the idea until the answer finally came in a momentary vision. "On one particular morning, when I started to shave, I found my razor dull; and it was not only dull, but was beyond the point of successful stropping. . . . As I stood there with the razor in my hand, my eyes resting on it lightly as a bird settling down on its nest, the Gillette razor was born."

It actually took another eight years—and the expert assistance of engineer William E. Nickerson—to work out the practical details of making the razor. The first blades were sold in 1903; in 1905 King C. Gillette put his name and signature on the wrapper, ensuring his fame in one of the most widely reproduced portraits in history. The diamond trademark was added in 1908. Designed by Fred E. Dorr, a company draftsman, it was drawn as a bold, simple symbol to be printed directly on blades and shaving brushes.

(C) Burma-Shave should be remembered as a pioneer brushless shaving cream, but instead is tied in our minds with rhyming signs by the side of the road. Clinton Odell came up with the idea for the shaving cream in 1925 while on a doctor-enforced sick leave from his insurance career. He took a family recipe for a cure-all liniment, and with the help of a local Minneapolis pharmacist, transformed it into Burma-Shave.

Allan Odell, Clinton's son, takes credit for the serial signs. He was in charge of selling the first Burma-Shave jars. He was having a tough time of it, when he noticed a set of signs along the highway advertising a gas station. With the grudging acquiescence of his father, he and his brother Leonard painted several sets of signs and planted them along two highways leading out of Minneapolis. When sales showed a jump in towns along the roads, the signs were adopted in earnest. The first rhyming signs appeared in 1929 (*Half a pound/For/Half a dollar/Spread on thin/Above the collar/Burma-Shave*). They remained a popular feature of highway travel for more than thirty years, until banished by the 1965 Highway Beautification Act.

(D) Old Spice men's toiletries, Shulton, Inc., Clifton, New Jersey

(A) 1905

(B) 1908

(C) 1979

(D) 1937

Tobacco

When we think of tobacco we think of brand names like Winston, Camel, Lucky Strike, and Mail Pouch, and we think of packages and slogans. The tobacco industry spends more of its income on advertising than does any other industry in this country, and its careful work has gone to our heads.

Tobacco has been one of America's important cash crops since the days of the Jamestown settlement. It was one of the principal exports in colonial times, and led the way in the nineteenth-century revolution in consumer packaging and brand identification.

Since the tobacco sold by different merchants and manufacturers is largely identical—one good-quality cigar of a given type is very similar to another—trade names have long been an important part of the tobacco business. These names began as marks on wooden kegs, often branded with a hot iron, to indicate the manufacturer or the region where the leaf was grown. By the 1850s, manufacturers had learned that an appealing name could help sell their tobacco, and they came up with such colorful monikers as Wedding Cake, Uncle Sam, Christian's Comfort, Cherry Ripe, Nature's Ultimatum, Winesap, and The People's Choice.

The Civil War brought tobacco a step closer to modern packaging. Manufacturers discovered a ready market for small cotton bags of smoking tobacco, especially among soldiers who had to carry their belongings on long marches. John Green of Durham, North Carolina, had some success selling small sacks of Bright leaf tobacco, a locally grown specialty with a mild flavor, but was wiped out in 1865 when General William Tecumseh Sherman led his forces into Durham to accept the surrender of Confederate General Joe Johnston. Troops from both sides helped themselves to Green's entire tobacco supply. Green assumed he had lost everything, but in fact he had gained new customers; as soon as the soldiers were back home they began to write to Durham for more of the tobacco they had tasted there. With a change

in brand name to **(A) Genuine Durham smoking tobacco** and a picture of a bull on the label, Green's product grew to be a national favorite, affectionately nicknamed Bull Durham. The idea for the bull is said to have come to Green from the bull's head on jars of Coleman's mustard, made in Durham, England.

While Green watched his stock of tobacco being plundered by soldiers, another man destined to make a mark in the tobacco business was on his way back to Durham after being released from the Union's Libby Prison in Richmond. Washington Duke arrived home to find his farm in shambles, with little left but some flour, a pile of Bright tobacco leaf, and two blind mules. He packed the tobacco in muslin sacks branded *Pro Bono Publico* (for the good of the public), and hitched up his mules to haul it into Raleigh for sale. He was pleasantly surprised to find that the reputation of Durham's Bright tobacco had spread before him, enabling him to sell the crop for enough cash to buy a supply of bacon.

Duke's tobacco business grew steadily, becoming W. Duke, Sons & Co., makers of brands such as **(B) Duke of Durham** and Duke's Mixture. And when James B. Duke, the youngest son, entered the business in 1881, it skyrocketed. With mechanized cigarette rolling, cutthroat pricing, and heavy advertising, Duke climbed to the top of the heap. By 1889 W. Duke, Sons & Co. was producing more than 800 million cigarettes a year, roughly 38 percent of the U.S. market. The following year, the five leading cigarette makers combined to form the American Tobacco Company, with James B. Duke as president. Duke went on to organize the makers of plug tobacco into Continental Tobacco in 1898, then formed American Snuff in 1900 and American Cigar in 1901. The Supreme Court eventually broke up American Tobacco in an antitrust action, but the ruling hardly slowed Duke down. He gave $100 million in his lifetime to Trinity College at Durham, later renamed Duke University.

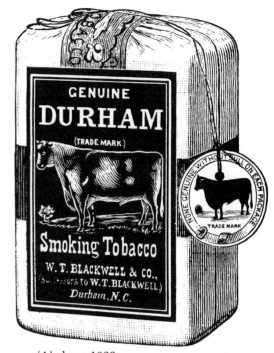

(A) about 1890

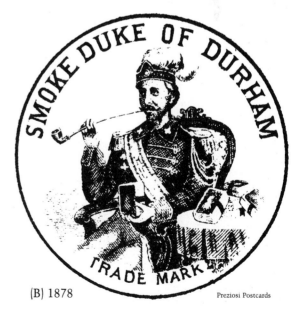

(B) 1878

The (**A**) **Camel cigarette** trademark is one of the most familiar commercial symbols in the world. The old beast has held his pose for the R.J. Reynolds Tobacco Company for more than seventy years, and can keep his chin up today with the sure knowledge that he has earned his place as an advertising classic.

He first appeared in 1913, when R.J. Reynolds, freshly split from American Tobacco by Supreme Court order, picked him as the mark for its first entry into the cigarette market. The firm had been in the tobacco business since 1875, with headquarters in Winston-Salem, North Carolina, but had not had a national sales success until it brought out Prince Albert smoking tobacco in 1907. Prince Albert's distinctive feature was its airtight tin package, which kept the tobacco moist much longer than the standard cloth bag. (And which inspired the old joke: "Do you have Prince Albert in a can?" "Well, why don't you let him out?") Encouraged by its good fortune, and newly independent of American Tobacco, the firm decided to challenge the Duke dominance in the cigarette market.

Reynolds chose a blended cigarette for its first effort, made from American and Turkish tobaccos. The name Camel was picked to suggest the Middle Eastern origin of the leaf. The package clearly called for a picture of a camel, and, by a happy chance, Barnum and Bailey's circus arrived in Winston-Salem just as the designers were looking for a model. One of the stars of the circus was an Arabian dromedary named Old Joe. Reynolds sent his stenographer, R.C. Haberkern, over to the circus with a camera, and from the photograph he brought back an artist sketched the immortal portrait, adding pyramids and palm trees for effect.

A massive advertising campaign launched the new Camel brand in the fall of 1913 with a momentum that was to sweep away all competitors. Sales climbed to 425 million cigarettes in 1914, 2.4 billion in 1915, and an incredible 10 billion in 1916. By 1921 Camel sales accounted for half of the entire cigarette market. That was the first year of the famous slogan, "I'd walk a mile for a Camel." Old Joe has become the most printed animal in world history—he's appeared on more than 100 billion Camel packages and in countless advertisements.

(**B**) **Bust the Trust tobacco,** Andrew J. Livingston, Newport, Kentucky

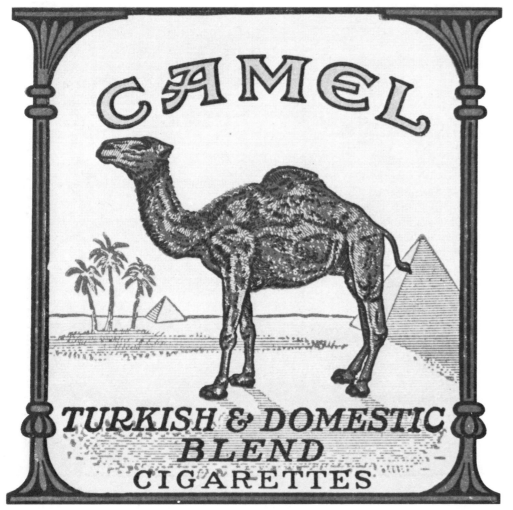

(A) 1921

(B) 1908

90

The American Tobacco Company, with J.B. Duke still at the helm, was a smaller company after 1911—the antitrust defeat pared off R.J. Reynolds, Liggett & Meyers, and Lorillard—but it was still a major force in the industry. It was not about to let Camel take the cigarette market without a fight. Duke's answer was **(A,B) Lucky Strike**, an old brand name applied to a new blended cigarette in 1916. The name had first been used on a brand of plug-cut chewing tobacco in 1856, in the era of the California gold rush and the great Colorado silver strikes. The 1916 cigarette was modeled closely on the Camel blend, and distinguished from it by the selling line "It's toasted"—an almost meaningless slogan, as *most* cigarettes, then and now, go through the same flue-curing process.

Not until 1930 did Lucky Strike catch up with Camel, and only after long and heavy advertising—including some of the first skywriting, in 1923, the Lucky Strike "Hit Parade" on radio, and such memorable slogans as "Reach for a Lucky instead of a sweet" and "With men who know tobacco best, it's Luckies two to one." The line "Lucky Strike means fine tobacco" was added to the box in 1942, and shortened two years later to the cryptic "L.S.M.F.T."

(A) 1886

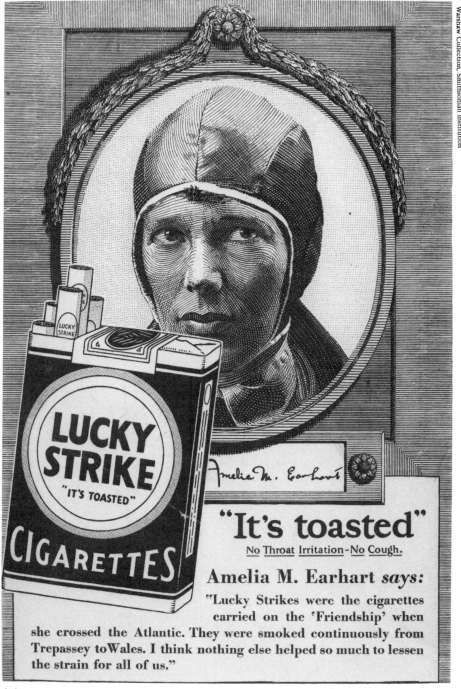

(B) 1928 magazine advertisement. Amelia Earhart did not smoke any brand of cigarettes. She signed this endorsement at the request of her flight crew.

(A) about 1940

(B) 1883

(A) **Yankee Girl chewing tobacco,** Scotten, Dillon Company, Detroit, Michigan.
(B) **Sweet Cob smoking tobacco,** Hirschl & Bendheim, St. Louis, Missouri
(C) **Granger chewing and smoking tobacco,** Liggett & Myers Tobacco Company, New York, New York
(D) **Coffin Nail cigarettes,** Leslie & Welsh, Buffalo, New York
(E) **Red Horse chewing and smoking tobacco,** B. Duwel & Bros., Cincinnati, Ohio

(C) 1924

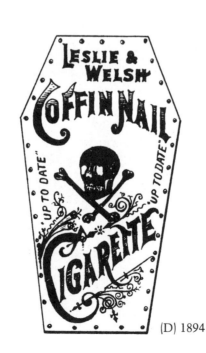

(D) 1894

(E) 1902

(A,B) Mail Pouch tobacco barns are a part of the rural landscape throughout much of Ohio, West Virginia, and western Pennsylvania. For those who've never seen them, they are billboard-sized advertisements hand-painted in black, white, and yellow on the sides of barns, and occasionally on other types of buildings. At one time the barn signs peppered the country from coast to coast, applied by local sign painters until the 1930s, then by two-man teams in cars who worked for Mail Pouch full time. Today a lone painter, Harley Warrick of Belmont, Ohio, keeps up the Mail Pouch barn tradition in a retrenched area radiating from Wheeling, West Virginia.

Bloch Brothers Tobacco Company, of Wheeling, began as a maker of stogies in 1879, then introduced West Virginia Mail Pouch chewing tobacco in 1897, made at first from stogie clippings and scraps. As demand grew, Mail Pouch included less scrap tobacco and more whole leaf, until in 1932 it dropped the clippings entirely. The barn ads began soon after the turn of the century (no one remembers the year) and around 1910 they took on the modern design with large block letters.

The Mail Pouch barn almost went the way of the passenger pigeon and the Burma-Shave sign when Congress passed Lady Bird Johnson's Highway Beautification Act in 1965. The new law prohibited commercial signs within 660 feet of all federally funded highways, and in one stroke of the pen made most Mail Pouch barns criminals. Highway officials painted over some of the barns; in 1969 the Helme Tobacco Company, current owners of the brand, abandoned the upkeep on even the legal ones. But friends of the barn signs successfully lobbied for a special amendment to the law, which in 1974 made allowance for "signs on farm structures or natural surfaces, of historic or artistic significance." The Mail Pouch signs were saved, and Harley Warrick was back on the job.

Today, Warrick maintains about 300 barn signs, while as many as 3,000 more carry the fading message painted decades ago. During the winter, when the weather keeps him off the barn circuit, Warrick does a brisk business painting birdhouses and mailboxes—each a perfect Mail Pouch barn in miniature.

(A) 1899

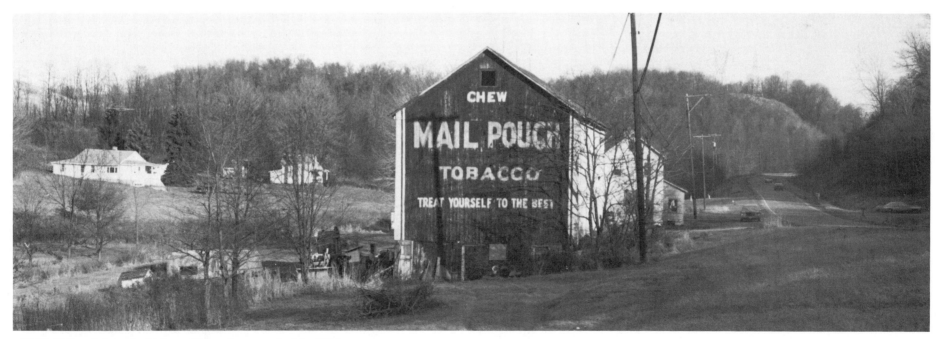

(B) Mail Pouch barn in Lisbon, Ohio, photographed in 1984

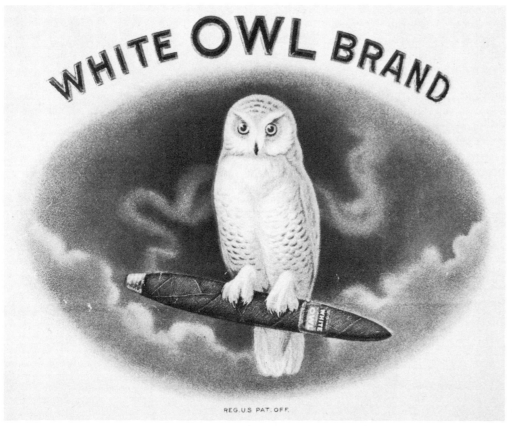

WHITE OWL BRAND

REG. U.S. PAT. OFF.

(A) 1921

The **(A) White Owl cigar** trademark has been in use since 1867, when the New York firm of Straighton & Storm adopted it as the symbol for a new cigar. According to a most romantic legend, Mr. Storm was pondering a name for the cigar when a white owl flew in the window of his Long Island home. He trusted the omen and brought out the Owl cigar. Straighton & Storm later became part of the huge General Cigar Company, which revived the bird for a line of "Invincible" cigars in 1916. A year later it became White Owl; the bird has perched on a lit cigar ever since.

(B) Petersons pipes, Harry L. Rogers, New York, New York
(C) Orlick pipes, L. Orlik Ltd., London, England
(D) Two Johns smoking and chewing tobacco, Spaulding & Merrick, Chicago, Illinois
(E) Bugler smoking tobacco, Brown & Williamson Tobacco Corporation, Louisville, Kentucky. Introduced in 1932, Bugler has become a favorite tobacco for roll-your-own cigarettes.

(B) 1935

(C) 1956

(D) 1886

(E) 1933

The **(A) Phillip Morris** bellhop began as an ordinary drawing on packages of cigarettes in 1919, then came to life in the person of a Brooklyn bellhop named Johnny Roventini. In 1933 Phillip Morris decided that it needed a radio voice for the bellhop symbol in order to take advantage of the growing advertising medium. Milton Biow, the firm's advertising manager, set out on a bellhop hunt that led him into most of the hotel lobbies in New York City, until he discovered the four-foot two-inch Roventini in uniform at the New Yorker hotel. The bellhop's perfect B-flat vocal chords were just what Biow was after. Johnny's memorable "Call for Phil-lip Mor-ris" punctuated many top radio shows of the 1930s and '40s, including "This Is Your Life," "The Rudee Vallee Show," and "Break the Bank."

(B) Red Eye chewing and smoking tobacco, Taylor Brothers, Inc., Winston-Salem, North Carolina
(C) Footprints chewing tobacco, Taylor Brothers, Inc., Winston-Salem, North Carolina
(D) Tom, Dick and Harry cigars, manufacturer unknown
(E,F) Willie the Penguin, mascot for Kool cigarettes, Brown & Williamson Tobacco Corporation, Louisville, Kentucky

"Call for PHILIP MORRIS*"* BOND STREET CIGARETTES

(A) 1923

(B) 1948

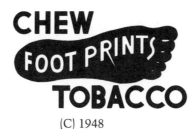

CHEW FOOT PRINTS TOBACCO

(C) 1948

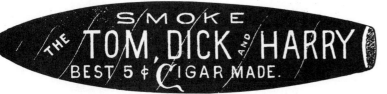

SMOKE THE TOM, DICK AND HARRY BEST 5¢ CIGAR MADE.

(D) advertising card, about 1910

(E) 1950

(F) 1962

Liquor

Bourbon whiskey is an American native, a national drink on a par with Coca-Cola, but it owes much of its fine character to Scottish immigrants who carried the distilling craft to Kentucky two hundred years ago. Settlers began to arrive in the Bluegrass region of Kentucky in the late eighteenth century, an area named Bourbon County in gratitude for French aid to the colonies during the American Revolution. (Bourbon was the family name of the last French kings.) They found fertile farmland and clear streams cleansed by the underlying limestone formations. Good crops and good water made the region ideal for the making of whiskey.

Reverend Elijah Craig is generally credited as the first distiller of bourbon whiskey. His first batch, in 1789, had all the necessary characteristics of the drink: it was made with corn as the primary grain, it was distilled in the territory then known as Bourbon County, and it was aged in oak kegs. Somewhere along the line, Kentucky distillers also learned to char the insides of the kegs in order to give the whiskey a smoother flavor.

Dr. James Crow arrived in Kentucky in 1823 and brought science to the art of distilling. Dr. Crow had received his diploma from the College of Medicine and Surgery in Edinburgh, Scotland. With his learning and his books, he settled on the banks of Grier's Creek, in Woodford County, Kentucky, then home to a number of crude distilleries. Dr. Crow, disgusted by the careless practices he saw at the stills, determined to come up with a precise formula that could guarantee a consistent level of quality from one batch of whiskey to the next.

In 1835 he began making a whiskey by the sour mash method, reusing a portion of the yeast from a previous batch. This whiskey's reputation soon spread well beyond Grier's Creek. During his lifetime, Dr. Crow sent barrels of whiskey to Washington, New York, Boston, and even his native Scotland. After Dr. Crow's death, in 1859, the still passed into the hands of W.A. Gaines & Co. The fame of the drink, by then known as **(A,B) Old Crow**, kept spreading. Daniel Webster, Henry Clay, Andrew Jackson, and Jack London were all fans of the drink, and Mark Twain once ordered twenty-five barrels.

(A) about 1900

(B) 1963

The original **(C) Old Grand-Dad** was a Kentucky distiller named Basil Hayden, Sr., who filled his first barrel in 1796. His grandson, Colonel Raymond B. Hayden, built a new distillery in Bullit County, Kentucky, in 1882 and named its product Old Grand-Dad after the family's founding distiller. During Prohibition, the Old Grand-Dad distillery kept right on working, but the bottles were marked "for medicinal purposes." Both Old Crow and Old Grand-Dad are made today by the National Distillers Products Company.

(D) Jack Daniel began making whiskey in 1857 as an eleven-year-old apprentice distiller in Lynchburg, Tennes-

see. By the end of the Civil War he was in business for himself. He marked his early clay jugs "Jack Daniel's Old Time Distillery"; in 1887 he started to call the whiskey Jack Daniel's Old No. 7— nobody knows why. Jack Daniel's, with its familiar square bottle and black label, is one of the most popular American whiskeys. Many drinkers think of it as a classic bourbon, but in fact it is not. Because it is made well south of the Kentucky border, it is classified as Tennessee sour mash whiskey.

(E) Just-A-Drop whiskey, Patrick T. O'Brien, Philadelphia, Pennsylvania

Jack Daniel, about 1885

(C) 1925

(E) 1906

(D) 1956

FOUR ROSES

(A) 1937

There are several stories about the origin of the (A) **Four Roses** brand name. The most romantic tells of a young man of the Old South who put the question of marriage to his sweetheart. She told him she would give her answer at a forthcoming ball. If her answer was Yes, she would show it by wearing a corsage of red roses. She wore the roses, they were married, he went into the whiskey business, and recalled the event years later when a brand name was needed. That story, though sweet enough, has a hollow ring to it. Another tale pins the name on four members of the Rose family, who made whiskey in Atlanta before the Civil War. (Just *which* four members is a hotly disputed point among the Rose descendants.)

We do know that a distiller named Paul Jones began making Four Roses whiskey in Louisville, Kentucky, around 1886. He had previously been in business in Atlanta, where he had purchased the distilling interests of a family named Rose. Frankfort Distillers, a division of Seagram's, makes Four Roses as a blended whiskey today.

(B) **Seagram's Seven Crown** has been the hottest selling whiskey in America since 1934. Its good fortune is due in part to a bold gamble that Samuel Bronfman made during the depths of Prohibition. In 1928 Bronfman merged his young distilling company with the established Joseph E. Seagram & Sons, a family-run business that had been making whiskey in Waterloo, Ontario, since 1857. With the newly added distilling capacity, Bronfman decided to build up his stock of aging whiskeys. He became convinced that Prohibition in the United States would soon come to an end. When Repeal finally came in late 1933, the Seagram warehouses held the largest stock of fully aged rye and sour mash whiskeys in the world. Seven Crown, Seagram's new premium brand of blended whiskeys, hit the stores running in the spring of 1934. The crowned-seven symbol was added to the label in 1949, and has served as a prominent feature of Seven Crown's advertising.

(C) **Southern Comfort**, a whiskey-based liqueur, was invented by a New Orleans bartender named M.W. Heron in the 1880s. In 1889 Heron moved on to Memphis, another bustling Mississippi River port, and there began to bottle his drink. He moved up the river once more, to St. Louis, before settling down with his own bar. A sign on the wall read, "St. Louis Cocktail, made with Southern Comfort. Limit 2 to a customer. (No gentleman would ask for more.)" The drink got an unsolicited boost with a new generation when Janis Joplin adopted it as her special comfort in the late 1960s.

(D) **Hollywood gin**, Consolidated Wine & Spirit Corporation, Los Angeles, California

(D) 1934

(B) 1950

(C) 1945

Most of the great American beers owe their existence to German immigrants who brought their skills and the recipes for the light German lager beers to the United States in the mid-nineteenth century. The beers got their start where the great waves of German immigrants landed—New York, Philadelphia, St. Louis, Milwaukee, and the Pacific Northwest.

The (A,B) Anheuser-Busch brewery started in 1852 as a dirt-walled pit with a wooden roof, built by Georg Schnieder. Eberhard Anheuser took over the failing St. Louis operation in 1860, and with the aid of his son-in-law, Adolphus Busch, brought it back to profitability.

Busch had emigrated from Germany in 1857 and landed a job in St. Louis as a brewing-supply salesman. Though his father-in-law provided the starting capital, Busch is generally credited with making Anheuser-Busch a leading national brewer. Busch enlarged distribution with refrigerated railroad cars and put together the teams of Clydesdale work horses that made the brewery's carts into working advertisements. And, with a friend named Carl Conrad,

Busch created (C) Budweiser ("The King of Beers"), in 1876.

The Anheuser-Busch A-and-eagle logo was added to the firm's beer labels in 1872 and registered with the U.S. Patent Office in 1877. The design has changed only slightly since then, and today is gaining new fame as a prominent feature on the packages of Anheuser-Busch's line of Eagle snacks. In the case of Eagle pretzels, the eagle *is* the snack—the pretzel loops are formed in the shape of the A-and-eagle logo.

The hop-leaf trademark of the (D) Pabst Brewing Company features a large *B* in its center. It does not stand for *beer* or *brewery*, but is a leftover from the Best Brewing Company, the family business that Frederick Pabst married into in 1862. Best had been making beer in Milwaukee since 1844. Pabst turned a cold eye on that long tradition in 1889, when he gave the brewery his own name.

In 1882 the brewery began to decorate its bottles of Select beer with a strand of blue ribbon. As those first bottles were hand-filled, with a cork stopper wired in place like a modern champagne bottle, the ribbon added

only a little trouble to the already slow bottling process. But by 1892 the Select bottles required three hundred thousand yards of silk ribbon a year. When Pabst finally switched to Crown bottle caps in 1906, it also changed over to a printed version of the blue ribbon. The name (E) Blue Ribbon had replaced Select a few years before, in 1897. Today it is Pabst's leading brand.

(A) 1896

(B) 1955

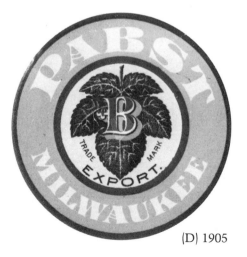

(D) 1905

(E) 1950

(C) 1886

(A) 1888

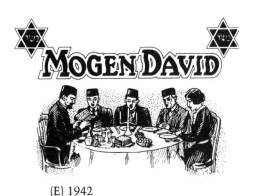

(E) 1942

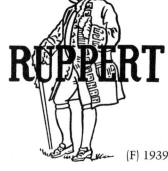

(F) 1939

(B) 1910

(C) 1903

(D) 1944

(A) Schlitz is "The Beer That Made Milwaukee Famous," but once it did its job there, it jumped ship. Today, Schlitz is made by the Stroh Brewery Company at six plants around the country, none of which are in the state of Wisconsin. The slogan has its origin in the great Chicago fire of 1871, which destroyed that city's brewing facilities. Joseph Schlitz, at the August Krug Brewing Company in Milwaukee, saw opportunity in adversity, and shipped a boat-load of beer down Lake Michigan to fill the gap. His beer opened Chicago's eyes to its brewing neighbor in the north, and showed Schlitz the path to greater sales through shipping. The brewery adopted the Schlitz name in 1874, and the belted globe trademark in 1888.

The idea for **(B) Ballantine's three-ring trademark** is said to have come to the founder of the brewery as he stared at the wet rings his beer mug left on the table. Peter Ballantine started the Newark brewery in 1839; the rings were adopted in 1880. At the end of Prohibition, the rings were assigned meanings—Purity, Body, and Flavor—adding a degree of complication to what had been a simple and elegant device.

A German immigrant named Peter Miller founded the Miller Brewing Company in Milwaukee in 1855. His premium beer, called simply Miller at first, was dubbed **(C,D) Miller High Life** in 1903 and took on a wildly dressed lady as its mascot. She started out standing on a case of beer with a whip in her hand, then in 1936 struck a pose on a crescent moon. When the brewery adopted the familiar "soft cross" label in 1944, they planted her right in the middle. She's no longer on the label, but still rides her moon on promotional plaques and mirrors.

(E) Mogen David wine, California Wine Company, Chicago, Illinois
(F) Ruppert Knickerbocker beer, Jacob Ruppert, New York, New York

Driving toward the **(A,B) Coors** brewery, in Golden, Colorado, one is struck by the lengthy aqueduct that parallels the road, bringing water to the plant from a source high in the mountains. The company promotes that water as the source of Coors beer's distinctive flavor.

Adolph Coors emigrated from Germany in 1868 and worked his way across the country with various jobs before starting the brewery in 1873, on the site of an abandoned tannery. He chose a view of Table Mountain, located next to the brewery, as a symbol for the beer in 1882. His successors began using a waterfall symbol in 1939,

and it has gradually supplanted the mountain.

(C) Rainier beer got its start in a small brewery south of Seattle, built in 1878 by a German immigrant named Andrew Hemrich. He named his premium beer for the mountain that soars over the city. During Prohibition a California brewery took over the rights to the Rainier brand, and it was some time after Repeal before the rejuvenated Seattle operation could get back its name.

(D) Olympia beer has provided a steady competition to Rainier ever since Leopold F. Schmidt opened his brewery in 1896. He chose Olympia, Washington, for the plant because of the deep artesian wells nearby that pumped water from beneath the Tumwater Valley. That's a picture of Tumwater Falls on the label.

(D) 1905

(A) 1948

(B) 1948

(C) 1914

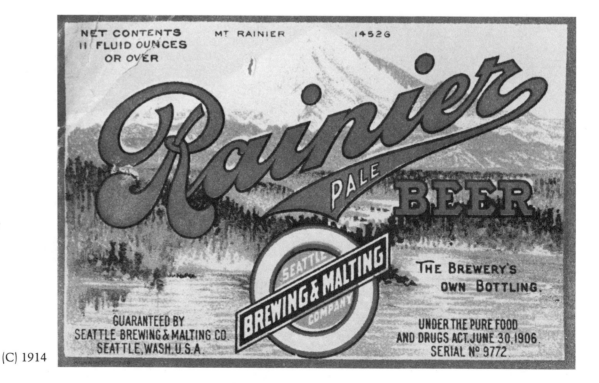

(A) 1961

Stores

As packaged, branded merchandise became more common in the late nineteenth century, merchants began to discover new opportunities in retailing. The new packages did not have to be wrapped or weighed, and the colorful, descriptive labels cut down on the need for storekeepers to assist shoppers in their selections. In many cases, the manufacturers' advertisements did the job of persuading customers what to buy long before they walked into the store. By the 1880s the Chicago mail-order houses of Sears and Montgomery Ward were able sell goods from a list that often gave no more information than the brand name, package size, and price. Self-service grocery stores in the 1920s cut sales help to the minimum and let the packages sell themselves. Thus self-service stores and catalogues not only took advantage of the changes in packaging but by their own spread helped to promote the change. Manufacturers, recognizing the growing importance of the new outlets, designed their packages to stand out on store shelves and made their sales pitches directly to consumers through more and better advertising.

(A) The Great Atlantic & Pacific Tea Company began as a cut-price tea store on Vesey Street in New York City in 1859, with a brilliant red-and-gold sign over the door. Using premiums, dramatic promotions, and competitive prices, the business built itself into a chain of four hundred stores by 1912. That year the company experimented with an economy grocery store in Jersey City, around the corner from the chain's most prosperous shop. The new store cut out credit, deliveries, and telephone orders to offer food at the lowest prices in town. The idea worked so well that it drove the older store out of business in a matter of months. The company went on an economy-store charge, opening 7,500 new stores over the next three years to become the country's largest food outlet. By the late 1920s A&P grocery stores sold one tenth of all the food sold at retail in the United States. The original red-and-gold sign became an identifying feature on all the new stores in the expanding chain; it was later reduced to a simpler circular logo.

Clarence Saunders took the idea of a pared-down grocery store a step further. In 1916 he opened his first **(B) Piggly Wiggly store** in Memphis, Tennessee, designed with all the food on shelves open to the customers. The only sales help stood at the cash register to total up the purchases. This was the first self-service grocery store. Though its innovations now seem commonplace, at the time they were considered remarkable. Each package was marked with its price, and shoppers collected their purchases in baskets. The store was laid out so that customers had to thread their way past all of the shelves before coming to the check-out counter. It may have been this back-and-forth, stockade-type layout that gave Saunders the idea for the store's name. Apparently the public was ready to do its own shopping and happy to keep the resulting savings. The Piggly Wiggly idea caught on so well that by 1922 the chain had grown to more than twelve hundred stores in forty states.

(C) Winn-Dixie Stores, Inc., Jacksonville, Florida. Founded as the Table Supply Company in Miami in 1925.

(D) IGA, Inc., Chicago, Illinois. Founded in 1926 as the Independent Grocers' Alliance to pool purchasing and meet the competition of the growing supermarket chains.

(B) 1984

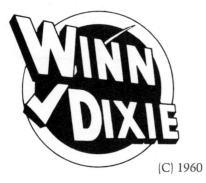

(C) 1960

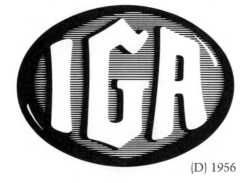

(D) 1956

(A) **Frank W. Woolworth** was a young salesman at the Moore & Smith Corner Store in Watertown, New York, when, in 1878, he was assigned the job of managing a five-cent sale. He ordered a batch of inexpensive items—combs, safety pins, buttons, pencils, and napkins—and spread them out on a table with some of the store's surplus merchandise. By the end of the sale day the table was empty, and Woolworth was sold on the idea of big profits from cheap items.

The next year he decided to test out the idea of a store stocked entirely with five-cent goods. He borrowed some stock from the Corner Store and opened his own shop, the Great 5¢ Store, in nearby Utica. Unfortunately, he had not picked a good location, and he closed the shop down after several months and set himself up again in Lancaster, Pennsylvania. There he had better luck. On his first day he sold more than

twenty-five hundred items—almost a third of the shop's inventory. In 1880 he added ten-cent goods to his stock and changed the name to Woolworth's 5 and 10¢ Store. His success there led him to open other stores. By 1886 he had six more and had added the classic red-and-gold sign, inspired by the signs of the A&P grocery chain. In 1913, with almost six hundred stores in operation, Woolworth constructed the world's tallest building for the company's headquarters in New York City. In 1932 the company finally broke its self-imposed barrier and added twenty-cent goods to its stock.

(B) **Safeway Stores, Inc.,** Oakland, California. The first store, in American Falls, Idaho, was opened in 1915.

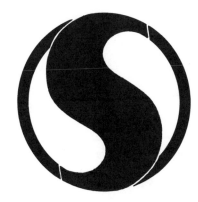

(B) 1958

(A) 1950

Label for Townsend Brothers canned oysters, registered with the U.S. District Court in New York City in 1867, three years before the first U.S. trademark law

The idea for canning food originated in France in 1809, when a wine maker and food supplier named Nicholas Appert discovered that cooked food could be preserved in sealed jars. News of the invention crossed the Atlantic, and before long canneries began to spring up in the United States, primarily in seaport cities, where the plants could remain open year-round handling seafood in the winter and produce in the summer. Baltimore, on the Chesapeake Bay, became an important canning center in the 1840s; the oysters, crabs, fish, tomatoes, corn, and peas preserved there provided a healthy supplement to the diet of pioneers moving West. The fishing ports of New York, Boston, and Portland, Maine were also homes to a number of early canners.

(A,B,C) William Underwood began to preserve fruit, pickles, and condiments on Boston's Russia Wharf in 1822. Like most of the early "canners," he actually packed the food in glass jars. While a method of preserving food in tin cans had been invented in England soon after Appert's discovery, canning was a slow process and required the labor of skilled tinsmiths. Only when machines for cutting and soldering tin came into use in the mid-nineteenth century did cans begin to replace glass as the major preserving container.

In 1868 William Underwood's sons began to can devilled ham with a picture of a red devil on the label, and two years later they registered the design under the new U.S. trademark law. The devil was assigned registration no. 82 (on a list that passed the one-million mark in 1974) and he now claims title as the oldest registered food trademark in use in the United States. He's been modernized repeatedly over the years. The *W* point of his tail, part of the lettering on the original label, was filed to a simple point, replaced, then taken away again. He's been given weapons, only to have them snatched back, and he's been getting thinner with each revision. The 1959 version, by Robert G. Neubauer, Inc., has given him a harmless-looking trident and a diabolical grin.

Burnham & Morrill began canning operations in Portland, Maine, in 1867 (Mr. Burnham had been part of an earlier partnership that supplied canned meats and provisions to the Union army from 1861 to 1865). The firm packed corn and meat that first year, gradually adding lobsters, clams, herring, and other items to its line. In 1927 it introduced **(D) B&M Brick**

Oven baked beans, now the staple product of the company.

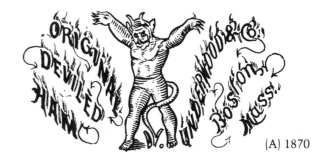

(A) 1870

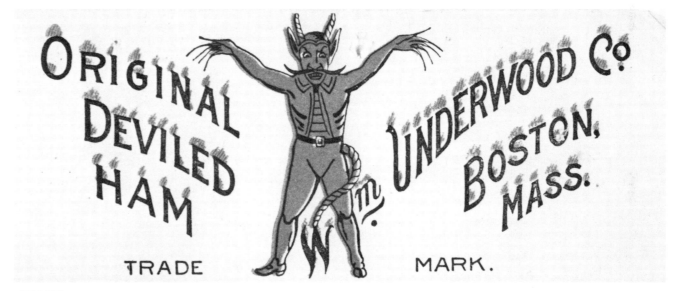

(B) 1905

(D) 1951

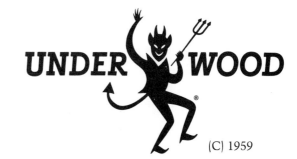

(C) 1959

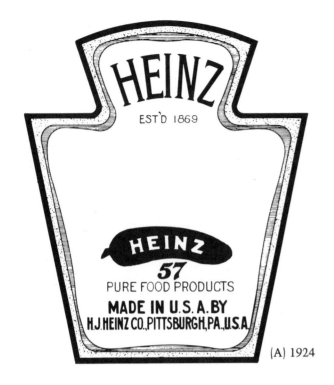

(A) 1924

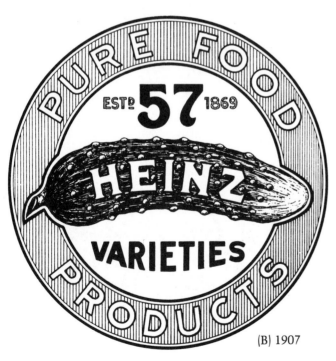

(B) 1907

(A,B,C) Henry J. Heinz entered the preserving business at the age of twelve, bottling horseradish from his family's garden and selling it through the streets of Pittsburgh. In 1869, at the age of twenty-five, he formed a partnership with L.C. Noble to bottle horseradish, vinegar, sauerkraut, mustard, and pickles. The enterprise grew quickly into one of the nation's leading packers of condiments, then, in 1875, found itself overextended and filed for bankruptcy. H.J. Heinz had to work himself out of debt over the next several years as manager of a new preserving firm started by his brother and a cousin. It was at the F. & J. Heinz company that he developed Heinz tomato ketchup (in 1876) and sweet pickles (in 1880). He finally cleared his debts and gained financial control of the business in 1888.

Heinz very early developed the three insignia that, with the Heinz name, continue to identify Heinz products—the keystone label, the pickle, and the "57 Varieties" slogan. The keystone la-

(C)
Heinz advertising card, about 1900

Preziosi Postcards

bel was used on barrels as early as 1880 and probably stemmed from Heinz's involvement as a young man with the Keystone Pickling & Preserving Works. It remains an appropriate symbol for one of the bigger businesses in the Keystone State. The pickle first appeared in 1889 as an additional mark on the labels, representing the Heinz specialty in pickles. Four years later, the pickle made a great splash at the Chicago World's Fair. Heinz had a booth in the food-products area at the fair but found it off the path taken by most visitors. So the firm scattered little brass disks, the size of coat checks, over the fairground, with a notice stamped on each that the finder was entitled a valuable souvenir at the Heinz exhibit. The crowds who showed up were handed bright green pickle pins—plaster pins in the form of tiny pickles, with *Heinz Keystone* arched across the front. The pickle ploy was so successful that neighboring exhibitors gave H.J. Heinz a testimonial banquet for his contribution to the food industry. Heinz has since given away millions of the pins, now made of plastic, to visitors at the Pittsburgh plant.

H.J. Heinz came up with the "57 Varieties" slogan in 1896, while riding an elevated train in New York City. He spotted a sign for a shoe store, announcing "21 Styles" of shoes, and immediately began applying the concept to pickles and condiments. Heinz made more than sixty different products at the time, but for reasons of his own, Mr. Heinz settled on 57 as the perfect number. As he later recalled, "58 Varieties, or 59 Varieties, did not appeal at all to me—just '57 Varieties.' When I got off the train, I immediately went down to the lithographer's where I designed a street-car ad and had it distributed throughout the United States." Heinz's "57 Varieties" have now grown to more than 3,000 different products.

Gail Borden was led to the discovery of condensed milk by the cries of babies on an Atlantic crossing, or so the story goes. An early settler of Austin, Texas, Borden was a man of many accomplishments by the time he made that ocean voyage in 1851. He'd served as the official surveyor and printer for the Republic of Texas, laid out the streets for the city of Galveston, founded the weekly *Telegraph and Texas Register*, and invented the Meat Biscuit, a foul-tasting food for travelers that won high honors at the London Crystal Palace Exhibition. But it was condensed milk that would make Borden's name a household word.

Other experimenters had proved that it was impossible to condense whole milk, but Borden had not read enough to be stopped by the prevailing theories. He purchased a vacuum pan from the Shaker Colony in New Lebanon, New York, and began his own tests. The boiling milk caused problems at first by sticking to the sides of the pan, and then foaming over the top. Borden's simple solution was to grease the pan. With that single innovation he perfected the manufacture of condensed milk.

Borden's condensed milk went on sale in 1858. As (D) Gail Borden's Eagle Brand condensed milk, a name adopted in 1866, it dominated the canned milk market for many decades. (E) Elsie became a mascot and spokesanimal for Borden's milk in the late 1930s. She started as just one aspiring starlet among a herd of other cartoon cows in a series of ads placed in medical journals. She showed such early promise that she was singled out for greater attention in an ad campaign aimed at general readers.

All through Elsie's career she seems to have been pulled to fame by her fans rather than pushed by Borden. The Borden exhibit at the 1939 New York

World's Fair consisted of an automatic milking machine and a herd of cows. Some visitors were curious about the machine, but three times as many wanted to know which cow was Elsie. Borden reacted by promoting one of the cows to a front-and-center role.

After the fair was over, the live Elsie toured the country raising money for war bonds, advertising Borden's milk along the way. When she gave birth to a calf in 1947, a contest to select a name drew a million entries. A set of twins in 1957 brought three million name suggestions. Even with that clear public support behind her, Borden management decided to retire Elsie in the late 1960s in favor of a sterile logotype. They were later surprised by a marketing survey that showed Elsie to be one of the best-loved trademarks in the country. By popular demand, Elsie is now back, both in animated commercials and as a live cow that makes appearances around the country.

(F) Carnation condensed milk was first made by the Pacific Coast Condensed Milk Company at a plant in Kent, Washington, in 1899. E.A. Stuart, the owner of the fledgling operation, hit on the name as the unlabeled cans began to pile up in his factory. He wanted a flower, to suggest freshness and sweetness, and he wanted one that would go with the bright red and white label he had in mind. As he walked by a cigar store in downtown Seattle one day, he was struck by a label with a large carnation. "The absurdity of calling a cigar Carnation struck me very forcibly," he remembered, "but led me to know that I had at last found a name for my milk." The bold red and white Carnation milk label still stands out brightly on grocery store shelves.

An advertising slogan was also needed for the milk, so Stuart traveled east to Chicago to talk with the Helen Mar, a young copywriter at the John Lee Mahin agency. He described the bountiful scenery of Washington, the "tender grasses" on which the cows fed, the "pure sparkling waters" they drank, and the "luxuriant trees" under which they rested. Mar listened, then exclaimed, "Ah, the milk of contented cows."

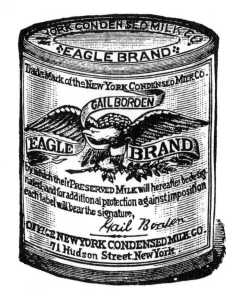

(D) 1892

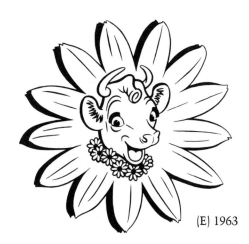

(E) 1963

(F) 1923

107

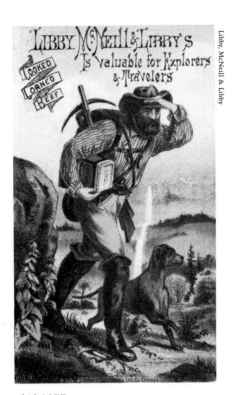

(A) 1877

Two brothers and a friend started **(A,B) Libby, McNeill & Libby** in 1868 to produced corned beef for shipment from Chicago to Eastern cities. The barreled corned beef could be shipped much more cheaply than live cattle and so could undersell fresh beef. The Libbys began to can the beef in a unique tapered tin in 1876, which they advertised extensively as a boon for miners, travelers, explorers, lumbermen, and sailors. The firm has since geared itself to more ordinary household consumption. It still cans corned beef (the original label design was replaced only in 1933), but also bottles tomato and grapefruit juice, and makes pie fillings, corned beef hash, and drink mixes.

(C,D) The Green Giant was born in 1925 as a trademark for canned peas. The Minnesota Valley Canning Company introduced a new type of pea that year, and wanted to label the cans "Green Giant." But the company's trademark attorney, Warwick Keegin, warned that the name was descriptive and would not afford protection as a brand name. He suggested that a picture of a giant be added to the label. That way, he might be able to claim that the name referred to the giant, not the peas.

The first giant was a wild-haired creature with a fur wrap. He wasn't even green. But he muscled his way past the trademark examiners in Washington. Keegin later argued for a truly

green giant, to put the brand name on firmer ground. After enduring ridicule and scoffing ("Who ever heard of a green giant?"), Keegin finally prevailed. In 1935 Leo Burnett, a young Chicago ad man, gave the giant a total renovation—adding green skin, a leaf cloak, and a smile.

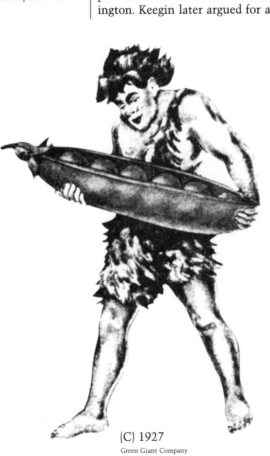

(B) 1900

(C) 1927

(D) 1935

The **(A) Bumblebee tuna** trademark came from a small salmon cannery operating near the mouth of the Columbia River in the 1890s. In 1899 seven canneries merged to form the Columbia River Packers Association. The new organization pooled the resources of the merging firms to build new canneries in Alaska, but allowed the old operations to continue packing with their old brand names. Bumblebee remained a minor brand until the 1930s, when Columbia began gradually to use it on more and more of its produce. In 1938 the company discovered a huge source of albacore tuna off the coast of Washington and began canning it under the Bumblebee label. The first Bumblebee design was a real bee. With each revision he's gotten friendlier and further from the biological truth. The current bee doesn't even have a tail, let alone a stinger, and instead of bee stripes, he's wearing a striped shirt.

The name for **(B) Birds Eye frozen foods** seems like a fanciful invention, but it actually comes from the name of the company's founder, Clarence Birdseye. Born to a prosperous New York family (his father was a judge on the New York State Supreme Court), Birdseye chose a more adventurous course for his life. He worked as a biologist in Labrador, a fisheries investigator, and a purchasing agent before getting the idea in 1923 for quick-frozen foods.

While Birdseye was in Labrador, he noticed that fish and caribou meat quick-frozen in the bitter Arctic cold tasted fresh and flavorful when thawed and cooked several months later. He knew that ordinary freezing didn't give the same results, so he theorized that it had something to do with the speed of freezing. Experiments in his Gloucester, Massachusetts, laboratory confirmed this, and by 1926 he'd built a twenty-ton belt freezer capable of quick-freezing food in commercial quantities. He began selling frozen fish in 1927, but it was not until General Foods purchased the operation two years later that a major marketing effort began. It was General Foods that created the bird symbol in 1930.

(C) Icy Point canned and frozen fish, Alaska Pacific Salmon Company, Seattle, Washington
(D) Star-Kist canned fish, Star-Kist Foods, Inc. Terminal Island, California
(E) Boatmans canned salmon, Griffith-Durney Company, Los Angeles, California
(F) Snow Crop frozen foods, Snow Crop Marketers, Inc., New York, New York

(A) 1953

(C) 1938

(D) 1971

(E) 1908

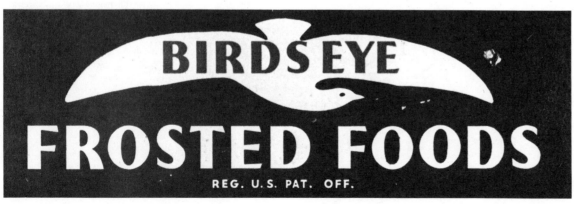

(B) 1930

(F) 1949

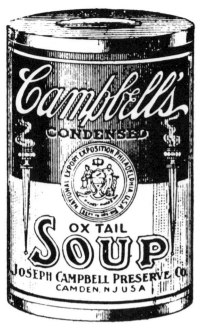

(A) 1902

(A,B,C,D) The Campbell Soup Company began as just another canning company, founded in Camden, New Jersey, in 1869. Partners Abram Anderson and Joseph Campbell preserved vegetables, jellies, condiments, and mincemeat. Their specialty was canned tomatoes, packaged with a homespun tall-tale label showing two men hauling a sofa-sized specimen (page 51). Anderson left the business in 1876 to start a competing venture that also canned fruits and concentrated soup. Campbell countered with its own line of soups in 1898, developed by a young chemist named John T. Dorrance after a research trip to the kitchens of Parisian restaurants.

The classic red-and-white label was inspired by the uniforms of the Cornell College football team, minus the shoes and helmets, and gilded with a medal won at the National Export Exposition in Philadelphia. At some point after 1905 the medal was quietly replaced by one from the Paris Exposition of 1900. It was this cosmopolitan version of the tomato soup can that Andy Warhol immortalized in his classic pop art painting.

To make the soup advertisements more appealing to women, Campbell added amusing jingles and, beginning in 1904, a stream of cherubic cartoon children drawn by Philadelphia illustrator Grace Wiederseim. Wiederseim began to draw at a young age, and she modeled the chubby kids (she called them Roly-Polys) on herself. Even as an adult she had a round face, a turned-up nose, and wide-set eyes. In a 1926 interview, she remembered how she came up with the initial characters. "I was much interested in my looks. I knew I was funny. I used to look in the mirror, and then, with a pencil in my round, chubby fingers, I would sketch my image as I remembered it. My playmates were always delighted with the results—and they always recognized me." When the kids appeared in the Campbell ads, they joined a trend of amusing advertising characters. Their debut coincided with Force cereal's Sunny Jim, the buck-toothed Oilzum driver, and the Zu Zu ginger snap clown. Unlike those other cartoons, the Campell Kids have lasted. In recent years they've grown a little taller and they've lost some of their baby fat, but Grace Wiederseim would still recognize herself in those familiar chubby cheeks.

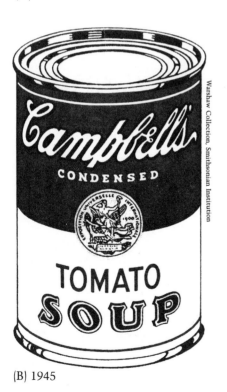

(B) 1945

(C) about 1910

(D) 1984

Campbell Soup Company

Grace (Wiederseim) Drayton, creator of the Campbell Kids

It took a mother to come up with the idea for commercially processed baby food—a mother with connections at the Fremont Canning Company, of Fremont, Michigan. Dorothy Gerber was straining peas for her seven-month-old daughter, Sally, one Sunday afternoon in 1927 when she asked her husband why the job couldn't be done at his canning plant. "To press the point," she recalled, "I dumped a whole container of peas into a strainer and bowl, placed them in Dan's lap, and asked him to see how he'd like to do that three times a day, seven days a week." The following day, Dan dutifully asked his father if the baby's vegetables couldn't be strained at the cannery. Their tests proved it could be done, and by the fall of 1928 the first **(A) Gerber strained baby foods** were on the market—carrots, peas, prunes, spinach, and vegetable soup.

The first tins of Gerber baby food were packaged with pictures of alphabet blocks on the labels. Artist Dorothy Hope Smith sent a charcoal sketch of a baby to the company on speculation, hoping that it might be used in advertisements. She explained in her letter that if the age and size of the child seemed right, she would finish the artwork in paint. But the Gerbers were so taken with her rough sketch that they bought it just the way it was. They used it for a few years in advertisements, then in 1932 put it on the baby food labels. Because it is so fragile, the original sketch is kept under glass in the company vault and handled only when absolutely necessary.

A lingering rumor holds that Humphrey Bogart was the model for the Gerber baby. In fact, a child named Ann Turner Cook sat for Smith's portrait. Humphrey Bogart would have been twenty-nine years old at the time the sketch was made.

The **(B) Stouffer's frozen food** business grew out of a restaurant operation. A.E. Stouffer had opened a small, stand-up dairy counter in downtown Cleveland in 1922 and by the 1950s, with the help of his wife and sons, expanded to a chain of restaurants in Detroit, New York City, and Philadelphia. In 1954, to meet the demand for take-out meals, cooks at Stouffer's Shaker Square Restaurant began to package and freeze the most popular dishes. That was the first step toward a business that now produces nearly 300 million packages of frozen food each year. Lippincott & Margulies designed the Stouffer's bean pot symbol in 1956.

(C) Van de Kamp's Frozen Foods started out as a Los Angeles potato-chip stand, opened in 1915 by Lawrence L. Frank and Theodore Van de Kamp. Salesgirls at the store dressed in Dutch costumes, and as the business grew, so did the emphasis on the Dutch theme. By the late 1920s Van de Kamp's Holland Dutch Bakers sold macaroons, pretzels, breads, and cakes out of eighty shops, all housed in miniature windmills, complete with blades that turned in the wind. From baked goods, the business evolved into sit-down coffee shops, and in 1959 a few of the stores started selling frozen entrees for customers to take home. Today, Van de Kamp's Frozen Foods is a division of the Pillsbury Company, and is no longer connected with the windmill-shaped restaurants to which it owes its start. And because its menu now includes Mexican and Chinese entrees, it is even phasing out the little windmill logo.

(A) 1928

(B) 1956

(C) 1967

Rose Treat

(A) 1891

Beverages

The dreamy-eyed damsel bearing a tray of hot chocolate has graced **(A) Baker's chocolate** products since 1872. Company legend surrounds her with a mist of romance. She is based on a painting titled *La Belle Chocolatière*, that captured the imagination of the president of the Walter Baker Company when he visited the Dresden Gallery in 1862.

According to the story told about the painting, the subject of *La Belle Chocolatière* was a waitress named Anna Baltauf who had the good fortune to be on duty at a Viennese chocolate shop when a prince stopped in to order some hot chocolate. She must have done her job well, because soon afterward Anna Baltauf became the Princess Ditrichstein, and was given the portrait of herself as a wedding present by her husband.

(B) Javarye coffee compound, Javarye Coffee Company, Portsmouth, Ohio

(B) 1897

The mustachioed gentleman whose portrait is affixed to **(A) Lipton tea** packages is Sir Thomas Lipton himself, founder of the great tea empire. Lipton made his first fortune as the owner of a chain of ham and bacon stores in Scotland and England. He entered the tea trade in 1888, and in 1890 went into the American market with tremendous success as a pioneer of packaged tea.

Sir Thomas's nautical attire is a tribute to his favorite hobby, yachting. He made five unsuccessful bids for the America's Cup and was preparing for a sixth at the time of his death at the age of eighty-one, in 1931.

A wholesale-grocery salesman from Toronto named Peter C. Larkin entered the American and Canadian tea markets in 1892 with a brand named **(B) Salada,** a word Larkin had once heard as the name of an Indian tea garden. In 1956 the company's advertising director thought of printing some food for thought on the tea bag tags. The messages have included: "Who lives content with little, possesses everything"; "The lowest ebb is the turn of the tide"; and "Your ship won't come in 'til you row out to meet it."

Brothers William and James Horlick emigrated from England to Racine, Wisconsin, and began making Horlick's Food in 1873, reformulated in 1883 as **(C) Horlick's malted milk.** The Beecham Group, a British firm, bought the business in 1969.

(A) 1947

Sir Thomas Lipton

(B) 1898

(C) 1947

113

(A) 1905

The **(A) Hills Bros. Coffee** company was started in San Francisco by Austin H. and Reuben W. Hills, who had emigrated from Maine to California in 1873. In 1882 the brothers bought a retail store called Arabian Coffee & Spice Mills, where they sold teas and spices and roasted and sold coffee. The turbaned figure arrested mid-sip has appeared on Hills Bros. packages since 1897. Although the pattern on his robe has been subtly revised, and his slippers have become slightly curlier, he has remained essentially unchanged for nearly a century.

(B) Maxwell House coffee is the namesake of the Maxwell House hotel in Nashville, where the famous blend made its debut in 1892. According to company legend, Maxwell House adopted the slogan "Good to the Last Drop" when Theodore Roosevelt, on a visit to the founder of Maxwell House in 1907, spoke the words after sipping a cup. But the president may have been influenced by advertisements of the past: in 1902 the slogan was used to advertise Peninsular Paints of Detroit, and a close cousin, "The Last Drop is as Good as the First," was registered as a trademark for **(C) Baker's chocolate** that same year.

GOOD TO THE LAST DROP

(B) 1926

(C) 1902 The last drop is as good as the first.

(A) Tropic-Ana, the Hawaiian girl who appears on Tropicana citrus products, was born in 1951. She apparently sprang almost fully formed from the head of Anthony Rossi, the founder of the company. He described her in detail to his advertising staff, who then committed her to paper. She is one of the few famous trademarks with a visible navel.

In 1927 the Perkins Products Company of Hastings, Nebraska, mail-order purveyors of flavorings, spices, and other household products, developed a powdered beverage mix that it packed in envelopes and called **(B) Kool-Aid**. By 1931 the product was so successful that Perkins discontinued everything else in its line, moved to Chicago, and devoted all its energy to meeting the demand for the little packets.

The company became part of General Foods in 1953, which created the inscrutable smiling-pitcher trademark three years later. It may or may not have been the inspiration for the ubiquitous "happy face" mark popular in the 1970s.

(C) Red Cheek apple juice, Berks-Lehigh Cooperative Fruit Growers, Inc., Boyertown, Pennsylvania
(D) Treesweet canned fruit juices, Treesweet Products Co., Los Angeles, California
(E) Orange Julius soft drink, Orange Julius Corporation, Los Angeles, California

(C) 1940

(D) 1935

(B) 1962

(E) 1948

(A) 1955

HIRES
ROOT BEER
THE GREAT HEALTH DRINK.
Package makes 5 gallons.
Delicious, sparkling, and
appetizing. Sold by all
dealers. *FREE* a beautiful
Picture Book and cards
sent to any one addressing
C. E. HIRES & CO.,
Philadelphia.

(A) 1891

(B) 1925

Soda water was introduced in the United States in 1807, and by mid-century bottlers of flavored soda water were plying their trade in many of the larger cities. But it was not until the last quarter of the century that carbonated drinks began to become widely popular, and even then they were for the most part mixed and sold at the counters of drug stores. Only in the 1890s, when bottled soft drinks became more common, did national brands come into their own.

(A) Hires root beer was one of the first drinks to achieve national prominence, though not in a form we would recognize today. Charles E. Hires first sold the drink as a package of dried roots and herbs, to be brewed into root beer at home. Records of the first years of his business have not survived, but we do know that he exhibited the mixture at the 1876 Centennial Exhibition in Philadelphia. By 1884 he was selling a liquid extract, and around 1893 bottlers started to sell the finished drink. For many years Hires used rosy-cheeked children in his advertisements to stress the healthful properties of the drink. All the children were happy and plump, but Hires never kept any particular child in the ads long enough to become a trademark.

Henry Millis began bottling sparkling cider in 1881, in the Massachusetts town named for his father. He later added ginger ale and other drinks to his line and gave them the brand name **(B) Cliquot Club**. Kleek-O the Eskimo boy, who moved onto the bottles' labels in 1911, was the handiwork of New York City artist I.B. Hazelton. Hazelton had been asked to draw a genie emerging in a mist from a bottle of ginger ale as the drink's symbol. Instead, he stretched his artistic license to the limit and dressed the genie in furs.

The crouching, half-draped fairy of **(C) the White Rock Mineral Springs Company** was originally a marble sculpture by Paul Thumann titled *Psyche at Nature's Mirror*, exhibited at the 1893 Chicago Columbian Exposition. The owners of the White Rock bottling company saw her there, and immediately fell in love, in a business sense. They'd been bottling natural mineral water from the springs at Waukesha, Wisconsin, since 1883, and they saw in Psyche a symbol of the purity and freshness of their water. They bought the rights to the artwork and put Psyche in all her splendor on the White Rock labels that same year. She survived undraped and uncensored until 1960, when the company finally got bashful and pulled her robe up over her breasts.

Jabez Ricker stopped for a drink at Maine's **(D) Poland Spring** in 1790, and was so taken with the water's imagined healing properties that he settled his family there. The Ricker home grew into an inn and stagecoach stop in 1793 and, eventually, under the stewardship of Hiram Ricker in the 1840s and '50s, into a major resort. Every president from John Adams to John F. Kennedy stayed at the Poland Springs Inn to take the waters and meet the Maine voters. The Ricker family started to bottle Poland Spring water in 1845, at the request of guests who wanted to keep drinking it after they left the resort. They added the circular trademark to the bottles in 1860, and with a small change (it is no longer classified as "mineral" spring water) the mark is still used.

(C) 1905

(D) 1876

Coca-Cola

(A) 1892

(A,B,C) Coca-Cola was invented in 1886 by John S. Pemberton, an Atlanta pharmacist and Confederate Army veteran. According to company legend, Pemberton took a jar of his new syrup over to Jacob's Drug Store in Atlanta one day in May 1886 and asked the fountain man to mix up a glass of the drink with ice water. By mistake, the druggist added soda water, but Pemberton was so pleased with the refreshing result that he decided always to prepare it that way.

While Pemberton gets credit for the recipe, the name Coca-Cola was suggested by Frank Robinson, Pemberton's bookkeeper. The name is a combination of two of the drink's more exotic ingredients—the South American coca leaf, and the African cola nut. Robinson, who was something of a penmanship expert, drew the flourishy version of the name that has identified the drink ever since. It is remarkable that these eight letters of script, penned in a style fashionable in 1887, have aged so gracefully that they seem in no way out of place on even the most modern soda-vending machine.

Coca-Cola grew from a local Atlanta concoction into the world's best-known refreshment through a combination of fortuitous distribution arrangements and a continued investment in advertising and promotion to build public familiarity with the drink. Soda fountains were given Coca-Cola signs, calendars, serving trays, clocks, fans, lamps, and a variety of other fixtures, while the public was constantly reminded of the drink in lavish advertisements. Beginning in 1894 the drink was sold in bottles as well as at soda fountains, through the company's first bottling franchise in Vicksburg. It was a worker at one of the bottling plants—Alex Samuelson of the Root Glass Company in Terre Haute, Indiana—who designed the classic Coca-Cola bottle in 1915. The fluted sides and bulging middle were intended to suggest the shape of a cola nut.

From the earliest days Coca-Cola advertisements have relied on the appeal of a catchy slogan. "Delicious and Refreshing" was the first, followed by "Good to the last drop" (1907), "The pause that refreshes" (1929), and "It's the real thing" (1941). From 1910 to 1940 the company also used its ads to fight what it saw as a dangerous trend among customers to ask for the drink by a nickname: Coke. Advertisements pleaded with buyers to "Ask for Coca-Cola by its full name only." Finally, in 1941, the company bowed to public pressure and adopted the nickname as an official name. Advertising slogans since then have included "Coke adds life," "Have a Coke and a smile," and "Coke is it."

Coke

(B) 1944

(C) 1922 advertising calendar

117

(A,B) Dr. Pepper came into being in 1885 in Waco, Texas. According to legend, the drink was first mixed by a young counter man at Wade Morrison's Old Corner Drug Store and was given its name in order to win approval from the owner. Morrison had come to Texas after being fired from a pharmacy in Virginia because he fell in love with the pharmacist's daughter. His Waco customers heard so much about his broken romance that they named the soda invention for the Virginia pharmacist, Dr. Pepper. The final formula for the drink was perfected by a local ginger-ale bottler named R.S. Lazenby after two years of experimentation. The drink remained a Texas regional specialty until the 1920s, when the company broke into larger territory with an advertising campaign pushing the drink as a between-meals energy source. The slogan, "Drink a bite to eat at 10, 2, and 4 o'clock," gradually shrank down to a mysterious "10, 2, 4" on the bottles. The memorable "I'm a Pepper" slogan of 1978 came from the advertising offices of Young & Rubicam.

(C,D,E) Pepsi-Cola, now the nation's number-two soft drink, was not an overnight sensation. The drink's meandering route to success is mirrored in the history of its trademark. Coca-Cola got its signature right on the first try, but Pepsi has gone through several versions in its effort to find a symbol to keep up with the times.

Caleb D. Bradham, a pharmacist in New Bern, North Carolina, came up with the formula for the drink and christened it Pepsi-Cola in 1898. Four years later he decided to sell the drink on a larger scale. Business boomed for Bradham and Pepsi until World War I brought disaster—first in the form of sugar rationing, which slashed production, and then in the wild price fluctuations of sugar just after the war. Bradham stocked up on sugar in May 1920 at what seemed a good price of twenty-two cents a pound, but when the price dropped to three cents just six months later he was done for.

Pepsi floundered in and out of bankruptcy for the next decade, under a parade of new owners. The turning point came in 1933 when, in a move of utmost simplicity and nerve, the company doubled the size of the Pepsi bottle to twelve ounces while holding the price at five cents. Within two years Pepsi measured its profits in millions of dollars. Few people who listened to the radio in the 1940s will forget the drink's great advertising jingle:

> *Pepsi-Cola hits the spot*
> *Twelve full ounces, that's a lot*
> *Twice as much for a nickel, too*
> *Pepsi-Cola is the drink for you.*

And few people who watched television in 1984 will forget Michael Jackson's version of "You're the Pepsi generation."

(A) 1905

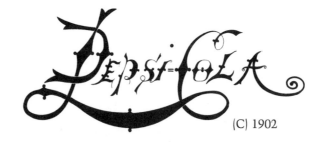

(C) 1902

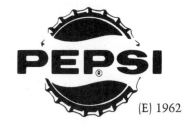

(E) 1962

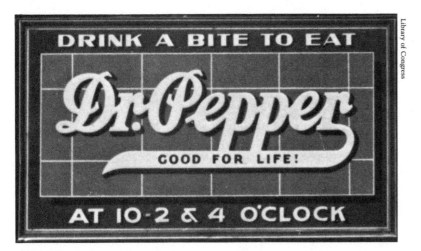

(B) 1938

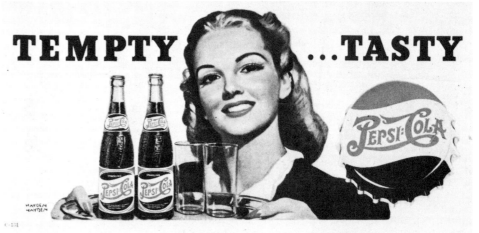

(D) promotional ink blotter, about 1950

(A,B) Moxie was once one of the country's most popular soft drinks, a serious competitor to Coca-Cola. And like Coca-Cola, Moxie started out closer to a medicine than a refreshment. In 1885 the Moxie Nerve Food Company of Lowell, Massachusetts, introduced the drink as a cure for "paralysis, softening of the brain, and mental imbecility." It came in a concentrated liquid, to be taken in wineglass-sized doses four times a day. But the company soon noted the growing popularity of bottled sodas and changed the Moxie image by adding carbonation. Though it probably is tastier now than it was in 1885, Moxie is still a powerful drink, with more than a hint of bitter aftertaste. Perhaps it was that bitter kick that earned *moxie* a place in the language as a word meaning *courage* or *spunk*.

Through the 1920s the Moxie following grew, encouraged by endorsements from such luminaries as George M. Cohan and Ed Wynn, and, later on, Ted Williams. Moxiemobiles, cars fitted with a life-sized artificial white horse in the back seat, promoted the drink at parades around the country. These were the glory years for Moxie, and they did not last. A huge rise in the price of sugar after World War II nearly did the company in, and the drink only managed to hold on in its most established home in the Northeast states. Moxie today is making a comeback, though it is still difficult to find outside of New England.

(C) 7-Up came from St. Louis in 1929, when Charles Grigg decided to branch out from the orange soda he was then making into the lemon-lime market. 7-Up first appeared only in seven-ounce bottles—hence the 7 in the name. The reason for the *Up* is less clear. Grigg may have been influenced by another popular St. Louis soda, **(D) Bubble Up**, which had been on the market since 1917. Whatever his thinking, 7-Up hit the spot with the public, and managed to bubble up over the six hundred-odd competing lemon-lime soft drinks to become an American standard.

(E) Lemon-Up, Lemon-Up Company, New Orleans, Louisiana

(F) Lemon Smash, H.B. Hunter Company, Norfolk, Virginia

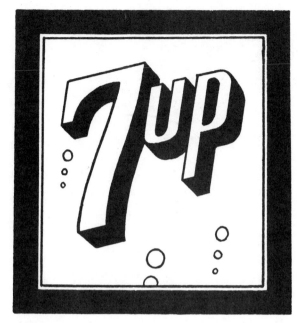

(C) 1935

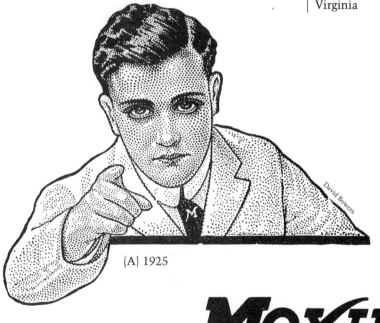

(A) 1925

MOXIE

(B) 1923

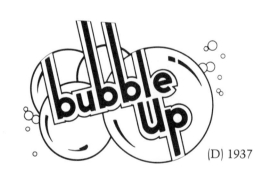

(D) 1937

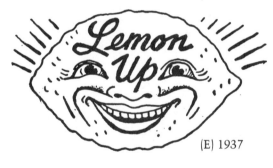

(E) 1937

(F) 1949

(A) 1907

Nobody can remember now whether there ever was a real **(A) Dr. Brown,** but records show that the beverage company started in New York City in 1869. The company is famous for inventing the cream soda, now copied by many other bottlers, and for creating a celery-flavored soda, which it makes today without competition. Schoneberger & Noble, then the makers of Dr. Brown beverages, introduced the celery tonic, now called Cel-Ray soda, in 1892. Bottled today by KBI, Inc., it has grown into a sort of cult drink, sold at all New York City delicatessens worthy of the name, as well as at selected locations in all fifty states and as far away as Hong Kong.

The years between 1900 and 1920 saw the introduction of a river of novel-flavored sodas, such as Peach Bounce, Cherry Smash, Marrowfood, Celery Cola, Delaware Punch, and Grape Smack. **(B) Orange Crush,** made in Chicago in 1916, was one of the first orange drinks, later to be identified by the "Crushy" figure who appeared on the bottles after 1928. The Coca-Cola Bottling Company of St. Louis answered with **(C) Grape Crush** in 1920.

"Down from Canada came tales of a wonderful beverage." This advertising line heralded the first U.S. bottler of **(D,E) Canada Dry pale ginger ale,** in 1923, and it so stirred the public's imagination that the drink became an overnight success.

By the time of its U.S. launch, Canada Dry ginger ale was already twenty years old and a proven favorite in its native Canada. John J. McLaughlin, a Toronto chemist and soda-fountain supplier, invented the drink in 1904 while striving to improve on the old-style ginger-ale recipes. His formula eliminated the dark brown color common among ginger ales of the time and cut down the sharp ginger flavor. His recipe has been widely imitated, but the brand name Canada Dry—conjuring up images of a cool, clean climate—continues to hold a loyal following.

"Crushy" (B) 1934

(D) 1921

(E) 1948

(C) 1920

120

Flour and Rice

Small local mills produced most of this country's flour through the middle of the nineteenth century. When branded at all, the flour carried the mill's name or the name of the grower. Sales were largely confined to the area in which the flour was made. George Washington registered his name as a mark for flour in 1772 by making application at the Fairfax County courthouse. His use of the mark was probably limited to flour from his own farm.

In the 1830s newly settled farms on the Western prairies began to ship surplus grain and flour East, upsetting the closed pattern of local milling. By the 1860s the northern plains states—Minnesota and the Dakotas—had become a major source of grain for the rest of the country. Large mills and nationally known brands began to play an important role in the market.

Caldwaller Washburn left his home in Maine in 1839 and headed West. After wandering through the Mississippi valley in a string of jobs, he stopped at Mineral Point in the Wisconsin Territory and hung out his shingle as a lawyer. He was able to amass a fortune over the next several years by buying up the land grants given to veterans of the Mexican War and selling them as valuable timber and mineral properties. In 1856 he bought a failing Minneapolis mill with a prime location beside the Falls of St. Anthony on the Mississippi River. He had placed himself in the right place at the right time. The Minnesota wheat crop grew from less than two thousand bushels in 1850 to fifteen million by 1869, and the millers of Minneapolis became important merchants of the state's most valuable crop.

Because of the fierce winters on the northern plains, farmers could not raise the fall-planted wheat grown in the East. Instead, they turned to a hard-kerneled wheat that could be planted in the spring. But because the shells of the spring wheat—the bran—shattered and mixed with the flour in normal milling, it sold for far less than the flour milled from Eastern wheat. Washburn, with the help of a Canadian engineer named Edmund La Croix, was one of the first to solve the problem. Their solution, using air currents and sieves to separate the flour from the bran, turned Minnesota flour from a second-rate product into a premium grade in the early 1870s and contributed greatly to the further expansion of wheat farming in the region.

Seeking further improvements, Washburn hired William de la Barre, an Austrian-born engineer, to find out about the advanced roller mills of Europe. While American mills relied on the stone grinding wheels that had been crushing wheat for centuries, the Europeans had developed an improved process using smooth porcelain rollers. In Germany, Switzerland, and Austria de la Barre found the doors shut to him, but in Budapest he was able to enter a mill disguised as a workman. The Washburn mill used what it could of the stolen technology and added its own improvements—most notably the replacement of porcelain rollers with steel. The technique soon spread beyond the Washburn plant, and the claims "roller process" or "patent" flour showed up on the labels of many competing brands.

When the mill's finest grade of flour won a gold medal at the first Miller's International Exhibition in 1880, it was renamed **(A,B) Gold Medal flour**. The circular design adopted as a stencil for barrelheads has carried through with little change as a design for consumer-sized bags of flour. Advertising manager Benjamin Bull thought up Gold Medal's most famous slogan in the early 1890s. According to one story, he was presented with a wordy advertisement for approval. Each paragraph began with "Eventually" and went on at length to describe the merits of Gold Medal flour. Bull, an argumentative man, crossed out all but the first "Eventually," and scrawled in the margin, "Why not now?" The Washburn Crosby Company merged with several other Midwestern mills in 1928 to become General Mills.

(A) 1902

General Foods

(B) 1916

Charles Alfred Pillsbury arrived in Minneapolis in 1869 at the age of twenty-seven. With the backing of a wealthy uncle who owned large parcels of land in Minnesota, the young Pillsbury purchased a flour mill on the Falls of St. Anthony. Like Washburn, Pillsbury began to improve the milling process in order to increase the quality and value of the flour. As a first step,

he hired Washburn's head miller, and with him got Washburn's improved technique for separating the bran from hard wheat flour. In 1878 Pillsbury himself made several trips to Hungary, where he not only obtained details of the roller process but actually bought some porcelain rollers for his mill.

The **(A) Pillsbury's Best XXXX** trademark was adopted in 1872, its circular

design created for marking barrels. The XXX symbol had long been used by bakers as a mark for premium-quality bread—its roots stretching back to the three crosses at Calvary. Pillsbury decided to improve on the idea with a fourth *X*, and added the word *Best* in large letters to get the point across.

The **(B) Pillsbury Doughboy** brought his soft-sell approach to the company's advertising in 1966 in a series of television ads for ready-to-bake dough. He walked, talked, and bounced right back when a finger was pressed deep into his

stomach. As a more likable character than a row of Xs could ever hope to be, he's become a symbol for the Pillsbury Company as a whole, a business that now extends to restaurants, ice cream, and frozen vegetables (through subsidiaries Burger King, Haagen-Dazs, and Green Giant).

(C) Drink Water flour, Morten Milling Company, Dallas, Texas

(D) Olympic flour and breakfast cereals, Portland Flouring Mills Company, Portland, Oregon

DRINK WATER

(C) 1924

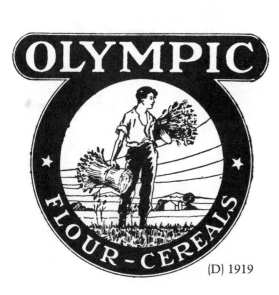

(D) 1919

(B) 1966

The Pillsbury Company

(A) 1901

The Sands, Taylor & Wood Company, of Brighton, Massachusetts, began as an importer and distributor of flour in 1790, making it the oldest flour company in the United States, and one of the oldest in any line of business. It gradually switched to the sale of domestic flour as American wheat production improved, and introduced the **(A) King Arthur** brand in 1896, for a high-quality white flour made from Minnesota wheat. Today King Arthur is the largest-selling brand of flour in New England. Like all of the old flour trademarks, the circular design was adopted for use on barrelheads.

(B) Kitchen Queen flour, Cape County Milling Company, Jackson, Missouri
(C) White Dough flour, Ismert-Hincke Milling Company, Kansas City, Missouri
(D) Kansas Maid flour, Hays City Milling and Elevator Company, Hays, Kansas

(A) 1906

(B) 1901

(C) 1939

(D) 1914

123

(B) 1906

In 1899 Richard Lindsey, the owner of the Royal Flour Mill in Nashville, Tennessee, needed to come up with a new name for the company's premium brand of flour. Lindsey mulled it over then did what what his heart told him was right—he named it after his three-year-old daughter, **(A) Martha White** Lindsey. She's still on the flour bags, and her brand has become one of the market leaders in the southeastern states. The slogan "Goodness Gracious, It's Good" came some time later and is still used in radio advertisements. Garrison Keillor, host of the popular radio show, "A Prairie Home Companion," may have had little Martha in mind when he thought up the slogan for his fictional Powdermilk Biscuits: "Heavens! They're Tasty!"

(B) Five Roses flour, Justin Rosenthal Soden, Emporia, Kansas
(C) Snow Lily flour, Enns Milling Company, Inman, Kansas
(D) Mother Hubbard flour, Hubbard Milling Company, Mankato, Minnesota
(E) King flour, General Mills, Minneapolis, Minnesota

(D) 1931

(A) 1948

(C) 1937

(E) 1937

(A) River Brand rice, River Brand Rice Mills, New York, New York. Now owned by Riviana Foods, of Houston, Texas, the brand name dates back to 1912.

(B) Uncle Ben's Converted Brand rice, Uncle Ben's, Inc., Houston, Texas. The real Uncle Ben was a Chicago maitre d' named Frank C. Brown, who posed for the trademark picture in 1946.

(C) Modern-Mother pie crust, Modern Mother Product Company, Council Bluffs, Iowa

(D) Creole rice, Goldberg, Bowen & Lebenbaum, San Francisco, California

(A) 1947

(B) 1952

(C) 1940

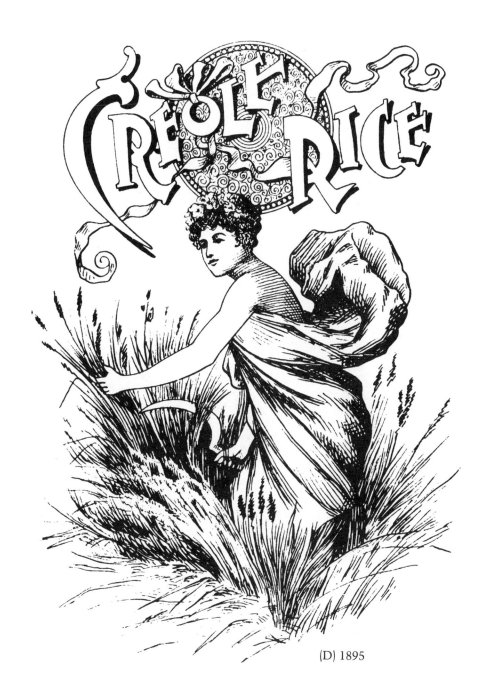

(D) 1895

Baking Needs

In 1921 the Washburn Crosby Company, miller of Gold Medal flour and forerunner of General Mills, found itself besieged with customer letters responding to an offer for a free flour-sack pincushion. Many of the writers also wanted the company's baking advice. They asked for recipes for apple dumplings and cherry pies, much the way neighbors would ask each other for kitchen tips. Sam Gale, head of Washburn Crosby's advertising department, saw to it that all of these letters were answered personally and decided that they should all be signed by a single, fictional spokesperson. He chose the name **(A,B,C,D) Betty Crocker** for the job. Her last name came from William G. Crocker, a popular treasurer and director of the company who had recently died; Betty was chosen as a familiar and friendly nickname.

Betty Crocker's personality evolved over the years as bits and pieces were added to make her a complete person. A worker named Florence Lindeberg provided her first handwriting in 1921; many workers in the Washburn Crosby test kitchens offered her baking expertise. Blanche Ingersoll became Betty Crocker's voice in 1924, when the company decided to put her on the radio. A year later, thirteen Betty Crockers were speaking over the airwaves in different parts of the country. Finally, for her fifteenth birthday in 1936, Betty Crocker got a face. Neysa M. McMein painted that first portrait, giving her a sensible and capable appearance, free of frivolity and glamour. She's been updated five times since then, always holding onto that reliable look and somehow managing to keep the wrinkles at bay.

(A) 1936 portrait by Neysa McMein

(B) 1954

(C) 1955 portrait by Hilda Taylor

(D) 1980 portrait

The Church & Dwight Company, makers of (A,B,C) **Arm & Hammer baking soda**, began as two competing companies, run by a pair of brothers-in-law. John Dwight started to make baking soda, then called saleratus, in 1846, in the kitchen of his South Hadley, Massachusetts home. As the business grew, it attracted the attention of Dr. Austin Church, who had married Dwight's sister. In 1867 he started his own baking-soda venture in New York City in partnership with his two sons. The Churches adopted a picture of an arm holding a hammer as a trademark. One of the sons had used the symbol for an earlier venture, the Vulcan Spice Mills, which had packaged mustard and other spices. Vulcan was the Roman god of fire and metalworking, expert at forging weapons for gods and heroes; the picture represents his arm preparing to swing the hammer down at an anvil. Dwight countered by decorating his baking-soda packages with a picture of a cow.

The brothers-in-law were never able to reconcile their differences, but their heirs merged the two businesses in 1896 to form the Church & Dwight Company. Arm & Hammer has continued as the firm's primary brand mark through a period of expansion into other products. The trademark was applied to washing soda in 1904, laundry detergent in 1970, and more recently to cat-litter deodorizer.

The American Sugar Refining Company introduced consumer-oriented packaging to the sugar industry at the turn of the century, replacing the general store's sugar barrel with brightly printed cartons, much the way Nabisco replaced the cracker barrel with smaller packages in the same period. The company packed its first sugar cartons in 1899 and two years later began to label them with the name that has become its primary sugar brand—(D,E) **Domino.** In 1915 Earl D. Babst moved to the presidency of American Sugar from a job as vice president at Nabisco; he repeated the packaging and advertising formulas that had worked such wonders on the cracker and cookie business. A sum of $1 million was set aside for advertising the Domino name, and the packaging operation was expanded to include the wrapping of individual sugar cubes. Domino rapidly grew into the leading sugar brand and still dominates the packaged-sugar market.

(D) about 1910

(E) 1901

(A) 1878

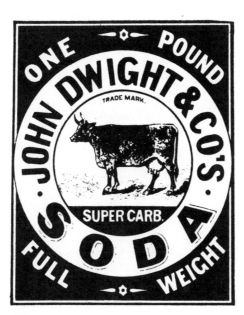

(B) 1876

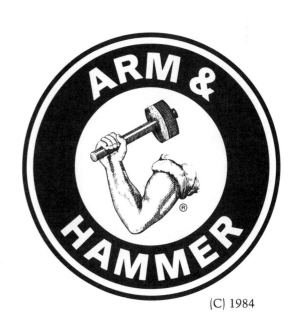

(C) 1984

(A) 1903

Thomas M. Biddle and J. C. Hoagland opened a drug store in Fort Wayne, Indiana, in 1865, where they began to mix a formula for baking powder. Previously, recipes that called for baking soda had required the addition of an acid, such as sour milk or vinegar, to activate the soda. Biddle and Hoagland's formula, which they called **(A) Royal baking powder,** included its own activator and soon became very popular. The druggists moved their operation to Chicago in 1875, then to New York City, and in 1929 Royal became part of the newly formed Standard Brands. Through it all, the Royal baking powder tin has remained steady as a rock.

Hulman Brothers began as a wholesale grocery business in Terre Haute, Indiana, in 1850. In 1899 it added its own brand of baking powder to the line, called Clabber, a word for sour milk—a reference to earlier times in baking when sour milk had been required in many baking-soda recipes. In 1923 the name was changed to **(B) Clabber Girl,** and under that trademark it is still sold throughout the Midwest and Southwest.

William G. Bell, of Newton, Massachusetts, began mixing his special blend of spices into **(C) Bell's poultry seasoning** back in 1867. The distinctive box with the turkey on one side and the bell on the other has decorated kitchens for generations, pulled off the spice rack every November when the time comes to stuff the Thanksgiving turkey. Sales of the seasoning are still growing steadily, but to capitalize on the other 364 dinners of the year, the company has now added ready-mixed chicken stuffing and a meat-loaf mix to its line.

The corn-bodied Indian maiden of **(D) Mazola corn oil** and **Argo corn starch,** was created in 1913 by the Corn Products Refining Company of New York City. She's lost a little weight over the years, though her figure is still far from shapely. Her parent company, no longer confined to work with corn, has shortened its name to the chicly corporate CPC International.

Best Foods

(B) 1923

(C) 1906

(D) about 1915

(A,B) **The Morton Salt girl** was born in a brainstorming session at the newly formed Morton Salt Company in 1911. The company had developed a free-running salt and a pour-spout container that it hoped would have great appeal to consumers. To publicize the new product, Morton had asked the N.W. Ayer advertising agency to prepare twelve ads for *Good Housekeeping* magazine. Ayer also submitted three substitute ads, and it was one of these that caught the eye of Sterling Morton, son of the company's president, when executives sat down to review the ad campaign. The picture showed a little girl under an umbrella, with a container of salt pouring out behind her. Ayer's slogan read, "Even in rainy weather, it flows freely." Morton loved the concept of the ad. "Here was the whole store in a picture—the message that salt would run in damp weather was made beautifully evident," he recalled. But it needed a better selling line, "something short and snappy, like 'Ivory Soap—It Floats.'" The assembled minds tried "Flows Freely," and "Runs Freely," and the old proverb "It Never Rains But It Pours." Finally, they settled on "When It Rains It Pours" for a slogan, and agreed to use the umbrella girl for one of the ads. Three years later, in 1914, they adopted her for the package. She has been updated several times through the years, most recently in 1968.

(C,D) **McCormick & Company,** of Baltimore, used a bee as a trademark for its line of spices and flavorings for many years. The firm's founder, Willoughby McCormick, thought the bee "discriminating . . ., courageous, and remarkably industrious." But when he died, in 1932, the bee lost its greatest fan. The designer Jim Nash wrote to the company in 1938, suggesting that its packages needed an overhaul to make them more attractive and easier to identify in stores. He expected his criticism to meet with a firm rebuff. Instead, he reached the company just as it was coming to the same conclusions on its own and was given the job of creating a new look. Nash replaced the bee with an enlarged rendering of the letters *Mc* as a design feature to unify all of the McCormick packages, and he simplified the color scheme to a combination of solid white, red, and blue.

(C) 1890

(D) 1939

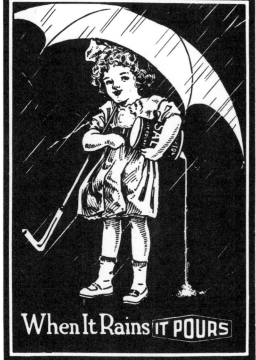

When It Rains IT POURS

(A) 1914

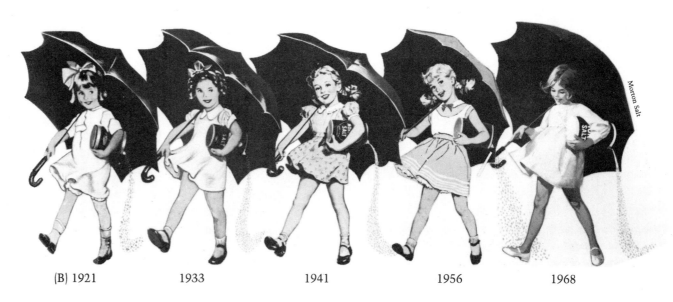

(B) 1921 1933 1941 1956 1968

Morton Salt

Breakfast

The great tradition of the American breakfast cereal dawned in the 1890s, when a growing public interest in healthful foods combined with revolutions in packaging, shipping, and merchandising to bring brand-name grains to the breakfast table. And at the front line, selling the new crop of breakfast foods and distinguishing each from the other, stood an imposing corps of trademark giants.

(A,B,C) The Quaker Oats man first appeared in 1877 as the mark of a small oatmeal milling com-pany in Ravenna, Ohio. The two owners of the firm later disagreed about who had created him. Henry D. Seymour claimed to have come up with the idea while searching through an encyclopedia. He was struck by the description he found of the Quakers—"the purity of the lives of the people, their sterling honesty, their strength and manliness." William Heston also claimed to be the Quaker's inventor. In his version, the idea came to him in Cincinnati when he came across a picture of William Penn. To Heston, the picture suggested quality, and seemed the ideal symbol for the new oatmeal venture.

While Heston and Seymour both claimed parentage of the Quaker Oats man, neither had much to do with his fame. They sold their Quaker Mill Company two years later, having made little headway in the oatmeal market. Through a succession of mergers, the Quaker wound up in 1890 in the hands of the giant American Cereal Company. With one of the first big advertising budgets behind him, he was on his way to stardom.

The American Cereal Company chose the Quaker to mark its principal oatmeal brand, which it pack-aged in a cardboard container bearing his picture. In 1891 the company filled entire trains with Quaker oats and ran them across the country with stops at every settlement along the way to give out free sam-ples. Gigantic Quakers appeared on billboards and wall signs around the world. One of the biggest sprang up on the White Cliffs of Dover—where it took an Act of Parliament to have him removed.

Through the years the Quaker has lost some of his initial sobriety. He smiled for the first time in a 1945 revision by Jim Nash, and he seems even happier in his current abstracted version, designed in 1971 by Saul Bass & Associates.

(D) Friends oats, Muscatine Oat Meal Company, Muscatine, Iowa. A low attempt to steal the Quaker's limelight.

(A) 1895

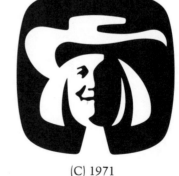

(B) 1945

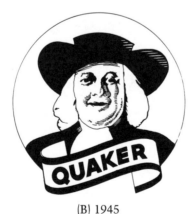

(C) 1971

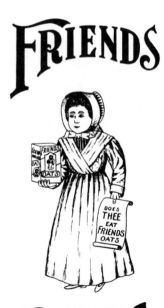

(D) 1895

(A) Cream of Wheat came out of Grand Forks, North Dakota, in the depression year of 1893. The Diamond Milling Company was struggling to survive in the face of low prices and reduced demand for its flour. The idea that was to turn the company's fortunes around came in a suggestion from one of the mill's employees.

Tom Amidon, Diamond's Scottish-born head miller, had discovered that wheat middlings—the unused hearts of the grain—made a tasty breakfast porridge. He often brought the middlings home to his family, who considered the cereal a special treat. As business at the mill was so slow, Amidon persuaded the owners to give his middlings a try with their New York brokers.

Amidon himself cut cardboard packages for that first batch of cereal. Another worker volunteered the name Cream of Wheat, and the words were hand-lettered on each of the boxes. Emery Mapes, one of the owners, came up with an old printing plate of a black chef with a saucepan over his shoulder, which was used, as he later recalled, to "brighten up the package." Without giving the broker any advance notice, the mill shipped ten cases of Cream of Wheat along with its regular carload of flour.

The telegrammed reply from New York surprised even Tom Amidon. "Forget the flour," it read. "Send us a car of Cream of Wheat."

The mill switched over entirely to the production of Cream of Wheat, and even then could not keep up with the demand. In 1897 the company moved to a larger plant in Minneapolis.

The original chef trademark survived until 1925, when he was replaced by the more realistic version we know today. According to the story, Emery Mapes noticed a handsome waiter working in Kohlsaat's Restaurant in Chicago and asked him to pose for a photograph. The man was paid $5 for the picture that has since served as the Cream of Wheat symbol, but, sadly, no record was made of his name.

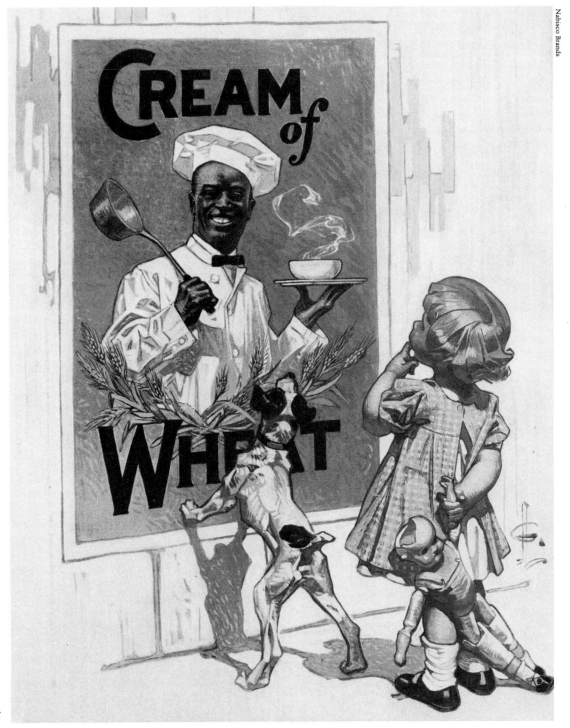

(A) 1909 advertisement by J.C. Leyendecker

(A) 1895

HEAT BEFORE
SERVING
TO RESTORE
ORIGINAL
CRISPNESS

WON ITS FAVOR
THROUGH ITS FLAVOR

(C) 1915

The cold-cereal breakfast—an American institution today—traces its origin to a health-food craze in the 1890s, centered in Battle Creek, Michigan. At the time, Battle Creek was the world headquarters of the Seventh Day Adventist Church, and from their doctrine of strict vegetarianism America's breakfast revolution sprang.

Dr. John Harvey Kellogg was one of the Adventists' staunchest supporters of healthful eating habits. He spread his views through the operation of his Battle Creek Sanitarium. Kellogg's patients at the sanitarium lived on a diet of nuts and grains, often prepared from recipes created in the hospital's experimental kitchen. Dr. Kellogg's early food innovations included meat and butter substitutes such as Protose, Nuttose, and Nuttolene, as well as foods that have better stood the test of time, like Granola, first made at the sanitarium in 1877. Patients were not allowed to drink tea or coffee, but received instead the home-brewed Caramel Coffee, made from bran, molasses, and burnt bread crusts.

One of the patients who sipped Caramel Coffee at the sanitarium in 1891 was C.W. Post, who arrived in need of revival after some troubling experiences in business. He stayed in Battle Creek after his cure and in 1895 began to sell his own coffee substitute, **(A) Postum Cereal food drink,** with the claim, "It Makes Red Blood." He followed two years later with one of the first widely promoted cold breakfast cereals. He called it Grape-Nuts cereal under the mistaken belief that grape sugar was formed from the wheat during the baking operation, and under the forgivable delusion that the cereal tasted like nuts. Post soon discovered that his health foods had a tremendous appeal to a public just awakening to the concept of a healthful diet. By 1901 Postum beverages and Grape-Nuts cereal were bringing him an income of close to $1 million a year.

Other health-food entrepreneurs took note of Post's good fortune and jumped into the breakfast-cereal boom. Dozens of new companies sprouted in Battle Creek to promote cereals with names such as Malta Vita, Strengtho, and **(B) Corno** (Carl F. Beach, Battle Creek, Michigan).

Dr. Kellogg might have been content to let the benefits of health cereals be promoted by others, but his younger brother, W.K. Kellogg, sought to take commercial advantage of the foods already being made at the sanitarium. He had particularly high hopes for a type of flaked cereal that Dr. Kellogg and he had invented in 1894. At first, the brothers made the flakes from wheat, but in 1898 they began to make them from corn as well, selling them as Sanitas corn flakes by mail to patients who had left the sanitarium and wanted to keep on Kellogg's diet.

In 1903 W.K. Kellogg tired of the restraints his brother had placed on him and the corn-flake business and set out on his own to promote the cereal. He changed the name to Kellogg's toasted corn flakes and improved the flavor by adding malt, sugar, and salt—ingredients that the doctor had opposed as unhealthy. Through an extensive advertising campaign and door-to-door sample giveaways in a number of cities, he was able to establish the cereal as an important breakfast staple.

(C) The Sweetheart of the Corn came to work for Kellogg's in 1907 as a symbol printed on each box of corn flakes. By one account, a Kellogg Company stenographer named Fannie Bryant posed for the picture. By another, she was created on speculation by the Ketterlinus Lithographing Company of Philadelphia—who tried at first to sell her to a farm-implement company, then replaced her armful of wheat with corn and brought her to Kellogg's.

(B) 1899

(A) Force wheat flakes for a time put up serious competition to Kellogg's in the flaked-cereal market. Introduced in 1901 by the Force Food Company of Buffalo, New York, and backed by a $1-million advertising campaign two years later, the cereal became an overnight success—a textbook case of the power of promotion. The star of the ads, and later the trademark on the Force package, was a strange little character named **(B) Sunny Jim,** a.k.a. Jim Dumps, the creation of artist Dorothy Ficken and jingle writer Minnie Maud Hanff. He entered each ad as the gloomy-faced Jim Dumps, then a jingle described his incredible transformation into Sunny Jim when he ate a bowl of Force. The ads were certainly appealing—Sunny Jim was as famous in his day as the Quaker Oats man or the Gold Dust twins—but the cereal didn't have staying power. Its bland flavor couldn't compete in the end, and it disappeared from market shelves in the 1940s, remembered with a grimace by those who ate it as children.

(C) Snap, Crackle, and Pop made their debut with Kellogg's Rice Krispies in 1941, bringing to life the sound the cereal made when flooded with milk. They set Rice Krispies apart from other breakfast cereals— the quiet ones—and managed to give a bowl of puffed rice a lively personality. The trio is still at work on the Rice Krispies box and in the advertisements, singing, dancing, and making their peculiar noises. Their features are not quite as angular now, and their ears are a size or so smaller, but their noses are still a match for Pinnochio at his worst.

(D) Tony the Tiger has been the spokesman for Kellogg's Sugar Frosted Flakes since 1953, an enthusiastic and *loud* supporter of his product. Never content with timid praise, he thinks the cereal is "Gr-r-reat!"

(D) 1960

(A) 1902

"Sun-ny Jim"

(B) 1904

(C) 1941

William Danforth was running a thriving animal-feed business in St. Louis when he decided to take advantage of the public's enthusiasm for breakfast cereals. He started with a cracked-wheat mixture in 1898, which he called Purina whole wheat cereal. To give the product quick credibility among the health-food faddists, Danforth approached one of the most popular whole-grain advocates, Everett Ralston, for an endorsement. Ralston agreed, but in return wanted

CHECKERBOARD

(A) 1900

the product to carry his name. So the Purina cereal was changed to (A,B) **Ralston health breakfast food.**

In 1900 Danforth decided to redesign all of the Ralston and Purina packages so that they would be easily recognized as products of the same company. In his search for an appropriate design element, he thought back to the days he spent working in his father's general store in Charleston, Missouri. But instead of quaint old boxes and barrels, what stuck in his memory was a family named Brown that came into the store every Saturday dressed in red and white checks. Mrs. Brown saved money by making all of the clothes from the same bolt of cloth, and the result was a family with a theme outfit as effective as a storefront sign. When it came time to go home, the Brown kids could be spotted and rounded up in few minutes. Danforth decided that if he could remember the red and white checks after all those years, they would make a perfect design theme and trademark for his cereals and grains. The Ralston Purina Company has used the checkerboard pattern on its packages ever since.

Maple syrup is one of the oldest North American delicacies. It was a regular part of the diet among northern Indians when the first European settlers arrived, and the new Americans grew to rely on it as

their principal sweetener. Molasses from the West Indies became available in the eighteenth century, but to New Englanders it couldn't compete in price with the home-made maple syrup. In 1800 U.S. production of maple syrup was four times as great as it is today.

As the population grew and the forests dwindled in size, maple syrup gradually became less of a staple and more of a delicacy. In 1887 Patrick J. Towle, of St. Paul, Minnesota, recognized the need for a blended table syrup, one with the flavor of maple but without the prohibitive price. He created a formula for a mixture of cane and maple syrups, and called it (C) **Towle's Log Cabin syrup**. In a show of marketing genius he packaged it in a small tin made in the shape of a log cabin. The package was distinctive, and since it was small enough to pour from at the table, it grew to be a familiar breakfast fixture.

The log cabin tin survived until World War II, when metal shortages forced the makers to change the package to a glass bottle.

(D) **Vermont's Pride syrup**, Vermont Maple Syrup Company, Essex Junction, Vermont

(B) 1902

(D) 1922

(C) 1914

Condiments

One of the specialties of Richard Hellmann's delicatessen in New York City was a home-made mayonnaise. He displayed it on his counter in a jar decorated with a blue ribbon and sold it to his customers in small wooden containers. In 1912 he began to sell the mayonnaise in glass jars, labeled **(A) Richard Hellmann's Blue Ribbon mayonnaise.** The name has since been shortened to Hellmann's, but a blue ribbon is still pictured on every jar. The mayonnaise is made today by Best Foods, a division of CPC International.

(B) Robert T. French founded a spice company in 1880, at the age of fifty-seven, with the hope that it would provide a livelihood for his three sons. After a couple of false starts in New York City and Fairport, New York, the enterprise settled into an old flour mill in Rochester in 1885, where the R.T. French Company grew into an important manufacturer of mustard. In 1904 the Frenches perfected a mild, golden-yellow mustard that quickly became a national favorite. Oscar Westgate, the company's advertising manager, created **(C) Hot Dan the Mustard Man** in 1935; for many years the little fellow served as an entertaining spokesman in French's advertisements.

Edmund McIlhenny first came to Avery Island, Louisiana, in 1862, fleeing the Union seige of New Orleans. After the war, in 1865 or 1866, he planted some chili peppers on the island, the seeds for which are thought to have come from the state of Tabasco in Mexico. He made a sauce from the peppers, which proved so popular among his neighbors that in 1868 he decided to sell it commercially as **(D) Tabasco pepper sauce.** He sold only three hundred and fifty bottles that first year, but in 1869 he sold several thousand, and three years later he opened a London office to handle the growing European business. The McIlhenny family still bottles Tabasco on Avery Island—Edmund's grandson Walter is now president of the company—and the sauce supports them very nicely, selling at a rate of fifty million bottles a year.

(E) Texas Pete hot sauce, T.W. Garner Food Company, Winston-Salem, North Carolina

Best Foods

(A) about 1920

(B) 1956

(C) 1936

(D) 1953

(E) 1952

135

Snack Food

For most of the nineteenth century the cracker and cookie business in America was carried on by small, local bakeries whose products were sold from open cracker barrels. But improved transportation and distribution systems after the Civil War allowed bakers to ship their goods beyond their established territories, creating at once fierce competition and a need for better packages.

Some bakers began to package fancy brands of crackers in tins and printed cartons on a limited scale soon after the Civil War. In 1889 **(A) J.D. Gilmor & Company,** a New York City baker, introduced clear-fronted cartons to display the crackers inside. But for the most part, crackers were sold through the 1890s in bulk barrels. Any brand identification was stamped on the surface of the crackers, as in the PW mark on **(B) Perfection wafers** made by the Perfection Biscuit Company, of Fort Wayne, Indiana.

During the 1890s competition, price-cutting, and unsettled business conditions led many bakers to merge into larger companies. In 1898 the **(C,D,E) National Biscuit Company** was formed by the merger of most of these merged companies with a number of independent bakers. The new baking giant was so huge that in its first year its sales accounted for 70 percent of the cracker and cookie business in America.

The new firm's first move was to create an entirely new brand-name cracker to be sold in a package specially designed to preserve its crispness. Adolphus Green, the lawyer who engineered the merger and was also the baking giant's first chairman, took charge of the new product's creation. For the recipe he settled on an exceptionally light and flaky soda cracker. But the name did not come easily. His first suggestions included Verenice, Bekos, Trim, Dandelo, Fireside, and Nabisco, none of which captured the imagination of the company's advertising agent, Henry N. McKinney of N.W. Ayer & Son. McKinney came back with Taka Cracker, Hava Cracker, Usa Cracker, Uneeda Cracker, Wanta Cracker, Takanoo, Racka, Nati, Pauco, Tanco, Onal, and Biscona. From the list, Green picked Uneeda, a word he would later boast of as "the most valuable in the English language."

The country's leading packaging experts were solicited for advice on a package that would keep the crackers fresh and free of contamination. In the end the solution came from Green's own law partner, Frank Peters. Peters devised a box of cardboard and wax paper and, much to his wife's alarm, converted his kitchen table into a treadle-operated packaging machine to test the practicality of the design.

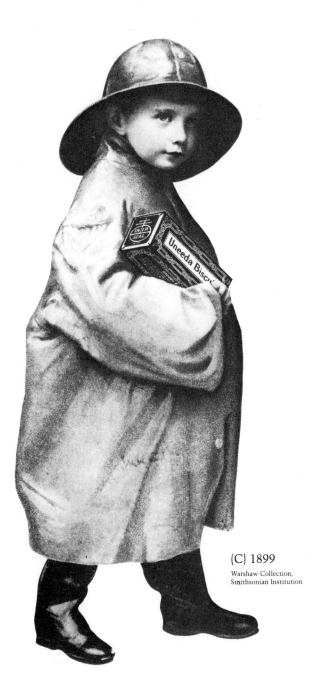

(C) 1899

Warshaw Collection,
Smithsonian Institution

(A) 1889

(B) 1908

As a final step, a symbol for the new product was needed—something recognizable and appealing, to appear both on the package and in advertisements. The Ayer agency came up with the answer to this problem as well. Gordon Stille, the five-year-old nephew of one of Ayer's copywriters, was posed in an oilskin rainhat and slicker; as the Uneeda biscuit slicker boy, he has become one of the best-known little boys in the world. In 1900, his second year on the job, he presided over the sale of 100 million boxes of Uneeda biscuits—roughly six packages for every family in the country.

The National Biscuit Company needed a symbol for itself as well. Green found one while searching through his collection of rare books. The simple design of an oval surmounted by a double-barred cross was used as a pressmark by the Venetian printers Nicolas Jenson and Johannes de Colonia as early as 1480, and variations on it were adopted by a number of other early printers. In medieval times the mark symbolized the triumph of the spiritual over the worldly, but it had also been used in ancient times as a symbol of royal power. Framed in the octagonal shape of a Uneeda biscuit, and filled with the word *In-er-Seal* (the name given to the unique wax-paper-lined package), it was adopted as the National Biscuit

Company's official trademark in 1900. The oval later enclosed the initials *N.B.C.* (1918), and the word *Nabisco* (1941). The current version, the red, triangular corner seal, was created in 1952 by Raymond Loewy Associates as a more versatile mark to be used on the fronts of all Nabisco packages.

The National Biscuit Company did not relax after the successful launching of Uneeda biscuits, but offered, in quick succession, Oysterettes crackers, **(F) Zu Zu ginger snaps** (promoted by Zu Zu the clown), Social tea biscuits, Fig Newtons, Premium saltines, Nabisco sugar wafers (in lemon, orange, chocolate, vanilla, and mint flavors), and, in 1902, **(G) Barnum's Animals crackers**. With their distinctive circus-cage box and string handle (originally added to make the boxes easy to hang from the family Christmas tree), the creatures have become one of the nicer benefits of childhood. Shirley Temple paid the cookies what may be their greatest tribute in her 1935 movie *Curly Top*, when she sang "Animal Crackers in My Soup."

(D) 1900

(E) 1952

Pressmark of Nicolas Jenson and Johannes de Colonia, Venice, 1481

(G) 1902

(F) 1902

(A,B,C) Mr. Peanut is now almost seventy years old, although a series of renovations have made him look younger today than when he was born. He sprang from the imagination of a thirteen-year-old Suffolk, Virginia, schoolchild, Antonio Gentile, who won $5 for the idea in a 1916 contest sponsored by the Planter's Nut and Chocolate Company. A commercial artist brought Gentile's rough concept to life, adding Mr. Peanut's distinctive monocle, top hat, and cane.

The motivating force behind the contest was the founder of the Planters Nut and Chocolate Company, a truly self-made man. **(D) Amedeo Obici** arrived in New York from Italy in 1889 at the age of twelve—alone, with little money, and unable to speak English. He managed to find his only relative in the United States, an uncle in Scranton, Pennsylvania, and he went to school there while working at his uncle's fruit stand in the evenings and on weekends. At nine-teen he opened his own fruit stand in nearby Wilkes-Barre. To distinguish his stand from others, he bought a peanut roaster and offered salted and chocolate-coated nuts as a specialty.

The peanut end of his business grew to the point where he was able to leave the fruit stand behind. His 1902 trademark registration indicates that by then he was actively promoting the peanut specialty. In 1906, with fellow immigrant Mario Peruzzi, he formed the Planters Nut and Chocolate Company. Obici chose the name Planters because it sounded "important and dignified." It certainly didn't get in the way of the company's growth. In 1913 Planters built a processing plant in Suffolk, Virginia, in the heart of peanut country. After several enlargements the plant now covers seventy-six acres.

(E) Buster peanuts, Peanut Products Company, Des Moines, Iowa

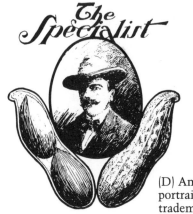

(D) Amedeo Obici's portrait on a 1902 trademark for peanuts

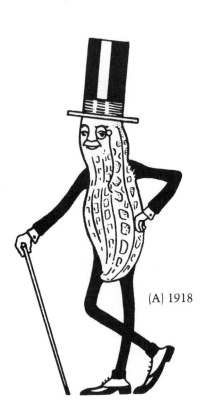

(A) 1918

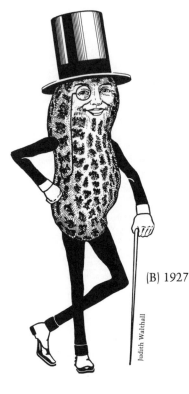

(B) 1927

Judith Walthall

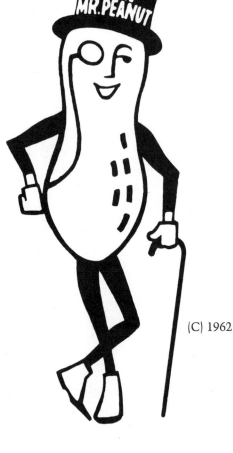

(C) 1962

(E) 1938

Take me out to the ball game,
Take me out to the park.
Buy me some peanuts and Cracker Jack,
*I don't care if I never come back.**

(A,B) Cracker Jack has earned a special place in the hearts of most Americans. For more than eighty years children have grown up with the popcorn-and-peanut candy, and each successive generation has accepted Cracker Jack as its own. For some reason, the sailor boy package with the prize inside just continues to hit the spot.

Cracker Jack traces its roots to a Chicago popcorn stand opened in 1872 by a German immigrant named F.W. Rueckheim. The young popcorn merchant was soon doing well enough to bring his brother Louis from Germany to help out, and as F.W. Rueckheim & Bro., the business expanded into candy-making. At the 1893 Columbian Exposition the Rueckheims sold a unique popcorn, peanut, and molasses candy—the earliest version of what would become Cracker Jack. The candy was popular but difficult to handle, as the kernels stuck together in blocks. Louis discovered the secret of keeping the kernels separate in 1896. *Crackerjack*, meaning *excellent* or *great*, had entered the language as a new slang word that year, and an attentive F.W. Rueckheim chose it as the candy's name.

A wax-sealed box, designed in 1899, preserved the freshness of packaged Cracker Jack and allowed it to be shipped to stores around the country. By 1902 the candy was well enough known to be included in the Sears catalogue without description, and in 1908 it earned candy hall-of-fame status in the song, "Take Me Out to the Ball Game." And all that notoriety came before the key feature—the prize—was added. Since 1912 every package of Cracker Jack has come with a "toy surprise inside." These have evolved from yo-yos, metal whistles, lead charms, and tops in the early days, to plastic toys, miniature story books, Super Hero stick-ons, and tiny tattoos in the years since World War II. The company has kept samples of all the toys ever sent out and maintains a display of some of the best at its Chicago headquarters.

Sailor Jack and his dog stepped onto the box in 1919. The little boy was modeled on F.W. Rueckheim's grandson Robert, who had a dog like the one in the symbol, named Bingo. Sadly, Robert died of pneumonia soon after the new box appeared. He is buried in St. Henry's cemetery, near Chicago, under a headstone with a carving of him in his sailor suit.

(C) Iten's O-Boy-O cakes, Iten Biscuit Company, Omaha, Nebraska

(A) 1924

(B) 1961

(C) 1921

*From "Take Me Out to the Ball Game," by Jack Norworth and Albert von Tilzer, 1908

(A) 1954

The **(A) Moon Pie** has acquired as loyal a following as a snack food could ever hope for, though one confined to its distribution area south of the Mason-Dixon line. For those who've never had the pleasure, a Moon Pie is a sweet sandwich formed by two graham-crackerlike cookies, a marshmallow center, and a coating of chocolate-, vanilla-, banana-, or coconut-flavored frosting. The Moon Pie was born in 1917 at the Chattanooga Bakery, in Chattanooga, Tennessee, and is now the bakery's only product. According to legend, the idea for the snack came from a traveling salesman who stopped in at the bakery and suggested that the company make a chocolate-coated marshmallow sandwich. Even legend can't explain the origin of the unusual space-age name, but the "Lookout" comes from Lookout Mountain near Chattanooga. The Double-Decker Deluxe Moon Pie, with three cookies and two layers of marshmallow, joined the original single-decker sandwich in 1969.

Newman E. Drake founded **(B) Drake Bakeries** in Brooklyn, New York, in 1896, to make pound cakes for sale at grocery stores. Ninety years later, the bakery still makes snack cakes, now at a modern plant in Wayne, New Jersey. Webster, the Drake duck, appeared in 1937 as an ambassador to the children who were becoming an important market for Drake's products.

(C) Angels' Food cakes, Samuel Sides, St. Louis, Missouri

(D) Eskimo Pie frozen confections, Eskimo Pie Corporation, Louisville, Kentucky

(E) Little Debbie cakes, cookies, and pies, McKee Baking Company, Collegedale, Tennessee. The original Little Debbie was the founder's granddaughter, Debbie McKee, who sat for the portrait in 1960.

(C) 1878

(E) 1964

(B) 1938

(D) 1984

The potato chip is an American invention. When a guest at Moon's Lake House in the resort town of Saratoga Springs, New York, asked for a "properly thin" French fried potato, chef George Crum angrily sliced a potato paper-thin and fried it up. To Crum's surprise, the customer loved the resulting "chips." That was in 1853, and Crum's Saratoga Chips soon gathered fame and imitators throughout the country.

Earl V. Wise began making **(A) Wise potato chips** as a way to get rid of an oversupply of potatoes. Wise ran a grocery store in Berwick, Pennsylvania, and in the spring of 1921 he found himself with too many spuds. Remembering his mother's homemade potato chips, he set about slicing and cooking the excess. His customers liked the chips so well that Wise not only sold that year's potatoes, but he began to order in quantity and sell the chips to other stores.

At first, Wise sold his chips in ordinary brown paper bags, but as the business grew, he searched for a more attractive package. In the early 1930s he became something of a packaging pioneer when he switched to cellophane bags. The Lynn-Fieldhouse advertising agency in Wilkes-Barre, Pennsylvania, created Peppy the owl as a symbol to be used in decorating the new packages. In 1959 Peppy was refined to a single owl's eye, now used to dot the *i* in Wise.

Popcorn is another American native, one with truly ancient origins. Kernels dating back almost six thousand years have been found among American Indian remains, and Cortés noted that the Aztecs wore strings of popcorn as jewelry. It is said that popcorn was on the table at the first Thanksgiving feast at Plymouth. Certainly the settlers learned very early how to grow and cook popcorn from the Indians. More recently, the habit of eating popcorn jumped dramatically during World War II, when sugar shortages forced many to turn to it as a substitute for candy. It was during the war that the custom of eating popcorn at the movies became widespread.

(B) Pep-Pop popcorn, Peppard Seed Company, Kansas City, Missouri
(C) TNT popcorn, Barteldes Seed Company, Lawrence, Kansas
(D) Pringle potato chips, Procter & Gamble Company, Cincinnati, Ohio
(E) Breyer's ice cream, Breyer Ice Cream Company, Philadelphia, Pennsylvania

(B) 1935

(C) 1929

(A) 1955

(D) 1969

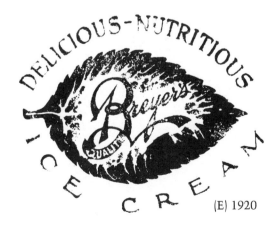

(E) 1920

(A) about 1910

(B) about 1940

Candy, because it is a small and inexpensive product, lagged behind the general shift to packaged, brand-name merchandise in the 1880s and '90s. Confectionery stores sold unwrapped candy by the pound; general stores sold it from glass jars, packed for the customer in a box or bag. While some individually wrapped candies began to appear at the turn of the century, the familiar, branded candy bar did not become commonplace until the 1920s. The pioneers of that change discovered a wide array of new outlets for their products, as drugstores, cigar stores, and newsstands found the wrapped candies far more convenient to handle and display. Many of the first names in packaged candies survive as best-selling brands today—names like Hershey's, Tootsie Roll, Wrigley, and Whitman's.

Milton Hershey started his confectionery career as a manufacturer of high-quality caramels in the 1890s,

making a small fortune over the course of several years. In 1900, at the age of 43, he decided to sell the caramel business and risk everything he had earned on a new venture—producing America's first mass-distribution five-cent chocolate bar.

He built a huge factory in the middle of the rich dairy region near Lancaster, Pennsylvania, where, around 1905, he began to make the **(A,B) Hershey's milk chocolate bar**. His plan was to make a fine chocolate bar using the freshest milk from the nearby farms, produce it in large enough quantity to permit a low price, wrap it individually so that it could be easily handled and identified, and sell it through as many stores as possible. His scheme worked out so perfectly that the Hershey bar grew quickly into an American icon. It is one of the most widely recognized products in the world, and one that earned its public acceptance largely without the benefit of advertising.

Hershey followed with **(C) Hershey's Milk Chocolate Kisses** in 1907, the **Mr.** Goodbar candy bar in 1925, and Hershey's syrup in 1926. Long before his death, Hershey donated the entire company to a school for orphaned children that he and his wife had established near the chocolate plant. Today the Milton Hershey School owns 55 percent of the stock in Hershey Foods.

(D) After Dinner mint candies, Artemas P. Richardson, Philadelphia, Pennsylvania. Now owned by Beatrice Foods.

(E) Beech-Nut candies, chewing gum, and other foods, Beech-Nut Packing Company, Canajoharie, New York. The trademark symbol has been used since 1899.

(C) about 1910

(D) 1904

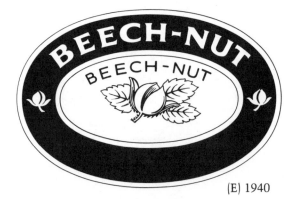

(E) 1940

(A) about 1925

(B) billboard advertisement, about 1925

Nabisco Brands

Library of Congress

(A) **The Baby Ruth candy bar** came from the kitchens of the Curtiss Candy Company in 1920 and in short order lifted the tiny Chicago firm into a position of national prominence. The company, which started with a five-gallon kettle in a leased room over a plumber's shop, tried out a number of candy recipes before hitting on the chocolate and peanut formula that so appealed to the world's sweet tooth. By 1926 Baby Ruth bars were selling at a rate of five million a day. Contrary to popular belief, the candy's name has nothing to do with baseball great Babe Ruth—who in 1920 had just joined the New York Yankees, and was only beginning to become a home-run legend—but was named for the daughter of former President Grover Cleveland. As an infant in the White House almost thirty years before, she had won the nation's enduring affection. In fact, the Curtiss Candy Company took Babe Ruth to court in 1930 to keep him from selling a competing candy bar in his own name.

(B) **The Oh Henry! candy bar** is another Chicago native, the brainchild of George H. Williamson, who left his career as a newspaper reporter in 1918 to open a candy shop. One of his inventions, a chocolate-covered nut and caramel roll, became so popular that he began to get orders for it from other candy stores. In order to maintain customer loyalty in this widening business, he started to wrap the bars in 1920, with the name Aunt May's Oh Henry! The name came from a young man who hung around the shop, attracted by several young women who worked there. When the women needed help lifting a heavy box, they would yell for him, and the call "Oh, Henry!" grew into a sort of joke among the workers.

When Leo Hirschfield came to New York City from his native Austria in 1896, he brought with him the recipe for the chewy chocolate candy that would become the (C) Tootsie Roll. Hirschfield opened a small candy shop that year and began to offer the candies as Tootsies. Unfortunately, he left no record of why he chose the name. One story holds that he named the candies after his first sweetheart in Vienna; another that it was his daughter's nickname. It is certain that the printed paper wrapper—added to the candy at some point near the turn of the century—helped to propel the Tootsie Roll's rise from a handmade neighborhood specialty to a worldwide bestseller.

(D) **Mary Jane candy bars** were first made at the turn of the century by the Charles N. Miller Company in a house in Boston's North End that years earlier had been the home of Paul Revere. The candy was named for Mr. Miller's favorite aunt, but some years later adopted the little cartoon girl as its trademark, probably modeled on Buster Brown's comic strip friend Mary Jane. (See page 196 for a discussion of other Buster Brown trademarks.)

(D) about 1920

(C) 1969

(A) 1950

Stephen F. Whitman of Philadelphia went into the candy business in 1842. When his successors decided to expand their market in 1912 with a box of assorted fancy chocolates, they came up with the name **(A) Whitman's Sampler**, and designed the package to suggest an old-fashioned needlework sampler. The messenger, with his unusual cross-stitched outfit, arrived on the package three years later. One of the better features of the Whitman Sampler package from the beginning has been the flavor index inside the lid, which has taken much of the risk out of choosing chocolates. The company completed the job in 1966 when it added an index to the bottom layer as well.

Frank C. Mars began making candies in the kitchen of his Tacoma, Washington home in 1911. Nine years later, at the age of thirty-seven, he moved his family and candy-making operation to Minneapolis, where he began to experiment with candies that might have national appeal. The Mar-O-Bar candy bar, his first try, was not a hit, but in 1921 he also brought out the Snickers bar (without the chocolate coating that it has today) and the Milky Way bar, both of which caught on in a big way. After a move to an even bigger plant in Chicago, the candy maker continued to come up with mouth-watering winners: the **(B) Mars almond bar** and an improved chocolate-coated Snickers bar in 1930, and in 1932 the **(C) 3 Musketeers bar**.

Frank's son, Forrest E. Mars, went into the candy business himself in 1940. In Newark, New Jersey, he started making the hard-coated chocolate candies which he named **(D) M&M's**—the combined initials of Mars and his associate Bruce Murrie. M&M's peanut chocolate candies followed in 1954. M&M's candies of both types have attracted a loyal eatership. When the company dropped the red candies from the M&M's assortments in 1976, fans across the country banded together to lobby for their return. To date all such efforts have been unsuccessful, but the movement is still very much alive.

(E) Necco wafers are made today in the same Cambridge, Massachusetts, plant from which they were introduced. The candies trace their origins to lozenges made on the first American candy machine—a lozenge cutter invented in 1847 by Oliver Chase. Chase and his brother went into the lozenge-making business in Boston that year. In 1901 their company merged with two others to form the New England Confectionery Company, one of the largest candy firms of the era. The company still produces Necco wafers, along with such other favorites as Canada mints, Bolsters, Skybars, and Candy Cupboard chocolates.

(B) 1950

(C) 1932

(D) about 1950

(E) 1905

(A,B,C) Life Savers were invented by Clarence Crane, a Cleveland candy maker and the father of writer Hart Crane. He advertised his Crane's Peppermint Life Savers as the cure for "That Stormy Breath." He gave the candies their name, their shape, and their first flavor, but he sold it all for $2,900 in 1913 before the candies had begun to show their real worth.

Edward J. Noble, the young New York advertising salesman who bought Crane out, put faith and energy behind the candies and found almost no limit to how far they could go. He abandoned the cardboard package used by Crane—after sitting on a store shelf the candies took on the flavor of the paste holding the package together—and began to wrap the rolls in foil. And he talked an ever-growing number of customers into putting the mints out by the cash register in grocery stores, restaurants, drugstores, bars, cigar stores, and barber shops. Noble was soon drawing a handsome return from the little candies—enough to allow him, in 1943, to buy the American Broadcasting Company for $8 million in cash.

The original peppermint flavor (Pep-O-Mint) was soon supplemented by Wint-O-Green and Five Flavors—the trio that still forms the backbone of the candy's business. Over the years they have been joined by such exotics as Violet, Clove, Tropical Fruit, and Butter Rum.

(D) Good and Plenty licorice-flavored candy, Quaker City Chocolate & Confectionery Co., Inc., Philadelphia, Pennsylvania

(E) Atomic Fireball jaw breaker candies, Ferrara Candy Co., Inc., Chicago, Illinois

(D) 1965

(E) 1954

(A) 1922

(B) about 1920

Nabisco Brands

(C) 1913 advertising card

145

Adams' New York Chewing Gum,

(A) 1905

(C) 1905

(B) 1926

Americans have chewed spruce resin since colonial times, but chewing gum as we know it came from Mexico soon after the Civil War. General Antonio Lopez de Santa Ana, famous for leading the siege on the Alamo, passed several years of exile from his native Mexico living in New York City, and he brought with him a quantity of chicle, the dried sap of the sapodilla tree. Legend has it that it was Santa Ana's chewing habit that gave Thomas Adams the idea of selling chicle in the United States. His first gum, **(A) Adams' New York** chewing gum ("Snapping and Stretching"), was pure chicle with no flavoring. Introduced in 1875, it sold well enough to encourage Adams in his plans. He followed with flavored gums, beginning with sarsaparilla and, in 1884, a licorice gum called **(B) Adams' Black Jack chewing gum,** the oldest flavored chewing gum on the market. **(C) Adams' Pepsin Tutti-Frutti chewing gum** came out in 1890. The Adams gums eventually became part of the American Chicle Company; today they are made by the Warner Lambert Pharmaceutical Company.

Frank Henry Fleer added chewing gum to the line of his family's flavoring business in 1885, and through inventive experimentation built it into the company's major product. He came up with candy-coated gum pellets called **(D) Chiclets** in 1899, and then began work on a gum elastic enough to blow into bubbles. His first bubble gum, called Blibber-Blubber, was not a success. An expert chewer could blow bubbles with it, but when they burst it took solvents and hard scrubbing to get the stuff off the face. Not until 1928 did the company find the perfect formula in **(E) Dubble Bubble gum.** Fleer sold the Chiclets business in 1909; they are now made by Warner Lambert, but Dubble Bubble is still made at the Fleer plant in Philadelphia.

(F) Eight Hour Union gum, Indianapolis Warehouse Company, Indianapolis, Indiana
(G) Bazooka bubble gum, Topps Chewing Gum, Inc., Brooklyn, New York. First made in 1938.

(D) 1904

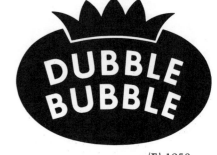

(E) 1958

(F) 1907

(G) 1947

(A,B,C,D) Wrigley's chewing gum came to us from the irrepressible and quick-thinking business mind of William Wrigley Jr. When he was eleven, Wrigley ran away to New York and supported himself for three months selling newspapers and doing odd jobs. At thirteen he began to work as a soap salesman for his father's business in Philadelphia. At twenty-nine he started his own business in Chicago—with a wife and child and $32 in cash.

Wrigley had great faith in premiums, and from the start he used them to boost his sales. He also paid close attention to his customers. When he noticed that a baking soda premium sold a lot of his soap, he switched to selling baking soda. And when a chewing gum premium moved his baking soda especially well, he shifted into the gum business. His first gum flavors, in 1892, were Lotta Gum and Vassar, followed the next year by Juicy Fruit and Wrigley's Spearmint. Doublemint gum, introduced in 1914, is now the company's bestselling flavor. Wrigley began using a spear-bodied elf character to promote his chewing gum sometime before World War I; eventually he matured into the cheerful Wrigley gum boy of the 1960s.

(E,F) Campfire marshmallows, Imperial Candy Company, Milwaukee, Wisconsin. Imperial brought out Campfire marshmallows in 1917, then sold the business to the Cracker Jack Company, which in turn was bought by Borden in 1963. The Campy character was first used in 1961.

Warshaw Collection, Smithsonian Institution

(A) about 1915

Warshaw Collection, Smithsonian Institution

(B) about 1915

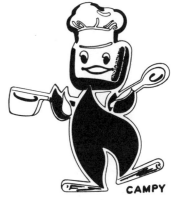

CAMPY

(F) 1961

(C) about 1915 (D) 1965

Redel's *Campfire* WHITE MARSHMALLOWS

"Toast them if you like"

NET WEIGHT 8 OZ.

(E) 1917

147

(A) 1887

Fruit and Vegetables

In 1877 William Wolfskill, a bold California orange grower, loaded an entire railroad car with oranges and shipped them across the country to St. Louis. The crates, branded Wolfskill California Oranges, arrived in Missouri a month later, the first large rail shipment of California oranges. Presumably, they were still fresh enough to sell.

The Southern Pacific and Santa Fe routes south to Los Angeles, completed in 1883, opened an even more abundant citrus region to Eastern markets. The railroads provided an outlet for the ever-growing surplus of California fruit and at the same time brought new farmers to the area—the Southern Pacific offered a one-way ride to California for a dollar through the 1880s.

With the expansion into a distant market, California growers discovered that they needed a means of identifying their produce to buyers and distinguishing it from their competition's.

William Wolfskill had burned his name onto the crates he shipped to St. Louis, but the printed label soon took over as a more colorful and dramatic method of marking. During the 1880s San Francisco printers moved into the huge new business of printing fruit-crate labels, largely by high-quality stone lithography, and often in dazzling palettes of ten and fifteen colors. (Modern color printing is generally done in four colors.) The labels showed beautiful women, sunny California scenes, and plenty of colorful oranges and lemons. The **(A) Porter Bros.** label emphasized the speedy method of transporting produce across the country by rail, though even in 1887 the trip was long enough that the firm sold only green and dried fruits.

The spread of new citrus orchards through southern California in the 1880s led to market gluts and lower prices for growers. In response, the growers began to organize into unions and cooperatives to limit self-defeating competition and to pool resources for more effective marketing. The Southern California Fruit Exchange, organized in Los Angeles in 1893, became the largest and most powerful of these cooperatives. In 1908 it adopted the **(B) Sunkist** name as a mark for its members' premium fruit and began its first advertising campaign. To make the name known to consumers, the exchange wrapped each of its oranges and lemons in printed tissue. The exchange changed its name to Sunkist Growers, Inc., in 1954, and today includes growers from both California and Arizona.

(C) Trublu fresh citrus fruits, William G. Roe, Winter Haven, Florida

(B) 1908

(C) 1923

The California Associated Raisin Company, a growers' cooperative founded in 1912, adopted the name **(A) Sun-Maid** for its raisins in 1915. The association had a booth that year at the Panama-Pacific International Exposition in San Francisco, for which it hired a number of young women as Sun-Maid representatives. Their uniform was a white skirt and blouse, with a thin kerchief and a red bonnet. Lorraine Collett, an eighteen-year-old from Fresno, was assigned the job of passing out free samples. In the mornings she walked around the fairground handing out boxes of raisins; in the afternoons she went up in an airplane and sprinkled raisins on the crowds below. Part way through the fair, she was also asked to pose for the picture on a new Sun-Maid raisin package. The modeling got her out of her morning footwork for a couple of weeks, but ended each day in time for the afternoon raisin flights.

Lorraine Collett Petersen kept her red bonnet folded in a drawer until 1976, when she presented it to the company, now called Sun-Diamond Growers of California. Her picture on the raisin box led to other modeling jobs, and even to a small part in the movie, *Trail of the Lonesome Pine.* Sun-Maid has modernized the trademark several times over the years, but has carefully held to the same basic design.

The Northwest Fruit Exchange started in 1910 as an organization of apple growers in Washington, Oregon, and Idaho. Three years later, the exchange sponsored a contest to come up with a trade name for its premium apples. Mrs. M.W. Stark, of Peshastin, Washington, submitted the winning entry: **(B) Skookum**, the Chinook word for *good* or *extra nice*. A Boston artist named Jack Sears drew the cartoon Indian head in 1914. Skookum is still the leading name in Washington apples, and the Skookum Indian still beams from the labels.

Lorraine Collett Petersen in 1982

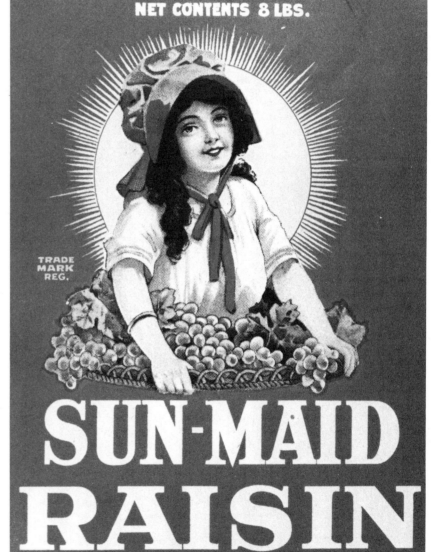

NET CONTENTS 8 LBS.

TRADE MARK REG.

SUN-MAID RAISIN

(A) 1922

Skookum

(B) 1966

149

(A) 1943

(B) 1943

Many of the early fruit labels and trademark designs were created to appeal to the consumer, the housewife who shopped for the family's groceries. But a 1918 study by the California Fruit Growers Exchange showed that less than one percent of the country's shoppers could remember the name of a single orange brand. Labels since the 1920s have aimed themselves at the jobbers who purchased fruit in bulk at East Coast auctions. The F.H. Hogue Company, of Yuma, Arizona, with its **(A) Foot High, (B) Blushing,** and **(C) Buxom** vegetable brands, clearly targeted the male wholesalers as its direct market. In the 1930s and '40s label designers also turned to dramatic and boldly legible lettering that could be read from across an auction room. The lettering of the **(E) Star Dust** fruit label (Exeter Orchards Association, Inc., Exeter, California) is the central element in the design.

(D) Ventura Maid fresh citrus fruit, Ventura Pacific Co., Montalvo, California
(F) Golden Boy fresh citrus fruit, Waddell and Son, Lindsay, California
(G) Andy Boy fresh vegetables. D'Arrigo Bros. Co., San Jose, California
(H) Farm Hand fresh tomatoes, Self & Jancik, Pharr, Texas

(D) 1941

(C) 1943

GOLDEN BOY

(F) 1945

ANDY BOY BRAND

PRODUCE U.S.A.

REG. U.S. PAT. OFF.

(G) 1954

STARDUST

(E) 1943

FARM HAND

(H) 1944

(A) Chiquita Banana is a war baby, invented in 1944 as a personal face for the consumer end of the multinational United Fruit Company. She might have disappeared into the crowd as just another pretty banana if it hadn't been for her hit song, written that same year by Garth Montgomery and Len Mackenzie. By the end of the war Chiquita's song was a genuine hit, sung by Xavier Cugat, the King Sisters, Charlie McCarthy, and Carmen Miranda. It was played by dance bands, jukeboxes, and radio disc jockeys as a popular song, in addition to the commercial airings paid for by United Fruit. Chiquita Banana had come to stay.

The United Fruit Company was pleased with Chiquita's new fame, but had no way of directly benefiting from her popularity. Shoppers in a grocery store had no way of telling which bananas were Chiquita's and which another brand, as the fruit was generally removed from the labeled boxes for display. The solution was a sticker, applied to each bunch of bananas beginning in 1947. Billions of the ubiquitous blue and yellow labels are stuck on bananas each year, making Chiquita not only the best-dressed but the most reproduced banana in the world.

(B) Harry and David, the Fruit-of-the-Month Club men, were brothers, and their last name was Holmes. They were born a year apart in 1890 and 1891, studied agriculture together at Cornell, and in 1914 took charge of a pear orchard bought by their father in Medford, Oregon. Their main produce was a giant DuComice pear, which the brothers sold to fancy restaurants in New York and Europe. Through the 1920s their business thrived, but in the Depression the market for expensive pears all but disappeared. Desperate for an outlet for their fruit, the brothers decided to try selling gift boxes by mail.

At the suggestion of G. Lynn Sumner, a New York advertising man, they prepared fifteen sample packages and sent them by messenger to a some of the most powerful corporate leaders in New York City. The response was tremendous. Walter Chrysler called within the hour, and orders followed from Owen D. Young, David Sarnoff, George Washington Hill, Alfred P. Sloan, and others. The fifteen-box sampling brought orders for a total of 467 gift boxes.

Harry and David sold six thousand gift boxes that first year, fifteen thousand the next, and in 1937 introduced the Fruit-of-the-Month Club, a mainstay of the business ever since. Though the brothers are both dead (David died in 1950, Harry in 1959), their grins and plaid shirts grace the front of some 80 million catalogues and brochures mailed each year.

(C) Sun-Rapt fresh citrus fruits, LoBue Bros., Lindsay, California

(C) 1946

(A) 1947

(B) 1959

Bread

(B) 1942

Brand names came to the bread business in the first few years of this century, close on the heels of Nabisco's successful Uneeda biscuits. In 1904 Butter Nut Boy bread appeared, and a number of bakers made licensing arrangements to use the popular Buster Brown and Mary Jane as brand marks. (See page 196 for a discussion of Buster Brown.) But most of the early branded breads were frustrated in their growth by the fact that they were generally sold unwrapped, and the brand images received their only reinforcement from stickers fixed directly on the loaves. Not until 1913, when an automatic bread-wrapping machine was invented, did brand names begin to become an important factor in bread sales.

Soon after the wrapping machine became available, the Taggart Baking Company of Indianapolis introduced a wrapped one-pound loaf called Mary Maid. It sold so well that the bakery decided to add a one-and-a-half-pound loaf in 1920. Elmer Cline was given the job of working out a new name and package. That summer Indianapolis hosted a huge balloon race, and as Cline watched the scores of balloons float through the sky on the evening of the race, the word *wonder* came into his mind. It struck him as a fine name for Taggart's new jumbo loaf. The spectacle of the sky filled with colorful balloons gave him the idea for the polka-dotted **(A) Wonder bread** package. Wonder bread remained an Indianapolis bread brand until 1925, when the huge Continental Baking Company purchased Taggart and adopted the name as a national brand. In the 1950s Wonder bread began building strong bodies eight ways, with the addition of vitamins and minerals to the batter. The count is now up to twelve, and may yet go higher.

The Quality Bakers of America Cooperative was founded by a group of wholesale bakers in 1922 as a means of confronting the competition offered by baking giants such as Continental. **(B) Miss Sunbeam,** the cooperative's trademark, was created in 1942 by New York City artist Ellen Segner. The ringlet-topped little girl appears today on bread from eighty-seven independent wholesale bakers.

Margaret Rudkin began baking **(C) Pepperidge Farm bread** in her Connecticut kitchen to provide a healthy whole-grain bread for her children in 1937. When she brought a sample loaf to her doctor he immediately ordered more for himself and his patients. From that start she began a mail-order business to other doctors and their patients, which eventually led to grocery store sales, and a staff of bakers and salespeople. By 1940 Pepperidge Farm bread was selling at a rate of twenty thousand loaves a week, and Rudkin had to move the business from her farm outbuildings and into a modern plant in Norwalk. The bread, cracker, and cookie business now keeps several plants around the country busy.

(C) 1970

(A) 1931

153

Restaurants and Hotels

Franchises have played an important role in American business for more than a century—the licensed dealers of Singer sewing machines and Ford automobiles provided both capital and motivated salesmen to their supplying manufacturers. But the franchise system has reached its zenith in the field of fast-food restaurants. The explosive spread of fast-food restaurants—from 3,500 in 1945 to 440,000 in 1975—has been almost entirely fueled by the pairing of astute licensers with ambitious buyers of franchised outlets. And the success of the franchises has depended on the careful building of strong and positive brand identifications.

Howard Dearing Johnson bought a Quincy, Massachusetts, drugstore in 1925 with a borrowed $500. Like many drugstores of that era Johnson's had a soda fountain, and he soon found that his heart was in that end of the business. He began to make his own ice cream, using a hand-cranked freezer in the basement of the store. Then he added real food to the menu—hot dogs, hamburgers, and other easy-to-cook fare. Within a short time, he'd turned the drugstore into the first **(A,B) Howard Johnson's** restaurant.

Johnson opened another restaurant in 1929 and made plans to expand even further. But the stock market crash shut off his sources of credit, forcing him to rethink his strategy. His solution was franchising. He convinced another businessman to open a Howard Johnson's restaurant on Cape Cod. Johnson received a fee for the use of the name and a contract to supply the franchise with food and supplies, while the new owner got a business with an established reputation. By 1935, despite the Depression, the Howard Johnson's chain had grown to twenty-five restaurants, and five years later to more than one hundred, stretching from New England to Florida. The first Howard Johnson's turnpike restaurant opened in 1940, on the Pennsylvania Turnpike.

Joseph Alcott, a freelance designer, created the Simple Simon symbol for Howard Johnson's in the early 1930s. At first, it was displayed in the form of paintings inside the restaurants. The design has become better known as a sillhouette on menus, weathervanes, neon signs, and packages of candy and ice cream. Alcott also suggested the orange and turquoise color scheme that has become the hallmark of the Howard Johnson's chain.

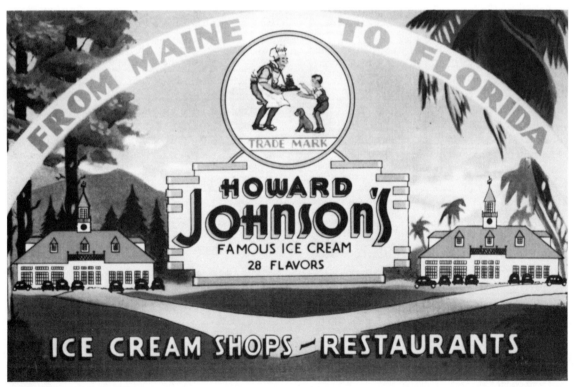

(A) 1940 souvenir postcard

(B) 1949

The first **(A) White Castle** restaurant opened in Wichita, Kansas, in 1921. With five counter stools inside, it probably didn't seem much of a threat to the bigger establishments in Wichita, but that ten-by-fifteen-foot box embodied two revolutionary ideas: it used its architecture as a sign and trademark, and it specialized in hamburgers. White Castle hamburgers cost just five cents back then (they held that price for many years), but the owners really meant it when they advised customers to "Buy 'em by the sack." Like the buildings, the burgers were on the small side. The sandwiches are a little bigger now, and so are the restaurants. The success of the White Castle concept can be measured by the wave of imitators that followed—from the White Tower chain that began in Milwaukee in 1926 to the dazzling array of golden arches, striped roofs, and blinking hamburger signs that now line our highways.

In 1936 Bob Wian bought an old diner on the main street of Glendale, California, for $300, money he raised by selling his car. He called it Bob's Pantry. About six months after taking over, he added a specialty double-deck cheeseburger to the menu, invented one night when some members of an orchestra came in and asked for something new and different. According to company legend, the name **(B) Big Boy** came to Wian several weeks later, when a rotund little boy walked into the store wearing oversized pants hung loosely from suspenders. Wian immediately saw the child as the embodiment of his double-deck hamburger, and the name Bob's Big Boy flashed before his eyes.

Wian sold the first Big Boy franchise to the Elias brothers in 1952, giving them the right to open Big Boy restaurants under their own name in the state of Michigan. There are now more than eight hundred Big Boy restaurants in the United States, Canada, and Japan, operating under such names as JB's Big Boy, Marc's Big Boy, and Frisch's Big Boy.

(C) Pig 'N Whistle restaurants, Los Angeles, California

(D) Little Tavern Shops, Inc., Washington, D.C. and Baltimore, Maryland

(A) 1947

(C) advertising postcard, about 1940

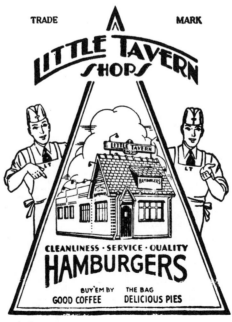

(D) 1949

(B) 1970

155

The first **McDonald's** restaurant was opened in Pasadena, California, in 1937 by two brothers, Maurice and Richard McDonald. It sold hamburgers but otherwise bore little relation to the McDonald's we know today. In 1939 they opened a second stand in San Bernadino, and it was here that they gradually worked out the details and added the flourishes that would make the chain an international institution. By streamlining the kitchen operation, putting infra-red lamps over a food-holding area, and selling everything on a self-service basis, they were able to offer fast, cheap food. And by making the building a standing advertisement, with two neon-lit, yellow arches sticking through the roof, they pulled in a constant stream of customers. (An even taller arch soared over the parking lot, with a hamburger-headed man named Speedy perched up top. He was retired in 1962.)

Ray Kroc was a fifty-two-year-old milkshake-mixer salesman when he came to San Bernadino to find out why the McDonald brothers needed eight of his machines. He was amazed at what he saw, and after two days of watching, he approached the brothers with an offer to sell their concept as a franchise. That was in 1954. By 1961 Kroc had licensed more than two hundred McDonald's restaurants, and that year he bought the brothers out for $2.7 million. By the time of his death, in 1984, Kroc had expanded the chain to almost eight thousand outlets worldwide, and had made the golden arches an internationally recognized symbol of American enterprise.

Ray Kroc's first McDonald's restaurant in Des Plains, Illinois, opened in June 1955

McDonald's Corporation

(A,B) Kentucky Fried Chicken got its start at the Sanders Court & Cafe, a motel-restaurant combination in Corbin, Kentucky. Harland Sanders ran the place, which he'd opened in 1932 at the age of forty-two. Sometime in his first few years in business, Sanders received the honorary title of colonel from the governor of Kentucky. He thus joined a massive army of inactive Kentucky colonels, whose number has included Fred Astaire, Bing Crosby, Jack Dempsey, Walter Cronkite, and Shirley Temple. (When Governor Albert "Happy" Chandler tried to thin the ranks, the colonels came their closest to becoming a real army.) Sanders was known as Colonel Sanders for the rest of his finger-licking career.

In 1939 Colonel Sanders discovered a method of frying chicken in a pressure cooker. Seventeen years later, when a new highway reduced Corbin to a scenic detour, he sold the restaurant at auction and set out to sell franchises, staking his hopes on the fried-chicken recipe. He was sixty-six years old when he took up the crusade for Kentucky Fried Chicken, and had adopted the dress of the traditional Kentucky colonel—a stereotyped character long used as a trademark for whiskey, coal, and tobacco. As he traveled the country giving his pitch, Colonel Sanders became his own trademark, the walking, talking symbol of his restaurants. When he sold out in 1964—after single-handedly building the chain to six hundred restaurants—his successors kept him on the payroll as their greatest promotional asset. Colonel Sanders died in 1980, at the age of ninety, but his face lives on as the registered trademark of the Kentucky Fried Chicken Corporation.

(C) Colonel Glen whiskey, Glenmore Distilleries Company, Louisville and Owensboro, Kentucky

(D) Southern Colonel coal, Great Lakes Coal & Dock Co., St. Paul, Minnesota

(E) Old Kentucky Colonel whiskey, American Medicinal Spirits Company, Louisville, Kentucky

(F) Kentucky Colonel smoking tobacco, Smith & Scott Tobacco Co., Paducah, Kentucky

COLONEL GLEN

(C) 1935

(D) 1940

Old Kentucky Colonel

(E) 1933

(F) 1920

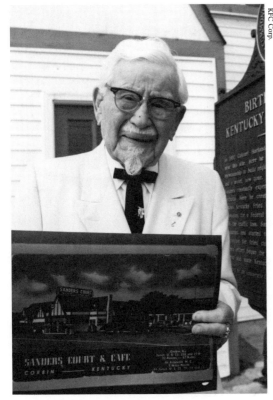

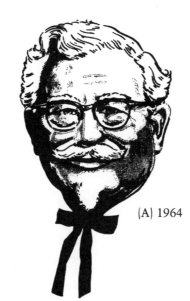

(A) 1964

Colonel Harland Sanders with a picture of the original Sanders Court & Cafe

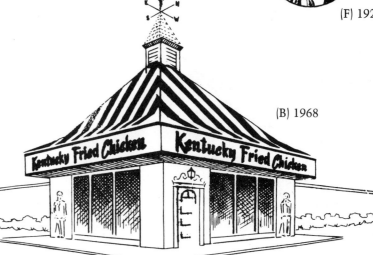

(B) 1968

James McLamore and David Edgerton opened a restaurant called Insta/Burger King in Miami in 1954, under an agreement with a franchiser in Jacksonville. They lost money for the first couple of years, then broke free of the license agreement by inventing an original chain broiler. They began to franchise their own **(A,B) Burger King restaurants** in 1956, gradually building the chain nationwide. The cartoon king-on-a-burger served as the firm's trademark until 1967, when Pillsbury bought control and replaced it with the modern word-burger design. Under Pillsbury's guidance, the Burger King chain has grown from 274 restaurants in 1967 to nearly 4,000 in 1984.

The founder of **(C) Wendy's restaurants** had a red-haired, pigtailed daughter named Wendy. When he decided to enter the fast-service hamburger fray in 1969, he picked her name and face to lead the charge. The first Wendy's opened in Columbus, Ohio, in 1969. Maybe it was family pride that energized the expansion from that one store to a chain of 2,500 in just fifteen years. Wendy's has shown no timidity in confronting the big guys head on. A 1984 television commercial ridiculing the competition made Wendy's slogan, "Where's the beef?" a national one-liner.

The **(D) Arby's restaurant** business got its name from its founders, but in an odd sort of way. The name comes from the initials R.B., for Raffel Brothers. Forrest and Leroy Raffel started the business with a restaurant in Boardman, Ohio, in 1964, and it grew with a combination of company-owned and franchised outlets. They wanted to name the chain Big Tex, but found a restaurant in Akron of that name that wasn't willing to bend. The cowboy hat, stylized since its earliest appearance in 1964, suits Arby's just as nicely as it might have fit Big Tex.

The first **(E) Pizza Hut restaurant**, in Wichita, Kansas, looked like a little hut, with a steep, peaked roof. Founders Frank and Dan Carney, two brothers still in college at Wichita State University, encountered their first big obstacle in the choice of a name. They had a sign for the building, but it had space for only nine characters. Pizza had to be part of the name, so the second word could only have three letters. A family member came up with Pizza Hut, a name that matched the building. By the end of that year, 1958, the brothers were doing so well that they added a second Pizza Hut; the following year they began to sell franchises. The chain adopted the peaked red roof as a mark for all its outlets in 1969.

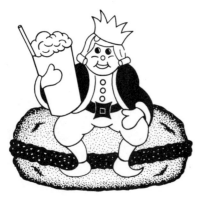

(A) 1960

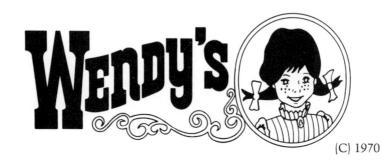

(C) 1970

(D) 1976

(B) 1969

(E) 1976

The specialty at **(A) Pig Stands**, as you might guess from their symbol, is a Pig Sandwich, made of barbecued young pig. Dr. R.W. Jackson opened the first Pig Stand in 1921 in Dallas and headed the Pig Stand Company until his death in 1955. There are now twelve restaurants in the chain, spread across the state of Texas.

Nathan and Ida Handwerker were slicing rolls for a living at Feltman's German Beer Gardens at Coney Island when they decided to go into the hot-dog business. Using Ida's recipe and Nathan's name, they opened their own Coney Island stand in 1916. Jimmie Durante and Eddie Cantor were among the early patrons (they were both singing waiters at Feltman's). With hard work, good luck, and a great location, **(B) Nathan's Famous hot dogs** have grown into a New York institution. - President Roosevelt grilled them at a lawn party for King George VI and Queen Elizabeth in 1939, and Nelson

Rockefeller, while governor of New York, declared, "No candidate can hope to carry New York State without being photographed eating a Nathan's hot dog."

(C) Chicken Delight restaurants, Chicken Delight International, Inc., Winnipeg, Manitoba. Originated in Rock Island, Illinois in 1951.
(D,E) Mister Donut restaurants, Mister Donut of America, Inc., Westwood, Massachusetts. 1964 version designed by Selame Design Associates.
(F,G) Dunkin' Donuts restaurants, Dunkin' Donuts, Inc., Randolph, Massachusetts. Begun in 1950 in Quincy, Massachusetts.

(A) 1969

(C) 1952

(D) 1946

(E) 1964

(B) 1955

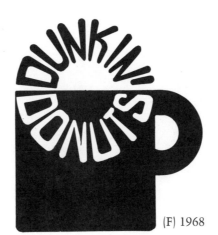

(F) 1968

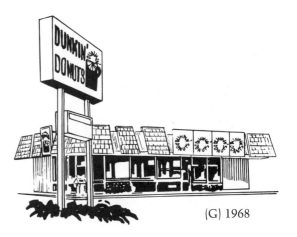

(G) 1968

The people at **(A,B) Holiday Inns** used to call their huge, light-encrusted sign the "Great Sign." Now they call it the "old sign," and its glossy, backlit replacement is known as the "new sign." The Balton Sign Company of Memphis designed the Great Sign in 1952, as the first hotel in the chain was under construction, even before a name had been chosen. As a final touch, Balton's draftsman penciled in "Holiday Inn" on the design sketch. Founder Kemmons Wilson liked both the sign and the name, and before the year was out the first of the signs was flashing its gigantic yellow star and arrow in front of the first Holiday Inn.

The Great Sign brought a touch of Las Vegas to highway landscapes across the country. It towered forty-three feet above the road and at night sparkled with 836 feet of neon tubing and 426 incandescent bulbs in a blinking color mix of green, yellow, orange, pink, blue, red, and white. It was impossible to miss and hard to drive by, but sadly, it eventually became too much. Each Great Sign drained electricity at a rate of $3,700 a year and cost another $2,400 for bulb changes and repainting. Add to that the $35,000 construction bill, and the sign was doomed. The new sign, designed in 1981, is cheaper, shinier, and simpler, but somehow just not as exciting.

(C) Best Western International, Phoenix, Arizona. An affiliation of independent hotels and motels, begun in 1946.
(D) Sleepy Bear, symbol of Travelodge motels, Travelodge Corporation, El Cajon, California. First used in 1954.

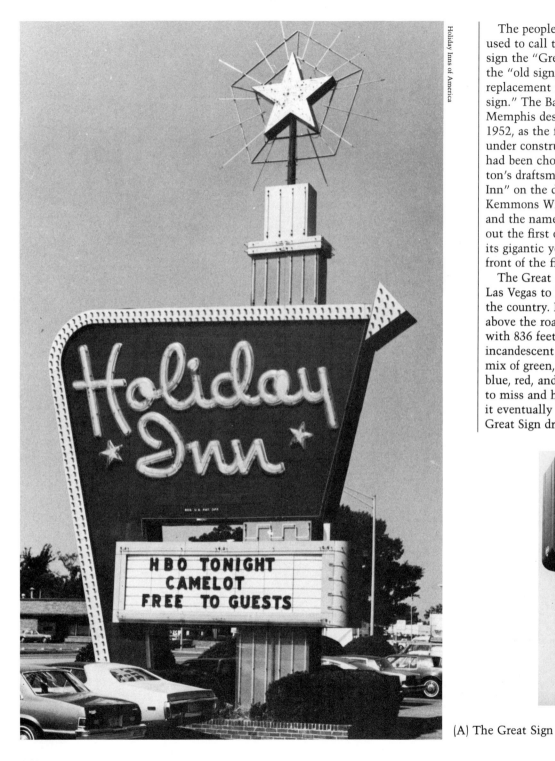

(A) The Great Sign

(C) 1976

(D) 1967

(B) The new sign

Machinery and Electronics

(A) Isaac Merritt Singer didn't invent the sewing machine; he just added some improvements. But his name has attached itself to the device as closely as Edison's has to the electric lightbulb. Bathelemy Thimmonier made a working sewing machine in France in 1829. He built eighty of them and set up a factory to sew uniforms for the French Army. But an angry riot of tailors broke into the plant and destroyed them all, ending work on the machine in France for many years. Several other inventors abandoned their designs for sewing machines because of the economic harm they might bring to tailors and seamstresses.

Elias Howe Jr. built a sewing machine in Boston in 1845 and pitted it in a race against five seamstresses to prove its worth. His machine won, and he was granted an important patent on the device the next year. Isaac Merrit Singer, an inventor and actor, saw some sewing machines at work in a Boston factory in 1850 and determined to make something that would not break down so often. After eleven days of concentrated tinkering, he came up with a machine that could run continuously, using a straight needle moved up and down through the cloth.

A patent battle between Howe, Singer, and several other inventors led,

in 1856, to the Sewing Machine Combination, America's first patent pool and a pioneer in the concept of franchising. The Sewing Machine Combination sold licenses to manufacturers for a single franchise fee, which was divided among the patent holders. Singer's company rapidly gained the lead among manufacturers when it introduced a Hire-Purchase Plan that allowed buyers to take the machine home for a $5 down payment—an early example of installment selling. Singer's marketing efforts in other countries made his machine one of the best-known brand names in the world by 1900. The S-and-seamstress trademark,

introduced in 1870, has, with small revisions, been the firm's primary trademark. In foreign versions the woman appears dressed in appropriate native garb. The mark at the woman's feet, a shuttle with crossed needles, is an earlier mark, adopted in 1865.

(B) Litofuge compound for steam boilers, Litofuge Manufacturing Company, New York, New York
(C) Waltham watches, American Waltham Watch Company, Waltham, Massachusetts
(D) Elgin watches, Elgin National Watch Company, Chicago, Illinois

(A) 1885

TRADE MARK (C) 1886

(B) 1886

(D) 1881

(A) 1889

(B) 1939

(C) 1969

Alexander Graham Bell spoke the first words over a telephone in 1876—"Mr, Watson, come here. I want you"—and formed the Bell Telephone Company the next year. **(A,B,C,D) The American Telephone & Telegraph Company** was founded in 1885 as a separate company to establish long-distance telephone service between cities, beginning with a line from New York to Philadelphia. Though Mr. Bell wasn't directly involved with A.T.&T., the company decided to draw on the goodwill associated with his name when they chose a symbol for their service. General Manager Angus Hibbard looked at some suggested designs, "crosses, triangles, circles, and other things," but they didn't seem right to him. As he remembered it, "I drew on my scribbling block of paper the outline of a bell and placed across it the words 'Long Distance telephone.' This looked good to me and I had our Drafting Department make a tracing and then a blueprint of the design and found we had before us the 'Blue Bell.'"

The ownership of the design has followed a complex course. A.T.&T., the creator of the bell symbol, took over the Bell company (American Bell Telephone Company) in 1899 and applied the trademark to what became known as the Bell System. In 1982 A.T.&T. divested itself of all the Bell subsidiaries, and they took with them the rights to the bell trademark. A.T.&T. adopted the globe trademark in its place.

Voorhees, Walker, Foley and Smith designed the 1939 version of the bell, and Saul Bass & Associates created the 1969 revision. Saul Bass/Herb Yager & Associates created the current A.T.&T. globe trademark.

(E) General Electric was formed in 1892 as a patent pool much like the Sewing Machine Combination, to bring together a number of complementary inventions controlled by competing interests. Thomas Edison invented the incandescent lightbulb in 1879; his Edison General Electric Company owned its patent along with many others. The rival Thompson-Houston

Company controlled the rights to the alternating-current transformer. With the combination, the General Electric Company was able to employ efficiently a range of key inventions that ushered in the electric age.

The circular GE monogram was designed in 1899 and registered that year as a trademark for all of General Electric's products. One story attributes its origin to a New York advertising man named A.L. Rich, who sketched it as a decoration for fan motors. Though widely told, the story has no evidence to back it up. General Electric has no record of ever working with Mr. Rich and can trace the design only to a sales-committee meeting of July 1, 1899, where it was decided to adopt the symbol as a general trademark. The symbol survives virtually unchanged, an effective mark that looks as good shrunk onto the tops of lighbulbs as it does covering the front of General Electric buildings.

(D) 1982

(E) 1899

(A) Nipper, the RCA dog, spent some time in the kennel during the abstract-logo years of the sixties and seventies. But a change in company management brought him back to the forefront in time for his one-hundredth birthday, in 1984. The original Nipper was born a lowly mutt in Bristol, England, and adopted by Francis Barraud, a landscape painter. Barraud owned an early phonograph, the type that played cylindrical records, and he was amused to see how Nipper put his ear to the horn whenever it was played. Sometime in the 1890s he made a painting of Nipper and the phonograph, which he titled *His Master's Voice*. Barraud tried to sell the painting to a London phonograph maker but found that they weren't interested. An artist friend suggested that he brighten up the picture by adding a brass horn in place of the black-painted one he had used, and told him he might be able to borrow such a horn from a small firm he knew called the Gramophone Company.

Barraud took his picture to the Gramophone Company with the idea of borrowing a brass horn and found a more enlightened bunch of art patrons. They not only lent him the horn but agreed to buy the painting—if he would also replace the phonograph with a gramophone that played flat records. In the original painting, the brush strokes

of the old record player can still be made out under the new paint.

Nipper died in 1895, but he has lived on in Barraud's painting as one of the best-loved commercial symbols on the market. He came to the United States in 1901 as the trademark of the Victor Talking Machine Company, makers of the Victrola record player, and in 1929

moved on to the Radio Corporation of America (RCA), when it purchased Victor. His life at RCA was complicated somewhat by competition from the circular **(B) RCA emblem**, adopted in 1923, but after years of struggle, Nipper seems to have won himself a secure spot in the company's marketing plans.

(B) 1948

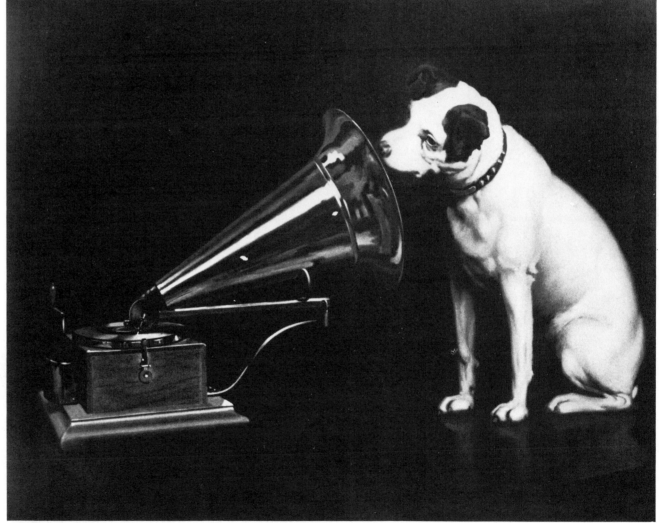

(A) about 1895

RCA

Thomas A Edison (A) 1900

(B) 1922

(C) 1957

(E) 1945

Ashton B. Collins, an official at the Alabama Power Company, dreamed up **(F) Reddy Kilowatt** in 1926 as a friendly character to personify the electric power industry. He's got a lightbulb for a nose, outlets for ears, two shocks of electric hair, and a lightning-bolt body. Collins licensed Reddy to power companies around the country for use in advertising and promotion. A competitor, Willie Wiredhand, was created for use by rural electric cooperatives in 1950. Reddy tried to zap Willie out of the market on a charge of trademark infringement, but the courts ruled in 1957 that the two would have to coexist.

(A) Edison records, phonographs, kinetoscopes, batteries, and X-ray apparatus, Thomas A. Edison, Orange, New Jersey
(B,C) Zenith radios, phonographs, and other electrical apparatus, Zenith Radio Corporation, Chicago, Illinois
(D) Nine Lives electric batteries, National Carbon Company, Inc., New York, New York
(E) Lewis-Shephard materials-handling machines, Lewis-Shephard Products, Inc., Watertown, Massachusetts
(G) Westinghouse Electric Corporation, Pittsburgh, Pennsylvania. Designed by Paul Rand and Eliot Noyes.

"NINE LIVES" (D) 1948

(F) 1943

(G)·1960

(A,B,C,D,E) **IBM** started out in 1911 as the Computing-Tabulating- Recording Company, a merger of three companies that made tabulating machines, computing scales, and time recorders. The name was changed to International Business Machines in 1924. As the name grew shorter through the years, arriving at the blunt IBM in the 1930s, the business grew at an impressive clip. The firm introduced the electric typewriter in 1935 and in 1936 won the contract to provide accounting machines and services to the Social Security Program. From accounting and calculating machines, IBM moved into computers, beginning with the ASCC (Automatic Sequence Controlled Calculator), built in 1944 in cooperation with Harvard University, and the SSEC (Selective Sequence Electronic Calculator) in 1948. The IBM 701, the company's first large vacuum tube computer, was completed in 1952. Nineteen of the massive machines were sold, primarily for government and research work. Since then, IBM has put out a steady stream of faster, smaller, and more powerful computers, as the company became a model of steady and dynamic growth.

Paul Rand was hired in 1956 to redesign the IBM logotype. He squared the holes in the *B* and made serifs on all three letters to match. In 1960 he attacked the letters again and came up with the digitized version. With minor modifications, it is still in use. The basic design has eight stripes, but a thirteen-striped variation is available for fancy work on stationery and business cards.

(F) **Texas Instruments** started out as a Dallas-based oil-exploration firm called Geophysical Service, Inc. In the 1940s it developed electronic devices to detect underground sources of oil and discovered that the equipment could also be used by the military to find submarines. After the war the company changed its name to General Instruments and concentrated its efforts on electronic manufacturing. But the Navy didn't like the name—it was too similar to that of another supplier. So, for lack of any better ideas, it was changed to Texas Instruments.

Texas Instruments got into the transistor business under license from Bell Labs in 1952. In 1954 its own research led to the discovery of a method for producing silicon transistors, the foundation of all subsequent solid-state computer technology. The firm adopted its map-of-Texas symbol in 1952.

(G) **Apple computers,** Apple Computer, Inc., Cupertino, California

(A) about 1924

(B) 1949

(C) 1956

(D) 1960

(E) 1970

(F) 1961

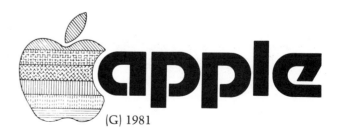

(G) 1981

(A) 1884

Hardware

The **(A) Samson Cordage Works** symbol, adopted in 1884, has the distinction of being the oldest active registered trademark in the United States. Many older trademarks were registered in the 1870s under the first U.S. trademark law (including the Underwood devil, the Fruit of the Loom symbol, and the John Deere deer). But in 1879, the Supreme Court ruled that law unconstitutional, and it was not until a new law came into effect in 1884 that registration provided trademarks with firm legal standing. The Samson mark was among the first filed under the revised statute.

James P. Tolman, of West Newton, Massachusetts, chose the Samson name and picture for his ropes in 1884 on the suggestion of his sister. He had invented an improved braiding machine that year, and his sister, who had traveled in Europe, thought that a painting of Samson would make a fitting symbol for his new ropes. According to family history, Tolman's wife and mother also helped with the design. Tolman incorporated his business as Samson Cordage Works in 1888, to match the name on the trademark. Today, as Samson Ocean Systems, the company makes high-strength ropes from synthetic fibers for markets that range from the space program to the fishing industry to us at home.

(B) Richard S. Reynolds started an aluminum rolling and converting business in Richmond, Virginia, in 1928, working from bar aluminum supplied by the Aluminum Company of America (Alcoa). In 1940 he decided to challenge the giant Alcoa and move into the business of refining aluminum. As a symbol for the crusading spirit of his growing venture, he chose a picture of Saint George battling the dragon. The idea apparently came both from a reading of Spenser's *Faerie Queene* and from Raphael's painting of the legend.

(C) Master locks, Master Lock Company, Milwaukee, Wisconsin

(D) W.C. Kelly flint edge axes, Kelly Axe Manufacturing Company, Alexandria, Indiana

(B) 1959

(C) 1925

(D) 1897

One summer morning in 1829, residents of Ware, Massachusetts, were greeted by a handbill that read, "Sam'l Colt will blow a raft sky-high on Ware Pond. July 4." **(A) Samuel Colt** was a fifteen-year-old schoolboy with an uncommon interest in explosives. Soon after that demonstration he ran away to sea. The story goes that while at the ship's wheel he conceived the idea of a gun with a revolving cylinder that could hold several charges to be fired through a single barrel. He filed his first patent application in 1832, and formed his first company, the Patent Arms Manufacturing Company, in 1836. By the time of the Civil War, Colt had become the premier name in pistols, and his Hartford, Connecticut, factory was one of the major arms suppliers to forces on both sides of the Mason-Dixon line. Colt died in 1862, nine years before the introduction of the famous Colt .45 caliber Peacemaker and Frontier revolvers, the traditional arms of the Old West.

(B) The United States Steel Corporation was launched in 1901 when a group led by J.P. Morgan purchased Andrew Carnegie's interest in the Carnegie Steel Company and combined that business with rail and mining operations into a fully integrated steel company. With capitalization of $1.4 billion, it was the largest business ever formed. The company adopted the initials USS for its logo in 1934; Lippincott & Margulies reworked them into the familiar circular symbol in 1960.

(C) Electric Brand hydraulic cement, Hiram Snyder, Brooklyn, New York
(D) Medusa cement, Sandusky Portland Cement Company, Sandusky, Ohio. Medusa is the figure from Greek mythology with hair of snakes whom no man could look at without being turned to stone.

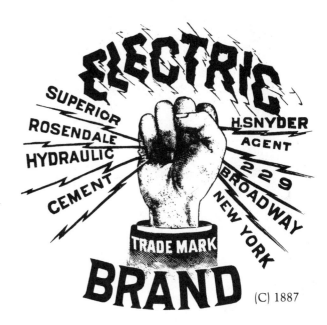

(C) 1887

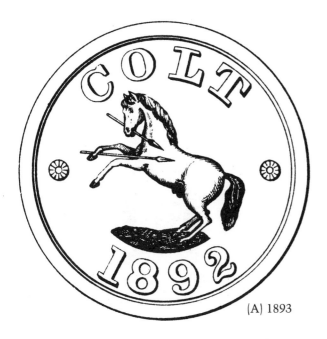

(A) 1893

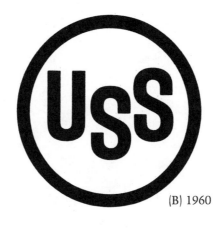

(B) 1960

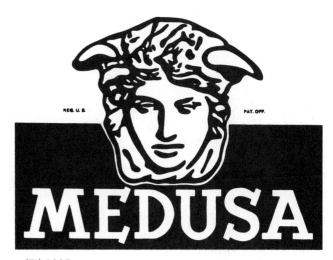

(D) 1905

167

Oil

1877

1882

The American petroleum industry got its start in the oil fields of western Pennsylvania just as the country was sliding into the Civil War. "Colonel" Edwin Drake drilled the first well in 1859, in the town of Titusville. Speculators and would-be oil men soon jammed the region, hoping for easy riches. Instead they got a lesson in the vagaries of a new commodity. A barrel of oil that sold for twenty dollars in 1859 fetched barely ten cents two years later—the phrase "the bottom fell out of the market" has its origin in the Pennsylvania oil fields.

As petroleum drove whale oil from the market, so did a small group of shrewd oil men, through their control of railroads, pipelines, and refineries, drive many independent drillers into bankruptcy in their struggle to stabilize prices. The towering figure among the refiner-strategists was a man named John D. Rockefeller.

In 1863, at the age of twenty-four, Rockefeller joined in a partnership to build an oil refinery in Cleveland. Two years later he bought a controlling interest in the business, and in 1870 he established the Standard Oil Company. With capital of $1 million—Rockefeller owned 27 percent—the company represented one tenth of the American oil industry. He would go much further. In 1882 he and his associates formed the Standard Oil Trust as a device to bypass state laws that prevented one corporation from holding shares in another. The trust formed a single organization from a group of refineries, pipelines, and marketing companies spread over many states. A change of law in New Jersey allowed a further realignment under several holding companies, the most important being Standard Oil (New Jersey).

The Standard Oil interests continued to grow, absorbing competitors as a steady diet until popular outrage against the monopoly caused the bubble to burst. On May 15, 1911, the Supreme Court ordered Standard Oil to divest itself of all subsidiaries.

The dissolution decree created a scattered group of companies with unbalanced holdings: some were left with refining plants, others with oil fields, pipelines, or strong marketing setups. Most clung to confusingly similar names. Standard Oil (New Jersey) now had to compete with Standard Oil of California, Standard Oil (Indiana), Standard Oil Company of New York, and Standard Oil (Ohio). The battle for the name turned out to be a big factor in the ensuing struggle for business.

Standard Oil (New Jersey) inherited the juiciest cut in the breakup, though it came out heavier in refining and financial assets than in production capability. It soon made up for the deficiency with the purchase of the oil-rich Humble Oil and Refining Company and with exploration overseas. For more than seventy years it has ranked as the largest oil company in the world.

In 1923 Standard Oil (New Jersey) adopted (**A,B**) **Esso** as its primary brand name—a none-too-inventive alliteration of S.O., the intials of Standard Oil. William O'Neill designed the long-standing oval version of the trademark in 1935. But because of conflicts with other Standard Oil trademarks, the company discovered that the Esso name was barred from use in much of the country. In fact, beginning in 1935, a succession of lawsuits whittled the territory down to eighteen Eastern states. The brand names Enco and Humble were used in the rest of the country. This surfeit of names not only confused the public but added expense to packaging and signage and turned national advertising into a major problem.

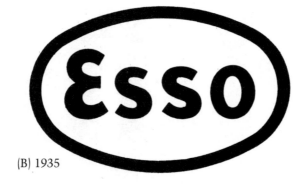

(A) 1926

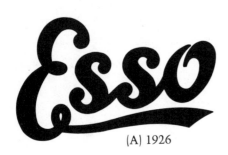

(B) 1935

(C) 1971

The company pondered an appropriate national name for years; in the end it took an outsider to do the job. In 1967 Raymond Loewy/William Snaith, Inc., took over the name hunt. The search team started with a computer printout of all possible four- and five-letter words, then narrowed that to 10,000 worthy of serious consideration. From that list, they chose 234 that seemed strong, distinctive, and easily pronounced; they narrowed these down to 16 names, and then to just 8. The final names were tested for problems in 56 languages and 113 local dialects. *Enco* was bumped when it was found to mean *stalled car* in Japanese. At one of the meetings to review this dwindling list, someone suggested **(C) Exxon.** It wasn't on the list, but what the heck, it sounded pretty good. The search team liked it, the president liked it, the board of directors liked it, and a consumer survey showed that buyers thought it was just fine.

Raymond Loewy/William Snaith, Inc., then went to work designing a logo and sign program, thoroughly testing the various possibilities. Finally, in the winter and spring of 1972–73, the big switch was made. Enco, Esso, and Humble gave way to Exxon at 25,000 service stations, 22,000 oil wells, 18,000 storage tanks and buildings, and on credit cards, sales slips, ID cards, uniforms, tank trucks, and ocean freighters. The cost of the change has been estimated at $100 million.

The **(D) Exxon tiger** was first used by Esso U.K. as a symbol of power in an advertising campaign that lasted from 1953 to 1957. A young Chicago advertising man, Emery Thomas Smyth, introduced the beast to the U.S. in a 1959 campaign for the Oklahoma Oil Company. He also came up with the slogan "Put a tiger in your tank." These early felines were of the wild, ferocious breed. The friendly cartoon tiger came from the advertising department at the Humble Oil & Refining Company in 1962. Ten years later, at the time of the Exxon name change, he was brought back to emphasize continuity, with the slogan "We're changing our name but not our stripes."

The Standard Oil Company of New York—once known as Socony from its cable address, and now as Mobil—came out of the Standard Oil breakup without production resources but with one of the best worldwide marketing operations. If oil companies can have personalities, it was the most educated, urbane, and outgoing of the Standard group. Its president, Henry Clay Folger, collected original editions of Shakespeare plays, and left them, with the Folger Shakespeare Library, for public use. The company also came through the breakup with the valuable **(E,F) Pegasus** trademark, which it had just adopted in April 1911. Jim Nash created the current version of the mark in 1933. In the 1950s and '60s the horse was nearly driven to extinction by overzealous modern designers. Peter Schladermundt convinced the company to play down the trademark in 1956. Eliot Noyes and Chermayeff & Geismar Associates later took up the attack, succeeding for a while in replacing one of the country's most popular trademarks with a lifeless, two-tone rendition of the word Mobil. Happily, Pegasus has returned to Mobil stations.

Standard Oil Company (Indiana) has used a torch symbol for identity since the 1920s, but for many years after the dissolution decree relied more heavily on the Standard name. Like Exxon, it eventually found the Standard trademark a barrier to growth outside of its established territory. Combination with the American Oil Company provided **(G) Amoco** as a second trade name, and a merged torch and Amoco oval began to appear on gas station signs in 1946. A more deliberate shift to the Amoco name was made in 1961 with the adoption of a comprehensive design program nationwide. Unlike Exxon's total switch, Standard kept the old name in the Midwestern states. Sandgren & Murtha revised the Amoco torch slightly in 1969 into the version now in use.

(G) 1969

(D) 1965

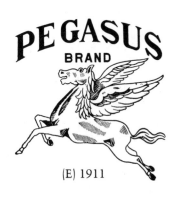

(E) 1911

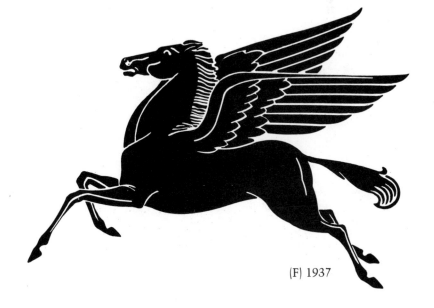

(F) 1937

The Ohio Oil Company was formed in 1887 by fourteen independent producers in northwest Ohio. It stood for a time in opposition to the Standard interests, but by 1911 it had become one of the many companies thrown out of the combination by the Supreme Court's decision. The company has retained a balance toward the production side of the business and has chalked up major discoveries in Illinois, Wyoming, Texas, California, Alaska, offshore Louisiana, and overseas. In 1930 it pur-chased the Transcontinental Oil Company, and with it the **(A) Marathon** trademark, in use since 1915. Renamed the Marathon Oil Company in 1962, the firm is now a subsidiary of U.S. Steel.

Standard Oil of California grew from an oil well in Pico Canyon, north of Los Angeles. To control competition, driller Frederick Taylor pooled other oil men into the Pacific Coast Oil Company in 1879, which in turn came into the Standard Oil fold in 1900. After the breakup, Standard Oil of California sold gas under the Socal brand within its territory, and adopted the names Calso and **(B) Chevron** for expansion into other states. It unified all its operations under the Chevron name in 1977.

Even before the 1911 breakup, some swaths had been cut through the Standard Oil monopoly. Texas passed an early antitrust law, and expelled the Standard interests from the state. Thus independent companies were the ones to profit from the country's next great oil strikes—beginning at Spindletop in 1901. Anthony Lucas used a rotary drill to find oil a thousand feet underground, financing his venture with money borrowed from T. Mellon & Sons of Pittsburgh. The Spindletop gusher marked the start of **(C) Gulf Oil**—named for the nearby Gulf of Mexico. Gulf found more oil near Tulsa in 1906 and opened the world's first drive-in gas station in Pittsburgh in 1913. The firm remained one of the giants in the oil business until 1984, when a takeover bid by T. Boone Pickens ended in a merger with Socal—the new combination renamed Chevron.

(D) Texaco also got its start at the Spindletop strike. Joseph Cullinan rushed to Texas when he heard the news, founded the Texas Fuel Company, and began buying cheap Texas oil to sell to the Standard interests in the East. In 1904, after Spindletop had dried up, the company discovered its own oil at nearby Sour Lake and became one of the nation's major producers. The Texaco star logo, of course, came from the Lone Star on the Texas state flag.

The Sun Oil Company, the firm behind **(E) Sunoco gas**, began in the Pennsylvania and Ohio oil fields as a competitor to Standard Oil. Founders J.N. Pew and E.O. Emerson started with natural gas, which at the time was not a part of the Standard strategy. They bought the largest natural gas well in Pennsylvania and in 1882 laid a pipe-line into the city of Pittsburgh. With money made on the sale of that venture, they invested in oil leases and pipelines in Ohio, founding the Sun Oil Company in 1890. From there the business moved into a Toledo refinery (1895), pipelines and shipping in Texas (1901), a refinery in New Jersey (1901), and oil discoveries in Oklahoma and Louisiana (1909). The company built the first Sunoco gasoline stations in 1920. Photographs show a forerunner of the familiar diamond-and-arrow sign planted squarely out front. The present yellow, blue, and red sign was introduced in 1954.

(A) 1946

(D) 1957

(B) 1945

(C) 1963

(E) 1961

(A) Shell Oil sprouted from a London curio shop that sold boxes decorated with shells in the 1820s. Marcus Samuel inherited this business, and with his brothers and cousins built it into a sizable importing and trading company. They stepped into the oil market in the 1890s, shipping Russian oil to the Far East in a direct challenge to the Standard monopoly. In 1901 Shell made a quick deal with Gulf to buy a large part of the oil found at Spindletop for shipment to Europe. Five years later Shell merged with Royal Dutch, a firm with huge reserves in the Far East, to form one of world's oil giants. The Shell symbol, used by the company since 1904, remains one of the most likable of the oil emblems.

(B,C) Harry F. Sinclair built one of the major independent oil companies in the tumultuous years of discovery and price fluctuation on the Kansas and Oklahoma oil fields. From a penniless start, he talked, borrowed, speculated, and drilled his way to the greatest fortune in Kansas by his thirtieth birthday, in 1907. Nine years later he founded the Sinclair Oil & Refining Corporation, worth an estimated $50 million. In 1929 he went to jail for his part in the Teapot Dome oil-lease controversy, but resumed his post at the company helm after serving a seven-month term.

Dino, the Sinclair dinosaur, grew out of a 1930 series of advertisements explaining the concept that the oldest crude oil makes the best lubricant. The first ads in the campaign used any old dinosaurs—a triceratops here, a tyrannosaurus there—but the public, for some reason, really went for the brontosaurus, and from 1931 on that long-necked vegetarian had an exclusive contract with Sinclair.

The popularity of the dinosaur ads sent the Sinclair marketing department into a sort of dinosaur frenzy. They put the reptiles on their oil cans with the slogan "Mellowed a hundred million years." They built a dinosaur exhibit at the 1933 Century of Progress Exposition in Chicago, funded dinosaur exploration by New York's Museum of Natural History, and in 1935 began giving out dinosaur stamps and stamp albums at the gas pumps. This last promotional ploy—collectors had to buy gas every week to complete the set—turned a lot of parents into Sinclair customers. Over the years the company brought out inflatable Dino toys and many other dinosaur delights. In 1959 it finally gave in to public pressure and put Dino on the sign. He was not allowed to mellow there for long, however. The business merged with the Atlantic Refining Company (an old Standard castoff) and Richfield, to become Atlantic Richfield in 1973. Dino's ancient oil is now sold at the Arco pumps.

(D,E,F) Phillips 66 got half of its name from brothers Frank and L.E. Phillips, who founded the company in 1917, but the 66 came virtually out of a hat when the company planned its first gas station ten years later. The new Phillips refinery had been built near Borger, Texas, through which Route 66 passed; at the time the road was a heavily traveled cross-country highway. The gasoline that would be sold at the first station had a specific gravity in the range of 66. But it was a chance remark that swayed the decision makers. A Phillips official was out in a test car filled with the new gasoline. Impressed with the power of the fuel, he said to the driver, "This car goes like 60 on our new gas." "Sixty nothing," replied the driver, "we're doing 66!" The official mentioned the incident at a meeting the next day, and someone asked where the car had been at the time. "Near Tulsa on Highway 66," he recalled. The superstitious committee chose the name Phillips 66 in a unanimous vote.

(D) 1928

(E) 1932

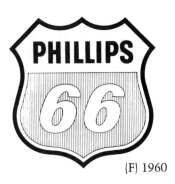

(F) 1960

(A) 1948

(B) 1931

(C) 1959

At the end of a hot day in the summer of 1895, bicyclists at Coney Island were surprised to find little green bottles of **(A) 3-in-One compound** tied to their handlebars. The bottles had been quietly attached to eight thousand bikes during the day in a promotional push for one the country's first brandname lubricants. George W. Cole invented the compound in 1894 for use on his own bicycle as a cleaning liquid, lubricant, and rust preventive. At first he packaged it in glass medicine bottles—that's what the folks at Coney Island got—but in 1914 it came out in a can with a spout. The company moved beyond the bicycle market quite early, and its advertising has suggested so many inventive uses for the oil (people have even tried it as a scalp treatment) that 3,000-in-One seems a better name.

Many lubricating oils have been popularized through victories on the racing circuit. The White & Bagley Company, of Worcester, Massachusetts, created **(B,C) Oilzum** in 1905 as an engine lubricant for automobiles. Race driver Fred Marriott put the oil in his Stanley Steamer and broke the world speed record in 1906, reaching a pace of 127 miles an hour at Ormond Beach, Florida. A new formula, Crystal Oilzum, was used by Barney Oldfield, Eddie Rickenbacker, and other racing stars. For a while it greased more Indianapolis 500 champions than any other oil. The Oilzum Kid, with his teeth and goggles, appeared with the oil in 1905.

He matured in 1910 into the handsome driver still on the cans.

Three businessmen in St. Joseph, Missouri, developed an oil additive in 1954, which they called **(D) STP** (Scientifically Treated Petroleum). Just as Oilzum had done years before, they concentrated their sales efforts on exposure through racing. No speed records or race victories fell to STP, but by word of mouth it grew into a profitable product. Studebaker bought the partners out in 1961, pushed STP even harder on the racing circuit, and finally brought home a winner when Mario Andretti captured the Indianapolis 500 in 1969. STP stickers decorated his car for the world to see.

(E) The Pep Boys, Manny, Moe & Jack, may look like cartoons but they were once real people. Maurice "Moe" Strauss, Emanuel "Manny" Rosenfeld, and W. Graham "Jack" Jackson opened an auto supply store in Philadelphia in 1921. They called the place Pep Boys for no good reason, then hired a local artist named Harry Moscowitz to draw their portraits. He turned out to be no Rembrandt, but the Pep Boys' smiling faces now shine from stores in seven states and the District of Columbia.

Burt Pierce invented **(F) Marvel Mystery oil** in the 1920s as an oil and gas additive. When asked what the secret of the formula was, he would reply, "It's a mystery." Hence the name. The red-and-black cans today look as mysterious as those of the 1920s, but apparently the contents still do the job. The oil is a favorite of mechanics as a remedy for stuck valves and other engine problems.

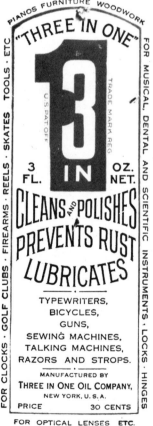

(A) 1905

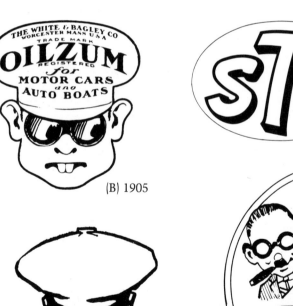

(B) 1905

(C) 1912

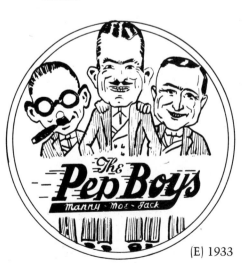

(E) 1933

STP

(D) 1966

(F) 1928

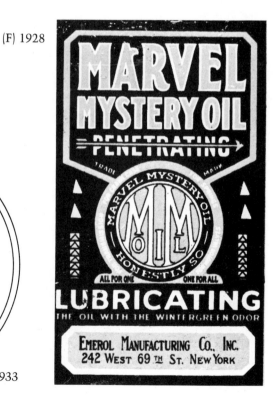

Transportation

American automobile pioneers lagged behind their European counterparts by a few years, but they more than made up the gap by quickly steering the industry toward cars built and priced for the mass market.

Charles and Frank Duryea built the first American automobile in Springfield, Massachusetts, in 1893, using their expertise as bicycle mechanics and a description of the German Benz car published by *Scientific American* in 1889. Others put together similar experimental vehicles over the next few years, including a man named Henry Ford. Ford built his first car in Detroit in 1896; he had to remove a wall of his landlord's barn to get it on the street. It is some measure of the man that he not only quieted the landlord's complaints about the barn but convinced him to help push the car.

Ford organized the **(A,B) Ford Motor Company** in 1903 with some capital from a Detroit coal dealer and a promise of stock to the Dodge brothers for their supply of chassis, engines, and transmissions. He managed to keep afloat by buying parts on credit and selling to dealers for cash.

The American car makers early distinguished themselves from the Euro-

peans by using the "American system" of interchangeable parts to economize and reach for the low-priced end of the market. Ransome E. Olds produced an inexpensive lightweight car—the Oldsmobile—as early as 1901. Henry Ford decided that the car for the masses would have to be more durable than the Oldsmobile. It should also be easy to operate and repair. His answer, in 1907, was the Model T—a tough, high-mounted car with a brilliantly simple 4-cylinder engine.

Having created the car, Ford and his engineers attacked the problem of making its production more efficient. After finding a number of obvious time economies, in 1913 they began to experiment with a moving assembly system, in which the machine moved past stationary workers who added the parts. Within a year the time required for chassis assembly had been cut from more than twelve hours to an hour and a half.

Between 1908 and 1916 the price of the Model T dropped from $850 to $360, while sales rocketed from 6,000 cars a year to nearly 600,000. By 1920 half the cars in the world were Model Ts, and a new one came off the assembly line every three minutes. Henry

Ford dazzled the public with his success; and, in 1914, when he doubled workers' wages to $5 a day, he became America's best hope for the future, the shining example of capitalism made good.

That is Henry Ford's signature on the Ford Motor Company logo (stylized and tidied up by chief engineer Childe Harold Wills). It first appeared on some Model C cars in 1904, on a brass plate at the base of the starting crank. The oval was added in 1912 for signs at Ford dealerships. It made its debut on Ford cars in 1928, when the Model A replaced the Model T as the standard model. The deep blue color of the symbol is significant. At Ford, that color is known as "Corporate Blue."

Some of the other famous names in American automobiles have more tangled histories. David D. Buick went into the automobile business in 1899, but his luck fell short of Henry Ford's. Buick left a plumbing-supply career for cars, and in three years lost his life savings. His valve-in-head engine was an important engineering advance, but he could not make the move from design to production. The **(C,D) Buick Motor Car Company** was bought by William C. Durant, a Flint, Michigan, carriage

maker. The scripty Buick trademark was registered in 1916, with the claim that it had been in use since 1904.

Durant's business savvy pulled the Buick to the front ranks of the auto field, at least for a while. In 1908 the Buick plant was the largest automobile factory in the world. That year, Durant used the solid Buick foundation to launch the General Motors Company, buying Cadillac, Oldsmobile, Oakland, and a number of small outfits. He even tried to buy Ford, but the two could not come to terms. His swift expansion plans collapsed just two years later when growing credit needs could not be met by sales income. A banking syndicate bailed the company out, but fired Durant and installed its own management team. Walter Chrysler, a railroad machinist from Ellis, Kansas, became Buick's works manager and eventually its president.

(C) 1915

(A) 1909

(B) 1928

(D) 1947

Durant jumped right back into the fray. In 1911 he formed a partnership with Louis Chevrolet, a Swiss racing driver who had worked as a mechanic for Buick. The **(A) Chevrolet Motor Car Company** came out with some winning models, notably a low-priced challenge to the Ford Model T, and in 1916 Durant managed to use the company's assets to regain control of General Motors. (Under the leadership of William Knudsen, Chevrolet created some very popular cars in the 1920s, establishing the long-standing Ford–Chevrolet rivalry in the American market. The Chevrolet cross dates from that later revival.)

Walter Chrysler was not happy with Durant's return to General Motors, so in 1920 he left to take charge of the ailing Maxwell Motor Car Company. He revived Maxwell in an odd way—by dissolving the company and reforming it as the **(B) Chrylser Corporation**. The Chrysler Six, its comeback car, was introduced in 1924. A medium-priced car with sophisticated styling and engineering, the Chrysler Six turned out to be a hit. The Plymouth and Desoto followed in 1928; and that year Chrysler bought Dodge Brothers and became the country's third largest automobile maker. Chrysler has held that spot ever since, despite some trying times in the mid-seventies. Lippincott & Margulies designed the Chrysler "pentastar" symbol in 1962.

General Motors introduced the **(C) Pontiac** Chief of the Sixes in 1926 as a competitor to the Chrysler Six. Like the Chrylser, the Pontiac was a high-styled, six-cylinder car with a competitive price; and like the Chrysler, it was a success with the public. The Indian-head symbol appeared as a medallion on the first model in 1926. It was changed to the profile version in 1928. General Motors would like us to believe that he is Chief Pontiac, the famous Indian leader who organized a powerful confederation of tribes two hundred years ago. In fact, the design's trademark registration in 1932 describes him as "a conventional Indian head, . . . not a likeness of any particular Indian." The name comes from the location of the plant, in Pontiac, Michigan. It may also pay some tribute to the Pontiac Buggy Company, which started things rolling for Pontiac back in 1893. That grandfather firm became the Oakland Motor Car Company, which, as a division of General Motors, made the first Pontiac cars. The Pontiac Motor Division replaced Oakland in 1932.

Six brothers started the **(D) Fisher Body Company** in 1908 to take advantage of the growing demand for carriage bodies by the automobile industry. The Fishers came from a carriage-making family, their father a carriage and wagon builder in Norwalk, Ohio, and their grandfather a carriage maker in Germany. The brothers brought an open mind to the building of automobile bodies; they knew that traditional carriage construction could not bear up under the stress of high-speed travel. Their blend of innovation and craftsmanship landed them an order from Cadillac for one hundred and fifty closed-car bodies in 1910—newsworthy at the time as the largest closed-car order ever placed. In 1919 the company became a part of General Motors. The Napoleonic coach trademark, adopted in 1922, was a tribute to the heritage of the fine coach craftsmen. For many years, the design was riveted to every car made by General Motors.

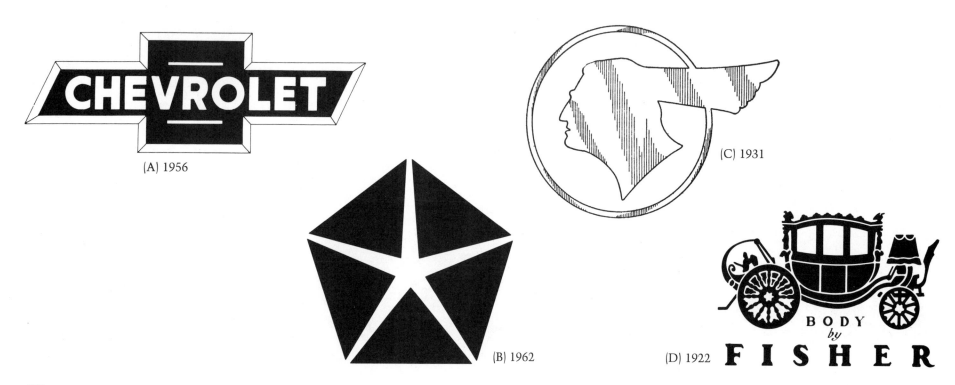

(A) 1956

(C) 1931

(B) 1962

(D) 1922

The five **(A) Mack** brothers also came from a wagon-making background. In 1900 they built their first motorized vehicle—a bus. It was the first bus ever made. In 1910 they brought out a hook-and-ladder fire truck, the first in America, and five years later introduced the AC Mack, the heavy-duty truck that cemented the Mack reputation as a truck builder.

Five thousand of the AC Macks went to war in Europe in 1917. The truck's brute strength and no-nonsense styling earned it the nickname "Bulldog" with the British troops. The name stuck. It seemed so appropriate to the men at Mack that they soon decided to apply it to their whole line of trucks. Their problem was to transfer the nickname in the public mind to some of the more conventional-looking models that began to replace the AC in 1927. Chief engineer A.F. Masury pondered the situation during a week-long hospital stay in 1932. While he thought, he whittled bars of soap. By week's end he had the answer in his hands: a bulldog figurehead to be attached to the radiator caps of all new trucks.

Masury's bulldogs, cast in metal, have peered from the hood of every Mack truck built since 1933. The biggest one stands guard outside the Mack headquarters in Allentown, Pennsylvania—and he stands without the Mack name beside him. The Federal Sign and Signal Corporation agreed that the bulldog was the only sign needed to identify the building.

(B) Great Dane trailers were first made in Greenville, South Carolina, in the 1920s. The dog's name was added in 1930. The owner had heard how great danes on European farms were used as work dogs to haul milk and other produce. The Steel Products Company of Savannah bought the business in 1931 and gradually expanded its market from Georgia and the Carolinas through the rest of the country. The Great Dane emblem first appeared on the trailers in 1935. He lost his spots around 1960, but otherwise looks about the same today as he did on the first trucks. Highway drivers see him most often on the white-and-black mud flaps hung behind the back wheels of Great Dane trailers.

(C) Cushman Cubs internal combustion engines, Cushman Motor Works, Lincoln, Nebraska (now Cushman-Ryan, a division of Outboard Marine Corporation)

(D) Bear wheel service and performance test equipment, Bear Automotive Service Equipment Company, Milwaukee, Wisconsin. First drawn in 1917 for the Bear Manufacturing Company, Rock Island, Illinois.

(E) Johnson outboard motors, Outboard Marine Corporation, Waukegan, Illinois, designed by Dave Chapman & Associates.

Mack Trucks, Inc.

(A) 1933

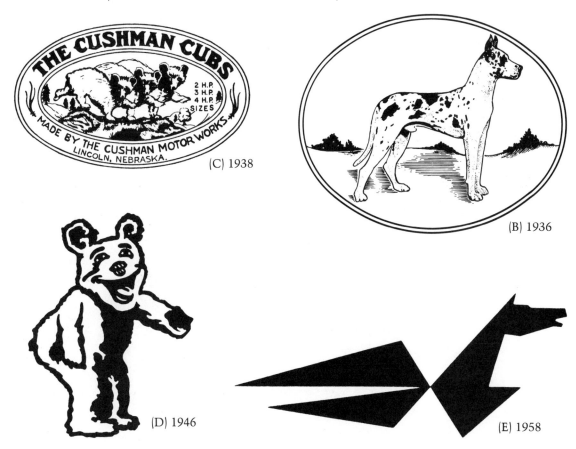

(C) 1938

(B) 1936

(D) 1946

(E) 1958

Charles Goodyear discovered the process of vulcanizing rubber in 1839, when he accidentally spilled a mixture of India rubber and sulfur onto a hot stove. Unfortunately, his invention came many years before important uses for the material could be found. Goodyear died penniless in 1860, and his business interests passed through a number of hands before becoming the property of the United States Rubber Company, now Uniroyal. His name, however, was appropriated by an Akron, Ohio, company that branched from breakfast cereal into rubber tires in 1898—becoming the Goodyear Tire & Rubber Company.

Frank A. Sieberling, at the age of thirty-eight, used the reserves of his father's business to take that amazing side trip. In casting about for an appropriate symbol for the venture, Sieberling fixed on a statue of Mercury perched on the newel post of his stairway at home. The winged foot of the Greek god seemed right for a company going into the tire business.

Sieberling quickly discovered that he had entered a field dominated by a few firms with an iron grip on key patents. Under a system of quotas handed out by the patent holders, Goodyear was allotted only 2 percent of the new market for automobile tires. He realized that he would need a manager with technical expertise in order to make even that meager allowance. He hired Paul W. Litchfield, an M.I.T.-trained engineer, for the role.

Litchfield designed the first Goodyear tire, formulated the rubber compound for it, and then set to work on improvements that might free the business from patent barriers. In 1905 he invented the "straight side" tire, a design that made tires easier to detach from the rim and less susceptible to damage from rim cutting when a car hit a bump. Three years later he came up with the first nonskid tread, made with a protruding diamond pattern. By 1910 Goodyear was making one-third of the tires for the U.S. automobile industry.

Litchfield developed a steel-reinforced rubber fabric for balloons and dirigibles in 1911, making the company the leader in American dirigible engineering and construction during World War I. After the war, the company forged ahead with a plan to promote commercial use of dirigibles. Goodyear began to build its own fleet in 1920 with the Pony Blimp, a nonrigid, helium-filled airship. The *Pilgrim*, shown here in a 1929 photograph, was an improvement on the original design.

Ultimately, the company hoped to establish commercial dirigible passenger service accross the Atlantic. But the loss of three airships to storms, and the destruction of the German *Hindenburg* in 1937, put an end to those dreams. The company's dirigible fleet served in World War II as an effective patrol against submarines. Four Goodyear blimps now serve the company as floating goodwill ambassadors—the *America*, the *Columbia*, the *Enterprise*, and the *Europa*. The airships carry television cameras at sporting events, and the programmed lights on their underbellies provide an unusual medium for nighttime advertising.

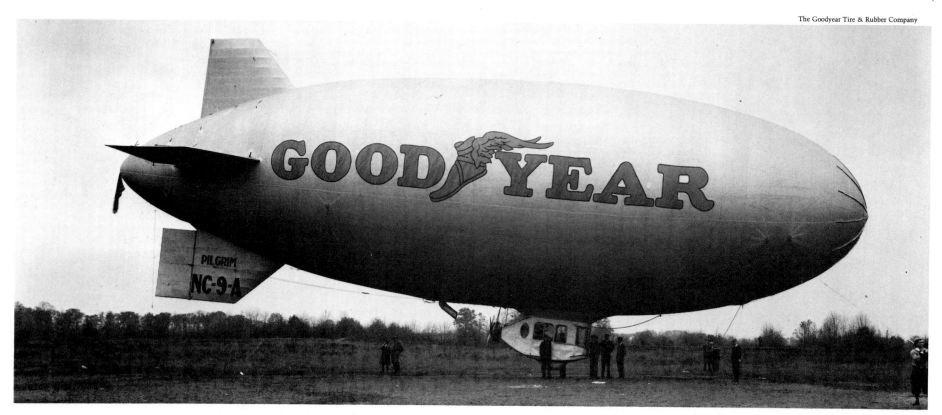

Burr E. Giffen was an eighteen-year-old advertising artist in 1907 when he had the idea one night for the **(A) Fisk Tire** boy. He got out of bed and made a rough sketch of the sleepy child with a candle in one hand and a tire in the other. And before he went back to sleep he jotted down a title, "Time to Re-tire." Giffen's boss and the people at Fisk liked the idea so much that they made it into a poster ad. Fisk revived the boy several years later in a wider ad campaign. He showed up in the *Satur-*

Time to Re-tire?
(A) 1914

day Evening Post in March 1914 and appeared as the primary Fisk symbol from that time onward. The United States Rubber Company bought Fisk in 1940, and the sleepy boy is now used as a trademark, on a limited scale, by Uniroyal, Inc.

The **(B) Greyhound Corporation** traces its roots to the mining regions of the Mesabi Range in northern Minnesota. Carl Eric Wickman and Andrew G. Anderson worked as drillers in the iron mines. In 1914 they found themselves with a Hupmobile agency and a single car that they could not sell. They began to run a ride service from the mine to the town of Alice, two miles away. That small idea grew, as Wickman and Anderson added more cars and drivers and started to drive further and further from Alice. And it spread through the competition their business attracted.

In 1921 Frank Fageol built an enclosed bus for intercity travel, which he operated from a base in Muskegon, Michigan. To identify his vehicles as part of the same line, he painted them all solid gray. According to legend, an innkeeper along one of the routes joked to a driver that the buses looked "just like greyhound dogs streaking by." Whatever the source of the nickname, by 1922 Fageol was advertising his bus line with the slogan "Ride the Greyhounds."

By 1925 more than 6,500 bus services plied their trade around the country. Most were small operations, and many provided inefficient service. Carl Wickman surveyed the situation and decided that the time was ripe for a larger organization. With financial backing from the Great Northern, Southern Pacific, Pennsylvania, and New York Central railroads, he began buying the smaller bus lines and forming an important single system. Frank Fageol's Greyhound system was one of the many absorbed into the new giant. Unlike the others, it did not lose its name to the larger firm. In 1930 Wickman's swelling operation became the Greyhound Corporation and it adopted the running dog as its trademark.

Citizens of Baltimore, Maryland, witnessed a historic event in the summer of 1830—a race between the first steam locomotive and a horse-drawn railroad car. The horse won.

The race was held along the tracks of the **(C,D) Baltimore & Ohio Rail Road**,

which at the time stretched just thirteen miles out of the city. The locomotive was the Tom Thumb, Peter Cooper's experimental engine. The Tom Thumb did drag some cars filled with dignitaries over the rails that summer, but horses did the railroad's work for another year.

The Baltimore & Ohio was one of the country's first ambitious rail projects. Begun in 1828, it aimed to connect Baltimore with the Ohio River, in order to make the city an important trading link to the Western states. The railroad reached the Ohio almost twenty-five years later, on Christmas Eve 1852. By then a number of Eastern cities had built competing lines west.

In later years, as the B.&O. spread its web of track, it found an important attraction in its connections to Washington, D.C. To identify itself more closely with that city, the railroad put the Capitol dome on its insignia in 1897.

(C) 1927

(D) 1963

(B) 1954

The **(A,B) Chesapeake and Ohio Railway** also links the Chesapeake Bay, at Washington, D.C., and Newport News, Virginia, with the Midwest. Its course through the coal regions of West Virginia has made it one of the great coal carriers. For a while the C.&O. offered direct competition to the B.&O., until the two roads were brought under the same corporate ownership. The Chessie Systems Railroads now controls them both.

The Chesapeake and Ohio might be just another railroad to us were it not for Chessie, the giant kitten who naps on the side of every boxcar, coalcar, and locomotive in the system. She's given the railroad a friendly, reassuring personality, an extraordinary thing for a coal-carrying freight line. The original artwork was done by Guido Gruenewald, an Austrian who specialized in etchings of cats. A copy on display in a New York City gallery caught the eye of Lionel C. Probert, a C.&O. executive who was planning an ad campaign to announce the line's new air-condi-tioned sleeping-car service. Here, he realized, was the perfect illustration for the ads.

The first Chessie ad ran in the September 1933 issue of *Fortune*, with the slogan "Sleep like a kitten." Readers responded with a flood of letters asking for copies of the print—Chessie had apparently touched a soft spot in the hearts of businessmen. The C.&O. advertising department saw that it had a hot item in the kitten and rapidly drew up a broader campaign. A 1934 Chessie calendar disappeared from sales offices faster than it could be produced. (The annual calendars have since become a sort of cult collectible. They picture real kittens, dressed in specially fitted railroad garb, at work on miniature trains.) Widespread advertising made Chessie a household pet even to those who never rode the C.&O. or sent freight over its rails.

The stylized Ches-C was created by Franklyn J. Carr in 1972 as a symbol for the Chessie System, which then included both the B.&O. and C.&O. rail-roads. The solid design was chosen for its versatility over the range of uses required for the symbol. It is particularly effective as a device painted huge on the side of train cars. The choice of the new symbol for the entire Chessie System marked a triumph for the kitten, but it also spelled the finish of the B.&O. Capitol dome.

President Abraham Lincoln signed the **(C) Union Pacific Railroad** to life in 1862. The line was named as one-half of a project to connect the Atlantic and Pacific coasts by rail. While the Central Pacific Railway built east from California, the Union Pacific built west from Omaha, Nebraska. Both railroads recieved government subsidies based on the mileage of their track. When they could not agree on a meeting point, they continued to build past each other in parallel lines. Congress ordered a compromise, deciding for the railroads that the historic meeting would take place at Promontory, Utah. On April 10, 1869, amid a crowd of about five hundred Chinese and Irish workers, locomotives pulled up from the east and the west for the formal tapping in of the golden spike. Much to the delight of the experienced onlookers, company officials from both sides missed the spike with their first swings of the sledge.

Jay Gould bought control of the Union Pacific during the financial panic of 1873 and proceeded to ransack it for at least $10 million before abandoning it to other managers in 1884. The line slid into bankruptcy in 1897 and was auctioned off to a group of new investors. Under their direction a major reconstruction effort began. The railroad emerged as one of the nation's strongest by World War I and later pioneered in the introduction of streamlined diesel locomotives and modern luxury passenger service. After a 1982 merger with the Missouri Pacific and Western Pacific railroads, the Union Pacific System now controls 22,000 miles of track from Chicago and New Orleans to San Francisco and Seattle.

(D) The Pennsylvania Railroad Company, Philadelphia, Pennsylvania

(A) 1973

(D) 1949

(C) 1898

The (A) **Atchison, Topeka, and Santa Fe Railroad** began construction west from Topeka, Kansas, in 1868. As the southernmost route across the plains, it became an important shipper of cattle, its stations the endpoints of the great cattle drives from Texas. The line reached Santa Fe in 1873—by a branch extension. Nobody seems to have consulted the surveyors when the railroad chose its name; the mountains west of Santa Fe forced the main line to run instead through Albuquerque.

Atchison, Topeka, and Santa Fe was quite a mouthful of a name and too long to read off the side of a speeding train. So the public and the railroad shortened it to the simpler Santa Fe. J.J. Byrne, the Santa Fe's passenger-traffic manager in Los Angeles, designed the cross-in-circle trademark in 1901. He is said to have made his first sketch of the idea at a meeting when someone mentioned the need for a new emblem. Byrne penciled the circle around a silver dollar (or a poker chip, in another version of the story), then sketched in a cross and the word *Santa Fe*. The idea for the cross came from the city name, which means *holy faith* in Spanish. In its final execution, the Santa Fe symbol pays tribute to the bold design styles of the Southwestern Indians.

The emblem of the (B) **Northern Pacific Railway** also draws on a powerful design from another culture. E.H. McHenry, chief engineer for the railroad, noticed the circular motif on the Korean flag during a visit to the 1893 Columbian Exposition. He found it a strong and memorable device, and at his suggestion the railroad adopted it as its trademark. As far as the railroad knew, it was simply an oriental decoration. Not until a missionary back from China stopped in at one of its offices did the company learn of the religious and philosophical meanings of the symbol. Familiar today as the yin and yang symbol, the design suggests life's oppositions and balances—male and female, light and darkness, motion and rest, fire and water.

(C) **Amtrak** came into operation in 1971 as a government-sponsored corporation charged with running the nation's passenger trains. It was originally called Railpax during legislative hearings and debates. Since that sounded more like a box lunch than a railway system, planners hired the Lippincott & Margulies design firm to think of a better name and come up with an identifying trademark. By May 1, 1971, when the first passengers rode the system, Amtrak was the name on the cars. The arrow design was chosen to convey the image of speed and purpose of direction.

The Wright brothers showed the world that mechanical flight was not just a dream, but their discovery was taken more seriously abroad than at home. Royal Dutch Airlines started air passenger service between Amsterdam and London in 1920, the same year Quantas began operations in Australia. Commercial air service in the United States did not begin until 1926, and then only with a stiff shove from the Postal Service.

Glenn Curtiss, who later founded the airplane-construction business that would become (D) **Curtiss-Wright Corporation**, flew the first piece of mail in 1910, in a trip from Albany to New York City. At the end of World War I, the Postal Service decided to go into the airmail business in a more meaningful way, using the experience gained by the military in many hours of combat and surveillance flying. In 1918 regular airmail service was established between Washington, Philadelphia, New York City, and Boston; two years later service west to Chicago and San Francisco began. Over the next few years, the Postal Service established routes and set up guiding beacons for safer night flights. Then in 1925 and 1926, it divested itself of the airmail business and offered it in pieces to private airlines on a contractual basis.

No commercial airlines then existed in the country, but within a matter of months companies formed to make bids on the routes. Those hastily formed firms became America's major airlines. Three of them, companies that would eventually become United, American, and Trans World airlines, started operations within two weeks of each other.

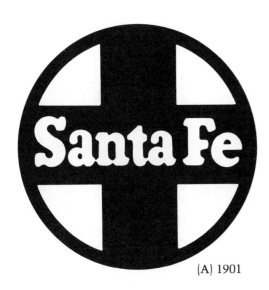

(A) 1901

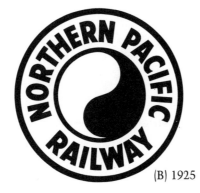

(B) 1925

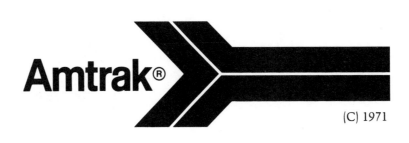

(C) 1971

(D) 1961

179

(A,B) United Airlines traces its origins to the bidders on three different airmail routes—Varney Speed Lines on the Elko, Nevada, to Pasco, Washington, course; Pacific Air Transport from Los Angeles to Seattle; and National Air Transport from Chicago to Dallas. Because Varney Speed Lines got its engines going a few days earlier than some other operators, United proudly hails itself as America's oldest air carrier.

(C) William Boeing got into the airplane business after a ride in a biplane convinced him that he could build a better aircraft. In 1915 he bought a seaplane from Glenn Martin and flew it around Seattle to get a fuller understanding of the workings of the craft. When it crashed he became more convinced than ever that he could do better. With the help of engineer G. Conrad Westervelt, he brought out the first Boeing airplane in 1916, assembled in an old Seattle boat shop. To keep work-ers busy, the shop also made bedroom furniture.

Boeing used his experience as an airplane builder to land the airmail route between San Francisco and Chicago. His access to the latest engines and planes gave him an advantage over competitors; he was able to enlarge on that edge with the purchase of the Varney, Pacific, and National airlines. The Boeing flying operations reorganized in 1931 to become United Airlines. Three years later, the two branches of the business separated completely. Boeing stayed in Seattle to become a premier builder of airplanes, jets, rockets, and satellites, while United moved to Chicago and established itself as one of the great world airlines.

The Boeing totem pole was designed in 1928 by Charles N. Monteith, primarily as a symbol for airline services. After the split with United, Boeing kept it as a mark for its aircraft. United ran through a series of shield-shaped trademarks from 1936 to 1974. The 1953 version shown here is by Charles Coiner of N.W. Ayer & Son. Saul Bass & Associates tossed out the shield in 1974 as suggestive of "conservatism, restriction, and control." They replaced it with the Double-U logo, designed to look better on the tail of an airplane.

(D) American Airlines had its origin in the Robertson Aircraft Corporation, which started flying mail between Chicago and St. Louis on the morning of April 15, 1926. A young pilot named Charles A. Lindbergh carried that first sack of letters. Just one year later he would rocket to fame in the first solo flight across the Atlantic.

The American Airlines eagle was first used in 1931. He's undergone some changes through the years, but he's still flying strong. The designer of the current version attempted to cut him out of the picture but backed off when employees mounted a vigorous Save the Eagle campaign.

(E) Trans World Airlines started out as Western Air Express, a mail carrier that began flights between Los Angeles and Salt Lake City on April 17, 1926. Another founding firm, Transcontinental Air Transport, launched coast-to-coast air and rail service in 1929. Passengers flew during the daylight hours, then connected with trains at night. A 1930 merger formed Transcontinental & Western Air, which inaugurated all-air coast-to-coast service the same year. TWA became Trans World Airlines in 1950—a smart name change that left the initials untouched. Rex Werner and Raymond Loewy Associates designed the TWA double globe in 1960. It was the central part of a corporate make-over that redesigned everything, from planes to ticket counters, offices, and ramps.

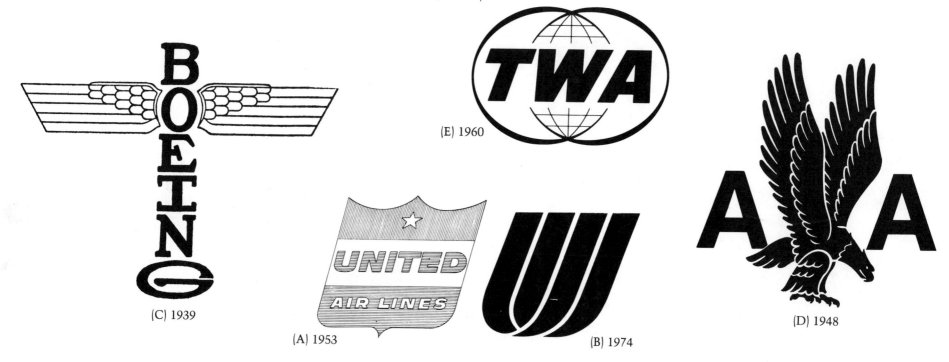

(C) 1939

(E) 1960

(A) 1953

(B) 1974

(D) 1948

Pitcairn Aviation began flying the mail from New Brunswick, New Jersey, to Atlanta in 1928, one of the last to jump into the postal business. The name changed to **(A,B) Eastern Air Transport** in 1930, and the airline began to carry passengers between New York City and Richmond, Virginia, with service extended to Miami a year later. Edward V. "Eddie" Rickenbacker, the World War I flying ace, took charge as general manager in 1935. He ran the airline for almost thirty years, stepping down in 1963. Former astronaut Frank Borman became the second great pilot to run Eastern when he took control in 1975.

Eastern used an eagle as its symbol from about 1935. Through a series of revisions over the years, the bird grew more and more stylized. Lippincott & Margulies came up with the current logo in 1965.

(C,D) Pan American Airways' airmail beginning was the route between Key West, Florida, and Havana, in 1927. The airline grew south, with passenger service to other Caribbean islands, then to Mexico and South America. Pan Am's early international and overwater experience led it to pioneer in other directions as well. In 1935 it launched the first transpacific air service aboard the *China Clipper*, with regularly scheduled flights between San Francisco and Manila; in 1939 it inaugurated service from New York to Marseilles. Pan Am was the first airline to serve meals in flight, in 1929, and the first to heat the food up, six years later.

Since 1928 Pan Am has used a globe for its logo. The early designs had wings, but industrial designer Edward L. Barnes stripped them off in a 1958 revision. He came up with the gridded globe as a symbol of "space and speed and air and precision," and chose a light blue color for its "fresh, atmospheric" look. Employees were allowed to keep their winged lapel pins.

(E) National Airlines, founded in 1934, built a strong domestic route system from a base in Florida. It merged with Pan Am in 1980. The sun logo was created in 1968 by Tom Courtos, of Papert, Koenig and Lois, as a symbol of the airline's southern orientation.

(F) People Express flew its first passengers in April 1981, in the wake of federal deregulation of the airline industry. In a matter of months People Express converted an abandoned terminal at Newark International Airport into one of the busiest in the country. Its formula: cheap flights. Along with a batch of other upstarts, People Express has provided the established carriers with their first real competition in decades. Levine, Huntley, Schmidt, Plapler & Beaver designed the airline's trademark in 1981.

In 1920 Donald Douglas founded the David-Douglas Company and began to make airplanes in an abandoned Los Angeles movie studio. As the **(G) Douglas Aircraft Company**, the firm has made the well-known DC (for Douglas Commercial) series of planes and jets. Douglas merged in 1967 with the McDonnell Aircraft Corporation of St. Louis, to become McDonnell Douglas. Douglas adopted a symbol of planes encircling a globe in 1924. Herbert Bayer, of Dorland International, came up with the basic modern logo in 1947; it has since been updated with new aircraft, missiles, and a stylized globe.

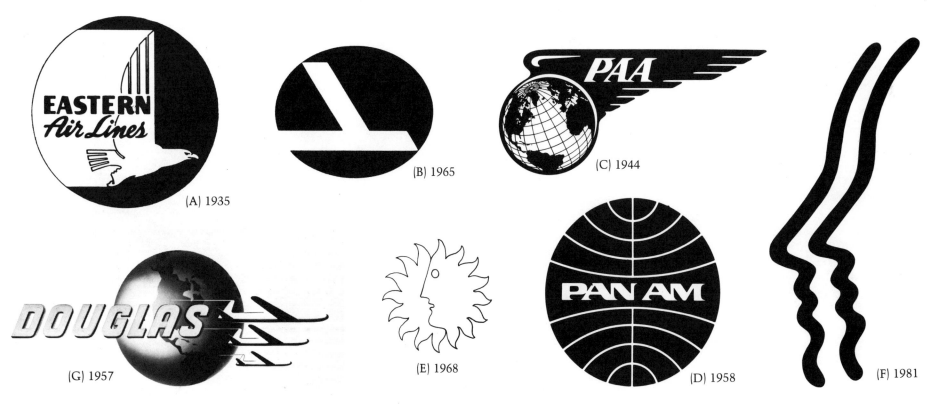

(A) 1935

(B) 1965

(C) 1944

(G) 1957

(E) 1968

(D) 1958

(F) 1981

Paint

When Henry Sherwin became interested in ready-mixed paints in the late 1870s, they were a novel concept in the paint business. Painters were accustomed to making their own paints from such ingredients as linseed oil, white lead, turpentine, and pigments, and most took a dim view of factory-made paints. The earliest prepared paints tended to strengthen this disdain by their poor quality and unreliability. But Sherwin thought the mixed paints might be the key to a huge new market of nonprofessional painters, if a reputation for quality could be established, and he was willing to take the risk.

In 1870 Sherwin left his linseed-oil business and joined with Edward Porter Williams to form **(A) Sherwin-Williams & Company** in Cleveland, Ohio. In 1880 this new partnership introduced its first prepared paint—sold with a money-back guarantee if it did not give better results than hand-mixed paint. Sherwin's careful work in creating the formula and the company's guarantee of the paint's quality paid off nicely as Sherwin-Williams paint became the first mixed paint to gain wide public acceptance.

The Sherwin-Williams "Cover the Earth" trademark went through a first draft as a symbol for a cleaning compound. George W. Ford worked in the early 1890s as the company's advertising manager at the same time that he held an interest in a firm that made Eureka cleaner. He first drew the globe for Eureka, with little brownies climbing over it with soap and brushes. When the Eureka company went out of business, Ford thought of modifying the design for Sherwin-Williams. His sketch of a can pouring paint over the globe first appeared on paint labels in 1893, with the unforgettable slogan "Cover the Earth." It has served as the company's trademark since 1895. Sherwin-Williams is still based in Cleveland, and the globe is still tilted so that the stream of paint lands directly on the company's world headquarters.

(B) Barreled Sunlight paints, United States Gutta Percha Paint Company, Saco, Maine, and Providence, Rhode Island

(C) Atlas paints, Geo. D. Wetherill & Co., Inc., Philadelphia, Pennsylvania

(D) Kuhn's paints, Kuhn Paint and Varnish Works, Houston, Texas. Sold in Texas and Oklahoma from 1907 through 1980.

(A) 1905

(B) 1922

(C) 1925

(D) 1922

The National Lead Company, formed in 1891, brought twenty-five makers of white lead under one corporate roof. The arrangement worked well for a time, but as the company grew, coordinating the sales and advertising of the many individual brands became more and more difficult. In 1907 National Lead decided to add a common trademark design to all of the products under the firm's umbrella to facilitate national advertising and to build a strong national brand.

By chance, an artist named Rudolph Yook had drawn a set of pencil sketches not long before this, showing a little Dutch boy in painter's overalls with a paint brush in his hand. Yook had made the sketches for an advertisement, to illustrate the fact that white lead was made by a Dutch process that had been standard for centuries. After rejecting a number of proposed designs, National Lead's president, Lucius Cole, remembered Yook's sketches and suggested the Dutch painter for a trademark.

The initial sketches gave the rough concept of the symbol, but for a finished painting the company commissioned Lawrence Carmichael Earl, a portrait painter from Montclair, New Jersey. Earl chose a neighbor as his model for the picture—nine-year-old Michael Brady—and paid him $2 an hour for his time. As his first task, Michael was asked to wear the costume of wooden shoes, overalls, and cap for several days of rugged play, so that they would look naturally worn-out. Earl's **(A) Dutch Boy** painting, when completed, achieved national fame on the labels of millions of cans of white lead, and later on cans of ready-mixed paint. Michael Brady's Irish parents were probably the most surprised of all to see their son become America's best-known Dutchman.

(B) Old "Pig Iron" paints, Pidgeon-Thomas Iron Company, Memphis, Tennessee
(C) Armstrong paints, Armstrong Paint & Varnish Works, Chicago, Illinois
(D) Gerts Lumbard paint brushes, Gerts Lumbard and Company, Chicago, Illinois

Warshaw Collection, Smithsonian Institution

(A) 1907

(B) 1948

(C) 1948

(D) 1937

183

(A) 1875

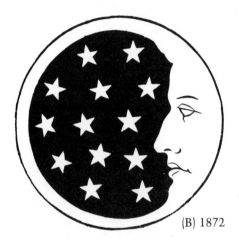

(B) 1872

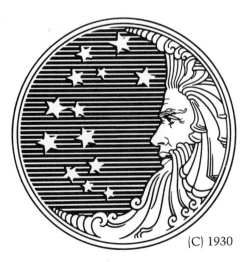

(C) 1930

Soap

The **(A,B,C) Procter & Gamble** crescent moon symbol grew out of crude star mark used to identify the company's Star brand candles in shipping. Soon after its founding in 1837, the company began shipping its soap and candles downriver from Cincinnati to New Orleans and other cities along the Mississippi. A wharf hand is said to have drawn the first star on a wooden crate of the candles in 1851, but it is possible that Procter & Gamble was using a more finished trademark by then. When the company registered the moon-and-stars design under the new trademark law in 1872, it claimed to have been using the mark for twenty-one years.

From the 1870s through the early years of this century the moon-and-stars design appeared as a prominent feature on Procter & Gamble packages, but it gradually shrank in importance. By the 1960s it was a tiny device printed near the list of ingredients on packages of such products as Head & Shoulders, Tide, Joy, and Hires root beer. Then in 1982 the design became the focus of a bizarre rumor that the company was involved in devil worship. Because an artist had chosen a field of thirteen stars as a patriotic gesture more than a century ago, one of the country's oldest trademarks was suddenly singled out as a satanic symbol. After three years of battling the false stories without finding a way to silence them for good, the company decided in 1985 to drop the mark from its products.

The **(D) Old Dutch cleanser** trademark has always been a woman of mystery. She has the build of a young girl but the forearms of a championship wrestler. And she has never shown her face. The Cudahy Packing Company, of Omaha, Nebraska, discovered her in 1905 while searching for a symbol to represent a new scouring soap. E.A. Strauss was thinking about the soap one day when he noticed a decoration painted on the frame of a picture in his home—a Dutch girl with a stick, chasing a goose. He realized at once that he had the symbol for his soap, and the name Old Dutch came into his head as the perfect match for the picture. The company liked his idea and lifted the Dutch girl virtually unchanged from Strauss's frame. The slogan "Chases Dirt" came later, in discussions of how to advertise the new product.

The public quickly accepted the Dutch girl as an old friend. She was used in cartoons to satirize Teddy Roosevelt's trust-busting crusade, and she served on World War I bond posters, her tough, aggressive stance as perfectly suited for war as it was for cleaning. But sadly, she was not immortal. When the Purex Corporation bought the brand name from the Cudahy Packing Company, they shortened it to a more modern Dutch cleanser, and replaced the old girl with a up-to-date Dutch maid. The new version has blonde hair, a trim figure, and a face.

Old Dutch Cleanser

Chases Dirt

MAKES EVERYTHING "SPICK AND SPAN" (D) 1905

The idea for **(A) Ivory soap** came to Harley Procter one Sunday morning in 1879 in the middle of a church service. As the congregation read from Psalms 45:8—"All thy garments smell of myrrh, and aloes, and cassia, and out of the ivory palaces whereby they have made thee glad"—Procter suddenly imagined a pure white bar of soap to be called Ivory. And since Harley Procter was the son of William Procter, cofounder of Procter & Gamble, he was able to bring his daydream to life.

James N. Gamble, son of the company's other founder, James Gamble, had perfected a hard white soap the previous year. Procter & Gamble's White soap was a high-quality bar intended to compete with expensive imported castile soaps. Harley Procter convinced the company elders to rename the soap Ivory, and he set about promoting it properly.

He hired a chemical consultant to analyze the soap for impurities and to compare it to three leading imported castile bars. The chemist found Ivory the cleanest of the four, its impurities measuring only .56 percent of its weight. Procter turned that figure around to create the memorable claim, "99-44/100%

pure." He decided to hang the marketing of the soap on the principles of purity, mildness, and versatility—"a laundry soap good for the nursery." But a manufacturing accident was what provided the key to Ivory's success. Late in 1881 a store sent the company a request for "more of that soap that floats." A quick check revealed that a batch of soap had been left in the crutching (stirring) machine too long, and had hardened with a small amount of air inside. As customers apparently liked the floating soap, Procter asked that the crutching machines be adjusted to make every bar of Ivory float in the same way. Ivory soap has now been floating for more than one hundred years.

(B) Dove tooth powders and dentifices, Charles G. Pease, New York, New York
(C) Swan laundry soap, Lever Brothers Company, Cambridge, Massachusetts
(D) Lever Brothers soap, Lever Brothers Company, Cambridge, Massachusetts

(B) 1901

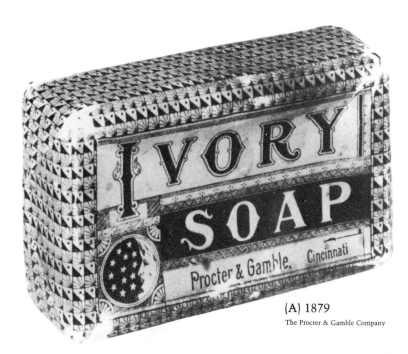

(A) 1879

The Procter & Gamble Company

(C) 1899

(D) 1905

MENNEN

(A) 1938

"HASN'T SCRATCHED YET"®

(C) 1984

WOODBURY'S

(B) 1912

"Hasn't scratched yet!"

(D) 1943

(E) 1919

(A) Gerhard H. Mennen immigrated to the United States from Germany at the age of fifteen, and as a young man attended the New York School of Pharamacy. After graduating, he bought a Newark, New Jersey, drug store. There, in 1878, he began to package his first product, Mennen's Sure Corn Killer, hand-packed in bottles in a room at the back of the store. In 1889 he brought out Mennen's Borated Talcum toilet powder. To appeal to mothers he put a picture of a baby on the front of the package—the child of a proud supply salesman who chanced to turn up at the proper moment to show off a photograph. As a personal guarantee of the quality of the powder, Mennen had his own name and picture imprinted on the lids. This personal endorsement apparently impressed buyers, for Mennen soon had his hands full with the talcum powder business and was able to move to larger quarters. Since then, the Mennen Company has added lotions, creams, and other skin-care products to its line, all sold with the reassuring portrait of Mr. Mennen on the packages.

John H. Woodbury's portrait, first used on packages of **(B) Woodbury's facial soap** in 1891, was not found so calming by the public. Many people thought it gruesome, and it quickly gained the nickname "The Neckless Head." Woodbury himself noted in 1893 that the mark had "received considerable criticism; one little girl called it a man with his head cut off. It may not be particularly attractive to some but attracts attention, and causes our ads to be read, and that is the point we aim at."

The J.T. Robertson Soap Company, of Manchester, Connecticut, first made **(C,D) Bon Ami polishing soap** in 1890. One of the directors of the firm, a local minister named Burgess, was given the task of naming all new soap brands, and he chose the name Bon Ami, French for *good friend*, for the polishing soap. The Bon Ami chick was created in 1901 by Louis H. Soule, who handled the soap's advertising and promotion efforts. He was initially drawn for an advertisement, but customers responded to him so positively that he was added to the package as a full trademark. In modernized form, the chick still sells the Bon Ami line.

(E) Peet's Crystal White family soap, Peet Bros. Manufacturing Company, Kansas City, Kansas

In 1881 a Californian gold prospector named Aaron Winters discovered a huge borax deposit in an isolated region of Death Valley. He sold his claim to a borax merchant, who then faced the difficult problem of moving the ore across the desert to the nearest railroad junction 165 miles away. At the time, ten- and twelve-mule teams were sometimes used to haul large loads through the desert, and the borax miners discovered that even longer teams could haul vastly heavier loads. Two ten-mule teams hitched together into a hundred-foot-long twenty-mule team could pull thirty-six tons without difficulty.

Mining began in 1883; over the next five years the twenty-mule teams hauled twenty million pounds of borax out of Death Valley—dragging their loads over the steep Panamint Mountains in temperatures that often soared to 130 degrees. Another borax strike much nearer the railroad line allowed the miners to retire the mules in 1890. Six years later the Pacific Coast Borax Company revived the memory of the teams when it began marketing borax under the brand name 20 Mule Team, with a drawing of the huge team on the package. To promote the general household use of borax, the company later put together an exhibition mule team, which toured the country and made appearances at major public events. The public's first encounter with the show team, at the 1904 St. Louis World's Fair, was a twenty-mule-team success—the mules were one of the greatest attractions at the fair. **(A)** Boraxo, a polishing cleanser of borax and soap powders, came out in the following year. The familiar tin package was designed in 1935.

Borax fans may remember the 1940 film *Twenty Mule Team*, starring Wallace Beery—a film that brought the real mule teams to forty cities in a massive promotional tour. And astute political observers may recall the many dramatic episodes of the television series "Death Valley Days," sponsored by 20 Mule Team Borax and hosted by Ronald Reagan.

(B) Lava soap, Procter & Gamble Company, Cincinnati, Ohio. Introduced in 1893.
(C) Breath-O-Pine cleaning disinfectant, Brondow Chemical Company, New York, New York
(D) Sledge Hammer lye, Wm. Schield Mfg. Co., St. Louis, Missouri
(E) Lifebuoy soap, Lever Brothers Company, Cambridge, Massachusetts

(B) 1946

(E) 1905

(D) 1922

(C) 1943

(A) 1936

(B) 1904

Sani-Flush

(C) 1929

A Miami, Florida, druggist named Benjamin Green got the idea of making a packaged suntan oil in the early 1940s after noticing that tourists in the area used all manner of home-made concoctions. He experimented with different formulas, using his own bald head as a testing ground, until he came up with the recipe for (A) Coppertone suntan cream in 1944. The first bottles carried a picture of an Indian chief, with the slogan "Don't Be a Paleface." Little Miss Coppertone replaced him in 1953, just as the company was gearing itself up for nationwide distribution.

(B) Woman's Choice washing powder, Acme Washing Powder Co., Shelbyville, Indiana
(C) Sani-Flush toilet bowl cleaning powder, Hygienic Products Company, Canton, Ohio
(D) Mr. Clean sudsing cleaner, Procter & Gamble Company, Cincinnati, Ohio

(D) 1957

Don't be a Paleface!

(A) 1953

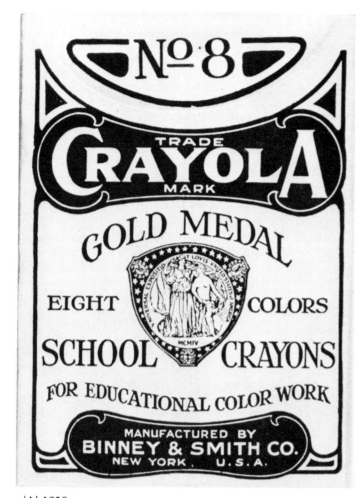

(A) 1928

(B) 1984

Office Supplies

There is something universally appealing about classic school and office supplies; even if our lives have slipped out of order, we can find solace in a well-organized box of pencils, paperclips, erasers, and pens.

Binney & Smith, the manufacturers of **(A,B) Crayola crayons** since 1903, is responsible for pushing countless American children to astounding heights of color awareness. Lucky owners of the jumbo 64-crayon pack become completely fluent in colors, and, as adults, can sprinkle their conversations with references to such exotic hues as "burnt sienna," "maize," "periwinkle," and "raw umber."

The founder of this extraordinary empire, Joseph W. Binney, began operations in 1864 in Peekskill, New York, as a small producer of hardwood charcoal and lamp black called the Peekskill Chemical Works. In 1880 he opened a New York office and invited his nephew, C. Harold Smith, and his son, Edwin Binney, to join the concern. The company expanded its line to include paints, then white chalk, then colored chalk, and, as the century turned, the colored wax crayon.

The Binney & Smith rainbow and nomenclature have always kept pace with the times: Crayola "fluorescent" colors, including "ultra green," "ultra orange," and "hot magenta," were added in 1972. "Prussian blue" was changed to "midnight blue" in 1958 by popular request; and "flesh" was changed to "peach" in 1962.

(C) Tenacity loose-leaf binders, Tenacity Manufacturing Company, Reading, Ohio

(D) Thomas' inks, L.H. Thomas Company, Chicago, Illinois

(C) 1924

(D) about 1900

189

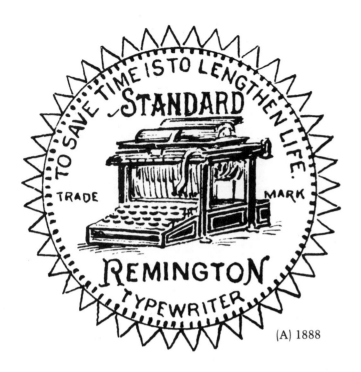

(A) 1888

(B) 1952

The first commercially produced typewriter, invented by Christopher Sholes, was made by **(A) E. Remington & Sons**, the gunmakers of Ilion, New York, in 1873. That earliest model, which printed in upper case only, sold for what was then a shockingly high price of $125. Mark Twain was one of the first proud owners of the Remington, and in 1876 he became the first writer to submit a typewritten manuscript to a publisher, when he affixed *Tom Sawyer* to the page with double-spacing.

Pure serendipity led the Minnesota Mining and Manufacturing Company, more commonly known as 3M, to the name **(B) Scotch Brand** for its tapes. In 1925 the fad for two-toned automobiles created a demand for masking devices to help car manufacturers achieve a clean edge where two colors met on the auto's body. 3M responded with a wide masking tape coated with a thin strip of adhesive on each edge. When the tape failed to stick properly, a disgruntled auto-body painter told his 3M salesman to take the tape back to his "Scotch" bosses and tell them to put the adhesive all over the surface of the tape. The slur stuck, the company took the painter's advice, and 3M has been marketing tapes under that name with the familiar tartan trim ever since.

In the 1940s, when the Borden Company made plans to introduce its new, dairy-based white glue to the market, its advertising executives recoiled at the thought of the beloved Elsie being considered as a possible source of adhesive. So they dreamed up **(C) Elmer**, apparently made of tougher stuff, to adorn the bottle.

In 1953 the French pen manufacturer Marcel Bich streamlined the company name to **(D) Bic** and staked his hopes on the ball-point pen. The original Bic pen, which entered the American market in 1958, is a marvel of simplicity—it's just a thin plastic tube filled with ink and punctuated by a ball in a socket—and the design has not changed at all since its debut.

(E) Tidy Touch carbon paper, American Ribbon and Carbon Co., Rochester, New York
(F) Codo carbon paper, Codo Manufacturing Corp., Coraopolis, Pennsylvania

(E) 1940

(F) 1942

(C) 1962

(D) 1965

The first wooden pencils were made in Bavaria in 1652, and for more than two centuries that country remained the world leader in pencil production. In 1856 a family of Bavarian immigrants, the Berols, founded the **(A,B,C) Eagle Pencil Company** in New York City as both an importer and manufacturer of pencils. Trademark registrations show that the picture of the eagle appeared embossed on the pencil by 1877, and he has stayed on his perch, in various incarnations and degrees of ferocity, ever since. The company, now called Berol U.S.A., is credited with making the first pencil with an inserted eraser (1872), the first mechanical pencil (1879), and the first successful pocket pencil sharpener (1893).

(D) Crane & Company, of Dalton, Massachusetts, has manufactured fine papers since 1801, always with a member of the Crane family involved. The company has occasionally strayed from its staple items of currency paper, which it produces for the United States government as well as for fifty other countries, and stationery. Just after the Civil War, Crane manufactured men's paper collars, and, during the 1930s, cigarette papers.

The **(E) Carter Ink Company**, maker of inks, adhesives, and felt-tip pens, was founded in Boston by William Carter in 1857. Today the company is part of the Dennison Manufacturing Company.

(F) Mallard pencils, Mallard Pencil Company, Georgetown, Kentucky
(G) Sphinx papers, Saxon Paper Corporation, New York, New York

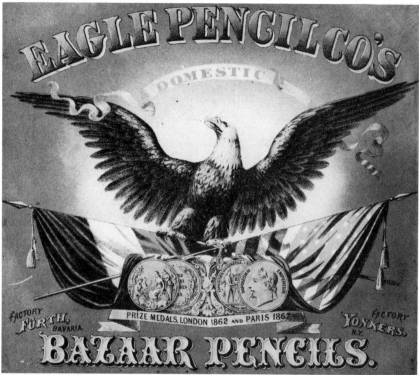

(A) about 1880

(B) 1893

(D) 1919

(C) 1936

(E) about 1900

(F) 1951

(G) 1964

191

Clothing

(A) Levi's 501 blue jeans—the riveted, button-fly denims—stand tall throughout the world as the classic item of American clothing. Coveted by black-market traders in communist countries, admired by chic wearers from Paris to Tokyo, the jeans have ridden the winds of fashion from their beginnings in the frontier West to a place of honor in urban society. And they have endured essentially unchanged for more than one hundred and ten years.

Levi Strauss came to New York from Bavaria in 1847 at the age of seventeen, to join his two brothers in their dry-goods business. In 1853 he took some stock and samples and boarded a clipper ship for San Francisco, hoping to join in the gold rush boom. Among his supplies were several rolls of canvas, which he planned to sell as material for tents and wagon covers. But he found a better use for the cloth. It made durable work pants for miners. (Company legend credits the idea to a grizzled old miner, who looked over Strauss's goods and said, "You should've brought pants.") He wrote his brothers for a supply of heavy cloth, and from what they sent he selected a thick cotton fabric from France, known as *serge de Nîmes*—later shortened to *denim*.

The rivets came from a Carson City tailor, Jacob Davis, who first tried them as a joke to satisfy a miner's demand for strong seams in his pant pockets. But they caught on in a serious way during the 1860s, and Davis wrote Levi Strauss for help in obtaining a patent. Strauss liked the idea, filed a joint application with Davis, and paid him for the right to use the rivets on Levi Strauss jeans. That year, 1873, marked the beginning of Levi's Patent Riveted 501 Waist High Overalls. The pants today are made exactly as they were then, minus a few rivets. A crotch rivet disappeared when it was found to cause discomfort to men sitting around a campfire, and the back-pocket rivets were removed because they scratched saddles and school furniture.

The two-horse guarantee patch has identified Levi's jeans since 1886. Like the pants, it has remained essentially unchanged for a century. Also like the pants, it has weathered its share of imitators—tugs-o-war between lions, oxen, and strong men.

(B) Lee blue jeans have been playing catch-up with Levi's for decades. They don't have the rivets, but they do have a zipper fly and, some think, a better fit. H.D. Lee started making denim overalls in 1911 to supply his Salina, Kansas, merchandising business. From overalls he moved into one-piece work suits, dubbed Union-Alls. When the U.S. Army chose Union-Alls as the official fatigue outfit in 1917, H.D. Lee was in the clothing business for good. Lee Riders followed in the 1920s, designed for cowboys, with a snugger fit and a wider crotch than conventional jeans. In 1945 the Lee people-brand was added to the pants as a strong, Western signature. With some thickening and roughening, the brandmark is still used.

(C) Samson pants, Greenwald & Co., Philadelphia, Pennsylvania

(D) Newburgher pantaloons, Improved Newburgher Pantanloons Manufacturers, Brooklyn, New York

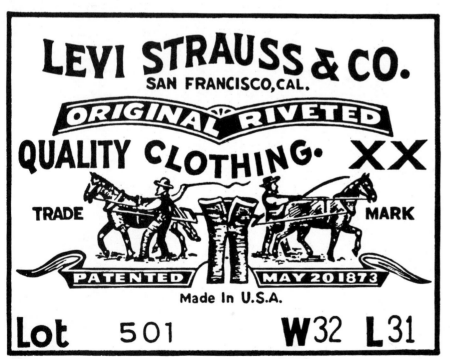

(A) 1978

(B) 1984

(C) 1894

The "SAM SON" PANTS.

(D) 1888

PULL HARD!

THIS REPRESENTS THE STRENGTH OF
THE IMPROVED NEWBURGHER PANTALOONS

The **(A) Brooks Brothers sheep** has been dangling by a ribbon since 1894. That must seem like a long time to the sheep, but it could have been worse—the firm has been in the clothing business since 1818.

That was the year Henry Sands Brooks opened his first store in lower Manhattan, to sell ready-made clothing, then a new departure from tailor-made apparel. Over the years the store developed a reputation as a gentleman's store, a shop for the well-bred and well-to-do. Abraham Lincoln ordered his frock coats from Brooks Brothers. J.P. Morgan suited there, as did F. Scott Fitzgerald, Cary Grant, Fred Astaire, the Duke of Windsor, and most of the Astors, Vanderbilts, and Rockefellers.

The business has now expanded into more than thirty-five branch stores in twenty-eight cities, in addition to the flagship store on Madison Avenue in New York City. Through it all, the country's oldest clothing store has managed to maintain its aura of dignity and prestige. It is still the reliable place to find well-made and correct men's clothing.

The **(B,C) Fruit of the Loom** trademark is one of the oldest in the textile and clothing industry, though it was not used on the famous underwear until 1938. The mark dates back to 1851, when a Miss Skeel began to apply hand-painted labels of various fruits to bolts of cloth sold in her father's store to draw the attention of customers. The labels also drew the notice of B.B. & R. Knight, a Providence, Rhode Island textile mill, which in 1856 began to use the painted fruit labels to mark the cloth it shipped to New York distributors. In 1871 the mill registered the name Fruit of the Loom as one of the first trademarks for textiles.

In the 1920s the Knight mill fell on hard times. To generate cash, the business began to license the Fruit of the Loom trademark to other manufacturers. In 1938 the Union Underwear Company—then famous as makers of union suits—purchased the right to use the name on underwear. The name and the product apparently made a good match, as Union Underwear's sales began to soar. The underwear company has since bought all rights to the Fruit of the Loom trademark.

The **(D) Jantzen diver** is an example of a trademark that led its company to fame and prosperity. She was drawn by Florenz Clark and her husband, Frank, in 1920, as a symbol to be used by the Portland Knitting Company of Portland, Oregon, to promote its Jantzen swimwear.

The little sliver of a figure first appeared in a 1920 Jantzen catalogue, where she lived a serene existence for a while. But in 1923 she made an enormous splash. Two Jantzen officials went to a convention in Washington, D.C., that year and took with them a batch of divers prepared as decals. They stuck two on their train window, did some promotion at the convention, and incited a genuine fad. People started clamoring for the stickers to put on their car windows and radiator grilles; the company sent out four hundred thousand that summer. Many cities thought the problem so menacing to traffic safety that they banned the Jantzen decals. The chief of police in Rockford, Illinois, decided that "keeping one eye on the figure of the bather and the other on the road is an impossibility." He set a fine for "persistent offenders."

The diver has undergone only slight changes through the years. In 1928 she took off her bathing socks and in 1948 switched to a strapless suit. She still wears a bathing cap, and she's managed to maintain her svelte figure.

(D) 1926

(A) 1914

(B) 1922

(C) 1970

(A) John B. Stetson grew up in a hat-making family in Orange, New Jersey, but, as one of the youngest of twelve children, he found no room in the family enterprise. So he headed for the frontier, ending up in the late 1850s in St. Joseph, Missouri. After a stint as a brickmaker he set off for the West—to Pike's Peak to mine for gold. The story has it that he made his first broad-brimmed hat on that trip across the plains and sold it to a passing bullwacker.

In 1865, at the age of thirty-five, he left the gold diggings and returned East to settle in Philadelphia. With $100 that he had saved from his mining work, he set himself up in the hat business. It was not long before he made use of his experience in the West to design a hat particularly suited to life on the frontier—a big, wide-brimmed hat tough enough to stand wear in bad weather. He called it The Boss of the Plains.

Stetson gathered all of his money, and all that he could borrow, to send a sample of the hat to every clothing and hat dealer in the West, with a letter suggesting an order for a dozen. His gamble paid off. The rapidly growing business sent him through a succession of new factories and eventually made his name one of the most familiar in the West. "Buffalo Bill" Cody wore a Stetson in his early scouting days, and later when he toured with the Wild West Show. So did Annie Oakley, Tom Mix, Gene Autrey, Roy Rogers, Dale Evans, and the Lone Ranger. The Royal Canadian Mounties have worn Stetsons since 1901 (made in the Ontario plant). The Texas Rangers wore them for many years, and National Park Service Rangers still do.

(B) Cannon towels and sheets got their start when James Cannon decided to challenge the dominance of Northern mills by building a textile mill in the South, near the source of raw cotton. In 1887, with the investment of local merchants and farmers, he built a mill in Concord, North Carolina, and began to produce Cannon cloth. The mill added the familiar Cannon symbol to its packages in 1916. Over the next decade, the company built the design into a major trademark by attaching it on a label to every towel and sheet manufactured, and by backing up that exposure with heavy advertising. In 1930 a test in seven department stores showed that customers preferred the Cannon towels over unbranded towels by wide margins—as high as eight-to-one in Peoria, Illinois. The little cannon has proved to be a mighty weapon. Today the firm makes sheets, towels, comforters, duvets, bedspreads, blankets, bath rugs, and draperies at eighteen plants in North Carolina, South Carolina, and Georgia.

(C) Excelsior needles, Excelsior Needle Company, Torrington, Connecticut
(D) Clark's Three Cord thread, Clark Thread Company, Newark, New Jersey

(A) 1935

(B) 1961

(C) 1893

(D) 1891

(A) **Charles F. Hathaway** became an early maker of ready-made clothing when he began to stock finished shirts in his Boston shop in the 1830s. He moved to Waterville, Maine, in 1837, to build his shirt-making operation in more peaceful surroundings. Women from local farms made the shirts—about two dozen a week at first—and Hathaway delivered them by stagecoach every month to stores in Boston. Sewing machines and railroads enabled him to expand production, and he gradually began to sell shirts throughout the country.

Hathaway's breakthrough came in 1951, when it hired the young advertising agency of Hewitt, Ogilvy, Benson and Mather to increase public exposure. David Ogilvy took charge of the account. He decided to attach an image of wealth, culture, and European elegance to the shirts from northern Maine. For his model he selected a White Russian expatriate named George Wrangell—a genuine baron with a background in journalism and advertising. In a flash of brilliance, Ogilvy brought an eye patch to the first photo session. The Hathaway Man was born.

The ad that would make Ogilvy, Wrangell, and Hathaway famous appeared in *The New Yorker* on September 22, 1951, with the headline "The man in the Hathaway shirt." For four years, succeeding ads in the campaign ran only in *The New Yorker*, emphasizing by their context the image of class and quality. Even with that tightly focused exposure the ads gained a tremendous notoriety. More important, they tripled Hathaway's sales. Baron Wrangell found a happy ending too. He married the heiress to the Four Roses whiskey fortune and settled into a Spanish villa with eleven servants.

The (B) **Woolmark** was designed in 1964 by Francesco Seraglio for the International Wool Secretariat, based in London. It is promoted in this country by the Wool Bureau, Incorporated, as a mark for wool products.

(C) **De Long hooks and eyes,** Richardson & De Long Bros., Philadelphia, Pennsylvania. Jokes about the "See That Hump?" slogan were popular at the turn of the century.

(D) **Missouri Mule work gloves,** Wells Lamont Corporation, Chicago, Illinois

(E) **Washington shirts,** Washington Shirt Company, Chicago, Illinois

(A) 1951

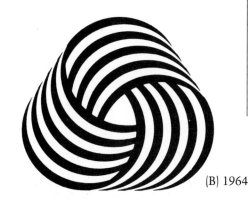

(B) 1964

See that **hump?**

(C) 1892

MISSOURI MULE

MEMBER OF THE MULE FAMILY

(D) 1947

Furnishers to His Majesty The American Citizen.

(E) 1907

Shoes

Buster Brown and his dog Tige were once famous cartoon characters, as popular in their day as Charlie Brown and Snoopy, but the pair is now firmly connected in our minds with children's shoes. R.F. Outcault, the creator of the first newspaper comic, the Yellow Kid (see page 56), came up with Buster Brown in 1902 for the *New York Herald*. Outcault had made some merchandising deals with the Yellow Kid, but he really went to town with Buster Brown. He set up a booth at the 1904 St. Louis World's Fair and sold rights to the character to any manufacturer willing to pay the fee. The next few years

saw Buster Brown soap, socks, coffee, flour, soda, harmonicas, apples, and shoes—in all, more than fifty different products came out with the Buster Brown name. From the melee, only two have survived: **(A) Buster Brown shoes**, and **(B,C) Buster Brown children's clothing** (Buster Brown Textiles, Wilmington, Delware).

The Brown Shoe Company of St. Louis took its name from founder George Warren Brown. By the time of the fair, the firm had already made a deal with Outcault, and its Buster Brown shoe exhibit won a Double Grand Prize. The company went on to

promote the shoes with touring midgets dressed like Buster Brown, who put on shows in shoe stores, theaters, and department stores between 1904 and 1930. Smilin' Ed McConnell and his Buster Brown Gang brought the character and the shoes to radio in 1943 and to television from 1951 to 1953. Still widely advertised, Buster Brown shoes continue to be a favorite with children.

(D) William L. Douglas rode the $3 shoe to social and political prominence. In the 1870s he began to expand his small shoestore business by selling to other stores. Eventually, with heavy advertising—always with his own face as

the prominent feature—he built the business into a chain of more than one hundred stores, with the shoes sold through five thousand additional dealers. Not satisfied with commercial success, Douglas used the fame he had gained from the ads, and his expertise in advertising, to launch a political career. In 1904 he was elected governor of Massachusetts—a remarkable victory for a Democrat in the same election that swept Republican Theodore Roosevelt into the White House by a huge margin.

(A) 1981

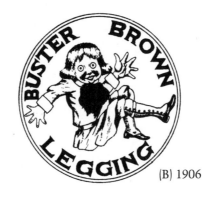

(B) 1906

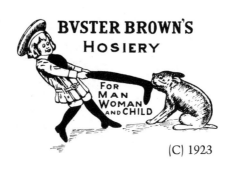

(C) 1923

W. L. DOUGLAS $3 SHOE FOR GENTLEMEN.

(D) 1891

The black **(A)** **Cat's Paw** cat is a familiar sight to anyone who has walked by a shoe-repair shop; as a window decal, the cat has come to be an almost universal symbol for shoe repairs. It is actually a mark for shoe soles and heels, designed in 1941 by Lucian Bernhard for the Cat's Paw Rubber Company of Baltimore. Cat's Paw soles, heels, and taps have been made since 1904.

(B) Converse Chuck Taylor All Star basketball shoes are the footwear of choice for those serious about the game. The U.S. Olympic team has worn Converse sneakers since 1930, and a close look near the floor at any professional match will show an abundance of Converse labels. In fact, Converse invented the high-topped canvas basketball shoe in 1917. That first model was dubbed the **(C) Converse All Star**. The Chuck Taylor All Star, a variant on the basic model, followed in 1921, named for a popular amateur star of the twenties and thirties. Taylor wore only Converse shoes throughout his playing career. To ensure that the right examples are set for others, Converse and other shoe companies now pay professional players good money to wear branded footwear. With plants in Lumberton, North Carolina, and Presque Isle, Maine, Converse is the country's largest manufacturer of athletic footwear.

Bill Bowerman and Phil Knight met at the Univerity of Oregon in 1958, while Bowerman was working as a track coach and Knight was an undergraduate miler. Bowerman's coaching led him to experiment with the design of running shoes, and by 1960 runners were breaking records wearing handmade shoes from his kitchen workshop. In 1964 the two men teamed up to form a new athletic shoe company, Blue Ribbon Sports, with a capital investment of $1,000.

At first they concentrated on importing and distributing Tiger Brand shoes from Japan, but a dispute with the Japanese firm led to a break in 1972, and Bowerman and Knight began to make and sell shoes under their own brand name—**(D) Nike**. That same year, even before the name was chosen, Knight asked Carolyn Davidson, a design student at Portland State University, to create a symbol to identify the new brand. She came up with the boomerang-shaped slash now known as the "swoosh," and was paid $35 for her effort. The Nike shoe business has since mushroomed to worldwide sales of more than $700 million, with maufacturing facilities in nine countries.

(E) Mail Carrier leather boots and shoes, M.D. Wells & Company, Chicago, Illinois

(F) Selz leather boots and shoes, Selz, Schwab & Company, Chicago, Illinois

(A) 1944

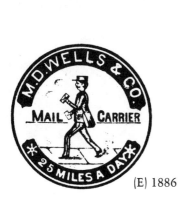

(E) 1886

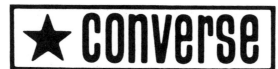

(C) 1967

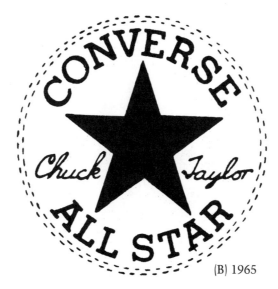

(B) 1965

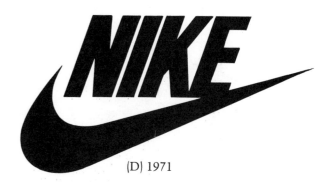

(D) 1971

(F) 1907

Insurance and Finance

Early fire-fighting services in this country were often connected with fire-insurance companies. To make certain that the firemen directed their attention to the right properties, the firms affixed prominent fire marks to the fronts of insured buildings. These fire marks also served as identification signs, or trademarks, for the insurance companies long before the service industries recognized trademarks as an important marketing tool.

A group of Hartford, Connecticut, businessmen established the **(A,B,C) Hartford Fire Insurance Company** in 1810. Within a few decades the scope of the business expanded well beyond its home town and included the buildings of Yale University, the homes of Robert E. Lee and Abraham Lincoln, and the property of Buffalo Bill's Wild West Show.

In 1861 the firm began to use an emblem with a stag, a variant of Hartford's city seal, which in turn had been copied from the seventeenth-century seal of Hertford, England. Hertford had originally adopted the design as a sort of visual pun. *Hert* (or *hart*) was another word for *stag*, and the seal showed the animal fording a stream. The insurance company revised the design in 1871 into a copy of Sir Edwin Landseer's painting *Monarch of the Glenn*. Reproductions of the painting were popular at the time, and the company's directors probably first saw the art in a lithographed edition. The basic design has remained virtually unchanged since 1871, though it is now rendered in a bolder and simpler style better suited to signs and television ads.

(D) **Merrill Lynch & Co., Inc.,** New York, New York. Designed by King-Casey, Inc.

(A) 1861

(B) 1947

(C) 1971

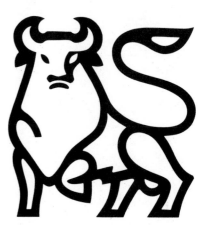

(D) 1973

(A) **The Travelers Insurance Company** opened its doors in Hartford, Connecticut, in 1864 with the specialized mission of "insuring travelers against loss of life or personal injury while journeying by railway or steamboat." The following year it expanded coverage to all accidents, with the exception of those caused by dueling, fighting, or riding races. The company used an umbrella as a symbol of insurance protection in ads as early as 1870 but did not put the umbrella up as a genuine trademark until 1960. Since then, the firm has given away thousands of bright red umbrellas each year and has printed the umbrella logo on such promotional items as golf balls, lapel pins, playing cards, sweaters, and sports shirts.

Two men playing bridge on a Chicago commuter train conceived the idea for the (B,C) **Allstate Insurance Company** one fall morning in 1930. Carl L. Odell, an insurance broker, suggested that a large mail-order business might do well in the auto-insurance business. And since his partner was General

Robert E. Wood, president of Sears, the concept moved quickly into reality.

Allstate had been used by Sears as a brand name for tires since 1926 and was simply borrowed for the new insurance venture. The slogan "You're in good hands with Allstate" was introduced in 1950, the creation of general sales manager David W. Ellis. At first the picture that went with the slogan showed a pair of cupped hands holding a car, but in 1956 the hands received an extra load when a house was added to reflect Allstate's expansion into residential fire insurance.

(D) **The Provident Trust Company** adopted Jean François Millet's painting *The Sower* as its symbol when it opened its doors for business in 1922. Though newly formed, the bank began with a portion of the assets of the much older Provident Life & Trust Company, established in 1865. No record remains of the reasons the bank chose Millet's masterpiece as its emblem, but we can assume that an executive was taken with the symbolism of the sower spreading his seeds for future reward. The bank had the design carved in marble on the front of its Philadelphia office that first year. When the Provident merged with the Tradesmen's Bank & Trust Company in 1955, it aquired an older ancestry; to make the most of the new lineage, the emblem was changed to read "Est. 1847."

(E) **Mutual Of Omaha Insurance Company,** Omaha, Nebraska. The company may be best known for its sponsorship of the television program "Wild Kingdom," on the air since 1963.

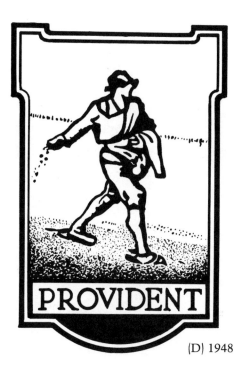

(D) 1948

THE TRAVELERS

(A) 1974

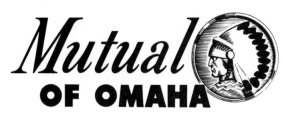

(E) 1950

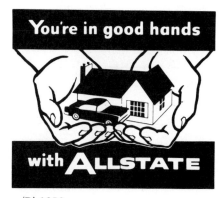

(B) 1958

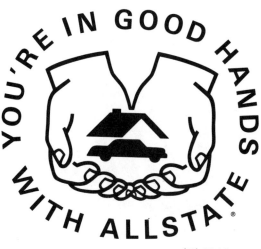

(C) 1966

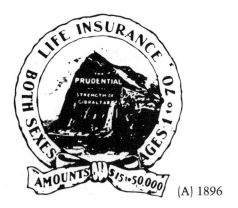

(A) 1896

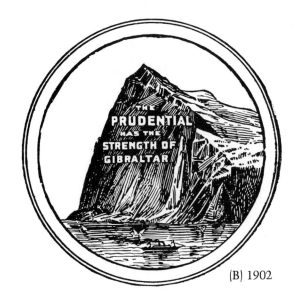

(B) 1902

(A,B,C) The Prudential Insurance Company of America was founded in 1875 as the Prudential Friendly Society, in Newark, New Jersey. Mortimer Remington, a young writer at the J. Walter Thompson advertising agency, came up with the Rock of Gibraltar trademark in 1896 for a series of advertisements. According to one story, he got the idea on the train from Newark to New York when the shape of Laurel Hill reminded Remington of the rock of Gibraltar. Another story traces the inspiration to Nathaniel Fowler's book *Building Business*, which referred to insurance companies with the phrase "solid as a rock," and which Remington read in 1896. To confuse matters even more, Nathaniel Fowler, a prominent advertising writer himself, later claimed that he had come up with the complete slogan.

The symbol was first published in *Leslie's Weekly* on August 20, 1896. Its border underwent slight changes over the years, but the rock itself held out against the threat of modernization until very recently. In 1984 Richard Kontir of Lee & Young Communications finally battered the rock into submission. It now appears as a striped triangle in a circle, scraped clean of its original character and romance but undeniably up-to-date.

The founders of the **(D) John Hancock Mutual Life Insurance Company** wanted to name their new enterprise for Benjamin Franklin, but when Massachusetts rejected their application for a charter, they tried again, in 1862, with the second patriot on their list. So instead of a balding figurehead, the company ended up with a famous signature as its mark, pulled straight from the Declaration of Independence.

(E) National Life Insurance Company, Montpelier, Vermont

(F) Nationwide Insurance Companies, Columbus, Ohio. Logotype designed in 1955 by Frank Potocnik to coincide with a name change from the Farm Bureau Mutual Automobile Insurance Company.

(D) 1951

(F) 1955

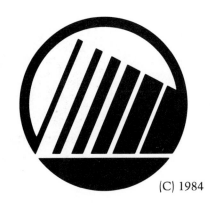

(C) 1984

(E) 1948

The Greek soldier emblem of the **(A) American Express Company** was adopted in 1951 in an attempt to fend off a growing counterfeiting problem. The company's traveler's checks had been printed by lithography since their introduction in 1891, and in the boom travel years after World War II counterfeiters found them easy prey. Losses due to forgery jumped to $5 million a year, nearly ten times the rate suffered in the thirties and early forties. At the suggestion of its counterfeit detectives, American Express decided to switch to steel-engraving and add a portrait to the design to make the checks more difficult to copy.

Some older officials wanted the picture to be a bulldog, the company's mascot from its beginning in 1850 as an express package carrier. The bulldog had nearly made it onto the traveler's checks in the 1920s, but the idea had been rejected as too expensive. Others suggested an American Indian, the company's headquarters building, or Henry Wells, its first president. But the American Banknote Company crushed all of those ideas with the news that a newly

commissioned engraving would take at least a year to execute. Instead, it offered a finished engraving of a helmeted Greek warrior, the work of artist Alonzo Foringer and engraver William Ford, which was sitting unused in its vaults. Faced with the hard reality of its mounting losses, American Express decided the portrait looked pretty good. The ancient Greeks hadn't had traveler's checks or credit cards, but at least they'd handled money, and the soldier seemed appropriately fearsome. So on January 1, 1951, American Express issued engraved traveler's checks with the warrior in the corner.

The design firm of Chermayeff & Geismar Associates created the **(B) Chase Manhattan Bank's** distinctive octagon logo in 1960. The simple yet dynamic design appealed to the bank's executives at once, and it has clearly appealed to executives at other banks as well. The abstract, interlocking design seems to have become a sort of model for the designers of other bank and insurance logos. The similarity among the symbols points out the difficulty designers face when charged with creating a distinctive mark within the limits of the pared-down abstract style.

(C) First National Bank and Trust Company, Troy, Ohio
(D) Virginia Commonwealth Bankshares, Inc., Richmond, Virginia
(E) Fireman's Fund Insurance Company, San Francisco, California
(F) First National Bank of Louisville, Louisville, Kentucky

(B) 1960

(F) 1973

(A) 1951

(C) 1970

(D) 1967

(E) 1976

Publishing and Entertainment

Λαμπάδια ἔχοντες διαδώσουσιν ἀλλήλοις.

(A) 1847

(B) 1956

Book publishers have used pressmarks since the first days of printing with movable type. Fifteenth-century Italian printers put their marks as a signature at the end of books, and the practice eventually became common to publishing around the world.

(A,B,C) The Harper brothers, James, John, Wesley, and Fletcher, opened a printing shop in New York City in 1817 and shifted the business into book publishing over the next several years. In 1847 the writer William Whewell commissioned an engraving of a hand holding a torch for use as an illustration on the title page of his book *Elements of Morality and Polity*. The Harpers were so taken with the picture that they began to use it as a colophon for other books as well. With small variations through the years, the Har-

per Brothers (now Harper & Row) torch has appeared in the original editions of such books as *Moby-Dick*, *Ben Hur*, and *Charlotte's Web*.

(D) The Viking Press was founded in 1925 by two young men in their twenties, Harold K. Guinzburg and George S. Oppenheimer. To give their new enterprise a respectable foundation, they acquired the one-man publishing house of B.W. Heubsch and its list of titles by James Joyce, D.H. Lawrence, Sherwood Anderson, and Thorstein Veblen. According to Viking legend, the partners had planned to call the venture Half Moon Press, and asked Rockwell Kent to design a colophon of Henry Hudson's ship. Kent responded with a drawing of a Viking *drakkar*, which they liked so much that they changed the name to match the colophon.

Rockwell Kent did draw the Viking pressmark, but that may be the only grain of truth in the story.

(E) Alfred A. Knopf was just three years out of college when he started his publishing business in 1915. He strove from the beginning to bring out high-quality literature in well-designed books. As he had little money to work with, he found an inexpensive niche in the publication of Russian works that had already been translated and typeset by British publishers. To represent his strongly Russian list, he chose the Russian wolfhound, or borzoi, as a colophon. Rudolph Ruzicka designed the the pressmark shown here. Knopf soon grew beyond Russian literature, and the Borzoi imprint has become a respected mark of quality on a wide-ranging list.

VIKING PRESS (D) 1925

1817 (C) 1969

BORZOI BOOKS

(E) 1922

Bennett Cerf and Donald Klopfer bought the Modern Library series from Boni & Liveright in 1925 and on its profits built **(F,G) Random House.** Rockwell Kent, who had been hired to draw the endpapers for the Modern Library, was in the office one day during a discussion of plans to publish some new books on the side. Cerf thought of the name Random House as they spoke, and Kent sketched the pressmark. The first books with the Random House imprint came out in 1927.

American publishers were among the first to see the potential of cheap editions for the mass market. From the middle of the nineteenth century, dime novels brought the public inexpensive stories of adventure and romance. Pulp magazines carried the cheap literature tradition into this century, and, in the 1940s, the mass-market paperback raised the idea to even greater heights.

The first ten paperbacks issued by **(H) Pocket Books** in 1939 included Pearl S. Buck's *The Good Earth*, James Hilton's *Lost Horizon*, Agatha Christie's *The Murder of Roger Ackroyd*, and Thornton Wilder's *The Bridge of San Luis Rey*. Each cost only a quarter and each carried a little picture of a kangaroo on the cover (nicknamed Gertrude by her friends). The success of those titles established Pocket Books as a publishing force and laid a path for others to follow. Pocket Books published Dr. Benjamin Spock's *Pocket Book of Baby and Child Care* in 1946; it was the best-selling paperback of all time. Gertrude the kangaroo is approaching her fiftieth year as Pocket Books' cover girl, and her current appearance is the work of Milton Glaser. The 1946 version, shown here, was drawn by the Walt Disney Studios.

(I) Penguin Books started in England in 1935 as a publisher of cheap paperback reprints; four years later Ian Ballantine opened a New York office to handle American sales. When World War II upset the regular shipments of books from England, Ballantine began to publish books instead of just importing them, and the American branch grew into an important independent publisher. The first Penguin pressmark was drawn by Edward Young, a twenty-one-year-old employee in the London office, who sketched the design from a live bird at the London Zoo. Typographer Jan Tschichold created the current version in 1949.

After the war, conflicts between the London and New York branches of Penguin led Ian Ballantine to launch his own company, **(J) Bantam Books,** in 1945. He received editorial and financial support from Grosset & Dunlap, and it was an editor there, Bernard Geis, who suggested the Bantam name. The pressmark shown here was drawn in 1950 by Bantam's art director, Don Gelb. Ballantine set out on his own again in 1952, to start Ballantine Books, while the company he left behind went on to publish such bestsellers as *Jaws*, *Airport*, *Future Shock*, *The Exorcist*, and *Valley of the Dolls*.

(K) Harlequin Books Ltd., Winnipeg, Manitoba

(K) 1963

(J) 1950

(F) 1927

(G) 1968

(H) 1946

(I) 1949

Across a wide swath of rural America, boys for the last century have grown up secure in the knowledge that they could make money in their spare time selling **(A) the *Grit*,** "America's Greatest Family Newspaper." Gene Autrey, John Glenn, Burl Ives, and Carl Sandburg all sold the *Grit* in their youth, part of a sales force that reached thirty thousand young peddlers at its peak.

The *Grit* began in 1882 as a Saturday paper for the town of Williamsport, Pennsylvania. But when it became clear that the town couldn't support them, the owners widened the paper's circulation to towns across Pennsylvania and eventually through the rest of the country. The guiding philosophy behind the paper has always been to present the news with an optimistic slant—what the *Wall Street Journal* described as "sunny-side up." It has been a winning formula. The *Grit* reached a peak circulation in 1969 of 1.5 million readers.

John S. Wright founded **(B) the *Prairie Farmer*** in Chicago in 1841 as the mouthpiece of the Western farmer. His dream was to bring to farmers the same opportunities for education as those available in cities. Through the paper, and his association with Abraham Lincoln, Wright was instrumental in the establishment of the land-grant university system. The paper also played a strong hand in the start of the Grange and the Farm Bureau, and it remains the country's oldest paper devoted to the interests of farmers.

(C) Bicycle playing cards, United States Playing Card Company, Cincinnati, Ohio. The popular brand of cards was introduced in 1885, at the peak of the bicycle craze, by Russell, Morgan and Company. The joker originally rode a high-wheeled model, but traded it in for a chain-driven safety bike in 1892. **(D) Black Cat playing cards,** Andrew Dougherty, New York, New York

(D) 1896

(A) 1905

(B) 1926

(C) 1904

(A) 1925

(A) *The New Yorker*'s top-hatted, monocled ambassador, known to friends as Eustace Tilley, graced the cover of the magazine's first issue in February 1925 and has returned like a spring flower every February since. He was drawn by the magazine's first art director, Rea Irvin, for reasons known only to herself, and his odd charisma earned him both the enduring affection of readers and the respect of the magazine's editors. More than just cover art, he is now the legal symbol of *The New Yorker*.

Hugh Hefner was an editor at *Children's Activities* magazine when he approached designer Arthur Paul in 1953 about starting a new magazine, which he wanted to call *Stag Party*. Paul didn't much like the name, but he decided to give it a try. He designed a sample issue, using a stag as the publication's symbol. Then, a few weeks before they were scheduled to go into production, Hefner got a letter from the owners of *Stag* magazine threatening a lawsuit. He picked the name **(B)** *Playboy* as an acceptable second choice.

Hefner wanted Paul to create a symbol for *Playboy* along the lines of **(C) Esky,** the lecherous, bug-eyed man used by *Esquire*. Paul settled on a rabbit, "the playboy of the animal world," as he put it, "to show that we didn't take ourselves too seriously." He gave the rabbit a bow tie, to suggest the sophisticated urban reader they hoped to attract, and drew him in a bold, simple style intended for use as a quarter-inch decoration at the end of each article. Paul has been amazed ever since by the worldwide fame of his creation. Except for the first issue, the logo has appeared as a hidden element on every *Playboy* cover. It is used to mark *Playboy* buildings and clubs, and is seen everywhere as a sticker, pendant, and T-shirt ornament.

No one knows how **(D)** *Mad* magazine's Alfred E. Neuman, the grinning idiot kid, got started. He is a peculiar folk creation used in cartoons and advertisements as far back as 1905. His prominent ears, vacant gaze, and toothless smile have all been with him from his early days, as has the slogan "What, Me Worry?" All *Mad* really added was his name and a wider notoriety. In 1954 a *Mad* artist saw a postcard of the kid pinned on a friend's bulletin board and decided to use him in the magazine. The classic *Mad* rendition of the boy, drawn by Norman Mingo, first appeared on the cover of a 1956 issue as a write-in candidate for president. Neuman lost the election, but found a permanent job as *Mad*'s spokesman and trademark.

(B) 1955

(C) 1935

Advertising postcard, about 1940

(D) 1955

205

(A) 1914

Movies, like books, are generally released with the maker's signature up front. But instead of tiny colophons, movie makers have produced spectacular visual symbols as their trademarks, and their full-screen presentation at the start of each film has earned broad public recognition for the marks.

(A) Paramount Pictures began in 1914 as a company to distribute feature motion pictures. Founder William Wadsworth Hodkinson was struggling to think up an appropriate name when he walked by the Paramount Apartments in New York City. The name struck him as appropriately boastful, and when he got back home he sketched a crude rendering of a mountain ringed by stars. Artist Vincent Trotta refined the idea into the finished film leader. A merger with Adolph Zukor's Famous Players Company and the Jesse L. Lasky Feature Play Company brought Paramount into the film-production business. Paramount's stars have included Mary Pickford, Douglas Fairbanks, Rudolph Valentino, Gary Cooper, Marlene Dietrich, John Wayne, and W.C. Fields, and *The Ten Commandments*, *Peter Pan*, and *The Godfather* are among its productions.

(B) The MGM lion followed a tradition of animal mascots among the early movie companies. Pathé had a rooster, Bison a buffalo, and Vitagraph a dog. The idea for the lion came from Howard Dietz, a Columbia graduate who did sales and promotion work for the young Goldwyn Picture Company. Remembering the lion mascot of his college football team, Dietz used his influence to land his fellow alumnus a movie role. In Goldwyn's merger with Metro, the lion won out over Metro's parrot to become the symbol for the powerful Metro-Goldwyn-Mayer studio.

(B) 1927

(C) 1936

He first roared in the 1928 talkie *White Shadows in the South Seas* and has since given his friendly introduction to such films as *Grand Hotel*, *Gone With the Wind*, and *The Wizard of Oz*.

Harry Cohn came to Hollywood from New York City, which may be the reason he picked **(C) Columbia Pictures** as the name of his new film company in 1924. The noble insignia, a living edition of the Statue of Liberty, was added to Columbia's films in 1936. She's been an appropriately uplifting standard-bearer for the works of Frank Capra—*It Happened One Night*, *It's a Wonderful Life*, *Mr. Deeds Goes to Town*, and *Mr. Smith Goes to Washington*.

(D) RKO Radio Pictures was formed in 1921 as a joint venture of the Radio Corporation of America and the Keith-Orpheum theater chain. The RKO studio brought Katharine Hepburn to the screen, paired Ginger Rogers and Fred Astaire, and produced Orson Welles's *Citizen Kane*. The radio tower symbol first appeared in 1937, but was retired for many years after Desilu Productions took over the studio in 1953. It is now bracing itself for a comeback, as RKO prepares to return to the movie business.

(E) The Twentieth Century-Fox Film Corporation came into being in 1935 as a merger of Joseph Schenck's Twentieth Century Pictures and William Fox's Fox Film Corporation. Its beacon-streaked monument to three-dimensional type is one of the most dramatic of the studio trademarks. Its has announced the films of Shirley Temple, Henry Fonda, Betty Grable, and Marilyn Monroe, and was the first of the movie insignias to go on the rack to fit the wide Cinemascope format in 1953.

Four brothers, Albert, Harry, Jack, and Sam, started **(F) Warner Brothers** in 1923 and led the industry into the sound era with *The Jazz Singer* and Busby Berkeley's musical extravaganzas. The shield appeared in 1935 and has adorned some box office greats, including *Casablanca*, *Jezebel*, *On the Waterfront*, and all of Bugs Bunny's films.

(F) 1941

(D) 1958

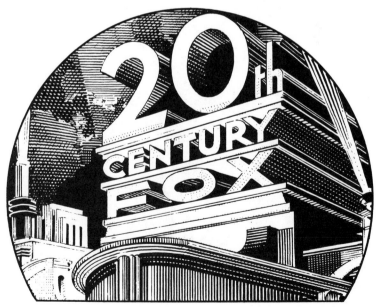

(E) 1936

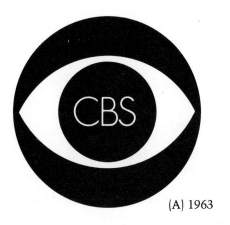

(A) 1963

Designer William Golden hit on **(A) the CBS eye** while he was serving in France during World War II—more specifically, while he was doodling. But it took some years to work the design through the hierarchy at CBS, once he got back to his job there. Not until 1951 did the eye make its premier on network television, floating serenely in front of a photograph of clouds.

Golden's eye was one of the leaders in the move toward spare, abstract trademarks in the postwar years. Unlike many of the modern symbols that followed it, Golden's creation is both simple and distinctive—recognized at once when flashed on the television screen. But because it is essentially a picture of an eye, it has proved a challenge to the police efforts of the CBS trademark attorneys. As one company executive admitted, "Bill Golden, after all, didn't invent the eye. God thought of it first." To protect the eye's legal status, CBS has had to prevent imitations from being used by private detectives and optometrists.

(B) American Broadcasting-Paramount Theaters, Inc., New York, New York
(C) National Broadcasting Company, Inc., New York, New York. The peacock was first chosen as a symbol for color television programming.
(D) The Woodstock concert, Woodstock Ventures, Inc., New York, New York
(E) The Supremes, Motown Record Corporation, Detroit, Michigan
(F) Recordings by the Rolling Stones, Musidor B.V., Amsterdam, Netherlands
(G) The Monkees television singing group

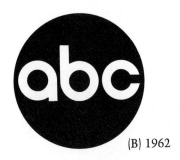

(B) 1962

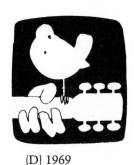

(D) 1969

(E) 1974

(F) 1976

(C) 1958

(G) 1966

Sporting Goods

In 1889 Sam Leeds Allen, a Philadelphia businessman, built a sled for his granddaughter with a steering device of his own invention. The sled was such a hit with the neighborhood children that he gave it a brand name, **(A) Flexible Flyer,** and began to make and sell it in quantity through his farm-implement company.

Flexible Flyer sleds were made in Philadelphia at the S.L. Allen Company for almost eighty years, building a reputation as the winter vehicle of choice among the fast-moving younger set. In 1968 the business was sold and moved to Medina, Ohio, and another sale in 1973 brought the factory to West Point, Mississippi.

(B) Albert Goodwill Spalding joined the Boston Red Stockings as a pitcher in 1871, the year the first professional baseball league was formed. He became one of the game's first star players, winning 205 of the 260 games he pitched for the team and bringing Boston the championship in four of the five seasons he played there. In 1876 Spalding moved on to play for Chicago; at the same time he started a company with his brother to manufacture baseballs. He joined the venture on a full-time basis at the end of the 1877 playing season. The business moved from Chicago to New York City to Chicopee, Massachusetts, as its line grew to include baseball bats, Indian clubs, tennis balls, hockey pucks, boxing gloves, footballs, golf balls, and all manner of sports equipment. A.G. Spalding & Bros. made the world's first basketball in 1894, at the request of the game's inventor, Dr. James Naismith.

(C) Double Header baseballs, J. de Beer & Son, Albany, New York

(D) Dead Red baseballs, Peck & Snyder, New York, New York

(E) Henley roller skates, Richmond Roller Skate Company, Richmond, Indiana

(B) 1905

(A) 1905

(C) 1919

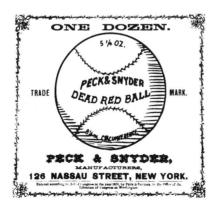

(D) 1870

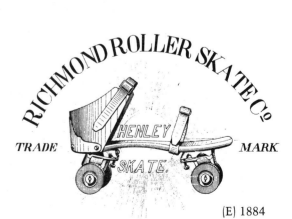

(E) 1884

Trade Unions

Just as manufacturers have used trademarks and distinctive packaging to build customer loyalty to their goods, so trade unions have used labels to enlist public support by identifying the products of union workers. In the struggle for higher wages and better working conditions, the union label has brought the power of the buying public to bear on otherwise isolated disputes. And because the labels cannot be applied without the consent of the manufacturer, they are also a symbol of labor-management cooperation.

The Carpenters' Eight Hour League, in San Francisco, introduced the first known union product mark in 1869 when it provided stamps to all planing mills working on an eight-hour day. The San Francisco chapter of the (**A**) **Cigar Makers International Union** produced the first union label in 1874 as part of a racial battle with Chinese workers. While later labels relied on public support of union aims, the first cigar makers' label appealed to racial hatred—with the words *white labor* prominently displayed. A modified label was adopted for national use in 1880, without the anti-Chinese wording. By 1900 the union was supplying two million labels each month to shops that employed union workers.

Other unions saw the success of the cigar makers' label and began to bring out their own. The (**B**) **United Hatters of North America** introduced its first label in 1885, and by 1890 labels were being used by the (**C,D**) **Boot & Shoe Workers Union**, the (**E**) **Horse Collar Makers National Union**, the Iron Molders Union of North America, and the (**F**) **International Typographical Union.**

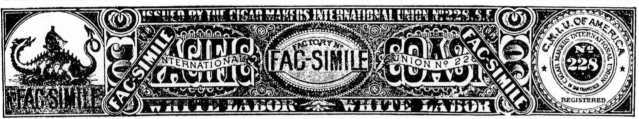

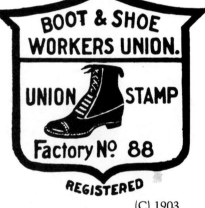

(A) about 1875

(C) 1903

(B) 1890

(E) 1890

(F) 1890

(D) 1890

(A) United Brotherhood of Leather Workers
(B) Carriage and Wagon Workers' International Union
(C) Coopers' International Union
(D) Cloth Hat & Cap Makers Union of Boston
(E) United Garment Workers of America

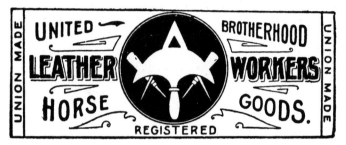

(A) 1900

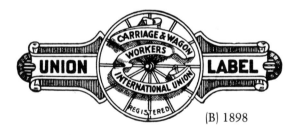

(B) 1898

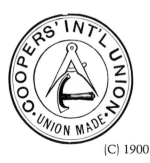

(C) 1900

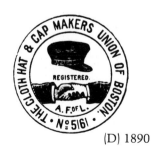

(D) 1890

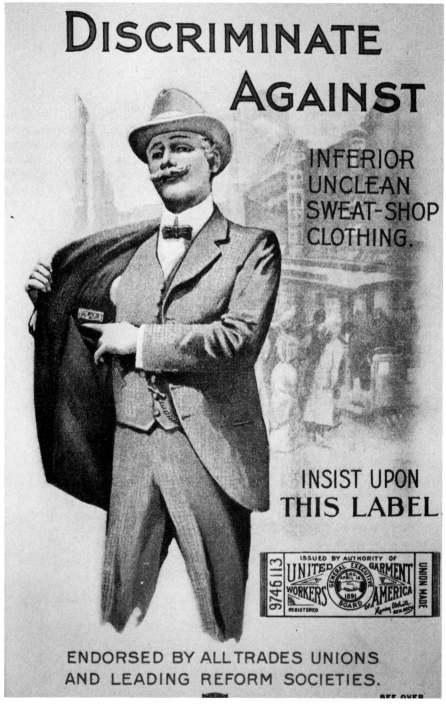

(E) 1902 advertisement

211

(A) 1894

(A,B) The American Federation of Labor, organized in 1881 to promote the interests of all member unions, recognized very early the power of the union label and in 1890 began to include a directory of the marks in its annual publication. In 1909 it went even further, forming the Union Label Department to serve the needs of the fifty-two member groups that were by then using labels in their work. Today, the Union Label & Service Trades Department of the AFL-CIO coordinates efforts to educate the public about union labels and is in charge of maintaining the official list of endorsed boycotts.

(C) Amalgamated Wood Workers International Union of America
(D) United Mine Workers of America
(E) Tack-Maker's Protective Union of the United States and Canada
(F) Brotherhood of Railway Carmen of the United States and Canada
(G) Operative Plasterers' and Cement Masons' International Association

(E) 1890

(G)

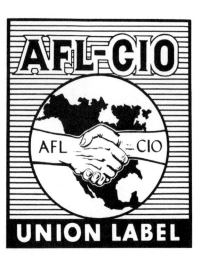

(B) 1956

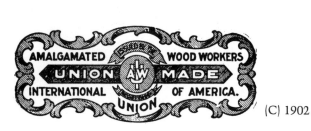

(C) 1902

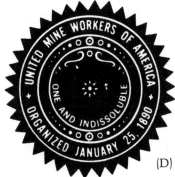

(D)

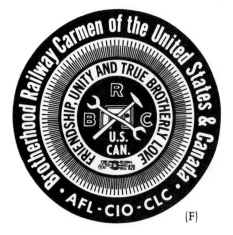

(F)

Perhaps the most famous of all the union labels is that of the **(A) International Ladies' Garment Workers' Union.** Introduced in 1958, it has been widely promoted on radio and television with a song that begins, "Look for the union label when you are buying a coat, dress, or blouse . . ."

(B) International Brotherhood of Teamsters, Chauffers, Warehousemen, and Helpers of America

(C) Industrial Union of Marine & Shipbuilding Workers of America
(D) International Molders and Allied Workers Union
(E) United Brotherhood of Carpenters and Joiners of America
(F) United Farm Workers Organizing Committee
(G) United Association of Journeymen and Apprentices of the Plumbing and Pipe Fitting Industry of the United States and Canada
(H) International Brotherhood of Electrical Workers

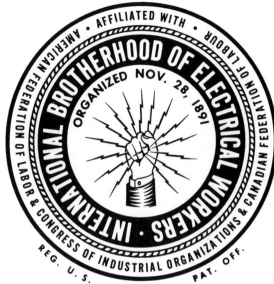

(H) 1971

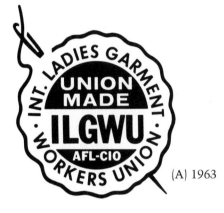

(A) 1963

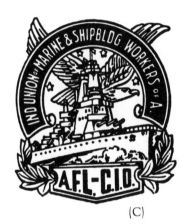

(C)

(E) 1900

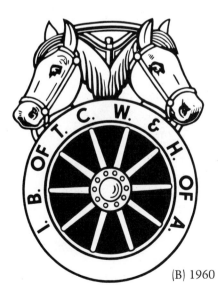

(B) 1960

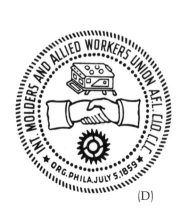

(D)

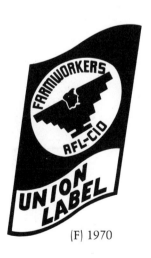

(F) 1970

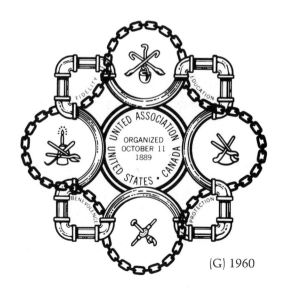

(G) 1960

Clubs and Groups

Robert S.S. Baden-Powell developed the idea of scouting while commanding British troops in South Africa. He rewarded the good work of his soldier scouts with a badge to wear on the sleeve, in the form of a fleur-de-lis, the design that marks north on a compass. He later used the honor patch as the emblem for the Boy Scouts. The motto "Be Prepared" also came from Baden-Powell's military days in South Africa. His troops chose it as their slogan, partly because it incorporated Baden-Powell's initials.

Scouting spread to the United States in 1910 with the founding of the **(A) Boy Scouts of America.** As a patriotic gesture, the fleur-de-lis of the British Boy Scouts was filled with a crested bald eagle. The **(B) Cub Scouts** were organized in 1930 as a starting ground for younger boys.

Juliette Gordon Low brought scouting for girls to the United States in 1912, with a troop of Girl Guides in Savannah, Georgia. The name was changed to **(C,D) Girl Scouts** the following year, and a national headquarters was established in Washington, D.C. For an emblem, the Girl Scouts chose a clover-leaf design, or trefoil. The basic outline of the emblem has held fast through the years but the filling has seen some changes—from an eagle to the contemporary profile emblem designed in 1978 by Saul Bass/Herb Yager & Associates, Inc.

(E,F,G) The Campfire Girls began in South Casco, Maine, in 1910, two years before the Girl Scouts. Cofounder Charlotte Vetter Gulick coined the Campfire watchword, "Wohelo," from the words *work, health,* and *love,* and wrapped it around the group's first em-

blem. The fire picture was added in 1946. When the group began to admit boys in 1975, the old name was shortened to Camp Fire, Inc., and two years later a stylized flame replaced the campfire emblem. Since 1913, children too young for the main program have been able to join the Blue Birds.

(E) 1910

(C) 1914

(F) 1953

(A) 1981

(B) 1982

GIRL SCOUTS

(D) 1978

(G) 1978

(A) 1960

(D) 1967

"GOOD WILLY"

*Where there's Goodwill
—there's a way.*

(C) 1952

Early efforts to provide out-of-school activities for disadvantaged boys led to the founding of local **(A) Boys' Clubs** in the 1870s and '80s. In 1905 the scattered groups organized as the Federated Boys' Clubs and chose Jacob Riis, the well-known social reformer, as their first president. Boys' Clubs of America is still going strong, providing group activities, recreation facilities, and job placement to boys across the country.

The blue-suited soldiers of the **(B) Salvation Army,** ringing bells and playing music around a fund-raising kettle, are a familiar Christmas sight. They've been hanging those kettles on street corners since 1891. The Salvation Army was founded in England in 1878 by evangelist William Booth and arrived in the United States two years later with missions in New York, New-

ark, and Philadelphia. The red shield has been leading the Salvation Army's war on sin and poverty since 1918.

Milton Caniff, the artist who created Steve Canyon and Terry and the Pirates, drew the Good Willy character for **(C,D) Goodwill Industries** in 1950. With his lunch box and wheelchair, Good Willy represents Goodwill's efforts to train the handicapped for employment. The bold-lined modern trademark, designed in 1966 by Selame Design Associates, is better suited to use on signs.

Organizations to coordinate fundraising for charities have been around since 1887. They were called War Chests during World War I, **(E) Community Chests** from the twenties through the forties, the National War Fund in World War II, and United

Funds in the fifties and sixties. The United Funds were reorganized in 1970 into the **(F) United Way of America,** which adopted the cupped-hand mark, designed by Saul Bass & Associates in 1972.

(E) 1945

(B) 1918

(F) 1972

215

A common sight on the roadside leading into towns and cities is a bank of signs with the emblems of fraternal organizations, alerting traveling members to the presence of local chapters. For most of the societies those signs are as far as their public-information programs go.

(A,B) The Masons are among the tightest-lipped of all the fraternal groups, though they announce their presence in the community with prominent buildings to house their local lodges. Masonic temples are easily recognized by the compass and square emblem over the door. The Masons use an encyclopedia of symbols in their rites behind those doors, but the compass and square is the only one allowed out in public. The *G* in the center stands for *God* and *geometry*.

Freemasonry began in England in the seventeenth century, when the working stonemason guilds began to accept educated gentlemen as honorary members. The practice had gained a strong foothold in the United States by the time of the Revolution, counting among its members George Washington, Benjamin Franklin, Paul Revere, and John Hancock. Masonic historians attribute many Revolutionary plots, such as the Boston Tea Party, to members of the organization, but without much substantive evidence. In 1826 a man named William Morgan disappeared after infiltrating the Masons for the purpose of exposing their rites. Many suspected he had been murdered, and the resulting outcry against the organization cut deep into its membership for several years. Two main branches of

Freemasonry survive in this country: the York Rite, culminating in the Knights Templar, and the Scottish Rite. Both share common initiation rites, so that new Masons can choose between them after moving partway up the Masonic hierarchy. The highest order of the Scottish Rite is the 33rd degree, the symbol of which is a double-headed eagle. The emblem's trademark registration claims use since 1801.

The Independent Order of Odd-Fellows also had its start in England, as a secret society of mechanics in the late eighteenth century. It came to this country with a lodge in Baltimore in 1819 and gained greatly from the public's anger at the Masons during the 1820s. Several "fun" orders split from the Odd-Fellows beginning in 1865, and in 1924 these combined into the **(C)**

Ancient Mystic Order of Samaritans. The Samaritans functions primarily as a mutual-aid society, but also contributes to programs for the mentally retarded.

(D) The Benevolent and Protective Order of Elks began as a drinking fraternity of vaudeville actors in 1868, led by an English singer named Charles Vivian. They first called themselves the Jolly Corks, after a British fraternity, then changed to the Elks after rejecting the Foxes ("too cunning"), the Beavers ("too destructive"), the Bears (judged "coarse, brutal and morose"). The Elks today are one of the largest and most secretive of the fraternal orders.

(A) 1975

(B) 1983

(C) 1961

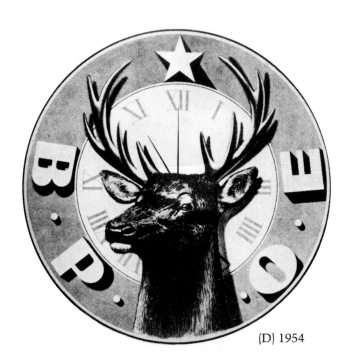

(D) 1954

(A) **The Order of Red Men,** like the Masons, claims roots in secret societies of patriots during the Revolution. It was not until 1813, however, that a society was formed with the Red Men name, and not until 1847 that local tribes joined into a national organization. The order reached a peak of more than half a million members in 1920 and today promotes the ideals of American patriotism and contributes to health care and education for American Indian children.

Perhaps the most service-oriented of all the fraternal societies is **(B) The International Association of Lions Clubs,** begun in 1917 by a young Chicago insurance salesman named Melvin Jones. He disliked the self-centered and commercial motives of the existing fraternal organizations and determined to form a club whose primary aim was to help others. The Lions Clubs today count more than a million members worldwide, engaged in all manner of charitable activities.

(C) Rotary International is also devoted to charitable work, concentrating on aid to the disabled. The group got its start in Chicago in 1905 and chose the emblem of the wheel at one of the first meetings. The earliest design was a simple wagon wheel, changed to a gear wheel in 1912. The current design, including a mechanically correct keyway in the center, was adopted in 1923.

(D) Kiwanis International began in Detroit in 1914 as the Benevolent Order of Brothers, a fraternal club of business and professional men. Members chose the name Kiwanis the following year, believing it an Indian phrase meaning *we trade.* They have since revised the translation to *we have good time—we make noise.* Founder Allen S. Browne was driven out of the De-troit lodge in 1915 when members began to suspect that he was making too much money from their entrance fees. In fact, Browne had started Kiwanis for his own profit, and it was not until the national organization paid him $17,500 in 1919 that he finally relinquished his rights to the Kiwanis name. Kiwanis today is a thriving organization of more than three hundred thousand members.

(E) Hells Angels motorcycle club, Oakland, California
(F) American Youth Hostels, Inc., Northfield, Massachusetts
(G) The American Automobile Association, Falls Church, Virginia

(E) 1982

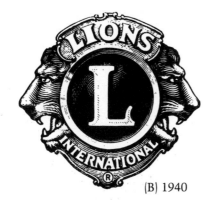
(B) 1940

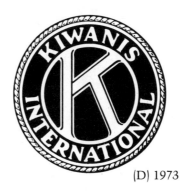
(D) 1973

(F) 1937

(A) about 1890

(C) 1951

(G) 1976

217

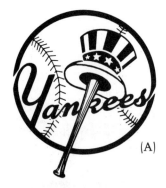
(A)

(E)

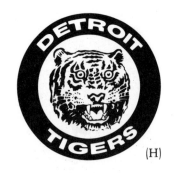
(H)

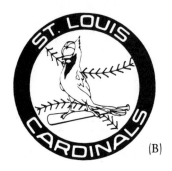
(B)

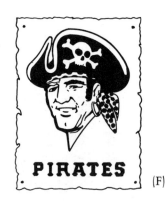
(F)

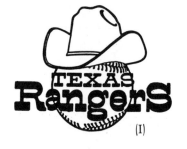
(I)

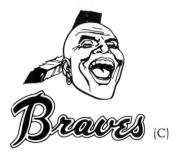
(C)

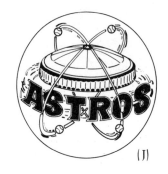
(J)

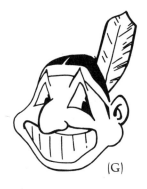
(G)

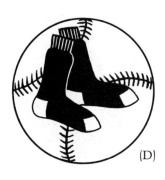
(D)

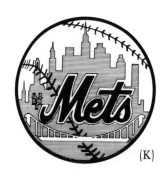
(K)

Sports Teams

The early history of baseball is clouded in legend and confusion. In 1907 a special committee named Abner Doubleday as the inventor of the game and Cooperstown, New York, as its birthplace in 1839. But references to baseball have been discovered in books published as early as 1744, and the game was certainly being played well before Doubleday came along. The baseball diamond with ninety-foot base lines was established in a set of rules laid down in 1845 by the New York Knickerbockers, and the nine-inning game length was fixed in an 1858 agreement between New York and Massachusetts teams. The first professional baseball league was formed in 1871, but problems with drinking and gambling at games led in 1876 to the founding of the National League of Professional Baseball Clubs, a dry organization that prohibited gambling and Sunday matches. The competing American League began in 1901. Since 1903 the two leagues have cooperated in staging a postseason World Series between their top teams, the first one won by the American League's Boston Red Sox.

(A) New York Yankees
(B) St. Louis Cardinals
(C) Atlanta Braves
(D) Boston Red Sox
(E) Minnesota Twins
(F) Pittsburgh Pirates
(G) Cleveland Indians
(H) Detroit Tigers
(I) Texas Rangers
(J) Houston Astros
(K) New York Mets

American football began as a college game, mixing the British sports of soccer and rugby. Rutgers and Princeton played the first intercollegiate game in 1869, with twenty-five players on a side and a round ball that could be kicked or butted only with the head and shoulders. McGill, in an 1874 series with Harvard, introduced some elements of rugby to the game—an oblong ball and rules that allowed players to carry it in their hands. By 1882 the game included a scrimmage line, a quarterback to receive the snap, and a system of downs and yardage gains to ensure aggressive play.

Professional teams began to take in the college graduates in the 1890s, beginning with clubs in small industrial cities in Pennsylvania, and spreading through New York, Ohio, and Indiana. The first attempt at a national organization came at a 1920 meeting in the back room of a Canton, Ohio, automobile agency. Jim Thorpe was appointed president of the resulting association, which became the National Football League in 1922. Since World War II professional football has challenged baseball as America's favorite spectator sport.

(A) Chicago Bears
(B) Buffalo Bills
(C) Seattle Seahawks
(D) Dallas Cowboys
(E) Atlanta Falcons
(F) Philadelphia Eagles
(G) Houston Oilers
(H) Denver Broncos
(I) Los Angeles Rams
(J) Washington Redskins
(K) Miami Dolphins
(L) Los Angeles Raiders

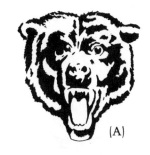
(A)

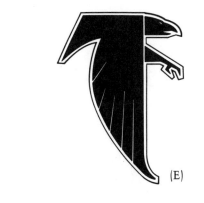
(E)

WASHINGTON

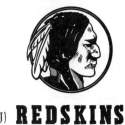
(J) REDSKINS
(I)

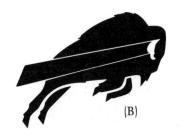
(B)

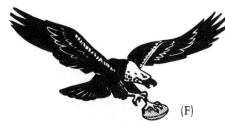
(F)

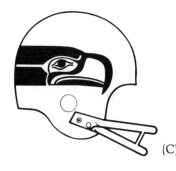
(C)

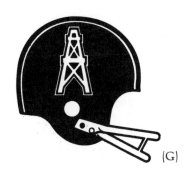
(G)

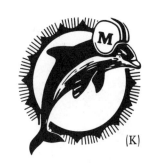
(K)

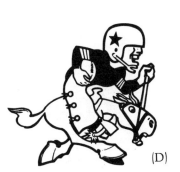
(D)

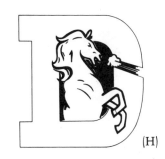
(H)

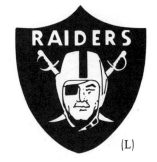
(L)

219

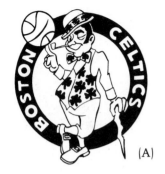

(A)

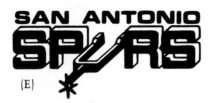

(E)

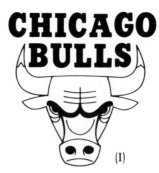

(I)

James Naismith and Luther H. Gulick (founder of the Campfire Girls) created basketball in 1891 as a recreational game for young people. Naismith taught it to his students at the Springfield, Massachusetts, YMCA, and through that organization the game spread quickly over the country. The first professional teams were formed in the 1890s, but they were not organized into a stable league for many years, and they trailed far behind college teams in popularity until after World War II. The National Basketball Association was formed in 1949. Through the fifties, it built basketball into a major professional sport—with the help of such crowd-pleasing stars as Bill Russell, Bob Cousy, and Wilt Chamberlain.

(A) Boston Celtics
(B) Los Angeles Lakers
(C) Cleveland Cavaliers
(D) Indiana Pacers
(E) San Antonio Spurs
(F) Milwaukee Bucks
(G) Washington Bullets
(H) Detroit Pistons
(I) Chicago Bulls
(J) Denver Nuggets
(K) Utah Jazz
(L) Philadelpia 76ers

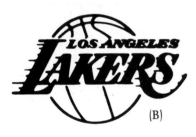

(B)

(F)

(J)

(C)

(G)

(K)

(D)

(H)

(L)

The first ice-hockey game was played in Kingston, Ontario, in 1855 between two teams from the Royal Canadian Rifles. Students at McGill University refined the game in the 1870s, drew up rules, and started an amateur league. Professional teams soon took advantage of the growing popularity of the game, and in 1909 they banded together in the National Hockey Association, which included teams from Montreal, Toronto, and Ottawa.

In 1893 Lord Stanley of Preston, the governor-general of Canada, presented a cup to be awarded to the best amateur hockey team in the country. The Stanley Cup slipped into the hands of professional players in 1912 as the prize for a playoff game between the NHA and the Pacific Coast Hockey League. In 1917 the National Hockey League replaced the NHA, and over the next several years it absorbed the teams of the PCHL. From six teams in 1942—Montreal, Chicago, Boston, Detroit, New York, and Toronto—the NHL has grown to twenty-one clubs extending as far south as Los Angeles.

(A) Edmonton Oilers
(B) New York Islanders
(C) Vancouver Canucks
(D) Philadelphia Flyers
(E) Calgary Flames
(F) Detroit Red Wings
(G) Toronto Maple Leafs
(H) Hartford Whalers
(I) Montreal Canadiens
(J) Chicago Black Hawks
(K) Pittsburgh Penguins
(L) Buffalo Sabres

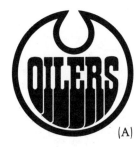
(A)

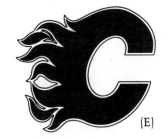
(E)

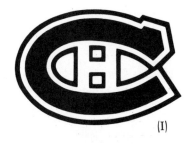
(I)

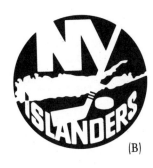
(B)

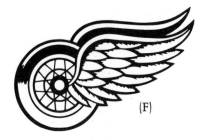
(F)

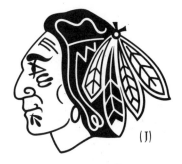
(J)

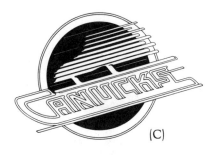
(C)

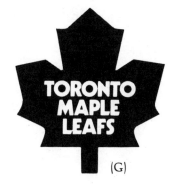
(G)

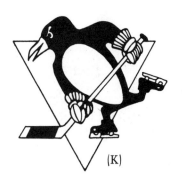
(K)

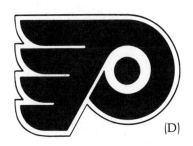
(D)

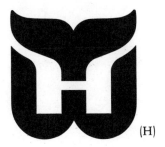
(H)

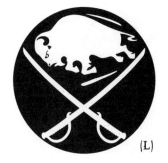
(L)

221

Some Foreign Favorites

This book is about American symbols, but a number of foreign trademarks have established such a loyal following in this country that it hardly seems fair to leave them out.

(A) Edouard and André Michelin ran a small rubber factory in Clermont-Ferrand, France, when an English bicyclist wheeled in for a tire repair. The brothers fixed the flat, but the difficulty of the job set them to thinking about tire design, and in 1891 they introduced the world's first detachable pneumatic tire. In the succeeding ninety years, the Michelins' business has grown from that small rubber factory with eleven employees into a worldwide operation with fifty-two plants.

Mr. Bib, the Michelin tire man, was created in 1895 by the artist O'Galop (Maurice Rossillon) for an advertising poster. In his debut appearance he held a champagne glass in his hand and gave a Latin toast: *Nunc est bibidendum* (Now is the time to drink). His full name, Bibidendum, came from that toast and has since been shortened to the more manageable Mr. Bib.

(B) Callard & Bowser candies and sweetmeats, Callard & Bowser, Ltd., London, England. Callard & Bowser has used the thistle symbol on its candies since 1860, and the current design is little changed from the one pictured here.

(C) Pears soap, A. & F. Pears, Ltd., London, England. The pear design has been used since 1878.

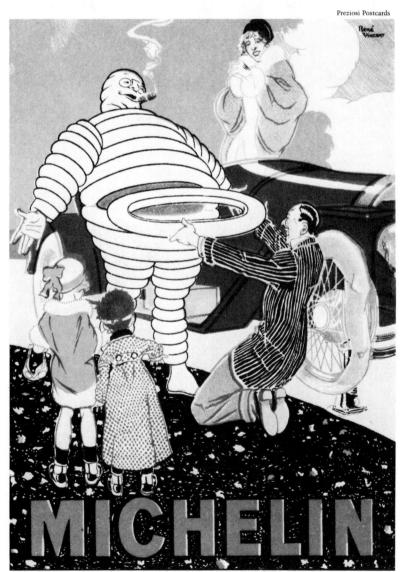

Preziosi Postcards

(A) advertising poster, about 1910

(B) 1894

(C) 1893

(A) J. & J. Colman of London first registered the Bull's Head trademark in the United States in 1886, for concentrated mustard oil. By then it was already an old and established symbol, famous enough to rate copying by the makers of Genuine Durham smoking tobacco (see page 89). According to the registration, the Colmans had used the design on their mustard products since 1855.

(B) Mercedes-Benz automobiles and trucks, Daimler-Benz Aktiengesellschaft, Stuttgart, Germany. The company has used the three-pointed star as a symbol for its cars since 1909.

(C) Volkswagen automobiles and trucks, Volkswagenwerk GmbH, Wolfsburg, Germany. The trademark was designed in 1950, and is now controlled in this country by Volkswagen of America, Inc.

(D) Austin automobiles, Austin Motor Company, England

(E) Kiwi boot polish, Kiwi Polish Company Proprietary Limited, Richmond, Australia. The Kiwi name and design were adopted in 1906 in honor of the founder's wife's homeland—New Zealand.

(B) 1957

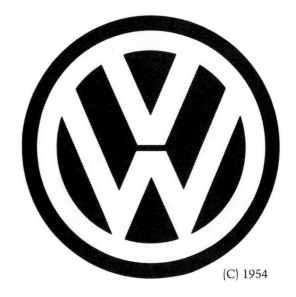

(C) 1954

(D) 1911

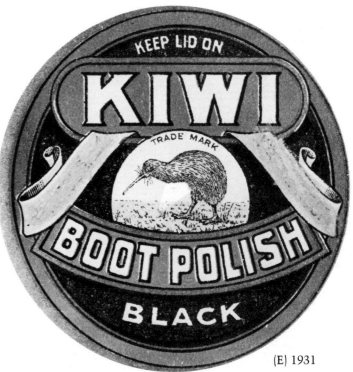

(E) 1931

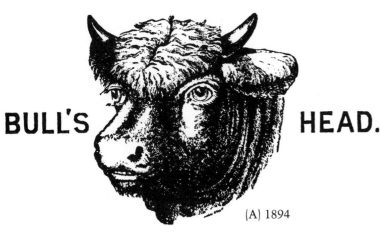

BULL'S HEAD.

(A) 1894

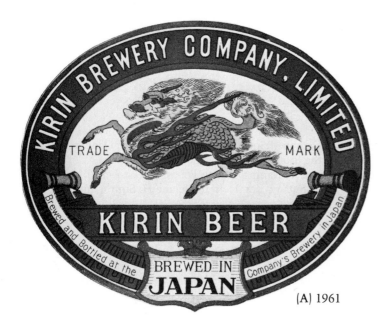

(A) 1961

(B) 1937

(C) 1933

(D) 1935

(E) 1914

(A) Kirin beer, Kirin Beer Kabushiki Kaisha, Tsurumi-ku, Yokohama, Japan. The dragon design has been on the Kirin beer label since 1885. A sharp-eyed reader of Japanese characters should be able to find the word *Kirin* hidden in the beast's mane.

(B) Cutty Sark blended scotch whisky, Berry Bros. & Company, London, England. The whisky was named in 1923 for the last of the great tea clippers, which had that year been saved for restoration as a training ship. Artist James McBey came up with the name and sketched the label.

(C) Johnnie Walker scotch whisky, John Walker & Sons, London, England

(D) Black & White blended scotch whisky, James Buchanan & Company, London, England

(E) White Horse scotch whisky, Mackie & Coy, Distillers, Glasgow, Scotland. The symbol, adopted in 1890, is taken from the sign of the White Horse Inn of Edinburgh, famous for its whisky since 1742.

Acknowledgments

The size and broad focus of this book require a list of thanks somewhat longer than most. The book would truly not have been possible without the help of a great many people. Special thanks are due to my editor, Gerry Howard, who suggested the project and encouraged me through the long course of its research, to Kerry Tucker, who gave perceptive advice at every stage, to Susanna Kaysen for her work with the final text, Rick Balkin for taking many of the worries off of my shoulders, and to Matt Ulinski, Laura Morgan, and Caryl and Michael Marsh for providing a home away from home during my research trips to Washington.

Perhaps the greatest debt is due to those at the Patent and Trademark Commission who bent over backwards to accommodate the special requirements of the project—Margaret Lawrence, Keturah Patrick, Ellen J. Seeherman, Oscar Mastin, William Craig, Linda Haskins, Kathy Dixon, Virginia Johnson, and Butch Campbell. Veteran trademark researcher John Jennison was always ready with advice to aid my work in the Trademark Search Room. Lorene Mayo, Vanessa Broussard, and Spencer Crew were also a tremendous help in guiding me through the Warshaw Collection of Business Americana at the Smithsonian Institution. And Bernard Riley, Curator of Prints and Photographs at the Library of Congress, provided timely insights into early trademark and copyright records. John E. Mara at the Union Label & Service Trades Department of the AFL-CIO was a great help in opening the door to research on trade union labels, and William H. Richter at the Barker Texas History Center, The University of Texas at Austin, uncovered some valuable material on cattle brands. Lippincott & Margulies, Inc. provided insightful material on current views of trademark function and design.

Many individuals and collectors provided artwork from their collections and expertise from their own research, including Don Preziosi, Newly Preziosi, Andreas Brown, Henry Deeks, David Bowers, Rose Treat, Jeanne Kantianis, and Judith Walthall. For their help in my search for the perfect Mail Pouch barn, thanks to Richard Tucker, Betty Tucker, and Don Tucker. And for his photographic contribution from the West Coast, thanks to Ken Boege.

The greatest cumulative contribution came from the many companies that provided me with information on their histories and with photographs of their trademarks. Thanks to Colette C. Carey at American Presidential Lines, Carol L. Cavan at Capitol Records, A.R. Huband and Carol Preston at the Hudson's Bay Company, Rhanda Elizabeth Spotton at Air Canada, Barbara Peterson at Boise Cascade Corporation, Richard E. Londgren at the Weyerhaeuser Company, the International Paper Company, Revere Copper and Brass Incorporated, Robert J. Chandler at the Wells Fargo Bank, Theresa G. Knoblich at The Quaker Oats Company, Diane Dunne at R.R. Donnelley & Sons, Land O' Lakes, Inc., Lee M. Albert at Savage Industries, Inc., Barrie H. MacKay at Shawmut Bank of Boston, V. Milton Boyce at 4-H and Youth Development, Richard D. Frybarger at Deere & Company, Ron Scherer at DeKalb AgResearch, Inc., Cameron C. Dubes at Future Farmers of America, Judy T. Massabny at the National Grange, Annette De Lorenzo at International Harvester, Frankye A. Dussling at The Upjohn Company, W.B. McDowell at E.R. Squibb & Sons, H. Kenneth Shaw at Scholl, Inc., Barbara Distasi at Shulton, Inc., D.J. Butler at the Helme Tobacco Company, Joyce M. LiSanti at The American Tobacco Company, Charles G. Lamb at the Brown & Williamson Tobacco Corporation, Robert J. Herta at The Stroh Brewery, Patti Jones at the Pabst Brewery Company, Cyndia Estook at the Adolph Coors Company, the Miller Brewing Company, the Rainier Brewing Company, Carl Bolz at Anheuser-Busch Companies, Debbie Carter at the Southern Comfort Corporation, Roger E Brashears Jr. and John J. Davis III at Jack Daniel Distillery, Lem Motlow Prop., Inc., N. Frontani at the National Distillers Products Company, Annette Perlman at Joseph E. Seagram & Sons, Inc., Ronald Giglio at Safeway Stores, Inc., Wells Norris at IGA Inc., G.E. Clerc Jr. at Winn-Dixie Stores, Inc., R. Dianne Higgs at Piggly Wiggly, Jo Ann Shurpit and William F. Kraeger at Libby, McNeill & Libby, Inc., Don Osell and Ann Waara at The Pillsbury Company, Les Landes at Pet Incorporated, Debbie Foster at Heinz U.S.A., Janis Astle at the Burnham & Morrill Company, James H. Moran at the Campbell Soup Company, Marguerite Dannemiller at the Stouffer Foods Corporation, Roberta E. Christ at Van de Kamp's Frozen Foods, the Gerber Products Company, Ken Defren, Helane H. Smith, and Kim Dickey at the General Foods Corporation, Larissa Albin at Hills Bros. Coffee, Inc., Greg Ernest at The Beecham Group, Jane Tesdall at Tropicana, Allan G. Bates at Salada Foods, Inc., Edythe Masten at Thomas J. Lipton, Inc., Harry E. Ellis at the Dr. Pepper Company, Harry Gold at KBI Inc., Philip F. Mooney at The Coca-Cola Company, Frank Sands at the Sands, Taylor & Wood Company, Nell Hopson at Uncle Ben's, Inc., David M. Feldman at Church & Dwight Co., Inc., Francis F. Brooks at The William G. Bell Company, Christine Pines at Best Foods, Hulman & Company, Jane Dudley at Morton Thiokol, Inc., David Stivers at Nabisco Brands, Elmer Richars and Alpheus E. Forsman at the Ralston Purina Company, the Kellogg Company, W.A. Stimeling, Steve Kunkler, and Kathy Kaufman at Borden, Inc., Lori Bevis at the Eskimo Pie Corporation, Linda Moser at the Perfection Biscuit Company, Judith C. Clark at Drake Bakeries, Marie Jordan at Tootsie Roll Industries, Inc., Deborah C. Ryerson and J. Brian Herrmann at the Hershey Foods Corporation, William R. Deeter at M&M/Mars, Linda Hanrath at the Wm. Wrigley Jr. Company, Steven M. Peck at Fleer Corp., Susan Funk at Harry and David, John Black at Skookum, Inc., R. William Winkler at Sun-Diamond Growers of California, Albin J. Moderacki at the Quality Bakers of America Cooperative, Gloria Rascoe at the Continental Baking Company, Nancy Fisher at the Howard Johnson Company, Billie Brown at Kentucky Fried Chicken, William Krestel at White Castle System, Inc., Lynn Stulik at the McDonald's Corporation, Curtis J. Wellington at Wendy's International, Sandy McDougald at AFA Service Corporation, Pizza Hut, Inc., Robert M. Rosenberg at Dunkin' Donuts Incorporated, Max Rosey at Nathan's Famous, Jo Martin at Chicken Delight International, Barry Pelissier at Big Boy Restau-

rants of America, Kris Stewart at Holiday Inns, Inc., Lori Wilt at Best Western International, Inc., Oscar Sales Jr., at Elgin Watch International, Inc., Renee Burton at AT&T, John I. Taylor at the Zenith Electronics Corporation, Charles A. Ruch at the Westinghouse Electric Corporation, Thomas G. Mattia, A.W. White, and Jonas Klein at the International Business Machines Corporation, Richard M. Perdue at Texas Instruments Incorporated, G.P. Foster at Samson Ocean Systems, Inc, Robert L. Shaffer at the Reynolds Metals Company, W. Richard Barnhart at the United States Steel Corporation, Hugh Wiberg at the Dennison Manufacturing Company, D.E. Follmer at 3M, Dean Rodenbough at Binney & Smith, Inc., Rita Coughlin at Berol USA, the Bic Corporation, Cheryl M. Bilinsky at The Pep Boys—Manny, Moe & Jack, Harvey Duck at the STP Corporation, Donald L. Stevens at The White & Bagley Company, John Leone at Boyle-Midway, the Phillips Petroleum Company, D.A. Stelzer at the Marathon Oil Company, Judith Kaminsky at Standard Oil Company (Indiana), Hugh B. Jordan at the Exxon Corporation, Donald Tuchman at the Mobil Oil Corporation, James L. Tolley and R.E. LeFaive at the Chrysler Corporation, Annette P. Brewer at The Goodyear Tire & Rubber Company, Sandi Gridley at OMC Lincoln, Keith M. Andrews at the Bear Automotive Service Equipment Company, Charles Henry at Great Dane Trailers, Inc., W.E. Restmeyer at Mack Trucks, Inc., R.E. Walters at the Ford Motor Company, The Greyhound Corporation, the Union Pacific System, Robert E. Gehrt at the Santa Fe Southern Pacific Corporation, Lloyd D. Lewis and Franklin J. Carr at The Chessie System Railroads, Sue S. Martin at the National Railroad Passenger Corporation, Kay Lund at United Airlines, Ann Whyte at Pan American World Airways, Elliott Trotta and Ethel Gammon at Eastern Air Lines, Anne Saunders at Trans World Airlines, John Hotard at American Airlines, People Express Airlines, Lee Lathrop and Marilyn A. Phipps at The Boeing Company, Harry Gann at the McDonnell Douglas Corporation, Patricia S. Eldredge at The Sherwin-Williams Company, Ben Stark at the Faultless Starch/Bon Ami Company, Joe Kern at the United States Borax & Chemical Corporation, Trena Packer at Plough, Inc., M.A. Molnar at The Mennen Company, Edward M. Ryder at The Procter & Gamble Company, Shirley M. Stadnicki at Spalding Sports Worldwide, Bob Mayhall and D. Hampton at Blazon-Flexible Flyer, Jim Lucas and Lester Schwartz at the Union Underwear Company, Mary E. Marckx at Nike, Inc., John R. Birkby at Brown Group, Inc., Hulene Morgan at the Cannon Mills Company, Suzanne B. Calkins at C.F. Hathaway, Robert R. Rosenthal at the Stetson Hat Company Group, Arthur McArthur at Jantzen, Inc., Brooks Brothers, Joyce Bustinduy at Levi Strauss & Company, David G. Lowe and L.M. Tarnoski at the Lee Company, Joseph A. Fazzino at The Hartford, Stephanie E. Yoder at the Provident National Bank, S.M. Getzoff at American Express, David Alcorn at Merrill Lynch & Co., Inc., Aubrey E. Hawes at The Chase Manhattan Bank, Rae Jones at the Allstate Insurance Company, Sandy Sandusky at The Travelers Companies, David Cotner at Nationwide Insurance, Richard Mathisen at The Prudential Insurance Company of America, Jill Frisch at The New Yorker, Margery B. Griffith at The United States Playing Card Company, William Gaines at E.C. Publications, Amy Horvath at Playboy Enterprises, Naomi L. Woolever at Grit, Lucia Kelly at Harper & Row, Publishers, Katharine Vogel at the George Meany Memorial Archives of the AFL-CIO, Charles H. Pillard at the International Brotherhood of Electrical Workers, Robert E. Lazar at the International Ladies' Garment Workers' Union, James E. Wolfe at the International Molders and Allied Workers Union, Melvin H. Roots at the Operative Plasterers' and Cement Masons' International Association, Vickie Krehbiel at the United Mine Workers of America, Clyde H. East at the International Typographical Union, the United Brotherhood of Carpenters & Joiners of America, the International Brotherhood of Teamsters, Chauffers, Warehousemen, and Helpers of America, Audrey F. Clough at Boy Scouts of America, Cheryle Bartolo at Girl Scouts of the United States of America, Dotti Thompson at Camp Fire, Inc., W. Allan Wilbur at the American Automobile Association, Emmett Thompson II at the United Way of America, David M. Cooney at Goodwill Industries of America, Inc., Leon Ferraez at The Salvation Army, Harold T. Swindler at the Ancient, Mystic Order of Samaritans, Jonathon Fiske at Rotary International, Kiwanis International, Lions Clubs International, the Great Council of the United States Improved Order of Red Men, the National League of Professional Baseball Clubs, Michelle Brown at NBA Properties, Bob Bell at the Licensing Company of America, the National Hockey League, the National Football League, Dawn E. Hawks and Linda M. Matynowski at Volkswagen of America, Inc., John Miller at The Buckingham Corporation, and the Michelin Tire Corporation.

BIBLIOGRAPHIC NOTES

Listed here are some of the richest sources of information drawn on in the research for this book. It is intended for those who may want to read further in particular areas, and is arranged loosely to correspond with the order of material in the book.

The greatest single source of information on trademarks is to be found in the trademark registrations at the Commission of Patents and Trademarks in Washington. Several libraries around the country have patent and trademark collections which include condensed versions of the registrations. Two journals for trademark attorneys, the *Trademark Bulletin* and the *Trademark Reporter*, also contain a wealth of information on trademark law and history. For additional information on the history of trademark law, see Clayton L. Smith, *The History of Trademarks* (1923), Orlando F. Bump, *The Law of Patents, Trade-Marks and Copyrights* (1877 and 1884), and Francis H. Upton, *A Treatise on the Law of Trade Marks* (1860). A good introduction to modern trademark law can be found in John D. Oathout's *Trademarks: A Guide to the Selection, Administration, and Protection of Trademarks in Modern Business Practice* (1981).

There are several good books on aspects of trademark design, including Barbara Baer Capitman, *American Trademark Designs* (1976), Egbert Jacobson, editor, *Seven Designers Look at Trademark Design* (1952), Ann Ferebee, *A History of Design from the Victorian Era to the Present* (1970), David E. Carter, *The Book of American Trademarks* (1972–1983, annual), Raymond Loewy, *Never Leave Well Enough Alone* (1950), and Cipe Pineles Golden, *The Visual Craft of William Golden* (1962).

Good general histories of American commerce and well-known merchandise brands can be found in Daniel Boorstin, *The Americans: The Democratic Experience* (1973), Alex Groner, *The American Heritage History of Business and Industry* (1972), David Powers Cleary, *Great American Brands* (1981), General Foods Corporation, *General Foods Family Album* (1948), Hannah Campbell, *Why Did They Name It?* (1964), and William Cahn, *Out of the Cracker Barrel: The Nabisco Story* (1969).

The back issues of *Modern Packaging* are a tremendous source of information on the history of package design and technology. Particularly useful are the special "Packaging Hall of Fame" articles printed monthly between 1949 and 1953. A good book on the history of packaging is Alec Davis, *Package and Print: The Development of Container and Label Design* (1967).

Good histories of advertising can be found in Stephen Fox, *The Mirror Makers: A History of American Advertising and Its Creators* (1984), Julian Lewis Watkins, *The One Hundred Greatest Advertisements* (1949), Ralph M. Hower, *The History of an Advertising Agency: N. W. Ayer & Son at Work, 1869-1949* (1949), Frank Presbrey, *The History and Development of Advertising* (1929), and the back issues of *Printer's Ink*, the trade journal of the advertising industry.

For background on the bald eagle as an American design motif, see Philip M. Isaacson, *The American Eagle* (1975), and for the full story of Uncle Sam see Alton Ketchum, *Uncle Sam: The Man and the Legend* (1959).

An excellent book on the stereotyping of blacks in commercial art is the Berkeley Art Center Association's catalogue, *Ethnic Notions: Black Images in the White Mind* (1982). A detailed history of the Aunt Jemima brand can be found in Arthur F. Marquette, *Brands, Trademarks and Good Will: The Story of the Quaker Oats Company* (1967). The Yellow Kid and Buster Brown are both discussed in Maurice Horn, *The World Encyclopedia of Comics* (1976), and Jerry Robinson, *The Comics: An Illustrated History of Comic Strip Art* (1974).

Several good books have been written on American slang, including Stuart Berg Flexner, *Listening to America* (1982), Harold Wentworth and Stuart Berg Flexner, *Dictionary of American Slang* (1975), and Charles E. Funk, *A Hog on Ice and Other Curious Expressions* (1948) and *Heavens to Betsy and Other Curious Sayings* (1955).

For a history of American cattle brands, see Ernest Staples Osgood, *The Day of the Cattleman* (1929), Oren Arnold and John P. Hale, *Hot Irons: Heraldry of the Range* (1972), Frank Reeves Sr., *A Century of Texas Cattle Brands* (1936), and Edward Everett Dale, *The Range Cattle Industry: Ranching on the Great Plains from 1865 to 1925* (1960).

Histories of the patent medicine business can be found in James Harvey Young, *The Toadstool Millionaires: A Social History of Patent Medicines in America Before Federal Regulation* (1961), Gerald Carson, *One for a Man, Two for a Horse* (1961), Henry W. Holcombe, *Patent Medicine Tax Stamps: A History of the Firms Using U.S. Private Die Proprietary Medicine Tax Stamps* (1979), and Sarah Stage, *Female Complaints: Lydia Pinkham and the Business of Women's Medicine* (1979). For background on some of the modern pharmaceutical companies see Tom Mahoney, *The Merchants of Life* (1954).

Frank Rowsome Jr., *The Verse by the Side of the Road: The Story of the Burma-Shave Signs and Jingles* (1965) is an entertaining book on the Burma-Shave signs, and includes a lengthy list of the jingles.

Histories of the tobacco industry can be found in Joseph C. Robert, *The Tobacco Kingdom* (1938) and *The Story of Tobacco in America* (1949).

A good history of beer-making and of the major beer brands can be found in Will Anderson, *The Beer Book* (1973), and for information about the early bourbon distilleries see Henry Crowgey, *Kentucky Bourbon: The Early Years of Whiskey-Making* (1971).

Fortune printed an article on chain stores in November 1934, and on Woolworth's (November 1933), and the A&P grocery stores (March 1933). For more information on chain stores and supermarkets, see Willard F. Mueller and Leon Garoian, *Changes in the Market Structure of Grocery Retailing* (1961), M.M. Zimmerman, *The Supermarket* (1955), and Godfrey M. Lebhar, *Chain Stores in America* (1962).

A good overview of the history of the American canning industry can be found in James H. Collins, *The Story of Canned Foods* (1924). Also of interest are F. Huntley Woodcock, *Canned Foods and the Canning Industry* (1938), Joe B. Frantz, *Gail Borden: Dairyman to a Nation* (1951), John D. Weaver *Carnation: The First 75 Years, 1899-1974* (1974), and Robert

C. Alberts, *The Good Provider: H. J. Heinz and his 57 Varieties* (1973).

For more information on soft drinks, see John J. Riley, *A History of the American Soft Drink Industry* (1972), Willard C. Martin, *Twelve Full Ounces* (1962), Roy W. Moore, *Down From Canada Came Tales of a Wonderful Beverage* (1961), Lawrence Dietz, *Soda Pop* (1973), and E.J. Kahn Jr., *The Big Drink: the Story of Coca-Cola* (1960).

A short history of the Minnesota milling business can be found in Dan Morgan, *Merchants of Grain* (1979), and James Gray, *Business Without Boundaries: The Story of General Mills* (1954) is a thorough company history.

The history of breakfast cereals is given in several company histories: Horace B. Powell, *The Original Has This Signature: W. K. Kellogg* (1956), Gerald Carson, *Cornflake Crusade* (1957), Arthur F. Marquette, *Brands, Trademarks and Goodwill: The Story of the Quaker Oats Company* (1967), William Cahn, *Out of the Cracker Barrel: The Nabisco Story* (1969), and General Foods Corporation, *General Foods Family Album* (1948).

John Salkin and Laurie Gordon, *Orange Crate Art* (1976) is an excellent book on the history of California fruit crate labels, and C.H. Kirkman Jr., *The Sunkist Adventure* (1975) provides a good history of the California Fruit Growers' Exchange.

For background on packaged bread, see William G. Panschar, *Baking in America* (1956), and Jack A. Cohon, *Bread Brands* (1949).

Max Boas and Steve Chain, *Big Mac: The Unauthorized Story of McDonald's* (1976) gives a lively history of McDonald's and some background on other chain restaurants. The official history can be found in Ray Kroc, *Grinding It Out: The Making of McDonald's* (1977). For the story of Kentucky Fried Chicken, see William Whitworth's article on Colonel Harland Sanders in the February 14, 1970 issue of the *New Yorker*.

Short histories of the major oil companies can be found in Anthony Sampson, *The Seven Sisters: The Great Oil Companies and the World They Shaped* (1975). Separate and more detailed histories can be found in books about the individual companies. Two that also discuss the company trademarks are Sinclair Oil Corporation, *A Great Name in Oil: Sinclair Through Fifty Years* (1966), and the Summer/Autumn 1961 issue of *Our Sun: A Magazine of the Sun Oil Company*.

Many books have been written on the history of the automobile industry, the railroads, and the airlines. Useful overviews include John B. Rae, *The American Automobile: A Brief History* (1965), John F. Stover, *American Railroads* (1961), O.S. Nock, *Railways of the U.S.A.* (1979), and Arch Whitehouse, *The Sky's the Limit* (1971). Interesting discussions of the Mack bulldog symbol can be found in Zenon C.R. Hansen, *The Legend of the Bulldog* (1974), and John B. Montville, *Bulldog: The World's Most Famous Truck* (1979).

Harry A. Cobrin, *The Men's Clothing Industry: Colonial Through Modern Times* (1970) provides a fascinating history of ready-made clothing. For more information on Levi-Strauss, see Ed Cray, *Levi's* (1978).

For a study of insurance company fire marks, see Alwin E. Bulau, *Footprints of Assurance* (1953).

A solid history of the publishing industry can be found in Charles A. Madison, *Book Publishing in America* (1966). For more information on paperback publishers, see Piet Schreuders, *Paperbacks, U.S.A.: A Graphic History, 1939–1959* (1981), and Thomas L. Bonn, *Under Cover: An Illustrated History of American Mass Market Paperbacks* (1982). Some interesting books on individual publishers and movie companies include Eugene Exman, *The House of Harper* (1967), Frank Jacobs, *The Mad World of William M. Gaines* (1972), Rochelle Larkin, *Hail Columbia* (1975), Leslie Halliwell, *Mountain of Dreams: The Golden Years of Paramount Pictures* (1976), J.G. Edmonds and Reiko Mimura, *Paramount Pictures and the People Who Made Them* (1980), and John Douglas Eames, *The MGM Story* (1975).

For information on the history of trade unions, see Henry Pelling, *American Labor* (1960), Joseph G. Raybeck, *A History of American Labor,* (1966), and M.B. Schnapper, *American Labor: A Pictorial History* (1972). For research into trade union labels, see the early issues of the *American Federationist* and the annual *AFL Official Book*.

Histories of fraternal organizations and their symbols can be found in Fred L. Pick and G. Norman Knight, *The Pocket History of Freemasonry* (1953), Allen E. Roberts, *The Craft and Its Symbols* (1974), Scottish Rite Masons' Museum of Our National Heritage, *Masonic Symbols in American Decorative Arts* (1976), Charles Edward Ellis, *An Authentic History of the Benevolent and Protective Order of Elks* (1910), and Ovid Miner, *Odd-Fellowship, Its Character and Tendencies, with Notes of Other Secret Societies* (1845).

Index

ABC, 208

Adams' chewing gum, 146

AFL-CIO, 212

After Dinner mints, 142

Air Canada, 36

Alcott, Joseph, 154

Alligator Bait whiskey and gin, 53

Alligator matches, 31

Allstate Insurance Company, 199

All Out fire extinguishers, 65

Amalgamated Wood Workers International Union of America, 212

American Airlines, 179–80

American Automobile Association, 217

American baking powder, 59

American Banknote Company, 201

American Broadcasting-Paramount Theaters, 208

American Express Company, 201

American Federation of Labor, 212

American files, 17

American Mutascope and Biograph films, 18

American Presidential Lines, 18

American Telephone & Telegraph Company, 162

American Tobacco Company, 61

American wire and cable, 58

American Youth Hostels, 217

Amoco petroleum products, 169

Amtrak, 12, 179

Ancient Mystic Order of Samaritans, 216

Andy Boy vegetables, 150–51

Angels' Food cakes, 140

Anheuser-Busch, Inc., 99

A O-K metal polish, 70

A&P grocery stores, 102

Apple computers, 165

Arby's restaurants, 158

Argo corn starch, 128

Arm & Hammer baking soda, 127

Armstrong paints, 183

Atchison, Topeka, and Santa Fe Railroad, 179

Atlanta Braves baseball team, 218

Atlanta Falcons football team, 219

Atlas paints, 182

Atomic Fireball candies, 145

A.T.&T., 162

Aunt Jemima pancake flour, 55

Aunt Sally baking powder, 54

Austin automobiles, 223

Ayer, N.W., & Son, 12, 129, 136–37, 180

Baby Ruth candy bar, 143

Badger corn, 26

Badger State beverages, 33

Bagley's Dandelion Compound, 36

Baker's chocolate, 112, 114

bald eagle, 16–19

Ballantine beer, 100

Baltimore & Ohio Rail Road, 177

Balton Sign Company, 160

Bantam Books, 203

Barnes, Edward L., 181

Barnum's Animals crackers, 137

Barraud, Francis, 163

Barreled Sunlight paints, 182

Bass, Saul, & Associates, 130, 162, 215, 182

Bass, Saul,/Herb Yager & Associates, 162, 214

Batter Up candy, 67

Bat tobacco, 66

Bayer, Herbert, 181

Bazooka bubble gum, 146

Beall, Lester, 37

Bear wheel service equipment, 175

Beats All erasers, 70

Beaver Brand cheese, 25

Beaver building paper, 31

Beaver gears, 32

Beaver State shakes, 40

Bee Brand spices, 129

Beech-Nut candies, 142

Beef Steak tomatoes, 51

Bell's seasoning, 128

Bell System, 162

Benevolent and Protective Order of Elks, 216

Benson, O.H., 77

Bernhard, Lucian, 197

Best Western hotels, 160

Betsy Ross flour, 23

Betty Crocker, 126

Bib, Mr., trademark for Michelin tires, 222

Bic pens, 190

Bicycle playing cards, 204

Big Blue B'ar soap, 33

Big Bonanza baking powder, 51

Big Boy restaurants, 155

Big-Deal tobacco, 72

Bininger's Pioneer bourbon, 47

Birds Eye frozen foods, 109

Cypress shingles, Clark, Fairhead & Co., Jacksonville, Florida, 1886

Bison Brand cotton seed oil, 28
Black Cat playing cards, 204
Black Jack chewing gum, 146
Black & White whisky, 224
Blue Pills for Blue People, Dr. Wilson's, 81
Blue Ribbon beer, 99
Blushing vegetables, 150
B&M Brick Oven baked beans, 105
Boatman's salmon, 109
Bob White fertilizer, 26
Boeing aircraft, 180
Boise Cascade Corporation, 37
Bon Ami polishing soap, 186
Bonnore's Electro Magnetic Bathing Fluid, 79
Boot & Shoe Workers Union, 210
Boraxo polishing soap, 187
Borden's condensed milk, 13, 107
Borzoi Books, 202
Boston Celtics basketball team, 220
Boston Red Sox baseball team, 218
Bow-Spring dental rubber, 57
Boys' Clubs of America, 215
Boy Scouts of America, 214
Breath-O-Pine cleaning disinfectant, 187
Brer Rabbit molasses, 31
Breyer's ice cream, 141
Bronco citrus fruit, 46
Brooklyn Bridge carbon paper, 42
Brooks Brothers, 193
Brotherhood of Railway Carmen of the United States and Canada, 212
Brown Moose boots, 24
Bubble Up soft drink, 119
Buckeye-Beckett papers, 36
Buckeye clover seed, 32; potatoes, 40; twine, 25

Buck's stoves, 32
Budweiser beer, 99
Buffalo Bills football team, 219
Buffalo Head fertilizer, 28
Buffalo measuring scales, 28; oars, 33
Buffalo Sabres hockey team, 221
Buffalo stock food, 28–29; tobacco, 28–29
Bugler tobacco, 94
Buick Motor Car Company, 173
Bull Durham tobacco, 8, 89
Bull Frog canned foods, 30
Bumblebee tuna, 109
Bunyan, Paul, 51
Burger King restaurants, 158
Burma-Shave shaving cream, 88
Burnett, Leo, 108
Buster Brown bread, 153; children's clothing, 196; shoes, 196
Buster peanuts, 138
Bust the Trust tobacco, 90
Buxom vegetables, 150
Byrne, J.J., 179

Calgary Flames hockey team, 221
California Bear vegetables, 40
Callard & Bowser candies, 222
Calumet baking powder, 59
Camel cigarettes, 90
Campbell's soup, 110
Camp Fire, Inc. (Campfire Girls), 214
Campfire marshmallows, 147
Campy, trademark for Campfire marshmallows, 147
Canada Dry ginger ale, 120
Caniff, Milton, 215
Cannon towels and sheets, 194
Capewell horse nails, 76
Capitol carbon paper, 23
Capitol Mills hosiery, 23

Capitol records, 23
Capo-Oil hair preparation, 87
Carnation condensed milk, 107
Carr, Franklyn J., 178
Carriage and Wagon Workers' International Union, 211
Carter, Joseph, 60
Carter's Little Liver Pills, 81
Carter's mucilage, 191
Cat's Paw soles, 197
cattle brands, 74–75
CBS, 208
Cedar Tree Brand fruit, 34
Chapman, Dave, & Associates, 175
Charlie, trademark for Star-Kist fish, 109
Chase Manhattan Bank, 12–13, 201
Chermayeff & Geismar Associates, 12, 169, 201
Cherokee coal, 58
Chesapeake and Ohio Railway, 178
Chessie System, 178
Chestnut Brand fish, 36
Chevrolet Motor Car Company, 174
Chevron petroleum products, 170
Chicago Bears football team, 219
Chicago Black Hawks hockey team, 221
Chicago Bulls basketball team, 220
Chicago Chief paints, 60
Chickasaw barrels, 61
Chicken Delight restaurants, 159
Chicklets chewing gum, 146
Chief of them All beverages, 57
Chinese Rat Destroyer poison, 56
Chiquita Banana, 152
Chrysler Corporation, 12, 174
Church & Co.'s soda, 127

The B.V.D. Patent SPIRAL Bustle.

Bradley, Voorhees & Day Manufacturing Company, New York City, 1885

Cigar Makers International Union, 210
Cinch tobacco, 69
Clabber Girl baking powder, 128
Clark, Florenz, 193
Clark, Frank, 193
Clark's Jumbo popcorn, 71
Clark's Three Cord thread, 194
Cleveland Cavaliers basketball team, 220
Cleveland Indians baseball team, 218
Cline, Elmer, 153
Cliquot Club soft drinks, 116
Cloth Hat & Cap Makers Union of Boston, 211
Coca-Cola, 12, 117
Cocaine, 83
Codo carbon paper, 190
Coffin Nail cigarettes, 92
Coiner, Charles, 180
Collins, Ashton, 164
Colman's mustard, 223
Colonel Glen whiskey, 157
Colonia, Johannes de, 137
Colt guns, 167
Columbia Broadcasting System, 208
Columbia Pictures, 207
Community Chests, 215
Consolidated safety oil, 168
Converse athletic footwear, 197
Cool as a Cucumber hats, 69
Coopers' International Union, 211
Coors beer, 101
Coppertone suntan cream, 188
Corn Belt corn, 41
Corno cereal, 132
Courtos, Tom, 181
Cracker Jack popcorn-and-peanut candy, 139
Crane papers, 191

Crayola crayons, 189
Cream of Wheat cereal, 7, 131
Creole rice, 125
Crocker, Betty, 126
Crockett, Davy, cigars, 44, whiskey, 64–65
Crushy, trademark for Orange Crush, 120
Cub Scouts, 214
Curtiss-Wright Corporation, 179
Cushman Cubs engines, 175
Custer coffee and vegetables, 44
Cutty Sark whisky, 224

Dale Brand fruit, 36
Dallas Cowboys football team, 219
Dandy paper bags, 53
Davidson, Carolyn, 197
Davis, Jeff, flour, 44–45
Davis, Perry, Vegetable Pain Killer, 8
Davy Crockett cigars, 44, whiskey, 64–65
Dead Red baseballs, 209
Deere, John, farm equipment, 76
DeKalb seeds, 78
Denver Broncos football team, 219
Denver Nuggets basketball team, 220
Department of the Interior Seal, 28
Detroit Pistons basketball team, 220
Detroit Red Wings hockey team, 221
Detroit Tigers baseball team, 218
De Long hooks and eyes, 195
Disney, Walt, Studios, 203
Dr. Brown's soft drinks, 120
Dr. Coderre's Red Pills for Pale and Weak Women, 81

Dr. Hess heave powder, 75
Dr. S.W. Kahn's hog medicine, 78
Dr. Pepper soft drink, 118
Dr. Scholl's foot remedies, 86
Dr. Williams' Pink Pills for Pale People, 81
Dr. Wilson's Blue Pills for Blue People, 81
Dr. Wood's Norway Pine cough syrup, 34
Dogongood stockings, 70
Domino sugar, 127
Donnelly, R.R., & Sons Company, 60
Dorland International, 181
Dorr, Fred E., 88
Double Header baseballs, 209
Doughboy flour, 65
Douglas Aircraft Company, 181
Douglas, W.L., shoes, 196
Dove tooth powders, 185
Drake's cakes, 140
Drayton, Grace Wiederseim, 110
Drink Water flour, 122
Dubble Bubble gum, 146
Duck Brand rubber boots, 32
Duke of Durham tobacco, 89
Dunkin' Donuts restaurants, 159
Durham tobacco, 8, 89
Dutch Boy paints, 183
Dwight, John, & Co.'s soda, 127

Eagle Brand condensed milk, 107
Eagle pencils, 191
Earl, Lawrence Carmichael, 183
Eastern Air Lines, 181
Easy Pickin toothpicks, 69
Edison, Thomas A., 164
Edmonton Oilers hockey team, 221
Egomatic egg candler, 77
Eight Hour Union gum, 146

McCrory Stores Corporation, New York City, 1938

Electric Brand cement, 167

Electrozone preparation, 80

Elgin watches, 161

Elks, Benevolent and Protective Order of, 216

Elmer's glue, 190

Elsie the Cow, trademark for Borden's condensed milk, 13, 107

Emmet Professional harmonicas, 53

Eskimo Pie frozen confections, 140

Esky, trademark for *Esquire* magazine, 205

Esquire magazine, 205

Esso petroleum products, 12, 168–69

Eureka seed corn, 50

Excelsior needles, 194

Exxon petroleum products, 168–69

Fahnestock's Vermifuge, 10

Fair & Square fertilizers, 72

Fan-Jaz beverages, 67

Fans cigarettes, 67

Farm Hand tomatoes, 150–51

Ficken, Dorothy, 133

Finer "N" Frog Hair furniture polish, 68

Fireman's Fund Insurance Company, 201

First Call pears, 65

First National Bank and Trust Company, 201

First National Bank of Louisville, 201

First Nines cigars, 66

Fisher Body Company, 174

Fisk Tire, 12, 177

Five Roses flour, 124

Flagg, James Montgomery, 22

Flexible Flyer sleds, 209

Flowers of Petroleum baldness cure, 87

Foot High vegetables, 150

Footprints tobacco, 95

Force wheat flakes, 133

Ford, George W., 182

Ford Motor Company, 173

Ford, William, 201

Foringer, Alonzo, 201

4-H Clubs, 77

Four Roses whiskey, 98

Fowler, Nathaniel, 200

Franklin Brand fruit and vegetables, 44

Franklin sugar, 43

Free for All fabrics, 20–21

Freemasons, 216

French's mustard, 135

Friends oats, 130

Frisby's May Cream cosmetic, 35

Frogline hats, 27

Fruit of the Loom, 193

Future Farmers of America, 78

Garrett's Hogg-Nogg hog remedies, 76

Gee Whiz liniment, 72

Gee-Whiz popcorn, 72

Gelb, Don, 203

General Electric, 162

George Washington tobacco, 43

Gerber baby foods, 111

Gerts Lumbard paint brushes, 183

Giffen, Burr E., 12, 177

Gillette razor blades, 88

Gilmor, J.D., & Company, 136

Girl Scouts of the U.S.A., 214

Glaser, Milton, 203

Gold Digger fruit, 49

Gold Dust washing powder, 52

Golden Boy citrus fruit, 150–51

Golden, William, 208

Gold Medal flour, 121

Good and Plenty candy, 145

Goodwill Industries, 215

Good Willy, trademark for Goodwill Industries, 215

Goodyear Tire & Rubber Company, 176

Gopher Brand flour, 31

Grand Slam ice milk product, 67

Grange, 78

Granger tobacco, 92

Granite Brand hames, 42

Grape Crush soft drink, 120

Great Dane trailers, 175

Great Seal of the United States, 18

Green, Adolphus, 136–37

Green Giant vegetables, 108

Green Mountain grapes, 50

Greyhound Corporation, 177

Gridiron hosiery, 67

Grit, 204

Grove's Yellow Kid chewing gum, 56

Gruenewald, Guido, 178

Gulf Oil, 170

Gust-O cereal, 72

Hair Root scalp treatment, 87

Hanff, Minnie Maud, 133

Hapgood, Theodore, 60

Harlequin Books, 203

Harper Brothers (Harper & Row), 202

Harry and David, 152

Hartford Fire Insurance Company, 198

Hartford Whalers hockey team, 221

Hartwell tool handles, 36

Hathaway shirts, 195

Hazelton, I.B., 116

Heart of America flour, 39

Registered Apr. 14, 1896.

HAWAIIAN HAIR ELIXIR.

ALOHA

THE WONDERFUL HAIR FORCER.

John W. Nelson, Lexington, Kentucky, 1896

Heinz foods, 106

Hellmann's Blue Ribbon mayonnaise, 135

Hells Angels motorcycle club, 217

Henley roller skates, 209

Heroin, 83

Heron Brand oranges, 25

Herpicide scalp remedy, 87

Hershey's chocolates, 142

Hewitt, Ogilvy, Benson and Mather, 195

Hiawatha corn, 57

Hickory tobacco, 34

Highway Beautification Act, 88, 93

Hills Bros. coffee, 114

Hires root beer, 116

His Master's Voice, 163

H-O cornflakes, 54

Holiday Inns, 160

Hollywood gin, 98

Holmes, Harry and David, 152

Homer Laughlin pottery, 17

Honest Dollar guano, 19

Honolulu Coffee Mills Kona coffee, 42

Horlick's malted milk, 113

Horse Collar Makers National Union, 210

Hostetter's Celebrated Stomach Bitters, 79

Hot Dan, trademark for French's mustard, 135

Houston Astros baseball team, 218

Houston Oilers football team, 219

Howard Johnson's restaurants, 154

Hudson's Bay Company, 24

Hunkidori cigars, 68; shoes, 68

IBM, 12, 165

Icy Point fish, 109

IGA grocery stores, 102

Imperial embalming fluid, 19

Indiana Pacers basketball team, 220

Indian River and Lake Worth Pineapple Growers Association, 50

Industrial Union of Marine & Shipbuilding Workers of America, 213

International Association of Lions Clubs, 217

International Brotherhood of Electrical Workers, 213

International Brotherhood of Teamsters, Chauffers, Warehousemen, and Helpers of America, 213

International Business Machines, 12, 165

International Harvester Company, 12, 77

International Ladies' Garment Workers' Union, 213

International Molders and Allied Workers Union, 213

International Paper Company, 37

International Typographical Union, 210

Iron Brand collars, 40

Iron Clad paints, 64

Iron Stone earthenware, 28–29

Irvin, Rea, 205

Iten's O-Boy-O cakes, 139

Ivory soap, 185

Jack Daniel's Old No. 7 whiskey, 97

Jack Rabbit flour, 30

Jackson, Stonewall, flour, 44–45

Jantzen swimwear, 193

Javarye coffee compound, 112

Jeff Davis flour, 44–45

Jefferson, Thomas, 9–10

Jenson, Nicolas, 137

Jim Dandy OK molasses, 70

John Deere farm equipment, 76

John Doe tobacco, 68

John Hancock Mutual Life Insurance Company, 200

Johnnie Walker whisky, 224

Johnson outboard motors, 175

Johnson & Johnson, 85

Jonah sperm oil, 168

Juicy Fruit chewing gum, 147

Jumbo Brand canned food, 71

Jumbolene lotions, 71

Just-A-Drop whiskey, 97

Kahn's hog medicine, 78

Kansas Maid flour, 123

Kellogg's cereals, 132–33

Kelly, W.C., axes, 166

Kentucky Colonel tobacco, 157

Kentucky Fried Chicken restaurants, 157

Kentucky Wonder flour, 40

Kent, Rockwell, 60, 202–3

Kenwood wool products, 26

Kernels cigars, 27

Kickapoo Indian medicines, 82

Kilmer, Dr. S. Andral, remedies, 80

King Arthur flour, 123

King-Casey, Inc., 198

King flour, 124

Kirin beer, 224

Kitchen Queen flour, 123

Kiwanis International, 217

Kiwi boot polish, 223

Knopf, Alfred A., 202

Knox gelatine, 53

Koko hair preparation, 87

Kontir, Richard, 200

Michigan Milk Products Association, Traverse City, Michigan, 1960

A.A. Ulman, St. Louis, Missouri, 1885

Kool-Aid, 115
Kool cigarettes, 95
Kornelia Kinks, trademark for H-O cornflakes, 54
Kuhn's paints, 182

La Belle Chocolatiére, 112
La Hunkidori cigars, 68
Land O' Lakes butter, 63
Landseer, Sir Edwin, 198
Lang's Takes the Cake icing, 69
Lariat flour, 49
Laugh at Mice exterminator, 56
Lava soap, 187
Lee blue jeans, 192
Lee & Young Communications, 200
Lemon Smash soft drink, 119
Lemon-Up soft drink, 119
Let's Go America shirts, 65
Lever Brothers soap, 185
Levine, Huntley, Schmidt, Plapler & Beaver, 181
Levi Strauss & Co., 192
Lewis-Shephard machines, 164
Lexington electrical apparatus, 22
Leyendecker, J.C., 60, 131
Libby, McNeill & Libby corned beef, 108
Liberty Bell toilet paper, 19
Liberty rice, 23
Liberty skin purifier, 17
Lifebuoy soap, 187
Life Savers candies, 145
Lincoln Cork Faced horse collars, 44
Lincoln paints, 44
Lions Clubs, International Association of, 217
Lippincott & Margulies, 12, 37, 84, 111, 167, 174, 179, 181
Lipton tea, 113
Lithocarbonized articles, 19

Litofuge compound, 161
Little Debbie cakes, 140
Little's Original Ointment for Sweaty Feet, 86
Little Tavern Shops, 155
Loewy, Raymond, 12, 77
Loewy, Raymond, Associates, 180
Loewy, Raymond,/William Snaith, Inc., 169
Log Cabin syrup, 134
Lone Star peanuts, 41
Longhorn gaskets, 49, wagons, 48
Los Angeles Lakers basketball team, 220
Los Angeles Raiders football team, 219
Los Angeles Rams football team, 219
Lucky Strike cigarettes, 12, 91
Lulu of Waterloo scouring powder, 70
Lu-Lu popcorn, 70
Lumen alloys, 25
Lynn-Fieldhouse agency, 141

McCormick spices, 12, 129
McDonald's restaurants, 156
McKinley's "Jumbo" grapes, 71
McKinney, Henry N., 136
Mack Trucks, 175
McMein, Neysa M., 126
Made in U.S.A. shoes, 20–21
Mad magazine, 205
Mahin, John Lee, agency, 107
Mail Carrier boots, 197
Mail Pouch tobacco, 92
Make-Um-Lay poultry powder, 77
Mallard pencils, 191
Maple City soap, 35
Mar, Helen, 107
Marathon petroleum products, 170

March vegetables, 65
Mars almond bar, 144
Martha Washington sugar, 43
Martha White flour, 124
Marvel Mystery oil, 172
Mary Jane bread, 153; candy bar, 143
Masons, 216
Master locks, 166
Masury, A.F., 175
Maxwell House coffee, 114
Mazola corn oil, 128
Medusa cement, 167
Mennen skin care products, 186
Mercedes-Benz automobiles, 223
Merrill Lynch & Co., 198
Mess Pork hog medicine, 75
Metro-Goldwyn-Mayer, 206–7
Miami Dolphins football team, 219
Michelin tires, 222
Miles shoes, 49
Miller High Life beer, 100
Millet, Jean François, 199
Milwaukee Bucks basketball team, 220
Mingo, Norman, 205
Minnehaha coal, 63
Minnesota Twins baseball team, 218
Minuteman tapioca, 64
Miss America vegetables, 38
Missouri Bear waterproof clothing, 32
Missouri Mule work gloves, 195
Miss Sunbeam, trademark for Sunbeam bread, 153
Mr. Bib, trademark for Michelin tires, 222
Mr. Clean cleaner, 188
Mr. Donut restaurants, 159
Mr. Peanut, 138

Mobil petroleum products, 13, 169

Moccasin canned goods, 35

Modern-Mother pie crust, 125

Mogen David wine, 100

Monarch of the Glenn, 198

Monkees, 208

Monteith, Charles N., 180

Montreal Canadiens hockey team, 221

Moon Pie marshmallow sandwich, 140

Moosehead beer, 25

Morton Salt, 12, 129

Mother Hubbard flour, 124

Moxie soft drink, 119

Mug-Wump Specific, 79

Munyon's Paw-Paw pills, 34

Mutual of Omaha Insurance Company, 199

M&M's candies, 144

Nabisco, 11, 136–37

Nash, Jim, 12, 129–30, 169

Nast, Thomas, 21

Nathan's Famous hot dogs, 159

National Airlines, 181

National Biscuit Company, 11, 136–37

National Broadcasting Company, 208

National Life Insurance Company, 200

National Park Service, 58

National Shawmut Bank of Boston, 61

Nation-Wide foods, 39

Nationwide Insurance Companies, 200

Nation Wide overalls, 39

NBC, 208

Necco wafers, 144

Neubauer, Robert G., 105

Neuman, Alfred E., trademark for *Mad* magazine, 205

Newburgher pantaloons, 192

New Orleans syrup, 53

New wire screens, 50

New Yorker, The, 205

New York Islanders hockey team, 221

New York Mets baseball team, 218

New York Yankees baseball team, 218

Nickeline stove polish, 52

Nigger Head Brand fruit and vegetables, 52

Nike running shoes, 197

Nine Lives batteries, 164

Nipper, trademark for RCA, 13, 163

No Humbug cigars, 70

Northern Pacific Railway, 179

Noyes, Eliot, 164, 169

Nufangl trousers, 69

Ogilvy, David, 195

Oh Henry! candy bar, 143

Oilzum lubricant, 172

Old Abe cigars, 43

Old American asphalt roofing, 58

Old Crow whiskey, 96

Old Dutch cleanser, 184

Old Faithful water colors, 42

Old Grand-Dad whiskey, 97

Old Kentucky Colonel whiskey, 157

Old "Pig Iron" paints, 183

Old Spice toiletries, 88

Old Virginia Log Cabin tobacco, 54

Olympia beer, 101

Olympic flour, 122

O'Neill, William, 12

1000 Mile axle grease, 38

On Track cigars, 69

Operative Plasterers' and Cement Masons' International Association, 212

Orange Crush soft drink, 120

Orange Julius soft drink, 115

Order of Red Men, 217

Oriole remedies, 33

Orlick pipes, 94

Our Country's Pride cheroots, 16

Outcault, R.F., 56, 196

Out O Sight traps, 72

Oxidental glue, 48

Pabst Brewing Company, 99

Pan American Airways, 181

Pan-Handle flour, 41

Panmalt coffee, 49

Papert, Koenig and Lois, 181

Paquita Lily toilet articles, 37

Paramount Pictures, 206

Paul, Arthur, 205

Paul Bunyan lumber, 51; vegetables, 51

Pears soap, 222

Pedolatum ointment, 86

Peet's Crystal White soap, 186

Pegasus petroleum products, 13, 169

Pelican yeast, 33

Penguin Books, 203

Peninsular milk, 41

Penn-Pakt vegetables, 40

Pennsylvania Railroad Company, 178

People Express, 181

Pep Boys, Manny, Moe & Jack, 172

Pepperidge Farm baked goods, 153

Pep-Pop popcorn, 141

Peppy, trademark for Wise potato chips, 141

Pepsi-Cola, 118

New York Advertising Sign Co., New York City, 1876

Perfection wafers, 136
Peterson, Lorraine Colett, 149
Petersons pipes, 94
Philadelphia Eagles football team, 219
Philadelphia Flyers hockey team, 221
Philadelphia 76ers basketball team, 220
Phillip Morris cigarettes, 95
Phillips 66 petroleum products, 171
Piggly Wiggly grocery stores, 102
Pig 'N Whistle restaurants, 155
Pig Stands restaurants, 159
Pillar Rock salmon, 38
Pillsbury Doughboy, 122
Pillsbury's Best XXXX flour, 122
Pine Cone boots, 35
Pinene medicated plasters, 25
Pinkham, Lydia, 83
Pink Pills for Pale People, Dr. Williams', 81
Pioneer cheroots, 46, macaroni, 47
Pitney-Bowes postage meters, 18
Pittsburgh Penguins hockey team, 221
Pittsburgh Pirates baseball team, 218
Pizza Hut restaurants, 158
Planters Nut and Chocolate Company, 138
Playboy magazine, 205
Plymouth Rock gelatin, 23
Pocket Books, 203
Poland Spring water, 116
Polo boot blacking, 52
Pontiac Motor Division, 174
Porcupine Chop teas, 33
Porter Bros. fruit, 148
Possum sardines, 27
Postum Cereal food drink, 132

Potocnick, Frank, 200
Potomac coffee, 39
Powhattan, trademark for the American Tobacco Company, 61
Prairie Farmer, 204
Prairie Flower flour, 36
Prall's Horse colic capsules, 77
Pringle potato chips, 141
Procter & Gamble, 9, 184–85, 187–88
Provident Trust Company, 199
Prudential Insurance Company, 13, 200
Psyche at Nature's Mirror, 116
Puritan paints, 41
Putnam Fadeless dyes, 64

Quaker Oats, 130

Radam's Microbe Killer, 80
Radio Corporation of America, 13, 163
Rag tobacco, 71
Rainier beer, 101
Ralston cereal, 134
Ralston Purina Company, 12, 134
Rand, Paul, 12, 164–65
Random House, 203
Rarin' to Grow seeds, 48
Razorback tools, 27
RCA, 13, 163
Red Cheek apple juice, 115
Red Cloud tobacco, 62
Red Cross trademark, 85
Reddy Kilowatt, 164
Red Eye tobacco, 95
Red Fox flour, 26
Red Horse tobacco, 92
Red Men, Order of, 217
Red Pills for Pale and Weak Women, Dr. Coderre's, 81
Red Warrior axes, 61

Remington, Mortimer, 200
Remington typewriters, 190
Revere Ware cooking utensils, 44
Reynolds aluminum, 166
River Brand rice, 125
Riverside Navel Orange Company, 20–21
RKO Radio Pictures, 207
Robin's Best flour 26
Robinson, Frank, 12, 117
Rodeo clothing, 48
Rolling Stones, 208
Ross, Betsy, flour, 23
Rotary International, 217
Rough on Rats exterminator, 56
Rough Rider axle grease, 65
Royal baking powder, 128, sewing machines, 60
Royer, H., leather, 47
Ruppert Knickerbocker beer, 100
Rushmore Brand smoked meats, 42
Rushmore Mutual Life Insurance Company, 42
Ruzicka, Rudolph, 202

Safeway grocery stores, 103
St. Jacob's Oil, 79
St. Louis Cardinals baseball team, 218
Salada tea, 113
Salvation Army, 215
Samaritans, Ancient Mystic Order of, 216
Samson Cordage Works, 166
Samson pants, 192
Sanders, Harland, 157
Sandgren & Murtha, 37, 169
Sanford's ginger, 54
Sani-Flush toilet bowl cleaner, 188
Santa Fe Railroad, 179

Standard Oil Co. of New York, New York City, 1907

San Antonio Spurs basketball team, 220

Savage Arms, 62

Schlitz beer, 100

Scholl, Dr. William M., 86

Scotch Brand tape, 190

Scott's Emulsion, 81

Scout tobacco, 47

Seagram's Seven Crown whiskey, 98

Sea Lion sardines, 32

Sears, Jack, 149

Seattle Seahawks football team, 219

Segner, Ellen, 153

Selame Design Associates, 159, 215

Selz boots and shoes, 197

Seraglio, Francesco, 195

Seven Crown whiskey, 98

7-Up soft drink, 119

Shawmut flour, 58

Sheboygan beverages, 57

Shell Oil, 171

Sherwin-Williams paints, 12, 182

Short Stop medicinal preparations, 66

Silent Sentinels electrical relays, 62

Sinclair petroleum products, 171

Singer sewing machines, 161

Skookum apples, 149

Sledge Hammer lye, 187

Sleepy Bear, trademark for Travelodge motels, 160

Smith Brothers' cough drops, 85

Smith, Dean, 37

Smith, Dorothy Hope, 111

Smokey Bear, 30

Smyth, Emery Thomas, 169

Snake Oil Liniment, 82

Snap, Crackle and Pop, trademark for Kellogg's Rice Krispies, 133

Snapper lawn mowers, 30

Snow Crop frozen food, 109

Snow Lily flour, 124

Son of a Gun pistols, 71

Soule, Louis H., 186

Southern Colonel coal, 157

Southern Comfort liqueur, 98

Sower, The, 199

Spalding sports equipment, 209

Speedball beverages, 67

Sphinx papers, 191

Sprucine chewing gum, 35

Square Deal bread, 72

Squibb, E.R., & Sons, 84

Squirrel Brand nuts, 27

Staale, Albert, 30

Stanley, Clark, Snake Oil Liniment, 82

Star Dust fruit, 150–51

Star-Kist fish, 109

State of California potatoes, 41

State-O-Maine fish, 40

Stetson hats, 194

Stewart Morrison Roberts, Ltd., 36

Stonewall Jackson flour, 44–45

Stouffer's frozen food, 111

STP oil additive, 172

Strauss, E.A., 184

Sulz-Bacher veterinary liniment, 78

Sunbeam bread, 153

Sunkist citrus fruit, 148

Sun-Maid raisins, 149

Sunny Jim, trademark for Force wheat flakes, 133

Sunoco petroleum products, 170

Sun-Rapt citrus fruit, 152

Supremes, 208

Swaim's Panacea, 79

Swamp Root, Dr. Kilmer's, 80

Swan laundry soap, 185

Sweeping the Nation sweeping compound, 39

Sweetheart of the Corn, trademark for Kellogg's corn flakes, 132

Sweet Cob tobacco, 92

Tabasco pepper sauce, 135

Tack-Maker's Protective Union of the United States and Canada, 212

Tar Heel whiskey, 41

Tater State potatoes, 40

Taylor, Hilda, 126

Teamsters, International Brotherhood of, 213

Tenacity binders, 189

Tennessee Statesman tobacco, 44

Texaco petroleum products, 170

Texas cement, 41

Texas Instruments, 165

Texas Pete hot sauce, 135

Texas Rangers baseball team, 218

Thomas' inks, 189

Thompson, J. Walter, agency, 200

1000 Mile axle grease, 38

3-in-One oil, 172

3 Musketeers bar, 144

Thumann, Paul, 116

Tidy Touch carbon paper, 190

Tilley, Eustace, trademark for The New Yorker, 205

TNT popcorn, 141

Tom, Dick and Harry cigars, 95, soap, 68

Tony the Tiger, trademark for Kellogg's Sugar Frosted Flakes, 133

Tootsie Roll candy, 143

Toronto Maple Leafs hockey team, 221

Totem Pole foods, 59

Crystaline Salt Company, Boston, Massachusetts, 1893

Towle's Log Cabin syrup, 134
Townsend Brothers oysters, 104
trademark law, 9–11
Trans World Airlines, 12, 179–80
Travelers Insurance Company, 199
Travelodge motels, 160
Treesweet juices, 115
Tropicana citrus products, 115
Trotta, Vincent, 206
Trublu citrus fruit, 148
Tru-Type citrus fruit, 59
Tschichold, Jan, 203
Tulepo hair restorer, 87
Turkey coffee, 31
TWA, 12, 179–180
Twentieth Century-Fox Film Corporation, 207
24-Hour Corn Cure, 86
"23 Skidoo" metal polish, 71
Two Johns tobacco, 94
Two Leaf paper towels, 35

Uncle Ben's Converted Brand rice, 125
Uncle Sam, 17, 20–22; ale, 22; cleanser, 22; coffee, 21; exterminating chemicals, 20–21; recruiting poster, 22; shoes, 20–21
Underwood canned food, 105
Uneeda biscuits, 11–12, 136–37
union labels, 210–13
Union malt liquor, 19
Union Pacific Railroad, 178
United Airlines, 179–80
United Association of Journeymen and Apprentices of the Plumbing and Pipe Fitting Industry of the United States and Canada, 213
United Brotherhood of Carpenters and Joiners of America, 213

United Brotherhood of Leather Workers, 211
United Farm Workers Organizing Committee, 213
United Garment Workers of America, 211
United Hatters of North America, 210
United Mine Workers of America, 212
United States Postal Service, 19
United States Steel Corporation, 12, 167
United Way of America, 215
Universal barb wire liniment, 75
Upjohn's Friable Pills, 84
Utah Jazz basketball team, 220

Vancouver Canucks hockey team, 221
Van de Kamp's frozen food, 111
Ventura Maid citrus fruit, 150
Vermont's Pride syrup, 134
Viking Press, 202
Virginia Commonwealth Bankshares, 201
Volkswagen automobiles, 223
Voorhees, Walker, Foley and Smith, 162

Wachusett sheetings, 61
Wackendorf's May Apple Alterative, 37
Walt Disney Studios, 203
Waltham watches, 161
Wampum canned goods, 57
Warner Brothers Pictures, 207
Washington Bullets basketball team, 220
Washington "Dee-Cee" clothing, 43
Washington, George, tobacco, 43
Washington, Martha, sugar, 43

Washington oranges, 44–45
Washington Redskins football team, 219
Washington shirts, 195
Wayagamack wood pulp, 63
Weicker, Theodore, 84
Wells Fargo Bank, 49
Wendy's restaurants, 158
Werner, Rex, 180
Western Delight flour, 48
Westgate, Oscar, 135
Westinghouse Electric Corporation, 164
West Virginia Mail Pouch tobacco, 93
Westward Ho tobacco, 46
Weyerhaeuser Company, 12, 37
Wheel In Your Head? headache tablets, 80
White Castle restaurants, 155
White Dough flour, 123
White Horse whisky, 224
White House apple cider, 39
White Owl cigars, 94
White Rock mineral water, 116
Whitman's Sampler chocolates, 144
Wiederseim, Grace, 110
Wild Pigeon mineral water, 27
Willie the Penguin, trademark for Kool cigarettes, 95
Wills, Childe Harold, 173
Winn-Dixie grocery stores, 102
Winona gloves, 63
Wise potato chips, 141
W.M. barbed wire, 75
Wolf furnishings, 31
Woman's Choice washing powder, 188
Wonder bread, 153
Woodbury's soap, 186
Woodstock concert, 208

Sheet music, P.J. Howley & Co., New York City, 1893

Woolmark, 195
Woolworth stores, 103
Wrangell, George, 195
Wrigley's chewing gum, 147

Yaller Kid candy, 56
Yankee Doodle macaroni, 20–21
Yankee Girl tobacco, 92
Yankee popcorn, 22
Yellow Kid, 56
Yook, Rudolph, 183
Young, Edward, 203
Young & Rubicam, 118

Zenith electrical apparatus, 164
Zu Zu ginger snaps, 137